SCULPTING FROM THE IMAGINATION:
ZBRUSH

3DTOTALPUBLISHING

SCULPTING FROM THE IMAGINATION:
ZBRUSH

3DTOTAL PUBLISHING

Correspondence: publishing@3dtotal.com
Website: www.3dtotal.com

Every effort has been made to ensure the credits and contact
information listed are present and correct. In the case of
any errors that have occurred, the publisher respectfully
directs readers to the **www.3dtotalpublishing.com**
website for any updated information and/or corrections.

First published in the United Kingdom,
2016, by 3dtotal Publishing.
3dtotal.com Ltd, 29 Foregate Street, Worcester,
WR1 1DS, United Kingdom.

Soft cover ISBN: 978-1-909414-33-4
Printing and binding: Everbest Printing (China)
www.everbest.com

Visit **www.3dtotalpublishing.com** for a
complete list of available book titles.

Editor: Marisa Lewis
Proofreader: Melanie Smith
Lead designer: Imogen Williams
Cover designer: Matthew Lewis
Designer: Joe Cartwright
Managing editor: Simon Morse

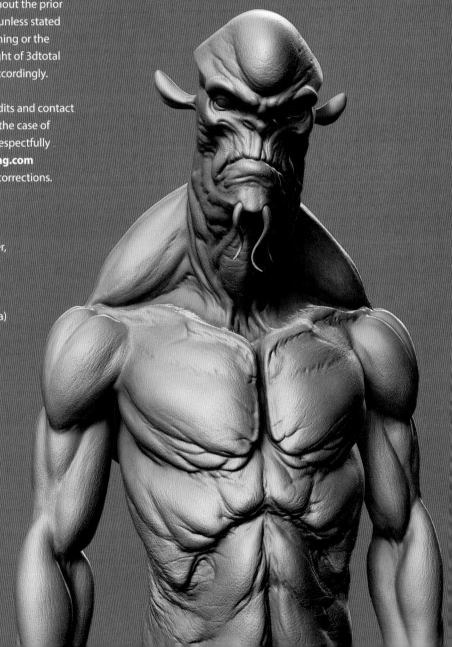

Right-hand image © Andy Chin

CONTENTS

INTRODUCTION

The act of sketching is a fundamental stage of every visual art. It's about capturing that spark of an idea before it gets away, and laying the foundation for bigger things. What you sketch *with* doesn't really matter – pen, pencil, traditional or digital, two dimensions or three – because that motivating spirit of curiosity is something that every artist has in common.

It hasn't always been easy for artists to spontaneously explore and experiment in 3D, with the measured art of polygon modeling not lending itself to a loose and "sketchy" approach. But Pixologic's ZBrush software has changed the landscape of 3D art, offering an intuitive way for artists – often from a traditional or 2D background – to step into the world of 3D, unlocking a whole world of creative potential that they might otherwise have missed.

Now, instead of modeling with vertices and faces, artists can work with digital clay that they can squash, stretch, cut, and carve, making discoveries through trial and error, just like a physical sculpture. ZBrush's approach is perfectly suited to rough, organic subject matter, making it a tool of choice for character and creature artists, whether they're students or professionals designing for films, games, and TV.

Like a drawing on paper, a ZBrush sketch can be an end in itself, or just the first step of a long, complex pipeline involving other tools or people. We love the pure simplicity of the ZBrush clay sculpt, and have dedicated this *Sketching from the Imagination* sequel to that stage of the process. We've gathered 50 brilliant 3D artists in this book to share their digital clay creations, from quick lunch-break sculpts to ongoing labors of love, and hope you enjoy this insight into their ideas as much as we do.

Marisa Lewis
Editor
3dtotal Publishing

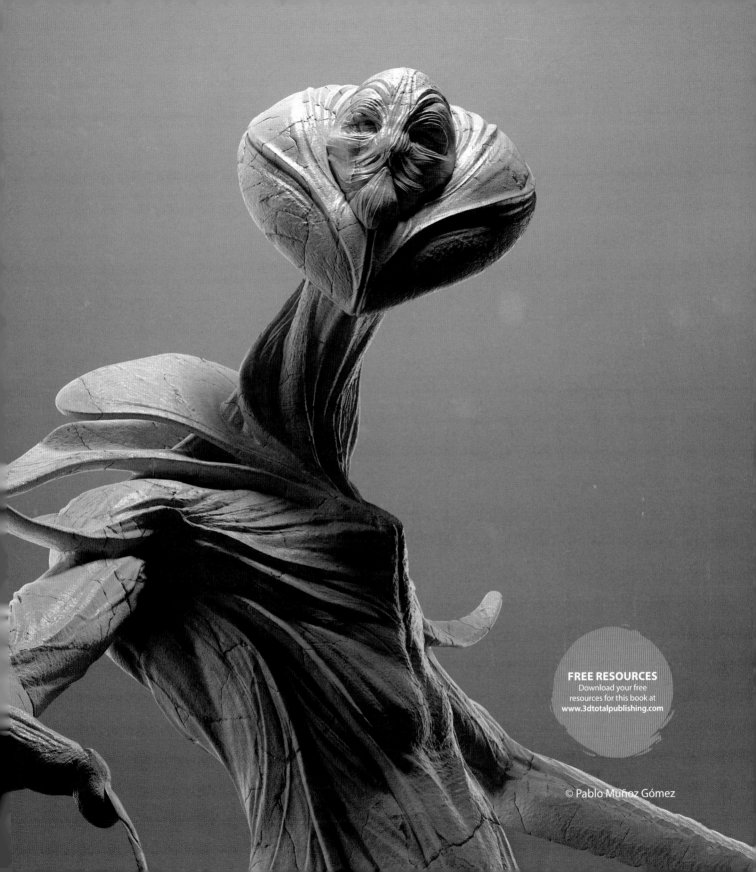

© Pablo Muñoz Gómez

ABDOULLINA, Taissia

www.bleuacide.artstation.com
All images © Taissia Abdoullina

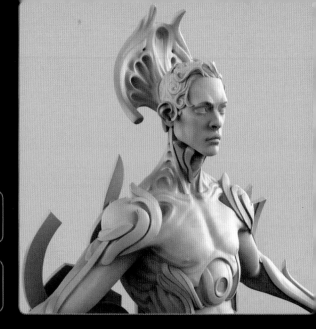

have been drawing for as long as I can remember, although I never took t seriously until in my early twenties, and I wish I hadn't waited that long. I am originally a 2D artist and I started doing 3D about three years ago and never stopped since. I am mainly self-aught, both in drawing and modeling, and am still learning every day.

NSPIRATION & IDEAS

deas can come from anywhere: fashion, movies, books, comics, music, history, nature, people in the streets. Anything and everything I can observe gets processed, altered, partly forgotten, mixed all together, and sometimes interesting things pop out of that. Some ideas need to be put on "paper" as color, light, and line. But other things just want to be "made," and even if they aren't as real in 3D as

a handmade object, it gives them a fast and efficient path into existence.

TOOLKIT

My favorite software packages are ZBrush, TopoGun, and 3ds Max, that's my basic modeling toolset. I mainly use the most common brushes; I like simple and efficient tools that get you straight to the point. I prefer to concentrate less on which tool I should be using and what it allows me to do, and more on what exactly I am sculpting.

SCULPTING WORKFLOW

My favorite workflow consists of starting with a simple primitive in ZBrush and messing around in DynaMesh mode. Figuring out how to quickly get from virtually nothing to my base shape is really fun and it's a good way to understand shapes better

Once I am done with a rough sculpt, I use ZRemesher on it to get a really clean base to work on further. I like to keep the number of polygons as low as possible to be able to get very smooth dynamic shapes, avoid artifacts, and keep the surface from looking like an agglomeration of melted wax.

"ANYTHING AND EVERYTHING I CAN OBSERVE GETS PROCESSED, ALTERED, PARTLY FORGOTTEN, MIXED UP ALL TOGETHER, AND SOMETIMES INTERESTING THINGS POP OUT OF THAT"

This page: A mecha design inspired by Greek mythology, Art Nouveau, and ancient Egypt.

Right-hand page: A big bad lizard

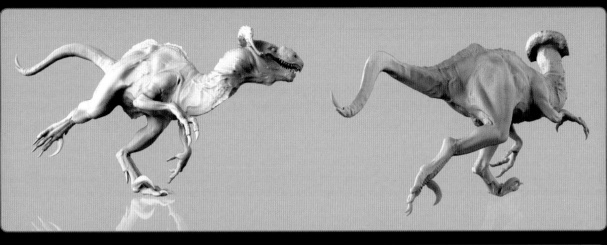

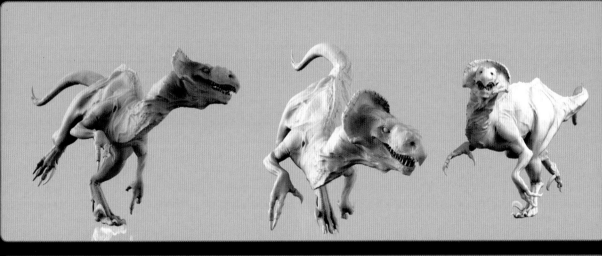

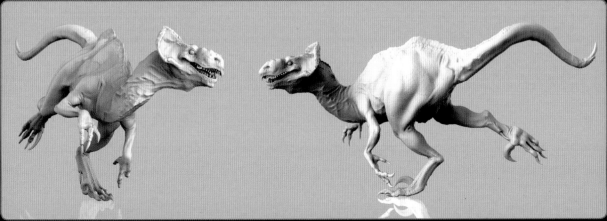

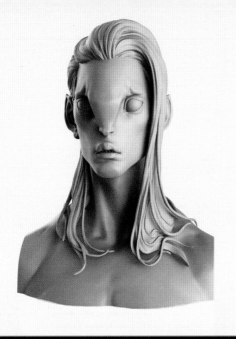

Left-hand page: A slightly stylized creature face with a very particular skull structure. The first time I attempted to sculpt this character, it was my first try at digital sculpting and honestly it was quite dreadful. I made a couple more versions of it afterwards and I'll probably keep doing that from time to time until there is nothing left to change. Although reaching that point may never happen – you can always evolve further.

This page: A rather fresh zombie face. It was meant to be quite realistic and completely original, so it isn't based on any particular reference.

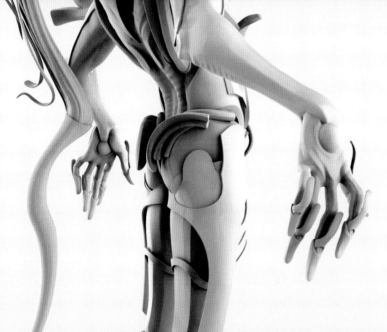

"I MAINLY USE THE MOST
COMMON BRUSHES; I LIKE
SIMPLE AND EFFICIENT
TOOLS THAT GET YOU
STRAIGHT TO THE POINT"

Both pages: A statue design with
organic vegetation-like shapes
inspired by stag imagery.

Both pages: Exploring shapes, styles, and attitudes in 3D helps me define a character design better. Even if you already have it sketched and basically worked out, when sculpting you generally realize that the drawn concept contains mistakes or impossible combinations of shapes. You have to make choices about what to keep or alter. Sometimes you'll stumble upon something even better than the original, or sometimes you'll have to start over and rethink the whole thing.

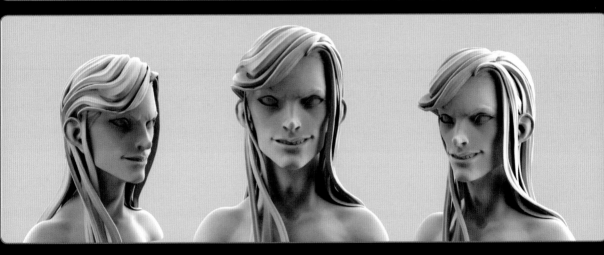

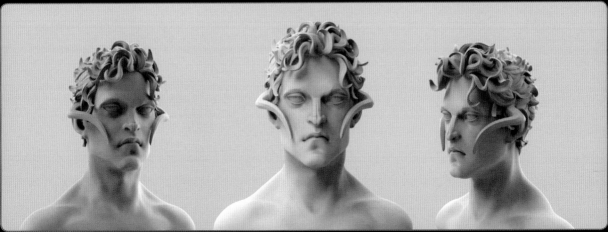

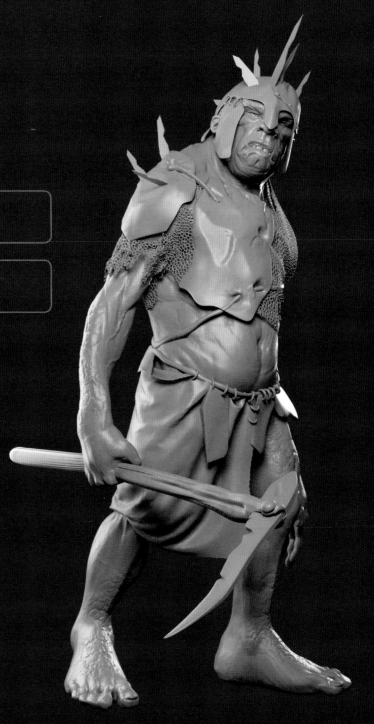

ALBA, Ruben

www.rubenalba.com
All images © Ruben Alba

I am relatively new to using ZBrush as a tool to sketch and polish my designs. I knew about this software a long time ago but I never had the chance to give it a try. When I realized that ZBrush could be a key tool in my design process, I began to be more and more interested in knowing about it. It was a great surprise to find that introducing this software to my workflow was complementary with other concept art techniques that I use, such as silhouette exploration, grayscale detailing, and "photobashing."

The learning process with this software was really amazing and still is! Each day I find something new about it. Being able to explore new design techniques within ZBrush just makes it more and more fun to use. It allows me to quickly generate ideas and visualize each aspect of the design really easily. Nowadays, the more information you give to the design and production pipeline, the better. ZBrush is in my opinion one of the fastest and easiest ways to make the design happen. It's a

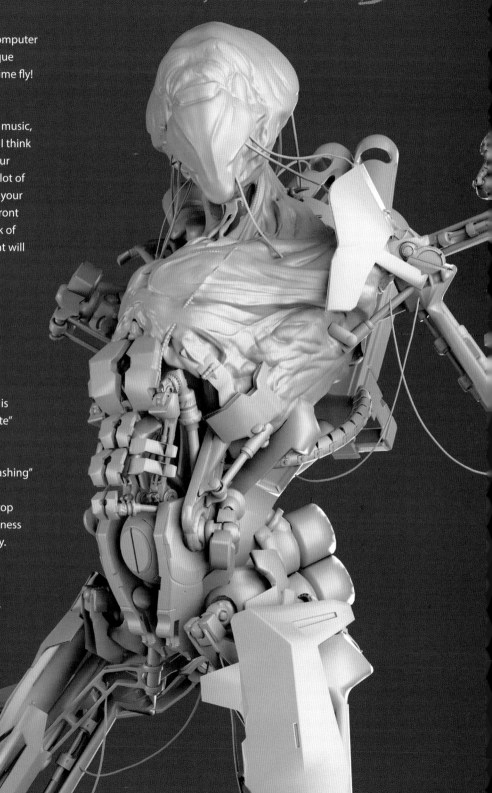

truly artistic software tool that merges computer graphics and traditional art with the unique power of making your imagination and time fly!

INSPIRATION & IDEAS

Most of my inspiration comes from films, music, family, personal experiences, traveling… I think being a concept artist is a way of life – your brain is always working and you spend a lot of time looking for a spark that switches on your inspiration. ZBrush helps you to relax in front of the computer and transform this "spark of inspiration" into quick sculpt sketches that will allow to you to feed your design process.

TOOLKIT

I don't use a lot of tools within ZBrush during the sketching process. The most important brushes for me are Move, Clay Buildup, and Dam Standard.

I also activate the DynaMesh option. This is a great feature that allows you to "generate" geometry without losing mesh density.

Sometimes I sketch in ZBrush using "kitbashing" by creating Insert Mesh brush libraries. With this special feature I can drag and drop geometry previously created, adding richness to the sketch in a very simple and fast way.

Left: I masked and extracted meshes from the ogre's body to create armor plates and clothes.

Right: I used the Curve Tube brush to create wires and details on this character.

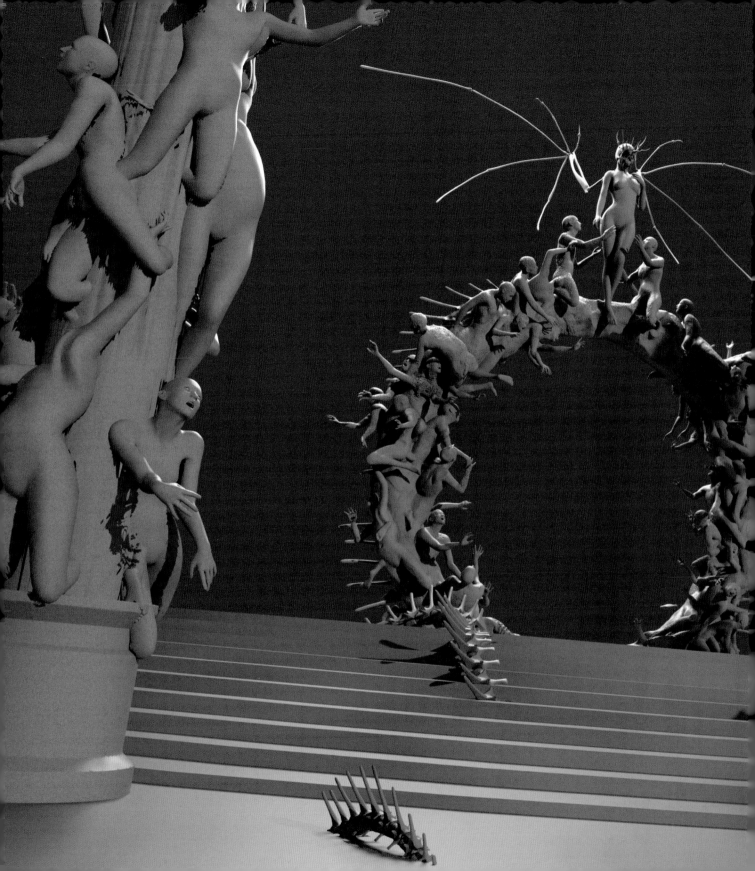

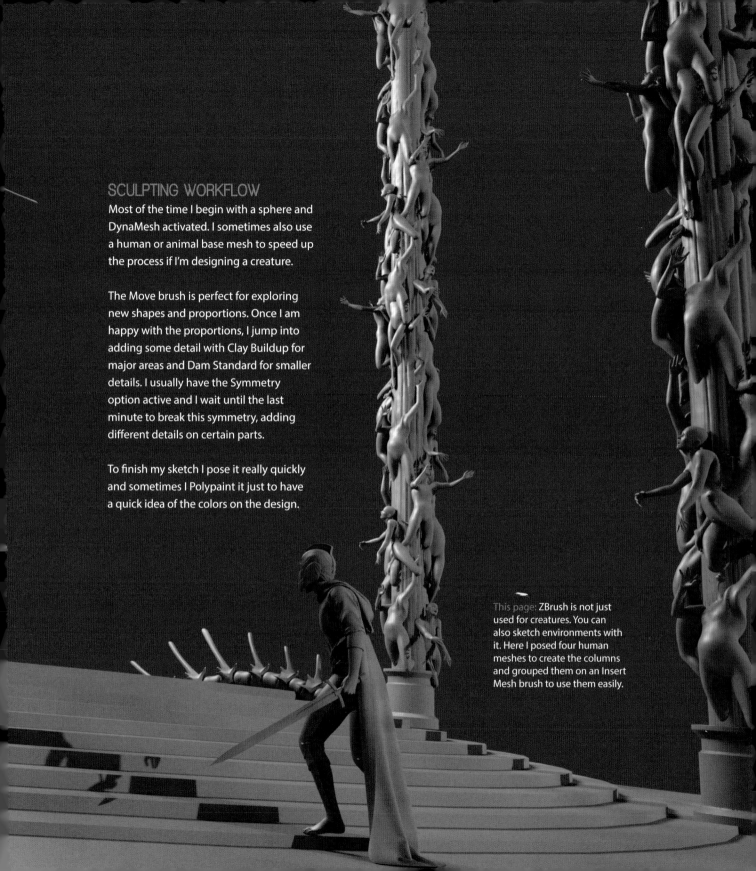

SCULPTING WORKFLOW

Most of the time I begin with a sphere and
DynaMesh activated. I sometimes also use
a human or animal base mesh to speed up
the process if I'm designing a creature.

The Move brush is perfect for exploring
new shapes and proportions. Once I am
happy with the proportions, I jump into
adding some detail with Clay Buildup for
major areas and Dam Standard for smaller
details. I usually have the Symmetry
option active and I wait until the last
minute to break this symmetry, adding
different details on certain parts.

To finish my sketch I pose it really quickly
and sometimes I Polypaint it just to have
a quick idea of the colors on the design.

This page: ZBrush is not just
used for creatures. You can
also sketch environments with
it. Here I posed four human
meshes to create the columns
and grouped them on an Insert
Mesh brush to use them easily.

Alba, Ruben

This page: **Anatomy practice** trying to find a nice and simple dynamic pose. I wanted to create a more humanoid werewolf with less creature-like features.

"I THINK BEING A CONCEPT ARTIST IS A WAY OF LIFE — YOUR BRAIN IS ALWAYS WORKING"

EXPLORING NEW IDEAS

Concept art is all about generating ideas. Sketching in 3D with ZBrush is great to make this happen. You can generate a base mesh and quickly modify it, trying to push the design and generate new shapes. As a concept artist, you can run out of ideas at some points, and in my opinion this is when you really need to use the best of your skills to generate more of them. ZBrush can certainly help with it!

Top left: I was looking for a "winged serpent" look. This was a sculpt from the early stages.

Bottom: One version of the snake's body.

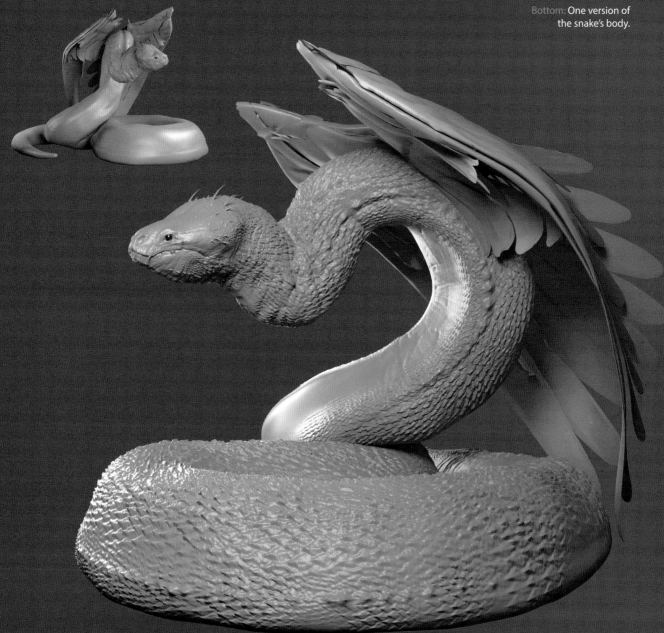

ANUFRIEVA, Olga

www.he77ga.ru
All images © Olga Anufrieva

ZBrush is a very good tool for quick sculpting and coloring. It's like sketching on paper, except you can look at 3D sketches from any angle. It really gives you an understanding of what your character looks like. It's much faster for me to sketch in 3D than to draw on paper. In ZBrush, I can make a character smile, make them sad or angry, and make a suitable pose. I can analyze and improve the body or facial proportions, and move the legs and hands to make any emotion. For a long time I had problems drawing characters from my imagination, probably because I saw them as volumetric in my head… or because I'm just bad at drawing! Now it's not a problem any more, because in ZBrush I can do it in just a couple of hours.

INSPIRATION & IDEAS

I have always been inspired by the work of talented 2D and 3D artists. Just looking at some galleries with their work in has given me many sleepless nights with ZBrush! Movies, cartoons, and computer games also give me creative ideas.

TOOLKIT

My usual set of brushes includes: the Standard brush for coloring, Clay Buildup for easily creating the overall shape, Move for stretching things, Dam Standard for small folds such as under the eyes, and Trim Dynamic for surfacing. Among other tools, I usually use DynaMesh and ZRemesher. Using these two in tandem, you can quickly achieve your desired results.

SCULPTING WORKFLOW

I start modeling my sculpts from a primitive sphere, and then use DynaMesh to sculpt the final result. For coloring, I use ZBrush's standard Polypaint tools on my models.

Above: An early version of *Little Mouse* (see page 24).

Right: An elf reminiscent of Yolandi Visser, who has a very memorable appearance.

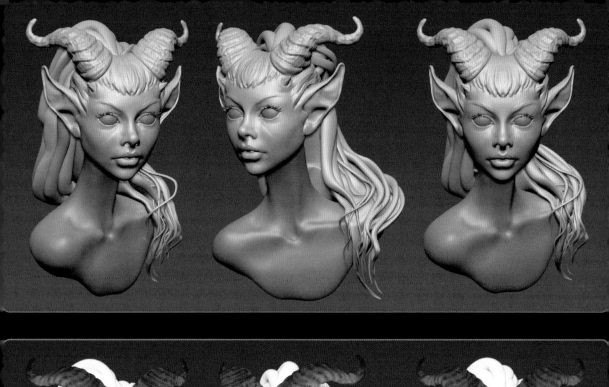
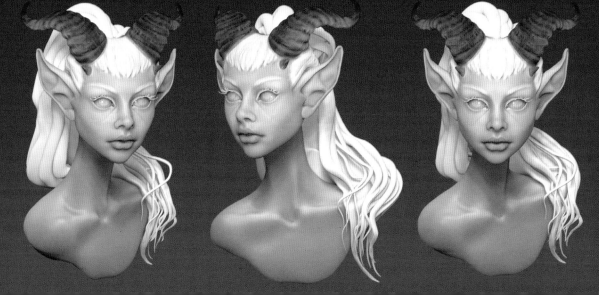

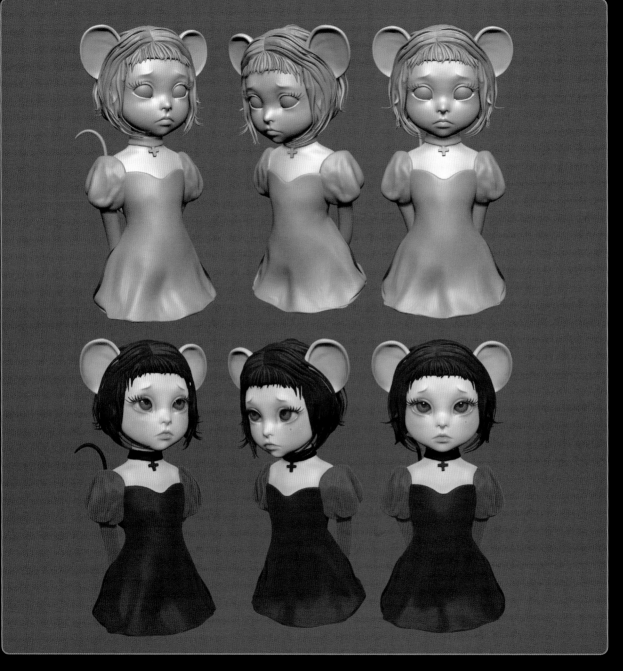

Above: *Little Mouse*. Training at lunch. Because of my bad mood, I sculpted a girl with a sad face.

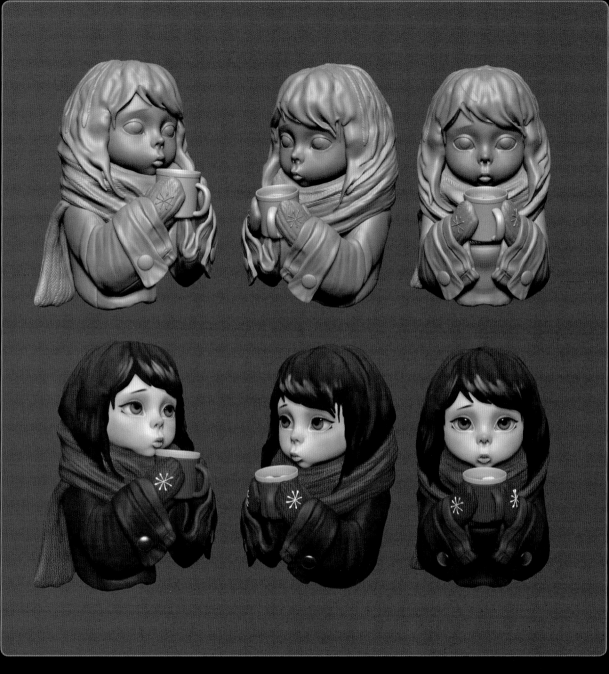

Above: Capturing the autumn mood of wanting hot chocolate and sleep.

This page: I like to sculpt elves – they're slender and graceful. My focus here was to portray an interesting pose.

Right-hand page: A training speed-sculpt created in two hours.

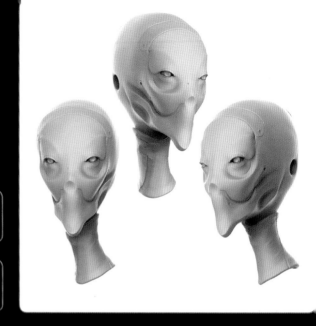

ATTARAN, Mohammad Hossein

www.mhattaran.com
All images © Mohammad Hossein Attaran unless stated

My excessive childhood love for robots and mechanical stuff surprisingly led me to study mechanical engineering. However, I decided to do my master's degree in Animation Directing after I got into 3D art at the age of twenty. I tried learning ZBrush a couple of times but felt disappointed with its strange and unnatural UI each time.

As I became came more familiar with ZBrush, I began to feel like I was born to use it and my progress continued to pick up pace. I could visualize all my fantasies easily and quickly without the need to worry about vertices and polygons. Soon I developed my own techniques and workflow, from sketching and blocking to rendering and compositing. I love creating mechanical creatures and hard-surface sculpts in ZBrush.

Although I had a background of pretty good drawing skills, I never got used to drawing my concepts in 2D. Maybe that's because in 3D sketching, you have a better perception of the whole model at a time; you can see it from any angle and modify the forms and shapes if needed. I've been in various projects now, from game and animation character design to sculpting collectibles.

INSPIRATION & IDEAS

Most of my projects usually start with a spark of intuition or an ambiguous form I've discovered. So I just dive into 3D sketching with these initial ideas.

"I COULD VISUALIZE ALL MY FANTASIES EASILY AND QUICKLY WITHOUT THE NEED TO WORRY ABOUT VERTICES AND POLYGONS"

I then try to form a specific silhouette by just playing around with the forms. I add the details when I'm happy with the overall silhouette. This is the phase where I get the benefit of references. Inspiration can come from anywhere. As I'm a hard-surface sculptor, I usually get inspired by other mechanical subjects, such as industrial and construction machines, but I also try to look into nature to find amazing forms.

TOOLKIT

I use ZBrush for almost all of the modeling process. It's a very handy software which lets artists apply their creativity at its highest level. The tools that I usually use are DynaMesh, Panel Loops, Transpose Master, Polygroups, and simple brushes such as Clip Curve, hPolish, Dam Standard, Clay Buildup, Layer, Move, Pinch,

Trim Dynamic, and many other Insert
Multi Mesh (IMM) brushes which I've
downloaded or made myself in 3ds Max.

I form the overall silhouette with
ZSpheres and Transpose tools. After
subdividing the mesh a couple of times,
I block out the principal forms with
the Clay, Clay Buildup, Dam Standard,
and hPolish brushes. I may even use
Insert Mesh brushes to add some basic
volumes to the model. When it's time to
add the details, I separate the surface
into numerous panels and pieces so
I can concentrate on each of them.

Both pages: I tried to convert a portrait
of a beautiful girl into a mechanical
one, while preserving some aspects
of her beauty. When I was happy with
her face, I started to play with her
silhouette by adding strange forms
around her. When the detailing phase
was done, I started to set her pose and
camera angles at the same time.

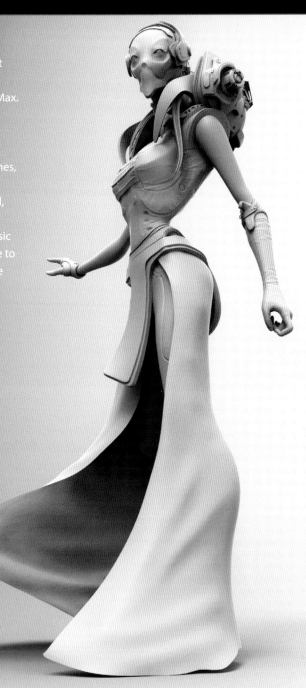

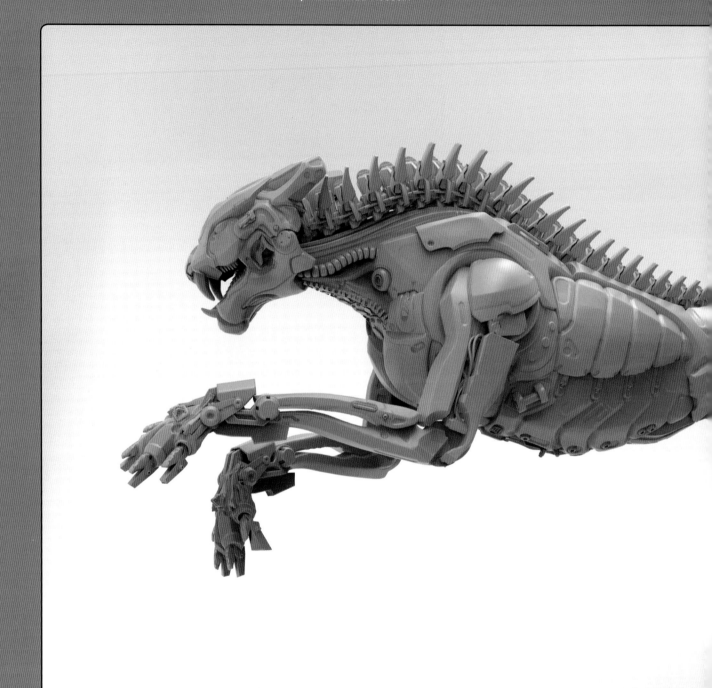

MECHANICAL CREATURES

To design mechanical creatures, you have to always try to keep them close to the organic forms. Refer to its organic identical part. The head is the most important part of a character and you should be very careful designing it. For example with my *Cheetah* sculpt, the most distinctive attributes in a cheetah's face are its black tear paths and its cat ears. Arms and legs have more functional and less decorative aspects compared to other body parts, so if the character is meant to be animated or is going to be built in real life, you should design it to be functionally correct.

Above: Here I made a cheetah's anatomy out of the usual ZSpheres, then formed the model using Move, Inflate, Clay Buildup, and the Transpose tool.

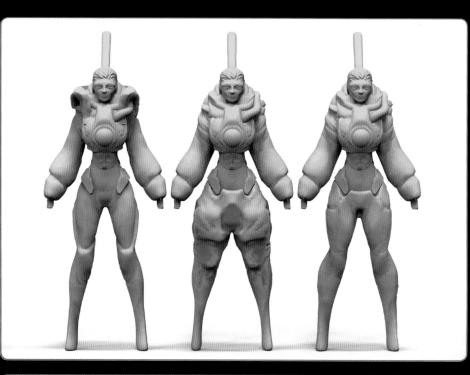

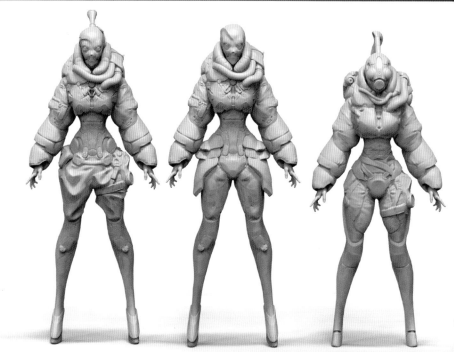

This page: **This was one of the rare projects for me that started with 2D sketching. I chose one of the sketches, then blocked it in ZBrush. I still had issues with her silhouette, since I'm an obsessive person! When I finally felt happy with the forms, I moved on to detailing. Sketch credit: © NAS Animation Studio**

Right-hand page: **I started the *Mine Lord* project out of nothing. I just wanted to create a purely mechanical character, so played around with the ZSpheres until I reached the basic shape. In the blocking phase, I gave the leg priority compared to the rest of the body, since I would lose the symmetry after relocation. I try to extract some familiar mechanical shapes out of the roughly blocked sculpt, and then develop and polish them nicely.**

"ALTHOUGH I HAD A BACKGROUND
OF PRETTY GOOD DRAWING
SKILLS, I NEVER GOT USED TO
DRAWING MY CONCEPTS IN 2D"

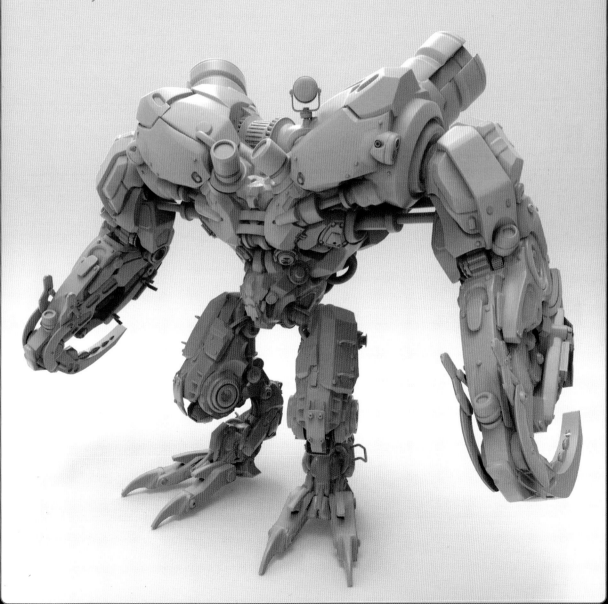

B. N., Vichar

www.vichar.carbonmade.com
All images © Vichar B. N.

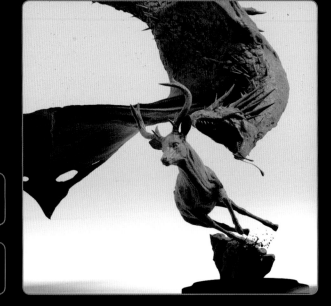

In my sculptures, I attempt to evoke movements, fluidity, and patterns inspired by nature, the movement of elements such as wind or water, combined with physical sensations. The ephemeral moment is also a big part of it: the perpetual motion that changes continuously into something else, so what we see at any one moment is just a fragment. This concept had been percolating in my mind for a while until I felt ready to experiment.

The advantages of 3D sculpting are: its speed; being able to make multiple iterations of an idea, quickly reshaping a sculpture without having to redo it; transforming an idea in unpredictable ways and exploiting the "accidents"; having access to feedback from a vast group of creative and talented people using the same tools.

These tools have changed our thought processes and resulted in a new paradigm for creativity. Technology is used in so many different fields, in so many different ways, that an infinite number of events or phenomena can now be created.

INSPIRATION & IDEAS

Sources of inspiration can come from the most unexpected fields and can be cross-combined in limitless ways. The world is full of magical things, patiently waiting for our wits to grow sharper. My inspiration is in the constant discovery of the infinite layers of my surroundings. This includes everything from the structure of grass, to the depths of our universe. If there is an intention to understand and completely open oneself up to what is being

observed, then patterns start to define themselves and intuitively assemble into interesting pieces of artwork. The richness of these observations is one aspect of inspiration.

TOOLKIT

The main software I use daily for digital sculpting is ZBrush. I also use Maya. I am always on the lookout for new ways to speed up my production pipeline and let me do more art and fewer technical processes. ZBrush has totally changed the way I create a 3D model. It's much more natural, fast, and simply is the closest thing to actual clay sculpting. Thanks to ZBrush, it is now possible to block a simple base shape that can be easily modeled, sculpted, and detailed. It also lets you create scenery and illustrations which blend 2D and 3D in one environment

SCULPTING WORKFLOW

I spend at least a third of my time doing research, downloading photos, and analyzing them. I sketch some simple shapes, make a collage, and get to know my subject better. I cannot stress enough how important this stage is.

I create a character with purpose – from clothing, to expression, to backstory. Where are they from? What is their motive? Your character should not always just "look cool." Create a piece that provokes an emotional response. I also create characters that will make me better as an artist as well as touch on software and technical approaches that I haven't tackled or encountered yet.

My approach is like that of a traditional sculptor. I start with an armature (ZSphere) and then add clay layer by layer. Once the basic form and shape are achieved, I pose the sculpture with Z Rig and work in symmetry to add more weight and tension, to attain a more realistic look. Usually I don't use alphas and instead I try to reach the final goal by manually sculpting. This helps me to learn the strengths and limitations of the software in depth.

And last but not least, feedback is important; it's good to ask people for their opinions. Sometimes they see things that you hadn't noticed. So when you're finished, show your work. It's good to have critics, you can learn a lot from them.

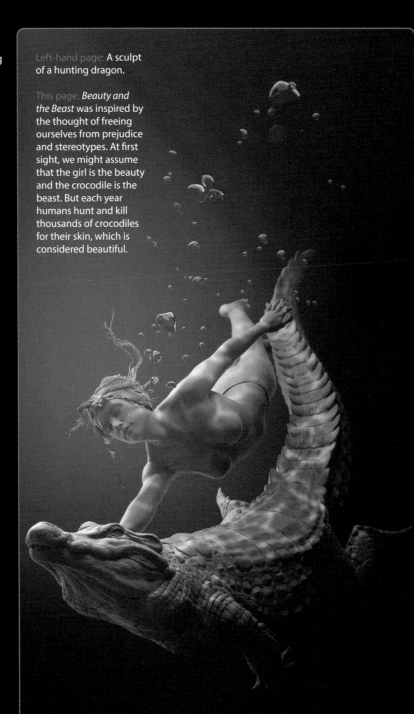

Left-hand page: A sculpt of a hunting dragon.

This page: *Beauty and the Beast* was inspired by the thought of freeing ourselves from prejudice and stereotypes. At first sight, we might assume that the girl is the beauty and the crocodile is the beast. But each year humans hunt and kill thousands of crocodiles for their skin, which is considered beautiful.

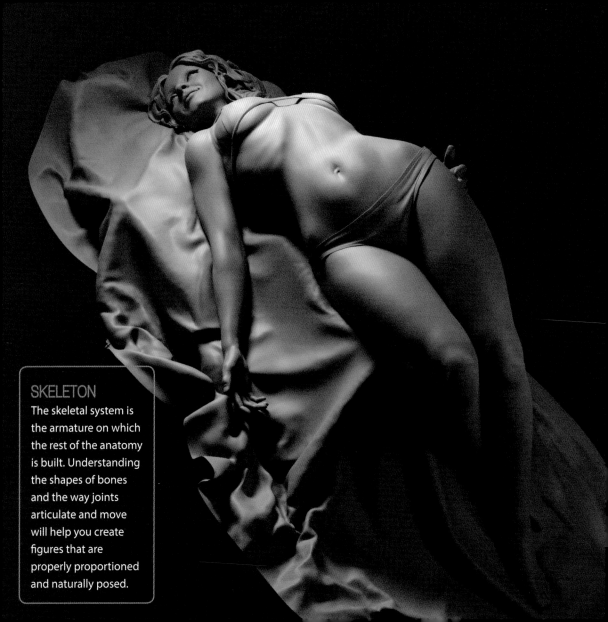

SKELETON

The skeletal system is the armature on which the rest of the anatomy is built. Understanding the shapes of bones and the way joints articulate and move will help you create figures that are properly proportioned and naturally posed.

This page: *Veiled Lady with Lamp,* an experimental work in progress.

This image: *The Kiss* was inspired by Auguste Rodin's sculpture.

This image: *A Shower of Summer Days*, one of my recent works in progress.

Inspired by the fairytale *The Pied Piper of Hamelin.*

This image:
A sculpt inspired by the story of Helen of Troy.

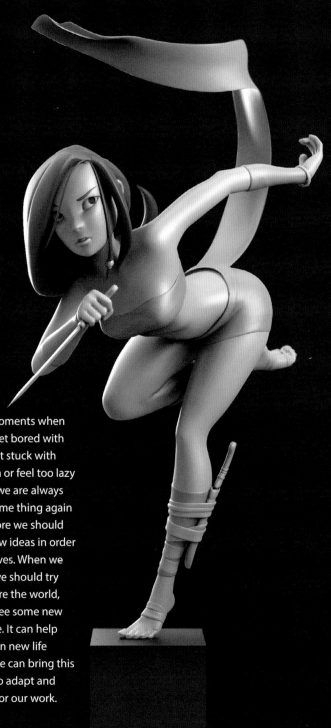

BOONYANATE, Kontorn

www.behance.net/dongkont
All images © Kontorn Boonyanate

My name is Kontorn "Dongk" Boonyanate. I am currently working at Igloo Studio, Thailand, in the capacity of modeler and artist. Previously I was working only on digital painting, and then I started practicing ZBrush three years ago. My design skills have been gradually improving ever since. Sketching my work out as a 3D sculpture helps me to adjust my designs more easily, and to see how different perspectives in the design work. It also helps me to reduce the pipeline of work.

INSPIRATION & IDEAS

The inspiration for my work comes from surrealist and minimalist styles of art. I try to express my work through the model-pose designing and shape editing. Sketching in 3D helps me to work faster and find new shapes more easily.

There are some moments when we artists might get bored with work, when we get stuck with finding a new idea or feel too lazy to work, because we are always working on the same thing again and again. Therefore we should always look for new ideas in order to improve ourselves. When we run out of ideas, we should try to go out to explore the world, go traveling and see some new perspectives in life. It can help us to relax and gain new life experience, and we can bring this experience back to adapt and use as new ideas for our work.

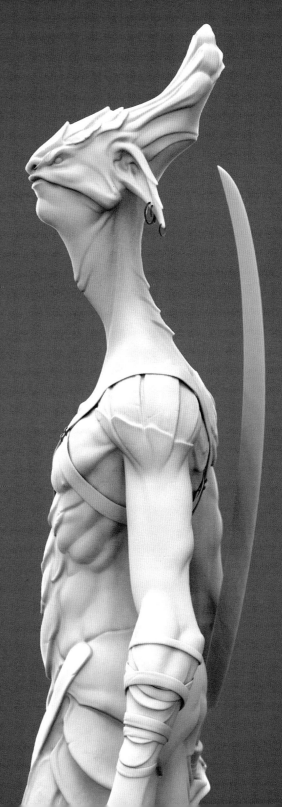

TOOLKIT

I use ZBrush for sculpting models and posing. Firstly I use ZSphere for designing the model and pose, then I use the Move brush for adjusting the shape. Next I use the Clay Spin and Clay Tubes brushes for sculpting the details of the muscles. For other small details, such as hair or wrinkles, I use the Dam Standard brush, and finally I use Trim Dynamic for smoothing skin and surfaces.

SCULPTING WORKFLOW

After designing the model and pose with ZSpheres, I shape the model from the lowest subdivision level without adding too many details, instead focusing on the model's shape. After finishing the first design, I use the Decimation Master ZBrush plug-in to reduce the number of polygons, then import the model into Maya to clean it up. Then I render the model in KeyShot, and finally finish the artwork by retouching with Photoshop.

Left: *Assassin* was a personal project to practice my character design skills. Try to sketch every day, with drawing or rough sculpts, to help you generate new ideas and get more practice in at the same time.

Right: *Samu*, one of my personal projects.

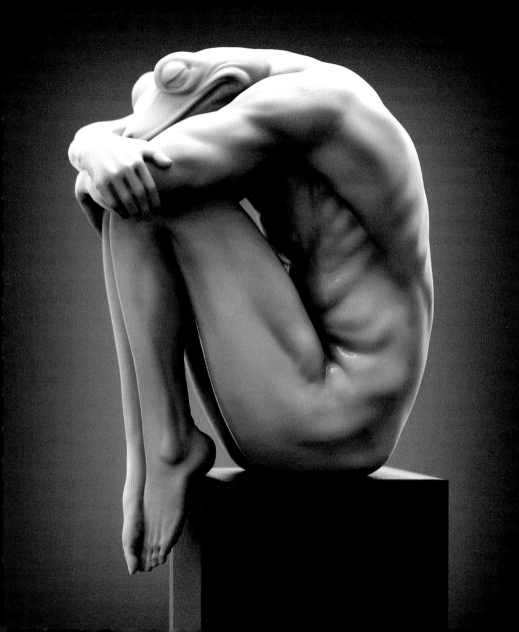

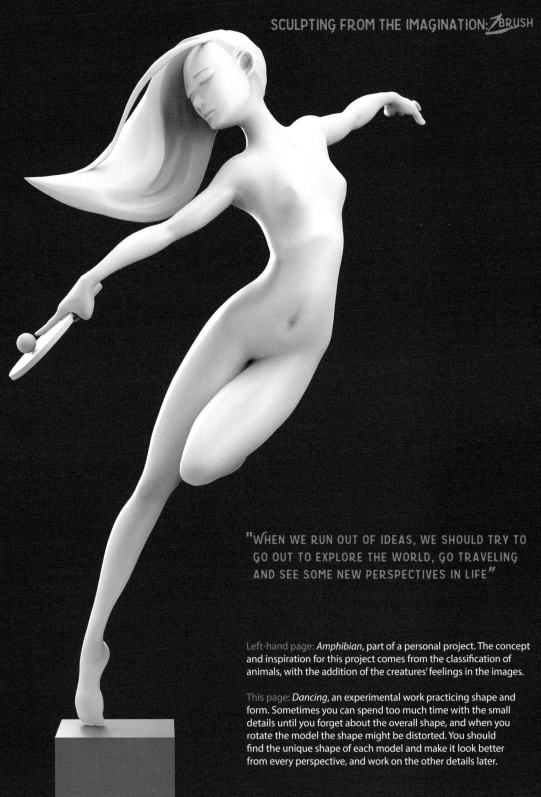

"WHEN WE RUN OUT OF IDEAS, WE SHOULD TRY TO
GO OUT TO EXPLORE THE WORLD, GO TRAVELING
AND SEE SOME NEW PERSPECTIVES IN LIFE"

Left-hand page: *Amphibian*, part of a personal project. The concept
and inspiration for this project comes from the classification of
animals, with the addition of the creatures' feelings in the images.

This page: *Dancing*, an experimental work practicing shape and
form. Sometimes you can spend too much time with the small
details until you forget about the overall shape, and when you
rotate the model the shape might be distorted. You should
find the unique shape of each model and make it look better
from every perspective, and work on the other details later.

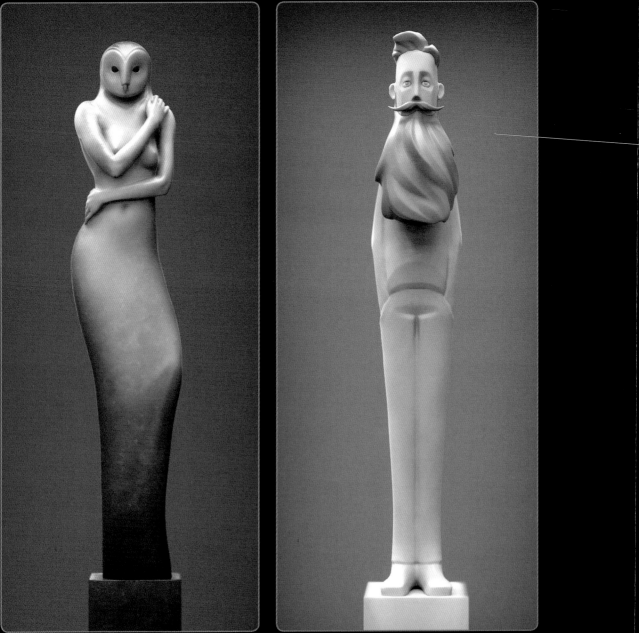

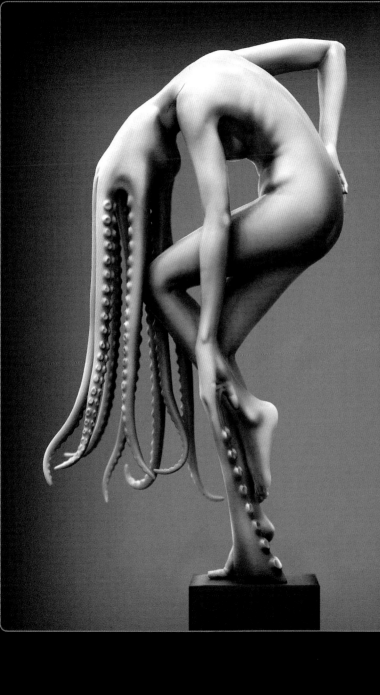

Far left: *Aves*, part of my personal project inspired by the classification of animals.

Left: *Hipster*, a sculpt experimenting with shape and form.

This page: *Mollusca*, part of my personal project inspired by the classification of animals.

BOVORNSIRISARP, Panuwat

www.eternity-nu.blogspot.com
All images © Panuwat Bovornsirisarp

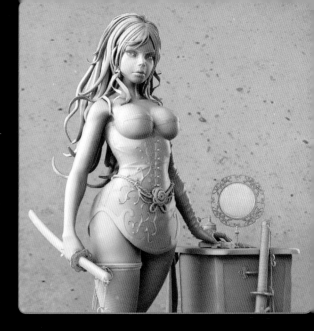

When I was young, I watched the Disney movie *The Lion King*, which impressed and inspired me so much that I have earnestly studied and created art since then. My passion is for sculpting models. It's kept me studying and practicing all the time to try to do my best.

INSPIRATION & IDEAS

I am inspired by everything around me: watching a movie, reading non-fiction, playing a game, traveling, or looking at websites of other 3D artists' artworks from around the world. I get many ideas from them, then apply them to my own work. I often use reference from real creatures in our world, then redesign, mix, and add some elements or details. Using a real creature as reference is very useful as it helps my designs look more realistic and alive.

TOOLKIT

I use several software packages to create my work, such as Maya, LightWave, and ZBrush. I use GoZ to import and export between software. In ZBrush, my basic brush tools are the Standard, Move, Clay Tubes, and Clay brushes. These are enough for me to start blocking shapes, and then I use the Dam Standard, hPolish, Pinch, and Trim Dynamic brushes for adding detail.

SCULPTING WORKFLOW

My workflow is quite simple. I begin with a quick sketch using DynaMesh, which is my favorite tool and is fast enough to depict my idea to digital clay. This tool makes me feel like I'm drawing on paper. I then send the model to Maya for retopology. Maya 2015 has introduced many new tools

for the modeler, but I always start my process of sculpting a character in ZBrush, like a traditional sculpture. It's easier for me to add or remove parts to make the perfect form and silhouette, then add more details later.

Above: *Assassin Girl*. Sculpted in ZBrush and rendered in V-Ray for Maya. I created brushes for the rope and hair, and used surface noise for the fabric details. The sword and mirror were created using ShadowBox, a very handy tool. I finally used Transpose Master for the pose.

Right: *Demon of the Forest*. I combined human and chameleon features for this design.

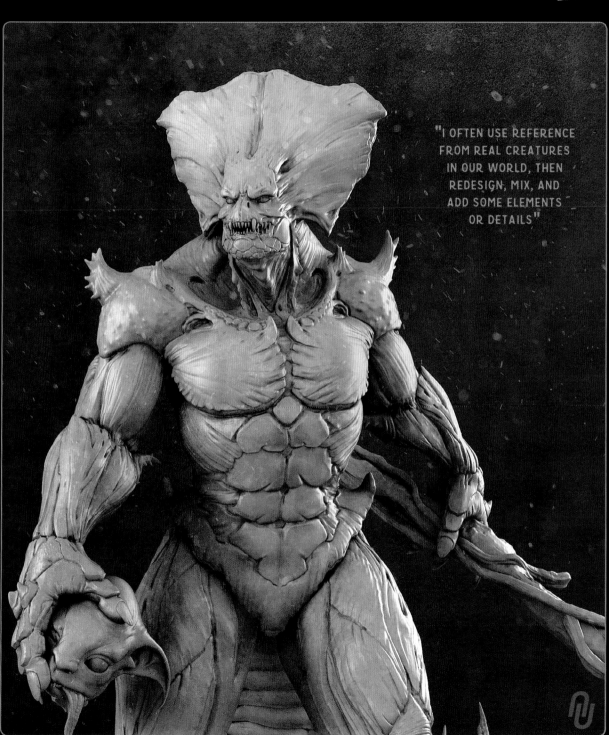

"I OFTEN USE REFERENCE
FROM REAL CREATURES
IN OUR WORLD, THEN
REDESIGN, MIX, AND
ADD SOME ELEMENTS
OR DETAILS"

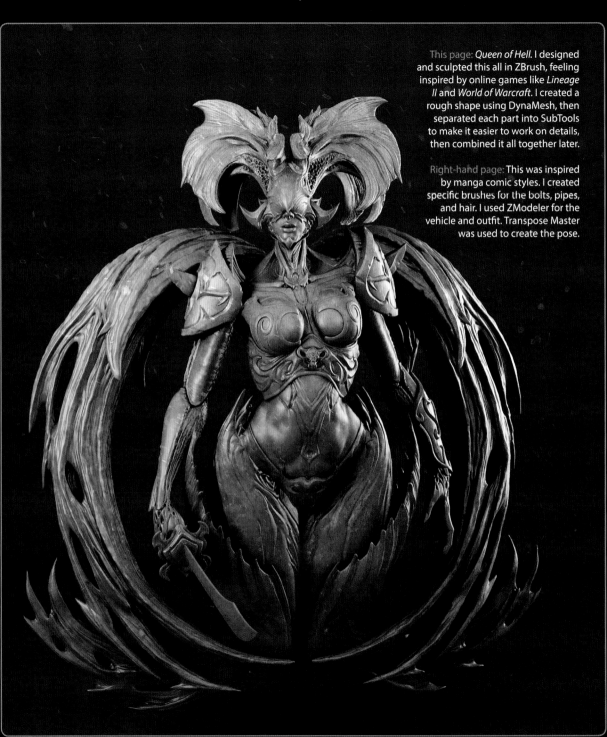

This page: *Queen of Hell*. I designed and sculpted this all in ZBrush, feeling inspired by online games like *Lineage II* and *World of Warcraft*. I created a rough shape using DynaMesh, then separated each part into SubTools to make it easier to work on details, then combined it all together later.

Right-hand page: This was inspired by manga comic styles. I created specific brushes for the bolts, pipes, and hair. I used ZModeler for the vehicle and outfit. Transpose Master was used to create the pose.

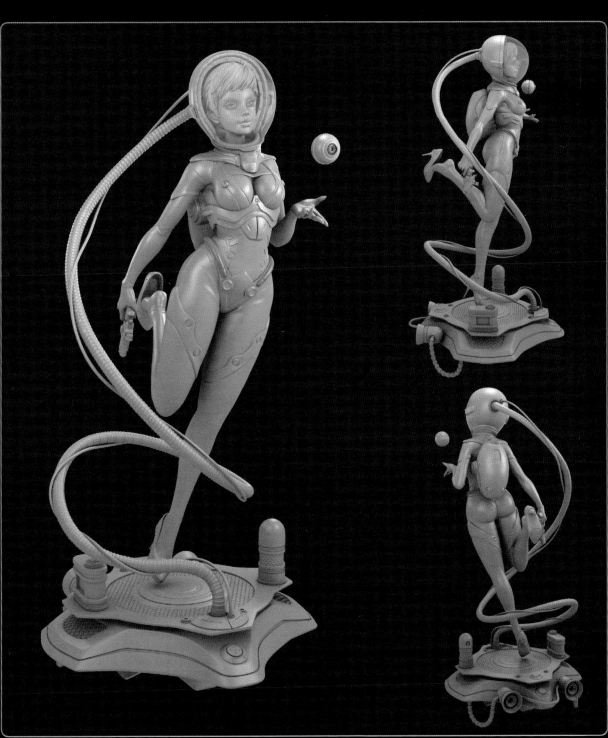

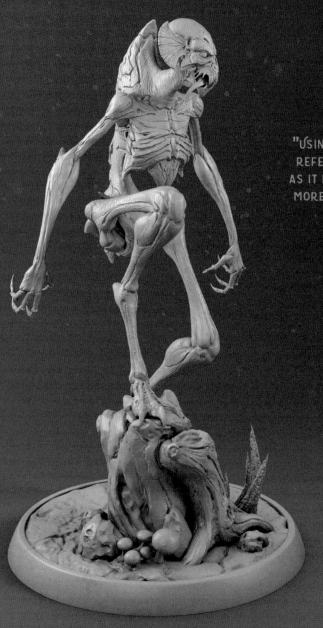

"USING A REAL CREATURE AS REFERENCE IS VERY USEFUL AS IT HELPS MY DESIGNS LOOK MORE REALISTIC AND ALIVE"

This page: *Zombie Skeleton*. Here I was inspired by *World of Warcraft*. I used the Standard brush with alphas 7 and 58 for this project.

Right-hand page: I mixed up a dragon with creatures from my imagination. ZBrush 4R7 has some awesome tools such as a NanoMesh and Array Mesh, which I used for the horns and scales.

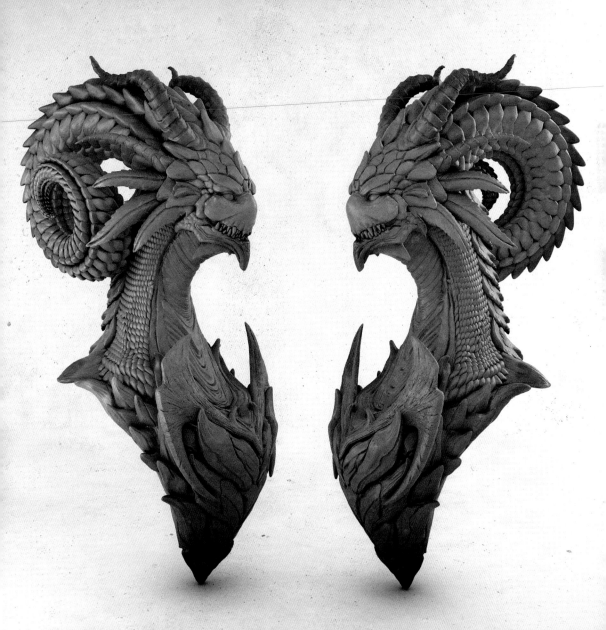

BRADDOCK, Paul

www.paul-braddock.com
All images © Paul Braddock

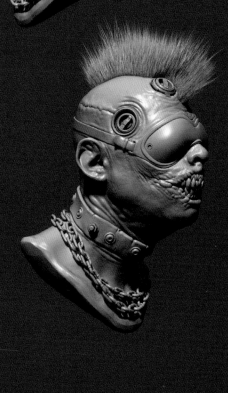

My name is Paul, and I've been working as a CG VFX artist in the film industry for over twelve years. I've been drawing and creating things for as long as I can remember. Through the course of my career path I've discovered that working sculpturally appeals to me the most. With ZBrush, I can work very quickly to sketch out rough ideas in 3D and easily polish them into more refined concepts.

Working in 3D means not having to commit to just one camera angle, lighting setup, or composition. Perspective and symmetry are figured out for me, so I can put all my efforts into purely thinking about the thing I'm trying to create. Before the advancement of tools like ZBrush, 3D modeling couldn't be described as a sculptural, and there was a real

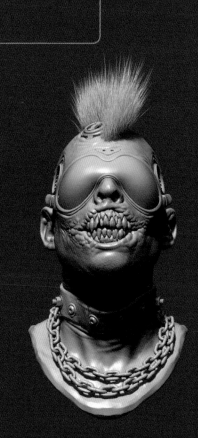

Both pages: **Concept sculpt of a post-apocalyptic biker or marauder-type character.**

disconnect to the creative process. However, now it really is just like working with clay. The ability to reuse previous work as a basis for new work is also a massive time-saver, something that sketching digitally has over traditional mediums.

Over the years, as I've become more proficient in digital sculpting, I've found that it's the quickest way for me to get ideas out. I can tell from very loose work whether something is going to work or not, and easily make changes if it isn't, or do something totally different.

INSPIRATION & IDEAS

My inspiration and ideas come from literally everywhere, there's no shortage. Sometimes it can be overwhelming with the constant flow of amazing art found online, in films, and so on; it can make it difficult to stick to an idea without wanting to jump ship and start something else. I try to at least stick to a theme, or style, and then change to something else for the next thing.

Nature is an endless and amazing source for inspiration. I love seeing sources from one world unexpectedly placed in another, such as a land-dwelling creature with fish-like qualities, for example.

I love automotive design and motorcycles from all eras, so that comes into play if I'm doing something mechanical.

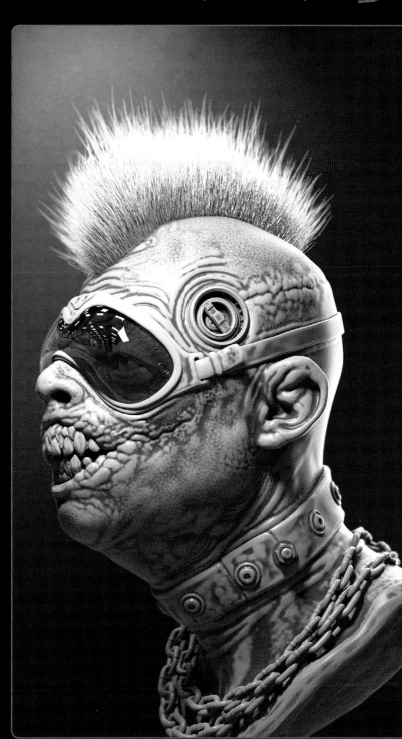

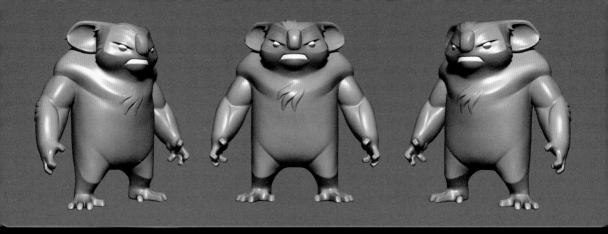

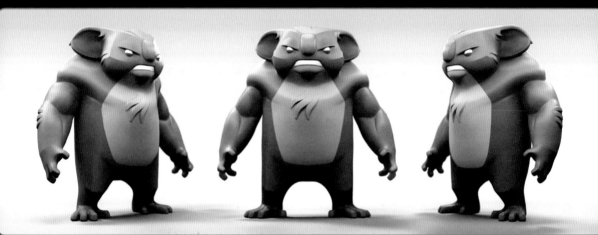

The challenge is to do something fresh, and original, but keep it aesthetic in some way.

TOOLKIT

ZBrush is my primary sculpting tool, I often use ZBrush and nothing else to make things, but I'll occasionally use Maya if it makes sense to do so. The brushes I use most are the Move, Clay, Dam Standard, Trim Dynamic, hPolish, Clip, Inflate, and Form Soft brushes. Clay is my preferred tool for building form, along with the Move brush. I find that Clay is very flexible, letting me make both big changes and subtle ones. Trim brushes are great for definition and structure, while Dam Standard is essential for roughing in details and cuts. Inflate is useful for fixing areas that become too thin, especially when using DynaMesh.

SCULPTING WORKFLOW

Most often, I begin with a DynaMesh sphere and just start pulling and pushing it around. I then start adding and removing forms with the Clay brush, and constantly refresh the DynaMesh. Insert brushes are great for bringing in parts from previous work, or taking advantage of the incredible library of 'kitbashing' sets you can buy for very reasonable money from places like Gumroad (**https://gumroad.com**).

Scans can be a very useful starting point. There's no need to begin from scratch, unless you specifically want

to. If I'm sculpting a crazy set of teeth for a humanoid character, I'll begin with a skull scan, DynaMesh it, and work over the top of it.

I also love using alphas for modeling, not just texturing. Any time you do a PBR render, you get a depth pass that can be used as an alpha to displace all the form and detail of the thing you just rendered, in a brushstroke.

Both pages: A stylized drop bear (a.k.a. koala), an Australian megafauna cryptid creature.

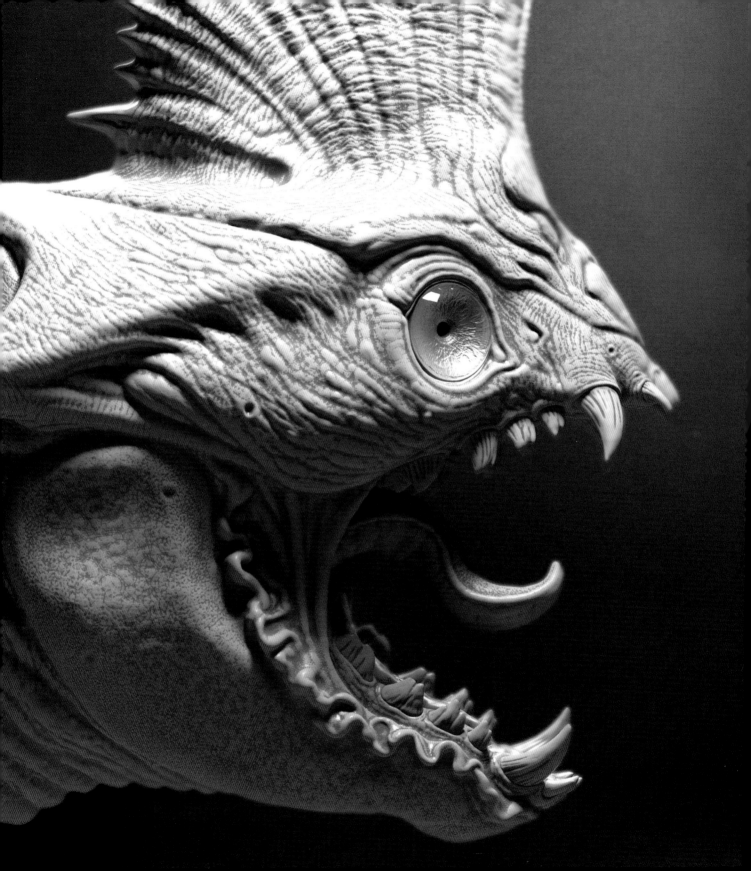

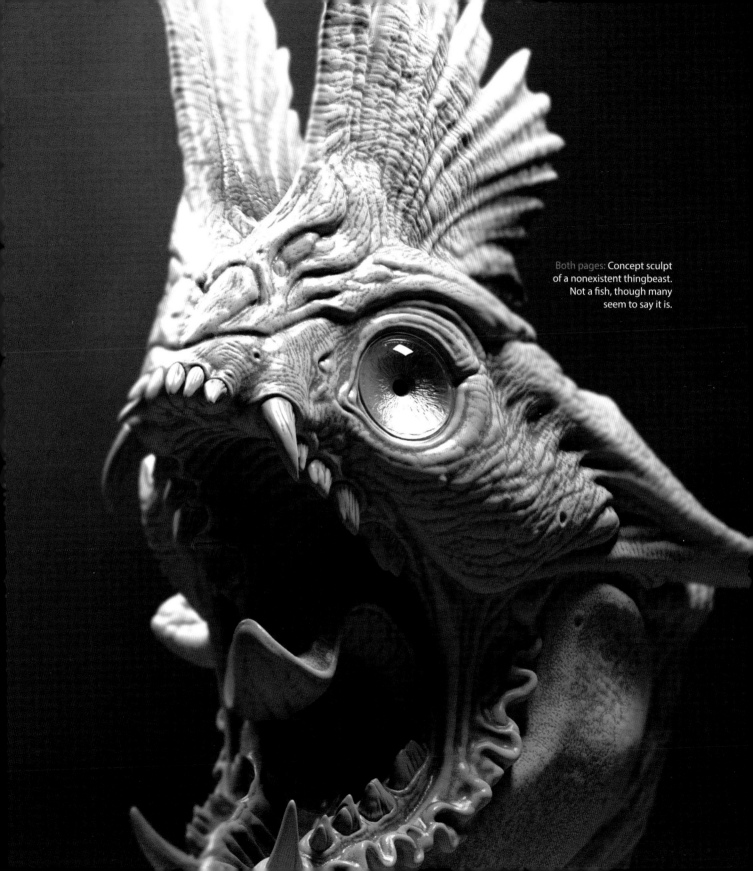

Both pages: Concept sculpt of a nonexistent thingbeast. Not a fish, though many seem to say it is.

BRANDÃO, Cézar

I have always loved the feel of a "sketch" piece, and was used to that when making a drawing, but I found my real love when I was introduced to ZBrush. To be able to achieve that feeling in 3D, and really quickly, is amazing. I can just open the software and start throwing all my ideas in there without any barriers.

What I do with my personal pieces is try to put down what I'm feeling at that moment. I might be sad, happy, angry, whatever. That's always what I try to achieve, to transmit what I'm feeling and draw it out of me. By doing this I believe we can put a little of our soul into that sculpture or drawing. I believe that's the reason I sketch, the reason I do what I do, and this is the medium through which I have chosen to express myself.

INSPIRATION & IDEAS
I look at a lot of fashion photos. I always imagine that I'm sculpting a fashion model, and at the end I'll take a "photo" of the girl as if she were

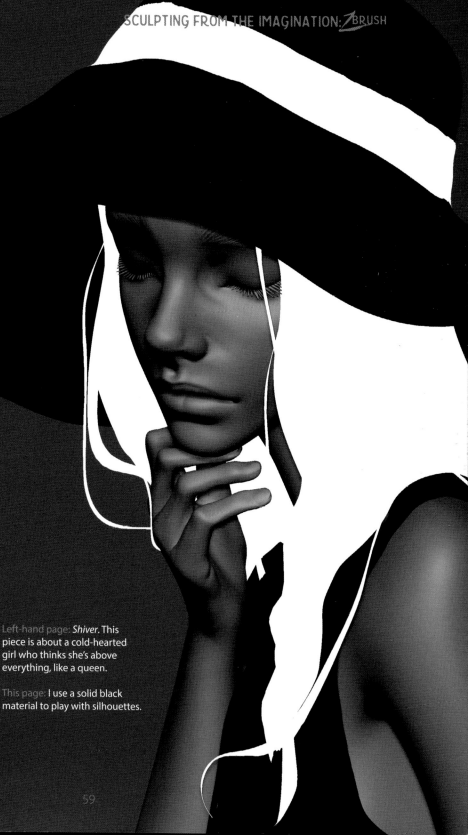

a real model. Most of the time I start with an image or idea in my head, but it always changes and never comes out the way I thought at the beginning. This is because I listen to music when I start sculpting, and I just go with the flow and see what happens.

TOOLKIT

To sketch I just use ZBrush and Photoshop – that's all I need. ZBrush now gives me all the freedom to do whatever I want, and I don't need any other software just to sketch any more. I like to finalize the images in Photoshop and add some graphic elements in the background, change colors, and so on. When I'm doing production work on functional models, I use 3ds Max, Maya, Topogun, xNormal, UVLayout, Photoshop, and ZBrush.

SCULPTING WORKFLOW

I try to use George Bridgman's techniques for my anatomy. In ZBrush I use a lot of DynaMesh so I don't have to worry about topology – I can just keep on creating. It's the same whether I want to create quick armor, a helmet, or anything else – I just grab a DynaMesh sphere and keep sculpting, or I use Extract and DynaMesh. I like to play a lot with silhouettes in my images, so I always select a black material in ZBrush and play around with that silhouette when creating clothing or hair.

Left-hand page: *Shiver*. This piece is about a cold-hearted girl who thinks she's above everything, like a queen.

This page: I use a solid black material to play with silhouettes.

59

Above: *Run and Hide.* Some feelings I had about a girl who ran and hid instead of confronting her fears.

Bottom left: We always see angels with wings and halos, so I wanted to try something different, but this is probably a little bit too weird!

Bottom right: *Patience.* Sometimes it's easier to just give away your whole life and quit everything, but with patience you will have your reward later.

Top left: This piece was created with the memory of a Californian girl in mind, from when I lived there. I miss that place!

Top right: One of my more recent female character sculpts.

Left: Another character sculpt using black and white for contrast.

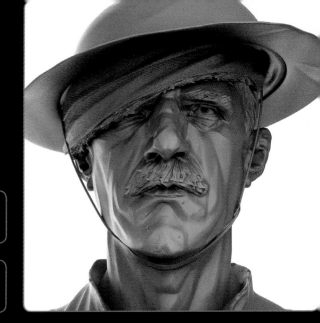

CAIN, James W.

www.jameswcain.co.uk
All images © James W. Cain

've had a fairly indirect route into the world of 3D. I studied illustration at the University for the Creative Arts in the UK while working freelance as a graphic designer, and continued working in the design field after I graduated.

In my thirties, however, I decided to spin the great wheel of artistic fortune once again, and lo and behold it landed on digital sculpting. Maybe that's a little too anecdotal – in truth I've found the transition to 3D pretty tough, but extremely rewarding. Coming from a more traditional background, I had at times been taught to seek out imperfection, the human element in my art. For a while this was something that I felt was at odds with the precise nature of the 3D software I had tried as a student. As ZBrush has matured

however, it's made a whole host of innovations available that have gradually eroded the technical side of 3D in favor of more artistic workflows.

One of the things I love so much about digital sculpting is that I now have the ability to pick up ZBrush and just start pulling out shapes and exploring. In ZBrush I can mature an idea from a ball of digital clay through to a final piece and have a lot of fun in the process. I think this is the sweet spot of making art for me. If there's fun in the process then I know I'm doing things right, irrespective of the outcome. For me, it truly is sketching in 3D.

INSPIRATION & IDEAS
I love historical and classic fiction themes in my work and always seek

these out when I'm sketching. On the whole though, I have quite an eclectic mix of inspirations that range from comic books and gaming, through to traditional arts history. One of my favorite artists is the Pre-Raphaelite painter John William Waterhouse, and I've been lucky enough recently to see his paintings in the flesh. I love the visual narratives in his work, even if it's a little unfashionable. Another artist is Burne Hogarth; his book *Drawing the Human Head* is especially influential in my work. I've also managed to collect a large library of various historical reference over the years which I love to dip into for ideas.

TOOLKIT
My usual brushes within ZBrush are Standard, Dam Standard, Inflate,

Snake Hook, Clay, and Clay Buildup for general sketching. DynaMesh and ZRemesher are essential features I use constantly when sculpting – without them my workflow would be continually interrupted by exhaustive retopology sessions. I've also recently added KeyShot to my toolset. This, together with the ZBrush to KeyShot Bridge, allows me to quickly check my sculpt under more realistic lighting. For hard-surface objects I use ZModeler or MODO. All of my images here have been rendered with KeyShot.

SCULPTING WORKFLOW

I always try to start with one of the DynaMesh ball projects that come with ZBrush, especially when sculpting heads. I do this because it lets me experiment with large shapes and forms straight away, and I don't feel like I'm being dictated to, which can sometimes happen when using base meshes. I'll then flesh out my shapes and forms, re-DynaMeshing where necessary. I use ZRemesher to get a better topology and for posing using Transpose Master if necessary. To finish I'll either decimate and export to MODO for rendering or transfer directly over to KeyShot.

Left-hand page: A sketch commemorating Remembrance Day in the UK in 2015.

This page: My female version of Dr. Frankenstein.

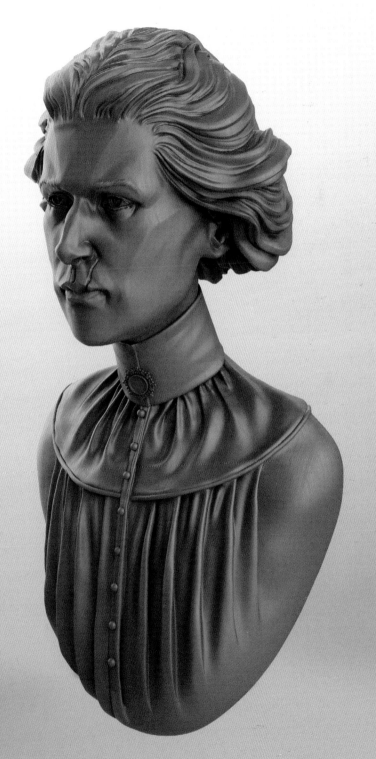

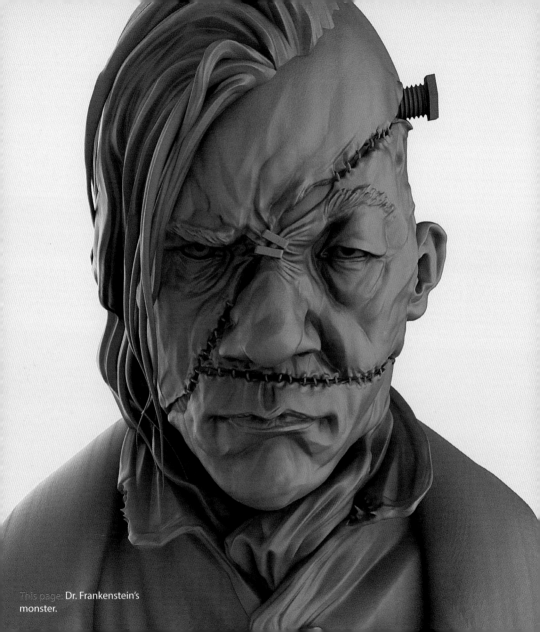

This page: Dr. Frankenstein's monster.

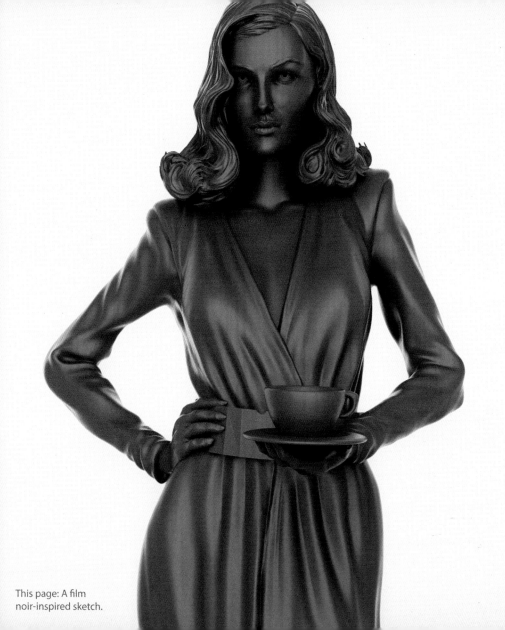

This page: A film
noir-inspired sketch.

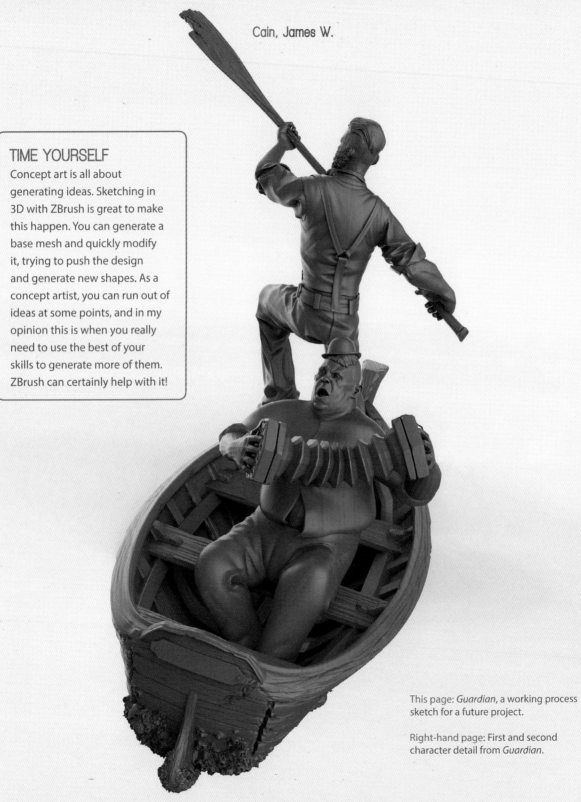

Cain, James W.

TIME YOURSELF

Concept art is all about generating ideas. Sketching in 3D with ZBrush is great to make this happen. You can generate a base mesh and quickly modify it, trying to push the design and generate new shapes. As a concept artist, you can run out of ideas at some points, and in my opinion this is when you really need to use the best of your skills to generate more of them. ZBrush can certainly help with it!

This page: *Guardian*, a working process sketch for a future project.

Right-hand page: First and second character detail from *Guardian*.

66

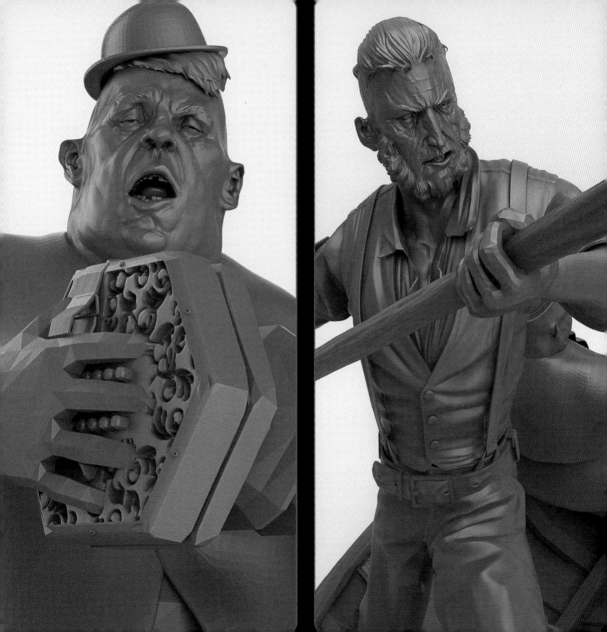

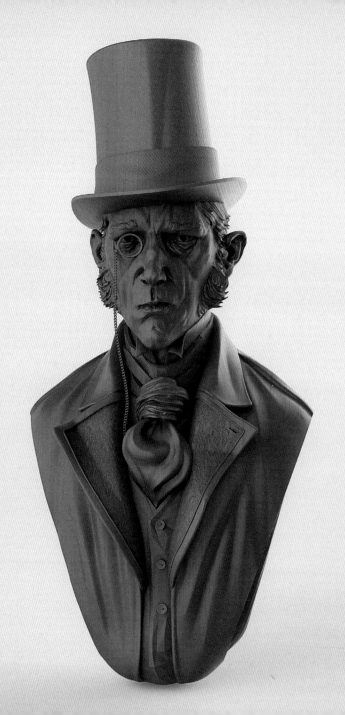

This page: Dr. Jekyll.

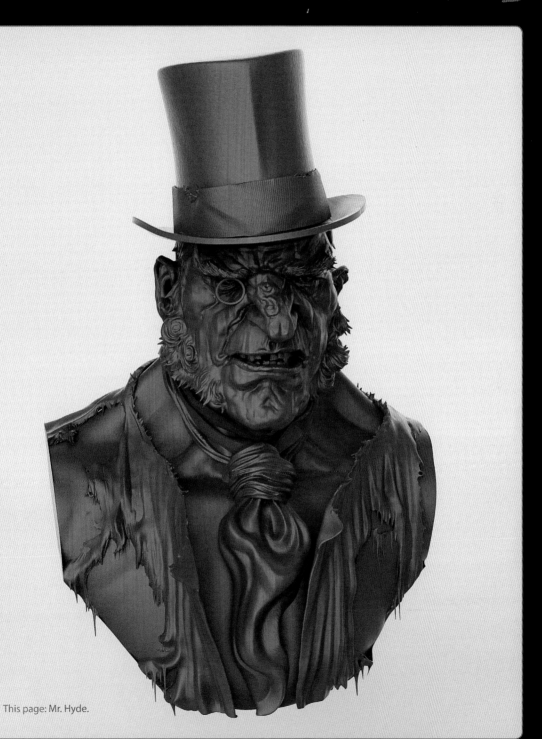

This page: Mr. Hyde.

CAMEHL, Tony

www.tonyeight.carbonmade.com
All images © Tony Camehl

The first time I saw *Star Wars: Episode I – The Phantom Menace* at the age of six, I was so fascinated by the designs of the creatures and aliens that I soon developed a huge interest in drawing. For years I learned how to draw and improve my skills. 2012 was the year I decided to specialize in creature design and I set myself the goal to learn something new each day in order to enhance my work.

But all beginnings are difficult. When I started drawing aliens from my imagination, I got frustrated very quickly because they didn't look good at all. Then I happened to find a software called Sculptris. The first creature I sculpted in 3D was by all means better than my first drawings. So I earned some money and bought ZBrush and since then I have improved my sculpting skills, as well as my visual library, by myself each day.

My ambition for the next few years is to design more full-body aliens. As well as that, I'm also interested in working together with other artists and exchanging experiences. In the meantime I continue learning new techniques and tricks in order to come up with even better designs.

Here I will talk about my learning process and all the blood, sweat, and tears I shed for the sake of what I love to do.

INSPIRATION & IDEAS
Either I am hiking in the mountains, watching a documentary, or reading something interesting in a magazine. I am lucky to get inspired really quickly and can then transform the influence from my surroundings into sketches. Inspiration is everywhere and that's why I try to keep my mind open for these motivating and stimulating impressions.

To explore my ideas in 3D, I usually start with a sphere and do some experiments in order to find interesting shapes that I can develop into a creature. While sculpting I also keep anatomy and design rules in mind for the creature to be realistic and inventive at the same time.

TOOLKIT
Most of the time I use ZBrush because I can sculpt rough concepts very quickly and customize my UI, which speeds up my process and makes me more comfortable while working

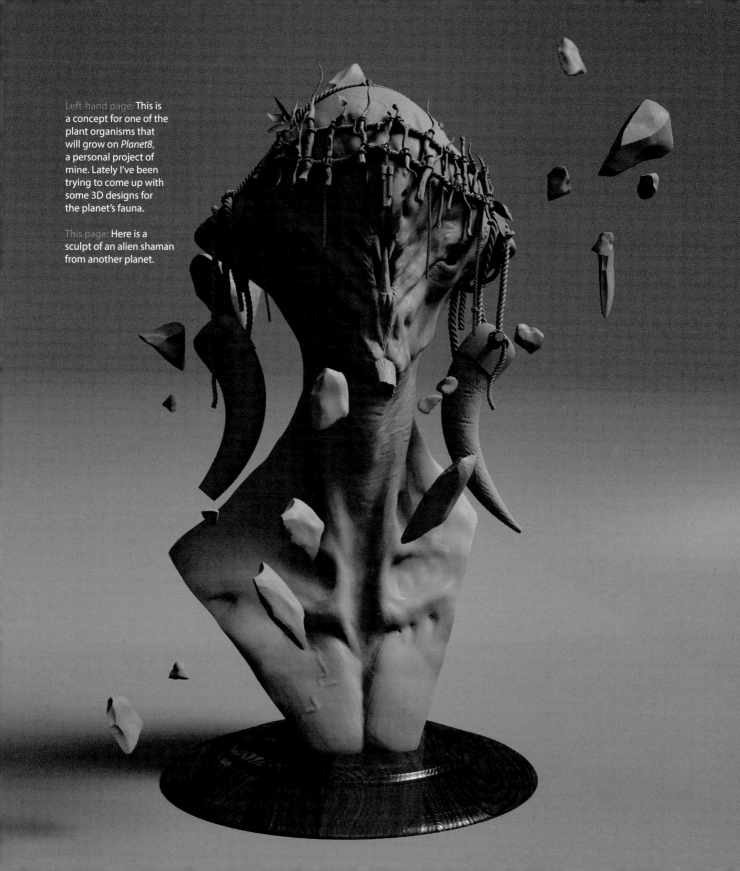

Left-hand page: This is a concept for one of the plant organisms that will grow on *Planet8*, a personal project of mine. Lately I've been trying to come up with some 3D designs for the planet's fauna.

This page: Here is a sculpt of an alien shaman from another planet.

with the software. For rendering I mainly use KeyShot for ZBrush and from time to time use OctaneRender because it has the function to render in real time and you can judge the outcome of the creature right away. At the very end I can add backgrounds, blur effects, and much more to my concept with Photoshop.

SCULPTING WORKFLOW

I am always trying out different workflows and most of the time I start sketching in ZBrush with a simple sphere. Sometimes I also use custom Insert Multi Mesh (IMM) brushes or even sketches with pen on paper to get the first idea out of my head. When I decide to start with a sphere in ZBrush, I turn on the DynaMesh function and begin to block in some major forms.

As soon as I like the main shape of the creature I start adding details and keep pushing and tweaking the model until I get a decent-looking creature. When I am satisfied with the overall look I use ZRemesher to get clean topology and ProjectAll to get all the information back from my DynaMesh object onto my subdivided one.

The last part of my workflow is rendering in KeyShot or OctaneRender and combining several render passes in Photoshop until I get the final illustration.

Right: The idea behind this one is that the sphere shapes at the back are visible so you can see the brain – I created it after watching a documentary on deep-sea creatures.

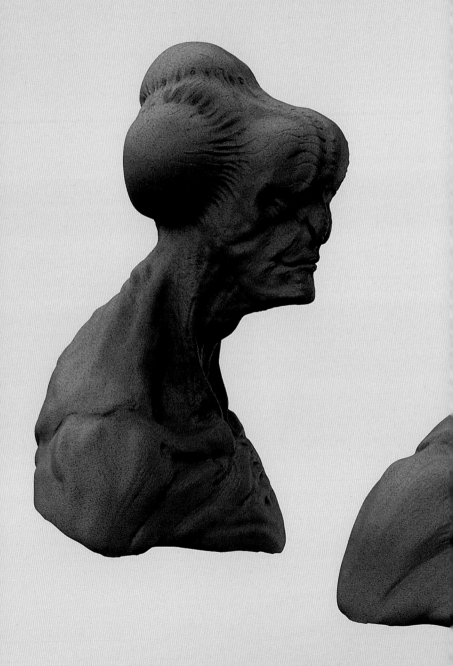

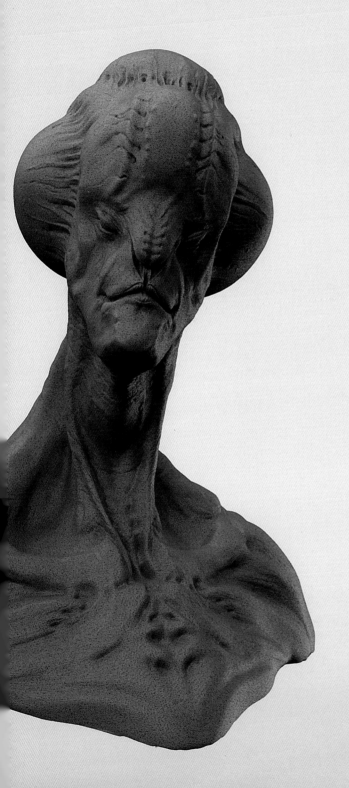
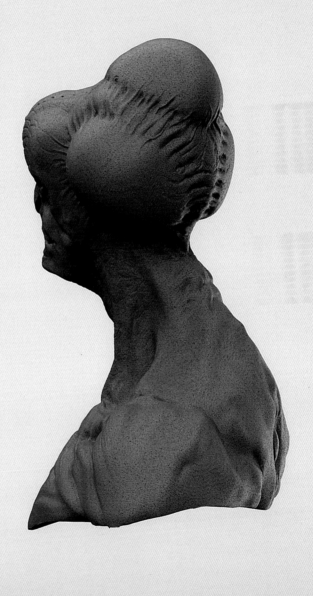

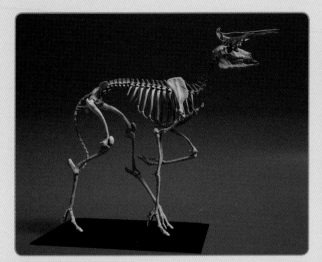
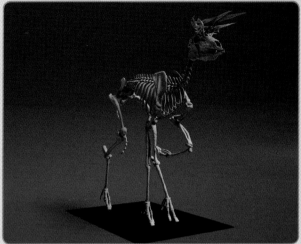

This page: At the end of 2015, inspired by Terryl Whitlatch's workflow, I started to completely change my workflow to create more scientific and believable creatures. This is the first step of building the underlying structure, beginning with the skull of the creature called the *Mirus Deer* for my personal project *Planet8*.

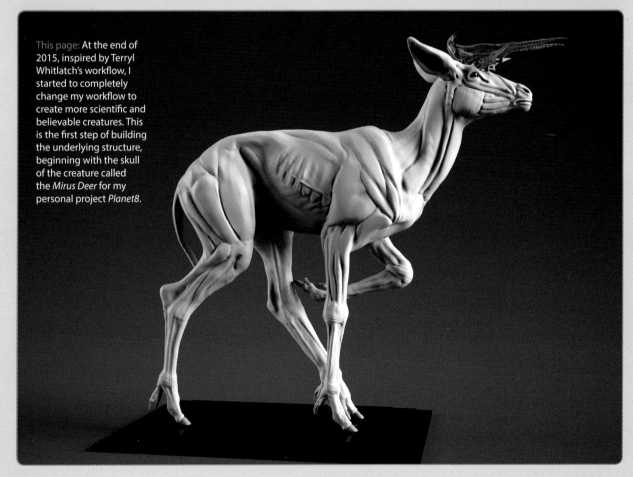

Below: This alien was sculpted in ZBrush to practice more humanoid creatures. I am planning to switch off the symmetry mode in ZBrush for my upcoming creature designs to improve my sculpting in asymmetry, so I can create better dynamic poses.

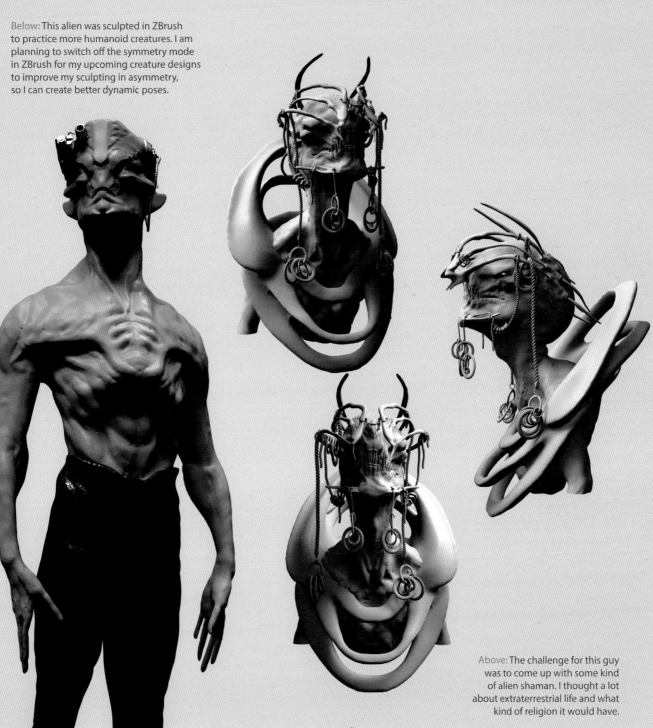

Above: The challenge for this guy was to come up with some kind of alien shaman. I thought a lot about extraterrestrial life and what kind of religion it would have.

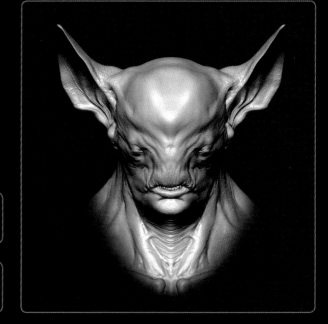

CHIAMPO, Andrea

www.artstation.com/artist/CA_ANDREACHIAMPO
All images © Andrea Chiampo unless stated

Everything began in 2013 during my second year of university. I was studying industrial design in Turin, Italy. A friend of mine showed me Pixologic's Sculptris and I immediately fell in love with it. After a few days, sculpting strange creatures and organic stuff had become my favorite hobby. Whenever I had spare time, this was what I did.

The next step was when I discovered digital art and its related websites, online forums, and communities. Admiring such badass artists made me want to improve my skills, but I also realized that Sculptris was not widely used and not very powerful. Everyone sculpted in ZBrush! So I made the big jump into this new exciting software. At first it was very difficult, but thanks to tutorials and motivation from online communities, I quickly learned the

basics and I started to properly enjoy it. I had found the perfect tool to express my creativity and finally I felt that I was giving soul to my creations.

I graduated in July 2014 and the time came to decide my future. With the help of some encouraging awards and magazine publications, I chose the path of concept art. After a few months of strong studies and practice, the hobby became a job, and I received my first exciting requests for freelance concept art work.

INSPIRATION & IDEAS

I sketch in 3D because it's the fastest way to explore new shapes and the coolest way to see the whole subject from any angle. I often take inspiration from nature, animals, insects, buildings, organic structures, and so on, but my

favorite way to initiate a 3D sketch remains to explore new shapes by extracting volumes from a sphere. For the first few minutes of a sculpt, I really like to randomly modify the Mesh so as to discover new irregular patterns and forms to start my design with. It's sort of like looking at clouds and trying to extrapolate things from my imagination.

TOOLKIT

ZBrush is a huge help in increasing the value of a project, giving an amazing quality to the work. Thanks to the wide range of brushes and tools you will be able to obtain an awesome level of detail. The tools I use the most are: Transpose to move and scale (also for masked parts), DynaMesh to regenerate, ZRemesher for lower subdivisions, and Clay Polish

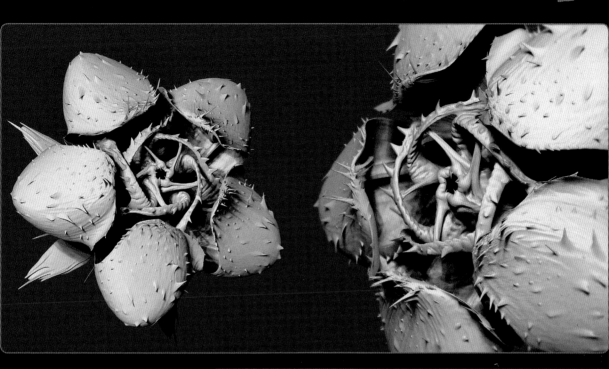

for hard-surface stuff. I principally use brushes like Standard with alphas; Dam Standard and Inflate, especially for bodies and wrinkles; Move for everything; hPolish for mechanical pieces; and the default Insert Multi Mesh (IMM) brushes to quickly insert a good base mesh to modify.

SCULPTING WORKFLOW

My favored personal workflow was born while I was sculpting a 3D model and the mesh was brutally damaged using too strong an alpha brush. Instead of carrying out a usual Undo, I started exploiting the "mistake," keeping control vertices on and stretching the mesh in an extreme way – basically taking advantage of it in order to make art. I often use this kind of technique

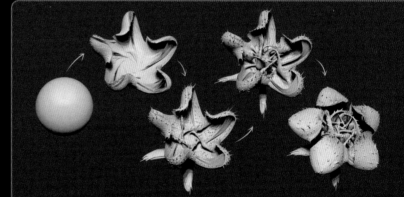

to quickly explore interesting shapes for characters, creatures, environments, and vehicles.

Anyway, I often start with ZSpheres, especially when I have a clear idea of what I have to do; sometimes I also start from default ZTools.

Left-hand page: I made this four-hour "Batman" sculpt for Facebook's Brainstorm group challenge.

This page (top): Thanks to Radial Count and the Snake Hook brush, you can quickly obtain this kind of shape. This is an alien-flower concept.

This page (bottom): A few steps starting from a sphere. DynaMesh is the best way for making cool intersections and joints

Above: Sometimes I start from a ZTool to have a good base to begin with. In this case I used the Dog found in the default Library.

Left: ZBrush's initial Dog ZTool on the left and my sketch on the right.

Right-hand page (top): An early truck concept for *Redout*, able to transport a floating ship with a magnetic system. In this kind of sketch, IMM brushes help me to have quick bases suitable for modifying.

Right-hand page (bottom): I often organize elements in different SubTools with various plain colors so I can properly visualize different blocks.

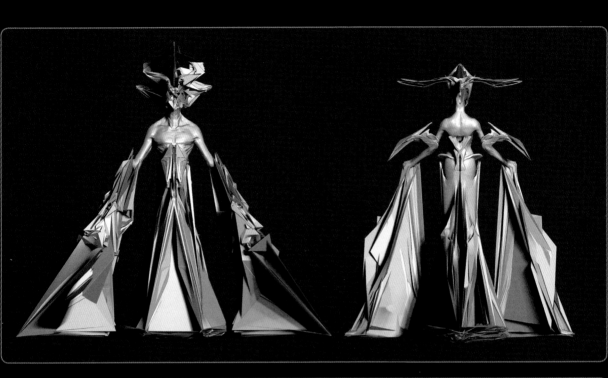

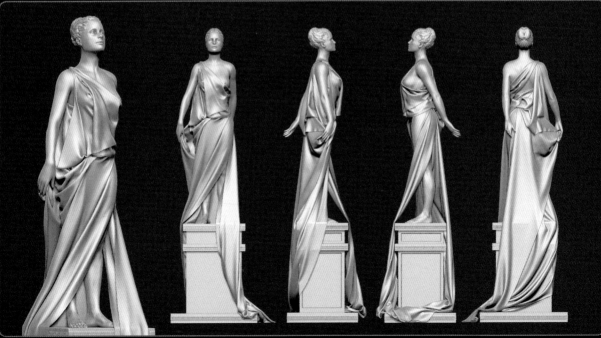

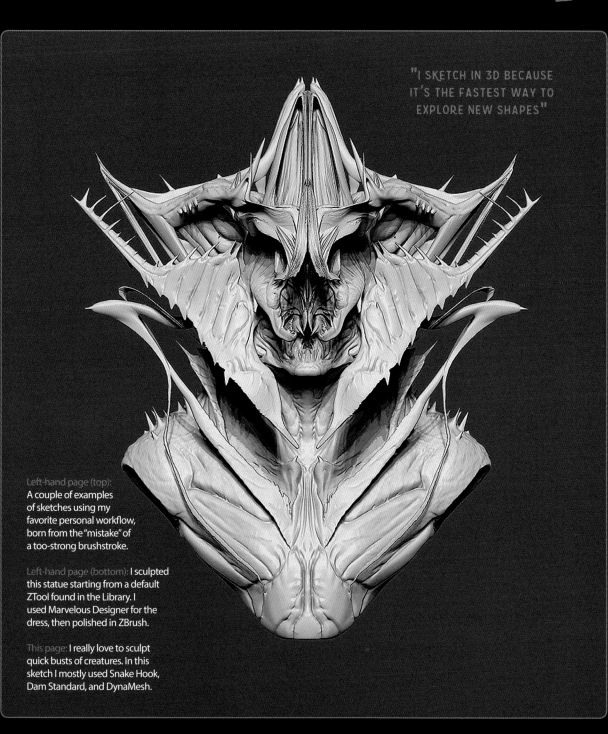

"I SKETCH IN 3D BECAUSE IT'S THE FASTEST WAY TO EXPLORE NEW SHAPES"

Left-hand page (top):
A couple of examples of sketches using my favorite personal workflow, born from the "mistake" of a too-strong brushstroke.

Left-hand page (bottom): I sculpted this statue starting from a default ZTool found in the Library. I used Marvelous Designer for the dress, then polished in ZBrush.

This page: I really love to sculpt quick busts of creatures. In this sketch I mostly used Snake Hook, Dam Standard, and DynaMesh.

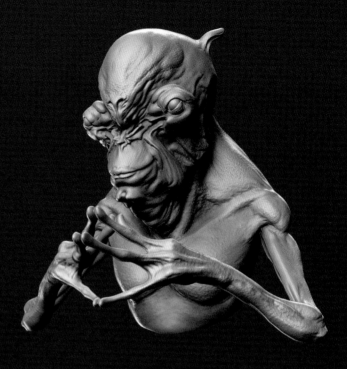

CHIN, Andy

www.andychinart.com
All images © Andy Chin

I'm a self-taught artist, primarily doing 3D creature sculpting in ZBrush. I occasionally do a bit of digital painting here and there, but I feel the most comfortable when I'm sculpting in ZBrush. I started doing digital art on the PC in 2014, and eventually picked up ZBrush sculpting by the end of September 2014. I definitely have a passion for 3D art, especially when it comes to creating creatures, and occasionally characters, from my imagination. ZBrush, over a short amount of time, has quickly come to play a major role in my life – and I'm glad it has! I try to get work done in ZBrush nearly every day to try and stay productive.

One of the most significant reasons why I sketch in 3D is because of just how much easier it is for me to be able to create my creatures and monsters in ZBrush, compared to sketching traditionally or generating ideas via other 2D alternatives. Ideas come more naturally to me when I'm sketching in 3D, and my creativity is usually greatly enhanced when I'm working in ZBrush. It's easier for me to visualize in 3D forms than it is in 2D, and 3D gives me a vast amount of freedom when it comes to design, such as creating interesting shapes, forms, unique features, and playing around with their characteristics.

Another reason why I'm so fascinated with ZBrush sketching is that I'm able to give my creations character and personality, making them seem all the more real and believable... and before I know it, I've got another creature on my hands!

INSPIRATION & IDEAS

My inspirations are mostly animals and interesting designs that I've picked up over time, and I gain an understanding of certain subjects by observation. If I'm feeling stumped, what I sometimes do is look up a variety of animal and insect references, and take my ideas and inspiration from the designs that I find appealing.

I do a ton of trial and error, experimentation, and exploring alternatives in order to find the shapes that I think look the best. I also think about interesting animal features that I could implement into my design to help it look more engaging and believable. At the beginning of the sketching process, I use very large brush sizes to quickly create the largest forms and avoid detailing early on.

TOOLKIT

I primarily use ZBrush and Photoshop only for my works. I try to keep my workflow as simple and straightforward as possible. I use ZBrush for how organic and easy the workflow is, and just how much freedom the software allows artists to have in terms of their workflow and ideas.

In ZBrush, I mainly use three brushes: Move, Clay Buildup, and Dam Standard. The Move and Clay Buildup brushes are excellent when it comes to creating forms, and the Dam Standard brush is excellent when it comes to creating organic details such as wrinkles. I occasionally also use Dam Standard as a way to mark important landmarks, and also to define and create new forms. Some other organic brushes I like to use in tandem with those three brushes are the Inflate and FormSoft brushes. They are excellent alternatives for adding organic forms and details.

Approximately ninety to one hundred percent of my texturing is simply Polypaint, and I finish it off with some Photoshop tweaking. Everything is rendered using ZBrush's default BPR. I composite all the render passes I get from the BPR within Photoshop.

SCULPTING WORKFLOW

I almost always start a new project with a default DynaMesh sphere in ZBrush, and I seldom use any base meshes. I use the Move and Clay brushes

Left-hand page: An evil little guy with a sinister smile! I really wanted to depict a personality within the creature by giving him a wide smile and conspiring hands.

This page: A quick sculpt of an alien.

at a large brush size to start constructing a base mesh that I can build my desired design from.

For me, the beginning part of the project, where I generate and explore ideas, is the most frustrating and difficult part of the process. If I can get past that, then it's mostly smooth sailing from there. I tend to avoid adding details in the early blocking-in stages of the sculpt, and instead I mark important landmarks as reference points for me to use later on in the sculpt, such as eye and mouth placement. Depending on the sculpt, I often check the silhouette to ensure it has a good "read" and looks appealing. Next, after I have generated a satisfying idea, I gradually increase the DynaMesh resolution of my sculpt as I continue adding progressively smaller forms and details.

After I'm satisfied with the direction the sculpt is going in and there is a decent amount of detail, I duplicate the mesh and utilize ZRemesher and Project to build new subdivisions. This way, I can work at a much higher polygon count than before and my details will be cleaner as well. Sometimes, I create a new Morph Target with which to pose the sculpt and add tiny details, such as scales and skin pores. This way, if I ever have a change of mind, I can easily revert back to the original by simply changing or deleting the new Morph Target.

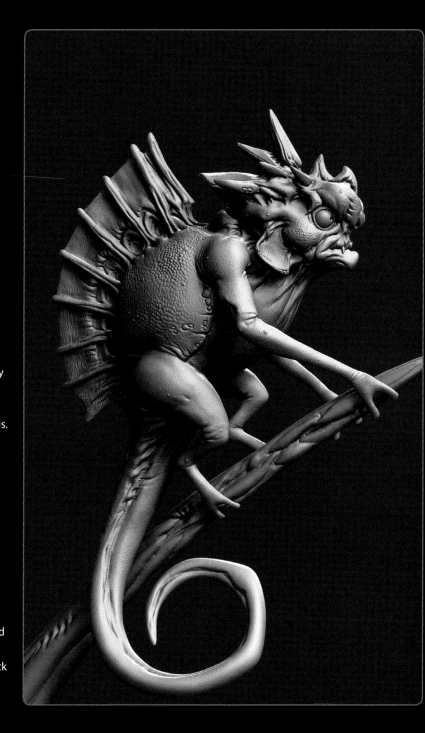

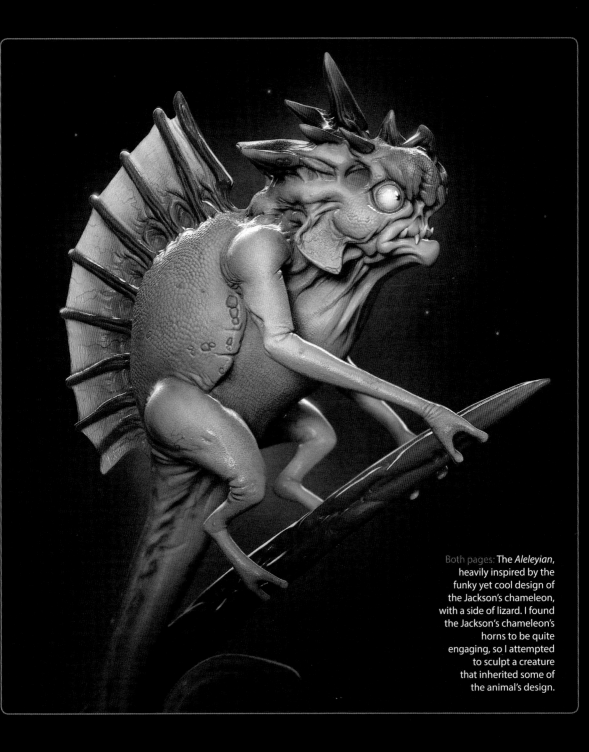

Both pages: The *Aleleyian*, heavily inspired by the funky yet cool design of the Jackson's chameleon, with a side of lizard. I found the Jackson's chameleon's horns to be quite engaging, so I attempted to sculpt a creature that inherited some of the animal's design.

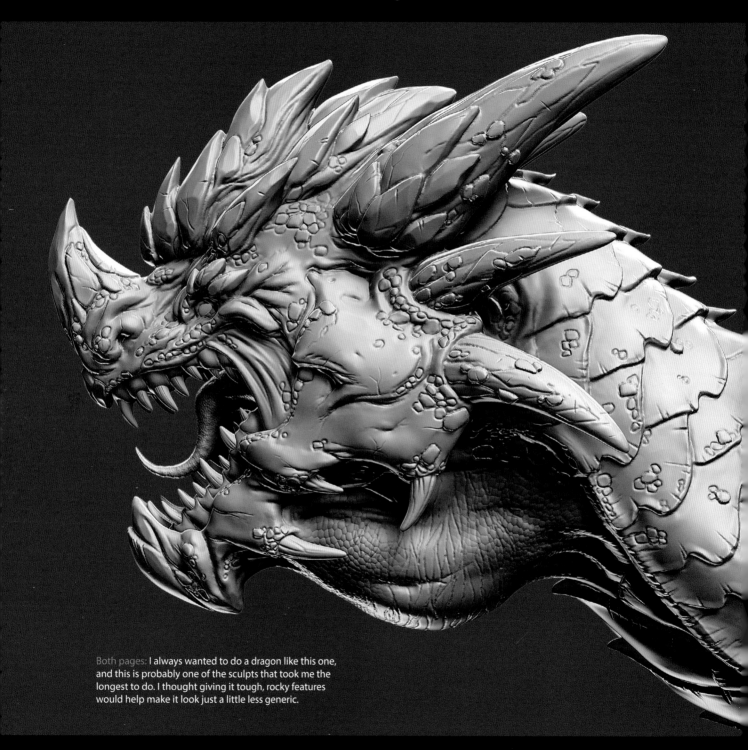

Both pages: I always wanted to do a dragon like this one, and this is probably one of the sculpts that took me the longest to do. I thought giving it tough, rocky features would help make it look just a little less generic.

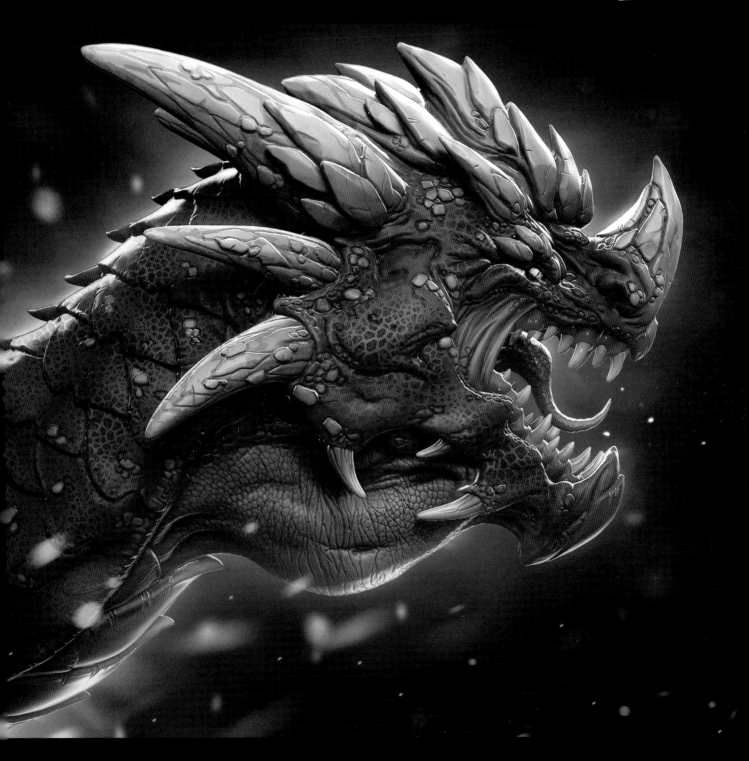

CROSSLAND, John William

www.revidge.tumblr.com
All images © John William Crossland

I have been working in the games and film industry as a character artist and freelance digital sculptor for the past six years.

After working on various projects, I have found it to be useful to concept ideas in 3D. ZBrush has some great tools for idea generation without any constraints.

INSPIRATION & IDEAS

For the past few years I have been doing a series of studies to help improve my concepting and idea generation. After doing a series of anatomical studies I felt I saw a definite improvement with each new study. Since then I have tried my best to study as much as I can – you never know what kind of project might come up!

TOOLKIT

In ZBrush I use the Standard brush for most things, but for concepting ideas out I will use the Clay brushes. They simulate the feeling of working with clay, which helps to rough out the forms and flesh out ideas. For modeling, I like to use MODO. It's got some great modeling tools and intuitive toolsets for the film and games industries. For rendering, I usually use Marmoset Toolbag 2 for any in-game ready assets, KeyShot for quick clay rendering and presentation work, and Photoshop for any color-grading and presentation.

SCULPTING WORKFLOW

I have found that I don't really use anything in particular. I often use ZSpheres as a base mesh and use DynaMesh to explore different styles and concepts into a final sculpture. I use ZRemesher to generate a retopologized mesh for my sculptures, making them easier to pose. Once a sculpt is ready I send it over to KeyShot, ready for lighting and rendering, after which I can usually use the render to take the concept further in Photoshop.

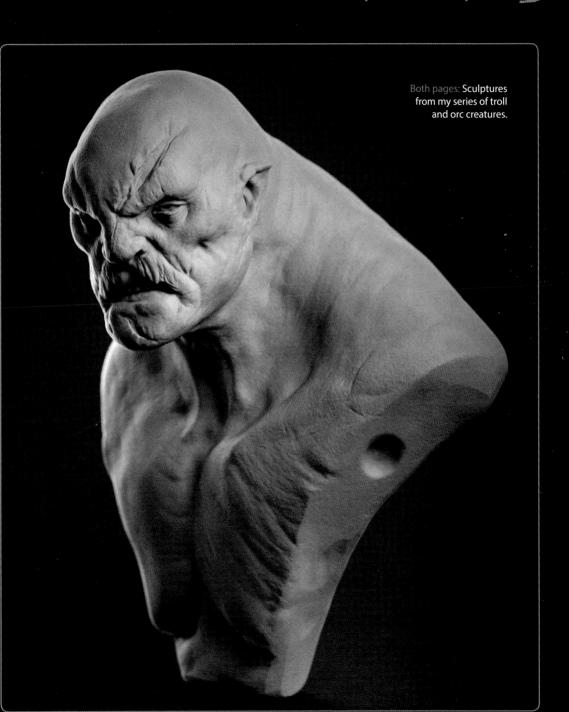

Both pages: Sculptures from my series of troll and orc creatures.

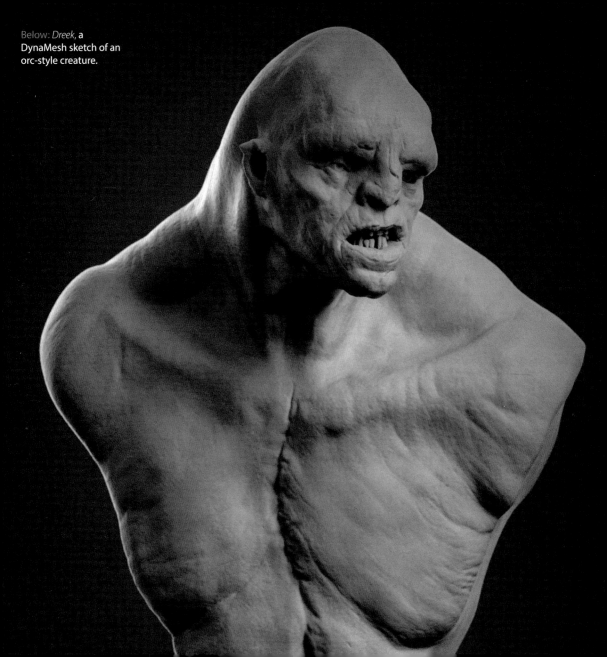

Below: *Dreek*, a DynaMesh sketch of an orc-style creature.

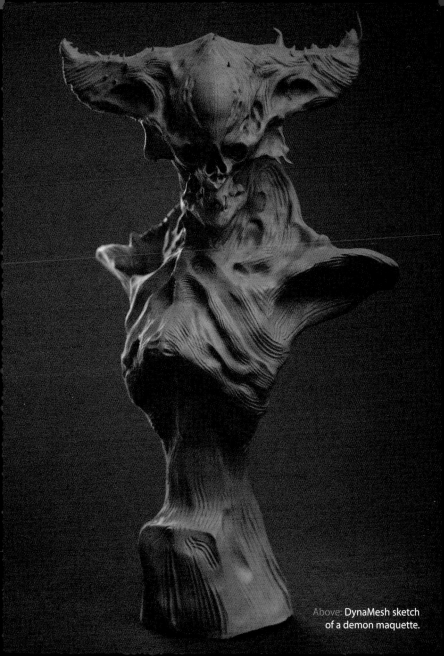

Above: DynaMesh sketch of a demon maquette.

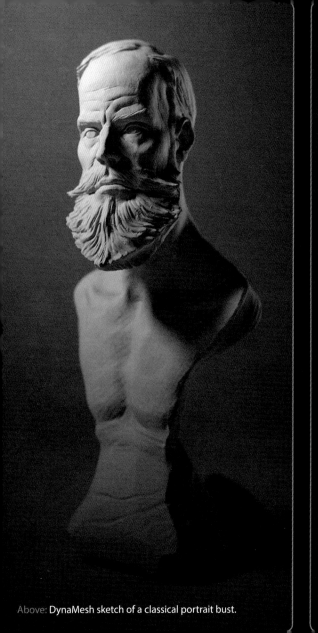

Above: **DynaMesh sketch of a classical portrait bust.**

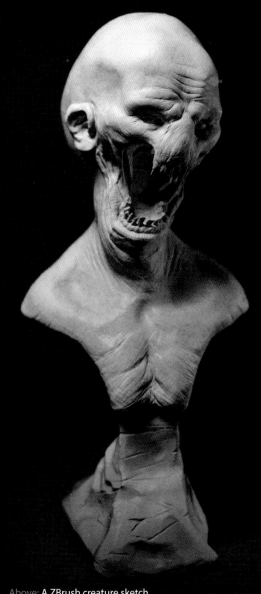

Above: **A ZBrush creature sketch.**

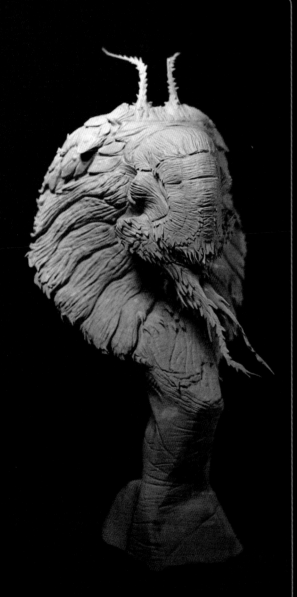

Above: Creature sketch of a lizard-style monster.

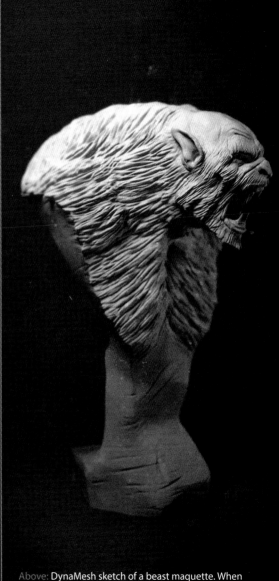

Above: DynaMesh sketch of a beast maquette. When presenting your sketch, try to keep it simple. Less is more with lighting. Study from life and from the masters.

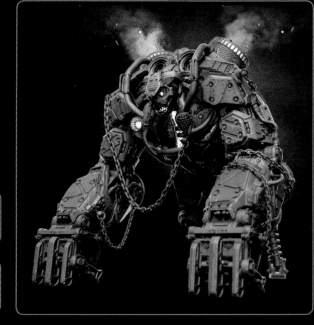

DAOUST, Frédéric

www.fredericdaoust23.artstation.com
All images © Frédéric Daoust

I've been using ZBrush since 2010 for all my 3D projects, and it's always been my favorite software with which to create digital art. 3D sketching is my first step in the creation of all my characters. If I start to work on a character from a concept, I will first begin by sketching the whole character, trying to focus only on the main shapes and the silhouette. It's a crucial step because it's creating the base and foundation of the whole project. If you're doing a character for a video game, for example, it's really important that you start with some solid shapes and silhouettes from all angles before diving into the smaller details.

I've also started to use 3D sketching this past year as a tool to improve my concept design skills. Starting from a sphere or any random mesh and exploring shapes and ideas has now become my favorite thing to do in my spare time.

INSPIRATION & IDEAS

One thing I like to do is to start with a random mesh or kitbash piece. For the first few minutes, I always have a chaotic approach of moving stuff, creating shapes, adding Insert Multi Mesh (IMM) pieces in a random way, until I stumble upon an interesting shape. It's similar to how some 2D artists use Photoshop's Lasso tool or random photos to find a starting shape to get inspired by. It's the most exciting part of the process because you never know what you're going to get!

TOOLKIT

I mainly use ZBrush for sculpting and my whole modeling process,

then use KeyShot for the rendering process and Photoshop for composition. It's a really powerful and artist-friendly trio of software that a lot of artists are using lately.

SCULPTING WORKFLOW

I love to start my sketches with a random mesh that I'll just stretch and modify to create something completely different. Most of the time I end up with some happy accidents that inspire me for the rest of the design. Once again, I really try to stay away from small details and focus more on the idea and the shapes, rarely spending more than two to five hours per sketch. If I stumble upon a good idea and feel inspired, I then spend one or two days polishing the character to have something nice to show. Most of the time I only polish the

character based on the camera angle that I know
I'll be using for the final image. It's a very fun and
fast process and everybody should give it a try!

Left-hand page: With this character I wanted to
make a big four-legged robot made out of some
heavy industrial machinery parts. One of the main
inspirations was the BigDog robot by DARPA.

This page: *Time Mage*. This sketch was meant to be some kind of
mage that can control time. Since I know that I'm just presenting
one image at the end, I don't spend any time modeling and
refining any of the pieces that are not visible or important

EMISSIVE OBJECTS

When I'm too lazy to add some colored materials to
my sculpts, I like to add just a couple of emissive areas
to the sculpt to add a little bit of color and a focal
element to the final image. In KeyShot you can apply
either the emissive material or the area light material
to any piece of your sculpt to make it glow. The area
light material acts more like a light and will bounce on
the mesh surrounding it, but is slower to render.

Above: A design created for the 2015 ZBrush Sculpt-Off.

Right-hand page: This mecha piece started out as a random lunchtime sketch.

"MOST OF THE TIME I ONLY POLISH THE CHARACTER BASED ON THE CAMERA ANGLE THAT I KNOW I'LL BE USING FOR THE FINAL IMAGE"

IMM BRUSHES

When I'm sketching in ZBrush I always use a certain amount of IMM brushes that I've gathered from the internet over the past few years. I mostly try to use them for smaller and non-primary parts of my characters to save a little bit of time. I mostly use IMM brushes as a tool to get fast details in less important areas of my design, not as something to drive the direction of my design. I sometimes use IMM brushes at the very beginning of a sketch and then deform randomly until I stumble upon a shape that inspires me.

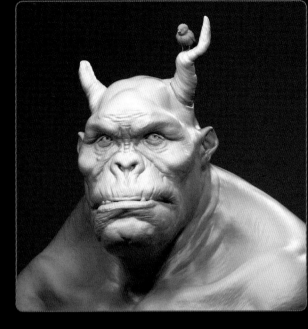

DIEPENDAAL, Ivo

www.ivodiependaal.com
All images © Ivo Diependaal

I came from a design background and started discovering 3D during my time at my graphic design school. I noticed that working only in 2D was not for me. I was fascinated by movies such as *Jurassic Park* and *Toy Story*, and when I got the chance to take an extra class (in 3D Studio Max, as it was back then), I did.

From there on I just kept learning and tried to get a grasp of all the software I thought I needed to know. After design school I enrolled in a 3D and VFX school where I discovered what I really liked to do. For me, that was modeling and texturing, and from there I went on to work for different studios, fulfilling those roles and working on my skills.

In my free time I like to sketch out and create my own 3D character

designs. Using ZBrush for this is ideal in my opinion. You can quickly make extensive changes and work freely without restrictions. Having something as simple as layers and a hundred undos is priceless!

If I'm not working on a personal project, I am probably catching up with friends or relaxing, watching some TV series and movies. I also like to travel so I try to do that as often as I can.

INSPIRATION & IDEAS

My inspiration mainly comes from my surroundings – people or things I see. There are always lovely things to discover in exotic countries, but also just while commuting to work, having a peek at that person with an unusual forehead or jawline. I love those extraordinary-looking people. Pinterest

or just an online search also do wonders for boosting the inspiration.

When I've chosen the type of character or creature I'm going to make, I go on exploring my options with a lot of references. I mostly work from a lot of strange references in the beginning, and the further I get, the more I focus on a specific style or other aspect in a select few images I have.

"THERE ARE ALWAYS LOVELY THINGS TO DISCOVER IN EXOTIC COUNTRIES, BUT ALSO JUST WHILE COMMUTING TO WORK"

I might start off by shaping the head of a character, taking reference from insects or fish, then finalize the shapes by using something totally different – from another species or

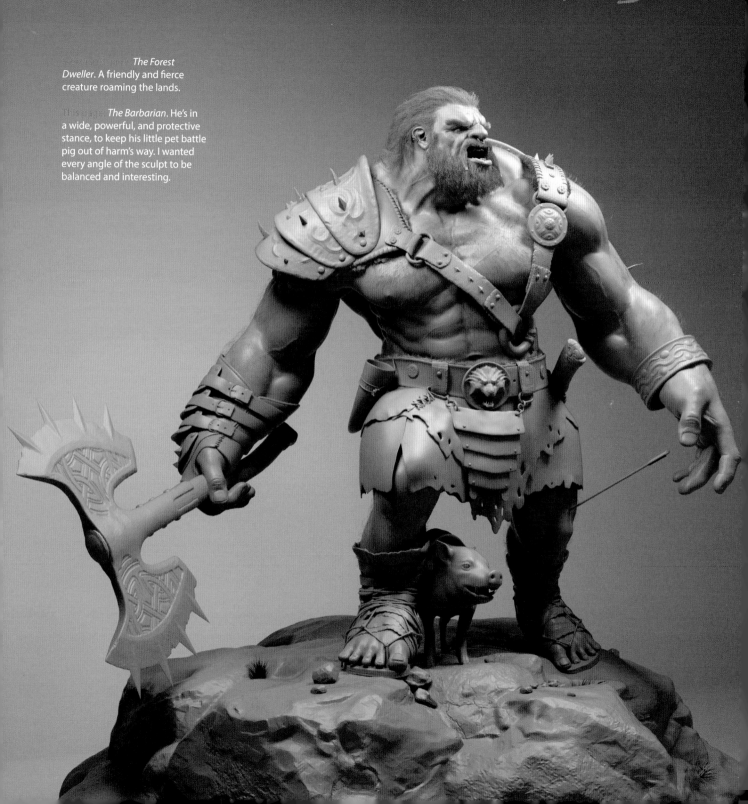

The Forest Dweller. A friendly and fierce creature roaming the lands.

The Barbarian. He's in a wide, powerful, and protective stance, to keep his little pet battle pig out of harm's way. I wanted every angle of the sculpt to be balanced and interesting.

very different character traits, skin types, expressions, limb details, and deformities. As long as one character trait is dominant, you can go pretty far with mixing up very strange and even totally opposite things.

TOOLKIT

The main software I use is ZBrush, Maya, MARI, and Photoshop. I use Maya for a lot of modeling for production, and also for rendering using Maya with V-Ray. I use ZBrush for sketching, and don't use a lot of custom brushes: mainly Move, Clay Tubes, Clay Buildup, and Dam Standard.

SCULPTING WORKFLOW

My favorite workflow would be using DynaMesh and ZRemesher to extensively tweak shapes and forms with the Pinch, Snake Hook, Magnify, and Inflate brushes. Besides that, I love mixing up different shapes in layers and sliding them around to get quick design ideas and optional changes visualized. I try to stay in DynaMesh for all the basic forms because it gives so much flexibility.

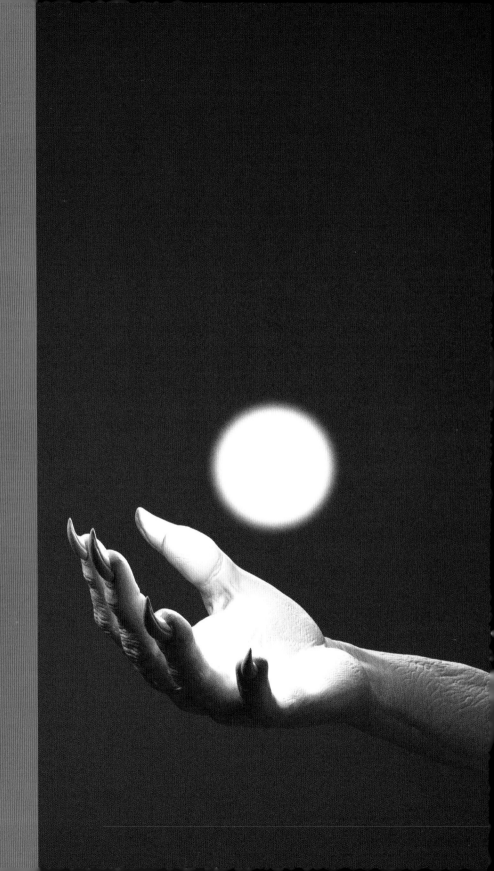

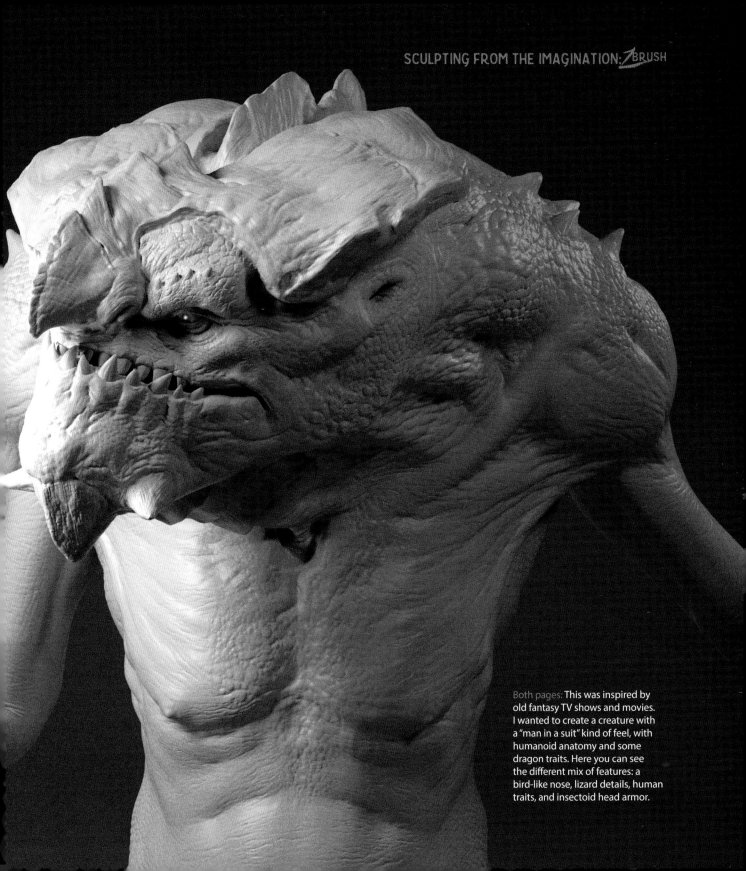

Both pages: This was inspired by old fantasy TV shows and movies. I wanted to create a creature with a "man in a suit" kind of feel, with humanoid anatomy and some dragon traits. Here you can see the different mix of features: a bird-like nose, lizard details, human traits, and insectoid head armor.

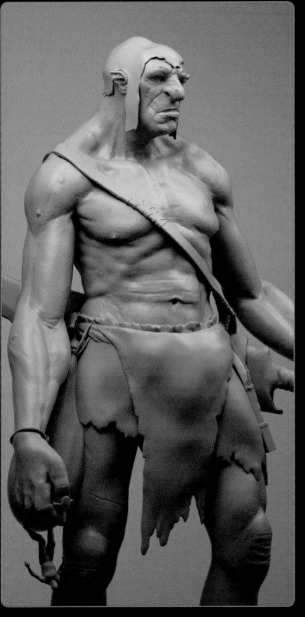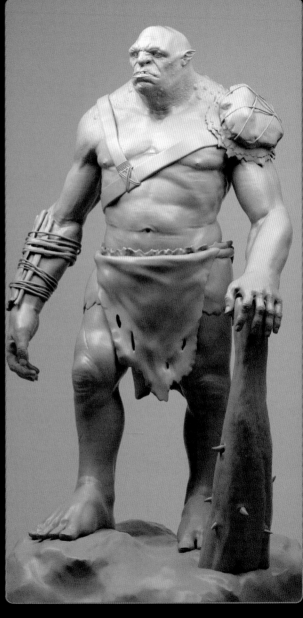

Left: A giant concept. He has to catch humans for his witch mother's
potions. He does not like it, but has to if he ever wants to be normal-

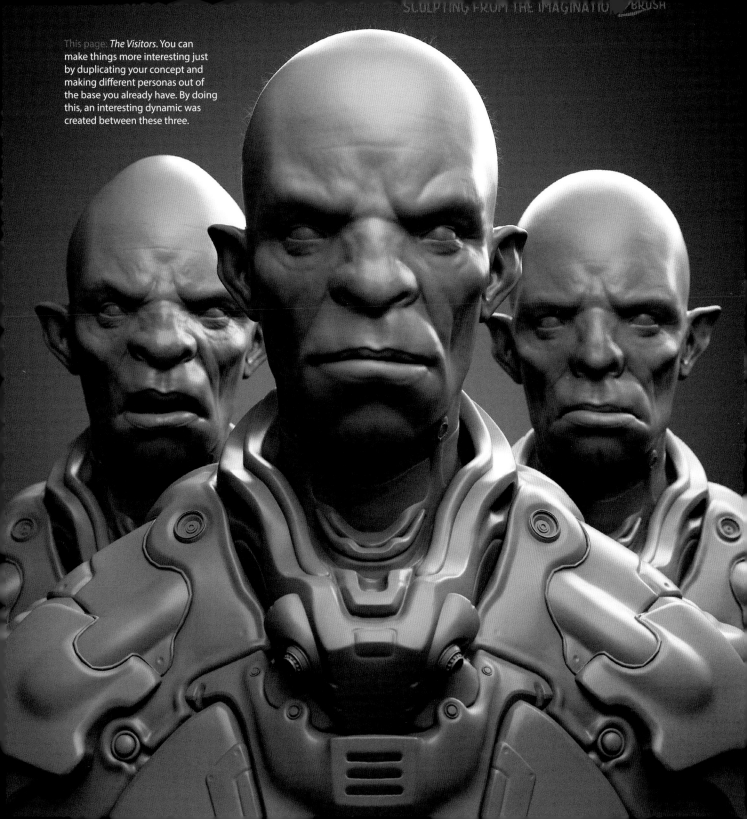

This page: *The Visitors*. You can make things more interesting just by duplicating your concept and making different personas out of the base you already have. By doing this, an interesting dynamic was created between these three.

ERDT, Benjamin

www.ben-erdt.de
All images © Ben Erdt unless stated

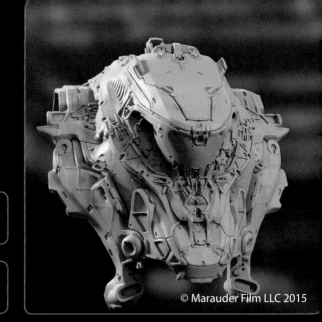

Before I did any 3D modeling, I had done a lot of custom-level design for d Tech based games such as *Quake I* to *Quake 4*. That was when I took my first steps into 3D and texture painting, and the interest for modeling kept growing with each asset that I made. Finally I wanted to try creating a custom character for one of my levels. That is how I got into character modeling and the basics of rigging.

A friend of mine also introduced me to ZBrush 2. Once I saw my first little monster dude textured and exported into a level, I was hooked and wanted to be among those who made all the cool characters and creatures for the games and movies. So through the years I kept teaching myself CG. Seven years ago I joined the game design high school in Munich. One

week after my graduation I attended the 3D Animation & Visual Effects program at Vancouver Film School, which was an amazing time. After I arrived back home, I applied to Guerrilla Games where I have been working for almost three years now.

I see sketching in 3D as a quick and fun way to create the first 3D representation of a 2D concept or a design idea. It also allows me to make design changes, improvements to articulation, and to eliminate any issues at a very early stage, which can save time during remodeling later on.

INSPIRATION & IDEAS
Most of my inspiration comes from nature as it provides an inexhaustible amount of ideas for shapes, form, lines, colors, patterns

and so on. For more techy-looking 3D models, I refer to real-life mechanics as well as documentaries, sci-fi movies, and games.

Besides that, I always have my list of artists who constantly inspire and remind me of what good design is. These include Jordu Schell, Simon Lee, Aris Kolokontes, Steve Wang, David Meng, Carlos Huante, Mike Nash, Vitaly Bulgarov, as well as others.

Most of my ideas start in 2D as pencil sketches which are then translated into 3D concepts that are still open for changes. Sometimes I start directly within ZBrush. First I try to establish a feeling that could lead to an interesting design direction. Starting to think a little bit about the character's or creature's backstory helps to flesh

out the design more. I still try not to get too attached to the design that early on. If there is something I am not happy with, I keep changing it until it fits the design feel I am going for.

TOOLKIT

My main toolkit currently consists of MODO, Maya, MARI, ZBrush, and Photoshop. The tools and brushes that I use inside ZBrush are a mix of the stock features and custom brushes. Some of the brushes I use constantly are the Standard, Dam Standard, Clay, Clay Tubes, Clip brushes, Move, Move Topological, hPolish, Trim Dynamic, and Insert Mesh. These are not too special and can be used

for a wide variety of tasks. Other brushes I use most of the time are a set of custom ones that I've created over the years, for organic surface detail and hard-surface sculpting.

SCULPTING WORKFLOW

When starting with a new 3D sketch, I use the DynaMesh feature and brushes like Clay Tubes, Move, and Standard. In the beginning I mainly focus on the basic shapes, forms, and silhouette and place some landmarks for what could become detailed areas later. When designing a creature which has long alien legs or multiple limbs, I sometimes use ZSpheres as a starting point. Once I am happy with the

primary and secondary shapes, as well as the silhouette, I use ZRemesher to get a cleaner edge flow and more even polygon distribution. I keep adding final detail passes to finish the sculpt. If I want to go for a textured look as the final concept piece, I add some color using Polypaint. The mesh is then quickly UV'd and decimated to be exported into MODO for rendering.

Left-hand page: A "Krieger" power armor designed for *Is This Heaven*, based on original concept art by Carlo Arellano and Bastiaan Koch. You can follow the movie's development at **www.facebook.com/isthisheavenmovie**

This page: ZBrush sketch of a tactical analyst.

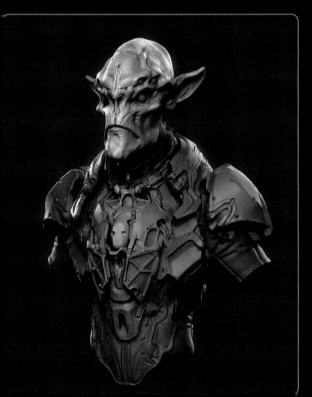

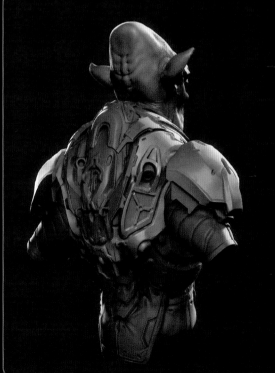

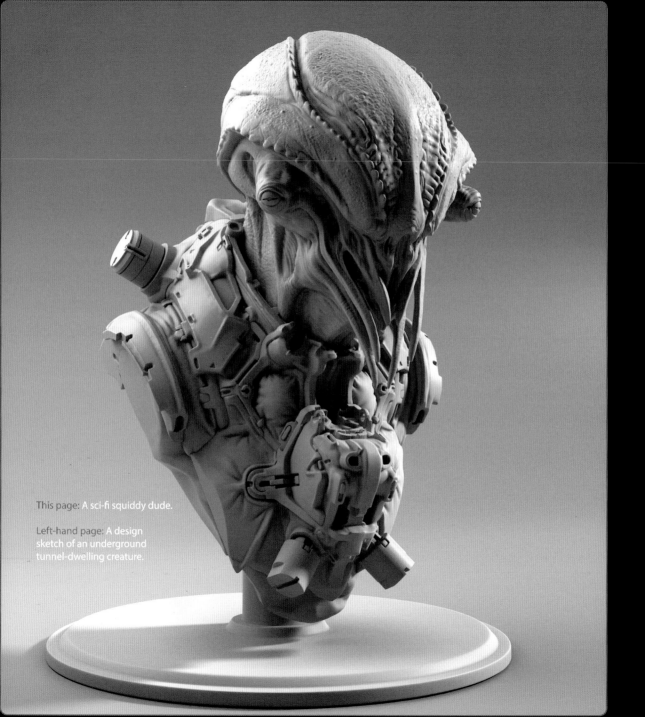

This page: A sci-fi squiddy dude.

Left-hand page: A design
sketch of an underground
tunnel-dwelling creature.

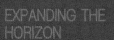

EXPANDING THE HORIZON

Personal projects are an opportunity to experiment in order to try out new tools, techniques, workflows, styles, and designs. It is important to keep pace in order to grow artistically. Continue pushing yourself through constant practice and try to see your personal work as a playground with lots of fun.

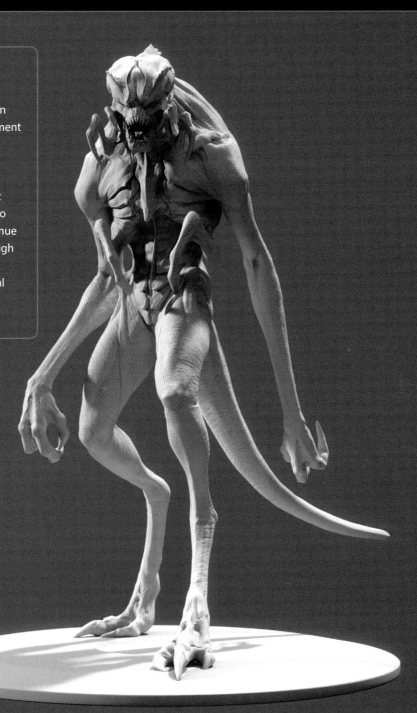

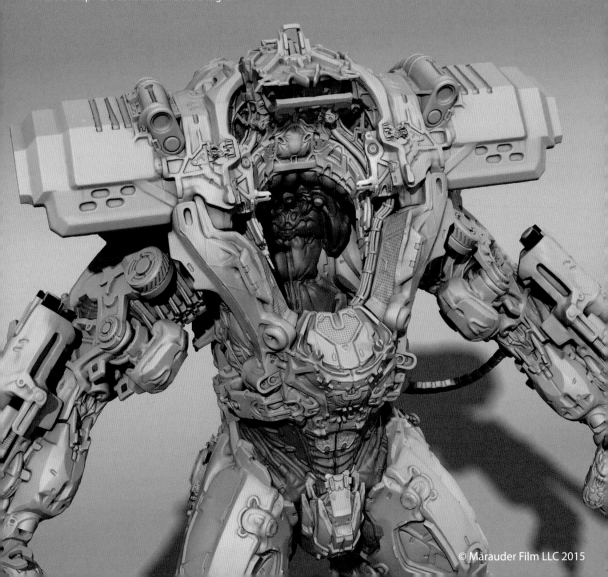

This page: Another part of the "Krieger" power armor designed for *Is This Heaven*, based on original concept art by Carlo Arellano and Bastiaan Koch. You can follow the movie's development at **www.facebook.com/isthisheavenmovie**

Right-hand page: The shipyard mechanic taking a coffee break. Most of the fabric elements such as the arms and cable wrap were done in Marvelous Designer.

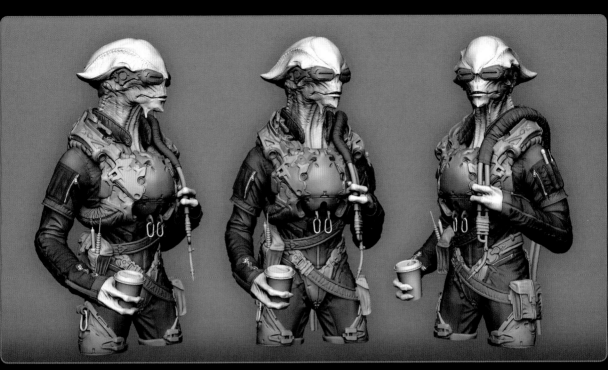

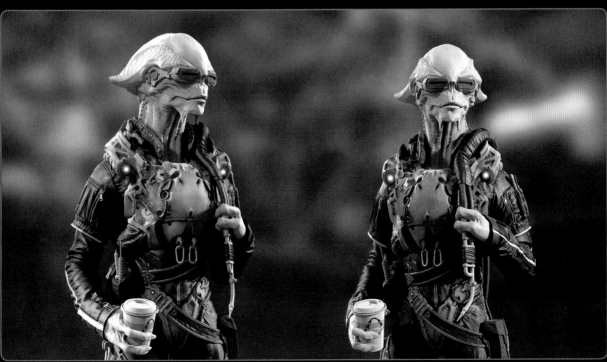

FIUZA, João

www.inkognit.carbonmade.com
All images © João Fiuza

Growing up with *Magic: The Gathering*, *Pokémon*, and dinosaur books was amazing. It made me gaze through the window pretending a big creature would rise from the horizon. It's mostly because of that that I became a concept artist. Eventually I would like to tell stories that people relate to and show them what I "see." Life is so much more interesting when you bring something magical into it.

There is a step I like to do before going into 3D, which is silhouette exploration in 2D. It helps me get fresher ideas. Once I go inside ZBrush I can quickly block out the shapes using DynaMesh. Try to always think about things in a real-world perspective; 3D will help you materialize it, enabling you to achieve the right forms and proportions, and that's what will make it believable.

I find sketching loosely in 3D very useful to sharpen and constantly improve my skills. Why? Well, for starters it's fast! Speed is always a struggle, right? We all have issues with time, so if it allows you to output designs quickly, that's already a winning situation. Not only that, but you'll be able to easily identify what it is that you most struggle with. Is it bony landmarks? Anatomy? Proportions? Just set a test for yourself: keep a daily habit of 3D sketching and you'll see how much you'll improve in just a single month. Practice makes perfect, I can't stress that enough!

INSPIRATION & IDEAS

My biggest source of inspiration has to be Tumblr. What I like most about Tumblr is that you get a whole range of different topics; you can

go from oranges to aye-ayes in a blink. I like to scroll through images until I find one that makes me feel something, that speaks to me, and then I try to capture that feeling in my own illustrations and sketches.

My second source of inspiration is real-life animals. Although I like to create beasts and aliens, there's a need to make them grounded in reality and functional, even if they are ruled by different forces from the ones of our planet. Creating believable anatomy that the observer can somehow relate to is halfway to selling your designs and ideas.

TOOLKIT

In my sketchbook you can see I have a very loose style. I don't like the idea of being restrained by technicalities

when I'm trying to set my mind free to explore, so that's where the brilliant DynaMesh comes in. For me and so many other artists this was a complete game-changer. No more having to limit yourself to polygon count, topology, or any other technicality that breaks your forward momentum. There are no obstacles; you can easily come up with multiple designs in a short amount of time. Basically your mind is the only limitation you have now.

When it comes to hard-surface modeling, however, I still use 3ds Max as it allows me to easily and accurately model low-poly pieces that I can then detail and even shape in ZBrush.

SCULPTING WORKFLOW

When it comes to sketching, my workflow is simple. I prefer to start with a sphere and turn on DynaMesh at a low resolution (something like 32 or 64). Working from a low division and building my way up when there's a need to have more detail in the mesh makes things more consistent, as it feels like I'm building my sculptures in layers. I also like to keep the parts of my model separated (arms, torso, legs), because when the time comes for more drastic changes, such as correcting posture/gesture, proportions, or even for posing, you are able to make them much more freely than if you had all parts in one single SubTool.

Left: I imagine this little gremlin as a tooth collector, giving a more gruesome look to the tooth fairy.

Right: Spidy is an example of the level of detail that works for me when thinking about 3D for illustration.

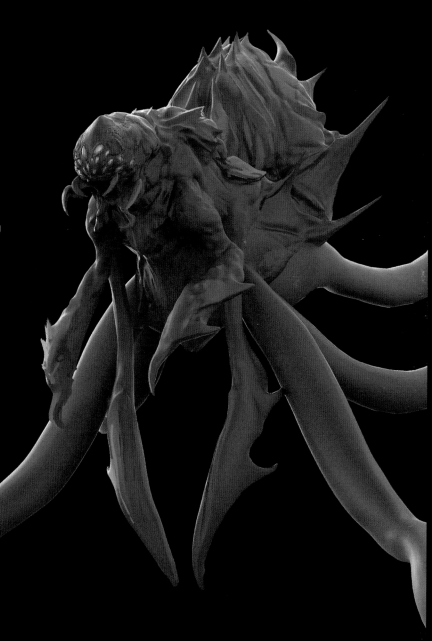

Above: This speed-sculpt was based on a drawing
I had laying in my sketchbook for quite a while.

Right: *Prelodius* belongs to a noble society that worked
as peacemakers between worlds, which became
infected by a strange virus on one of their travels.

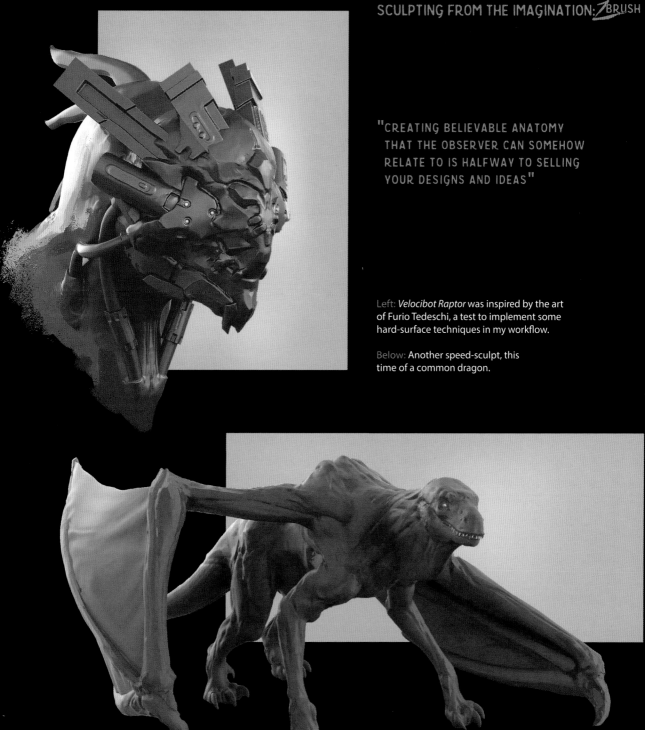

"CREATING BELIEVABLE ANATOMY THAT THE OBSERVER CAN SOMEHOW RELATE TO IS HALFWAY TO SELLING YOUR DESIGNS AND IDEAS"

Left: *Velocibot Raptor* was inspired by the art of Furio Tedeschi, a test to implement some hard-surface techniques in my workflow.

Below: Another speed-sculpt, this time of a common dragon.

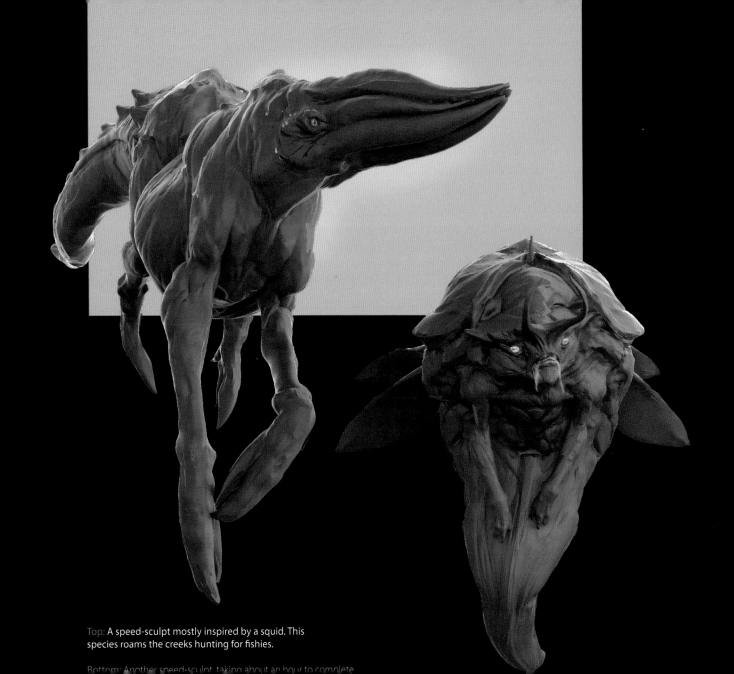

Top: A speed-sculpt mostly inspired by a squid. This
species roams the creeks hunting for fishies.

Bottom: Another speed-sculpt, taking about an hour to complete.

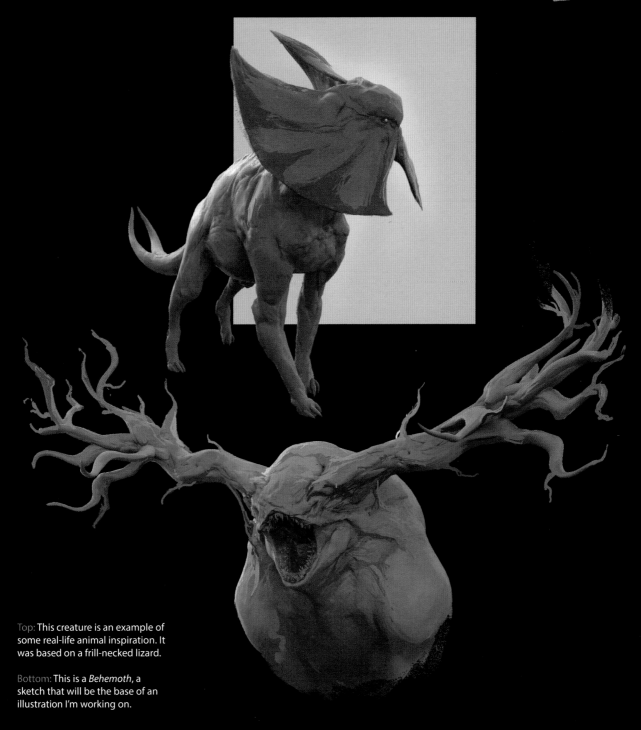

Top: This creature is an example of some real-life animal inspiration. It was based on a frill-necked lizard.

Bottom: This is a *Behemoth*, a sketch that will be the base of an illustration I'm working on.

GAO, Xin

http://funkyboy.artp.cc/cover
All images © Xin Gao

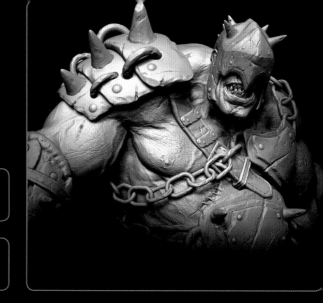

I'm a 3D character artist and have used ZBrush for about seven years. When I started out, I would begin with a 2D sketch so I could draw the concept in a very short time, but this caused some problems as some 2D designs don't look good when implemented in 3D software. This made me change my 2D sketch again and again, wasting a lot of time. This was a very troubling thing until ZBrush's DynaMesh appeared, and I began to make 3D sketches in ZBrush. I found this way very convenient.

With ZBrush, you can use a simple model to quickly create an organic shape, do a whole lot of experiments until you're sure you want a shape, view the model in 360 degrees, then add details. It's really straightforward and more efficient than a 2D sketch, as all you need is your model

INSPIRATION & IDEAS

My inspiration comes from movies, pictures, and novels. I often create a foundation model in ZBrush, then use the Move brush to drag the model around. The process is very free most of the time; I may not have a clear idea, but I just experiment and explore in ZBrush. Occasionally there will be a surprise and I get a very special shape, and then I start carving deeper details. This is a kind of improvisation that I think is very interesting. But mostly you need to watch and pay attention to things around you – these are your references, so keep them in mind while you work, and your ideas will go smoothly.

TOOLKIT

I often use ZBrush, 3ds Max, and Photoshop, generally beginning my

work in ZBrush. So that I can design in an intuitive way, I use DynaMesh in ZBrush, often with these brushes: Standard, Clay, and Dam Standard. The Standard brush can quickly draw the general structure, while Clay is useful for muscles. Dam Standard can cope with tiny wrinkles and be very soft to carve the details of the sculpture. These brushes all work well in conjunction with the Smooth, which smooths the surface of my models.

"ENRICHING EVERY DETAIL MAY BE A TEDIOUS PROCESS, BUT YOU MUST KEEP YOUR PATIENCE"

SCULPTING WORKFLOW

When I have a new idea, I create a DynaMesh. Using the Move brush, I drag this basic model around to try different shapes, like kneading

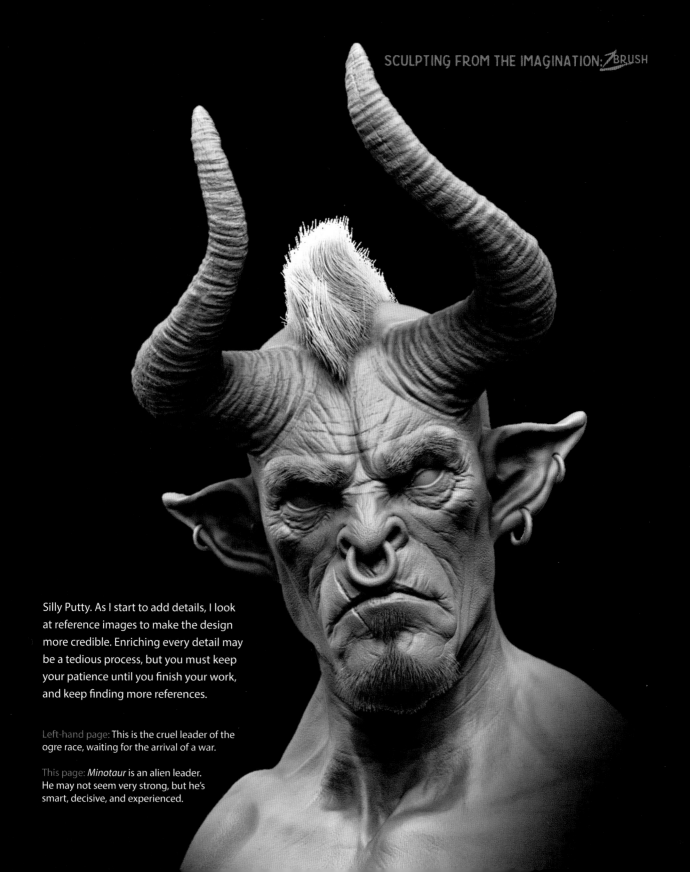

Silly Putty. As I start to add details, I look at reference images to make the design more credible. Enriching every detail may be a tedious process, but you must keep your patience until you finish your work, and keep finding more references.

Left-hand page: This is the cruel leader of the ogre race, waiting for the arrival of a war.

This page: *Minotaur* is an alien leader. He may not seem very strong, but he's smart, decisive, and experienced.

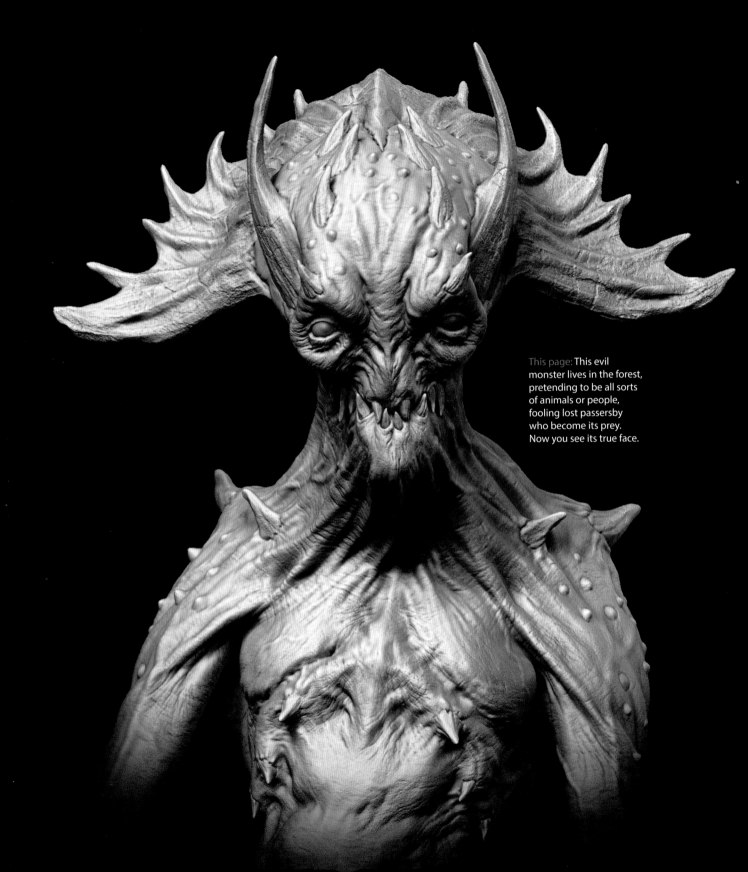

This page: This evil monster lives in the forest, pretending to be all sorts of animals or people, fooling lost passersby who become its prey. Now you see its true face.

This page: *Three Eye Wizard* is an alien whose third eye can see the future. He has no mouth to speak with, but his tentacles receive information from everything.

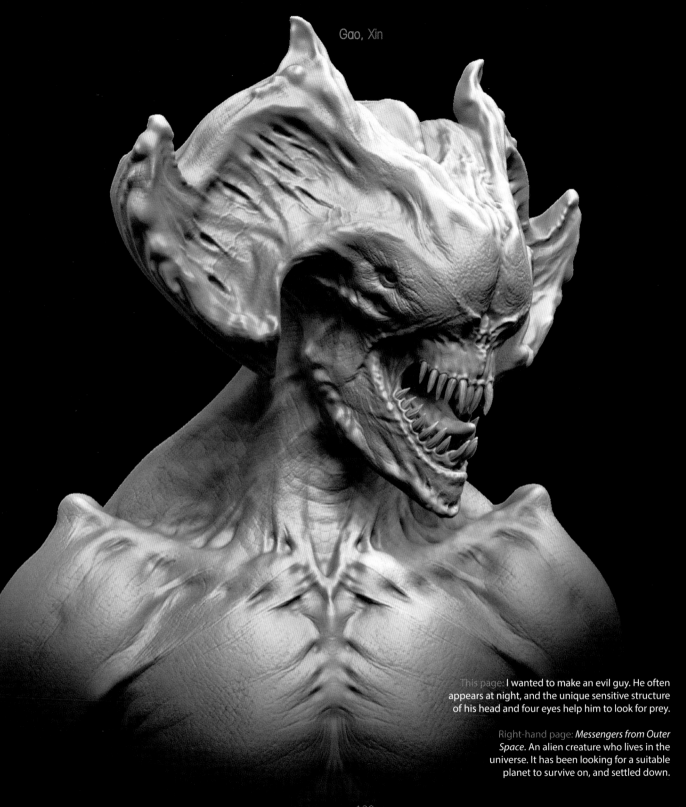

Gao, Xin

This page: I wanted to make an evil guy. He often appears at night, and the unique sensitive structure of his head and four eyes help him to look for prey.

Right-hand page: *Messengers from Outer Space*. An alien creature who lives in the universe. It has been looking for a suitable planet to survive on, and settled down.

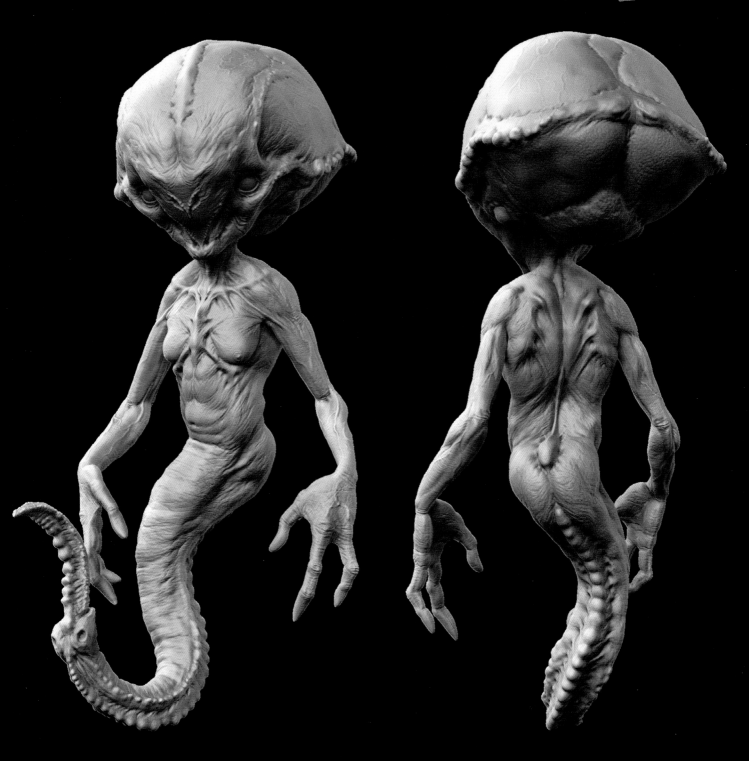

GAZA, Victor

www.vickgaza.com
All images © Victor Gaza

From a professional standpoint, I often have to produce very efficient and optimized artwork that is appropriate for real-time rendering. Unfortunately, this gets less creative from time to time as it requires more technical attention. In order to stay creative and keep improving on my artistic skills, I try to fire up ZBrush daily, before and/or after work, and sculpt 3D sketches or small-scale studies. This is when I try to improve whatever skills I think I lack, be it hard-surface, anatomy, portraits, or creatures, for example.

But really, most importantly, I try to keep the daily sculpt sessions loose and fun, and not put pressure on myself to create any portfolio-worthy sculpts, so that I can just enjoy the process and not focus on the end result. As long as I learn new skills

and expose myself to exercises I've done less of in the past, I can then get more confidence to apply the newly acquired skills to bigger pieces for my portfolio. Generally, my weekends are for portfolio work, stuff that I polish more and take my time with, though most of the ideas and techniques that are reflected in my portfolio come from my daily ZBrush sketch sessions.

INSPIRATION & IDEAS

What truly moves and inspires me are the people (or teams of people) who either invent new techniques and workflows before everybody else, or who push design, details, and polish to an incredibly high level, while having access to the same tools and resources as the rest of us, such as Craig Mullins, Mike Nash, Vitaly Bulgarov, and Rafael Grassetti.

Additionally, with the risk of sounding clichéd, I would also like to mention that currently my most tangible source of inspiration is my workmates from Guerrilla Games, who are so insanely skilled and hard working. I am incredibly proud to be part of the team.

TOOLKIT

ZBrush is pretty much my main tool of choice and my favorite by far. I use it for 3D sketching and concepts, and also in production. I have used it for character, asset, and environmental work, both organic and hard-surface. It's awesome.

I also use Maya for various tasks and am looking into learning MODO for poly modeling in the near future. For texturing, I use Substance Painter and Photoshop. Generally I try to keep an open mind

regarding software. The moment a new software package or workflow stands out to me, I give it a shot, and if it's better or faster than what I currently use, I incorporate it into my workflow.

SCULPTING WORKFLOW

My sculpting workflow is fairly simple. I basically use the Standard, Clay Buildup, and Move brushes the most, especially in the initial stages of a piece. Dam Standard, Clay, and Trim brushes are also my go-to brushes.

Lately I've tried really hard to work zoomed out as much as possible. I try to avoid working up close to my model, so as to not lose track of the "bigger picture" and get lost in details, even though unfortunately my obsessive nature sometimes gets the best of me. Most importantly, I try to work in hourly chunks to stay focused, in which I avoid social media altogether.

"CURRENTLY MY MOST TANGIBLE SOURCE OF INSPIRATION IS MY WORKMATES FROM GUERRILLA GAMES, WHO ARE SO INSANELY SKILLED AND HARD WORKING"

Left-hand page: One of my oldest pieces, done at university while I was still experimenting with ZBrush.

This page: Some retopology was done outside of ZBrush, and some cloth simulated, but the majority of work was strictly ZBrush.

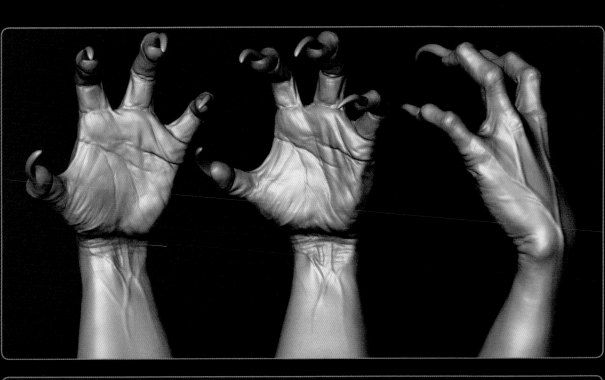

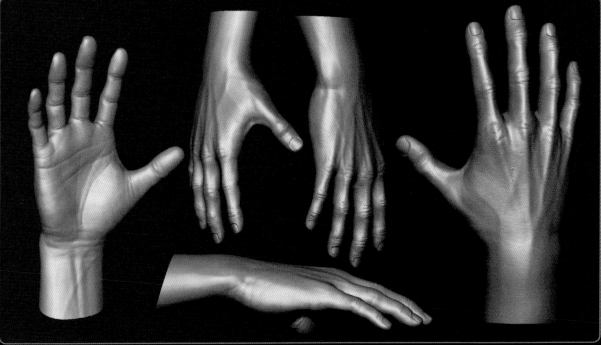

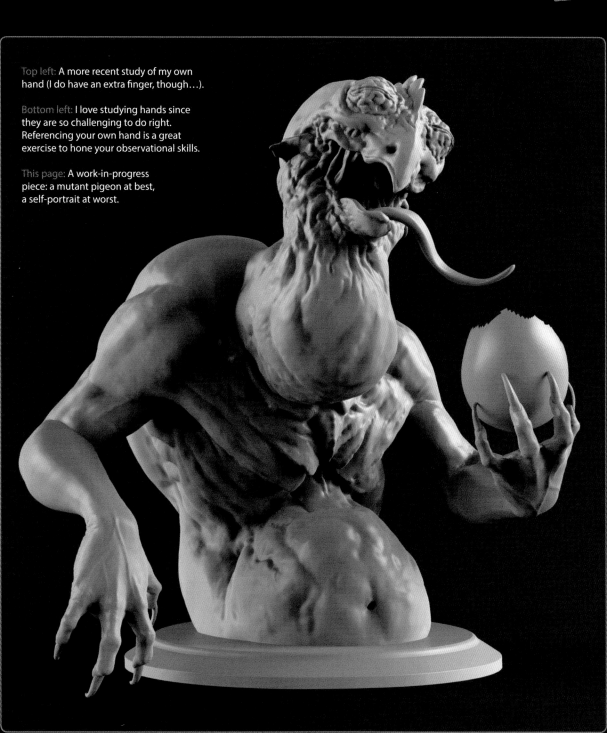

Top left: A more recent study of my own hand (I do have an extra finger, though…).

Bottom left: I love studying hands since they are so challenging to do right. Referencing your own hand is a great exercise to hone your observational skills.

This page: A work-in-progress piece: a mutant pigeon at best, a self-portrait at worst.

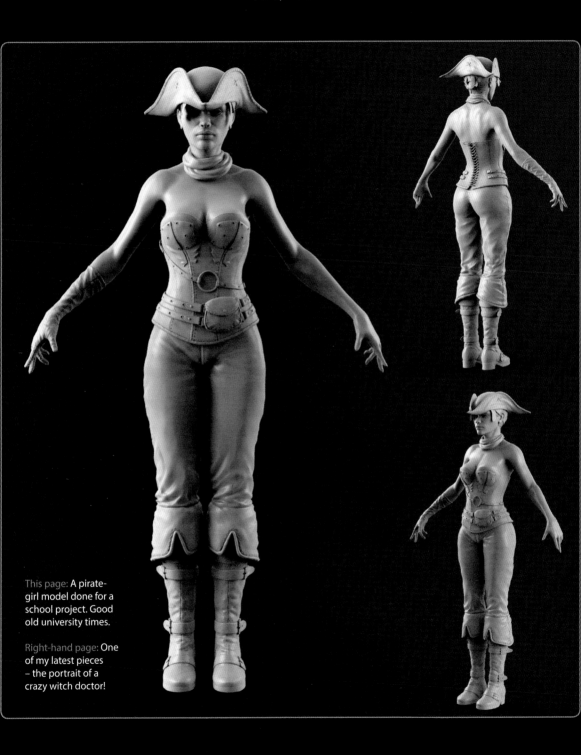

This page: A pirate-girl model done for a school project. Good old university times.

Right-hand page: One of my latest pieces – the portrait of a crazy witch doctor!

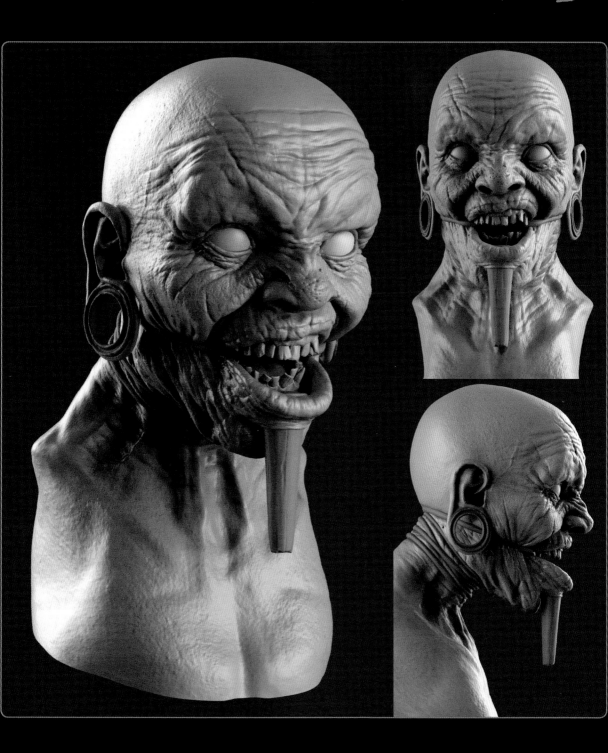

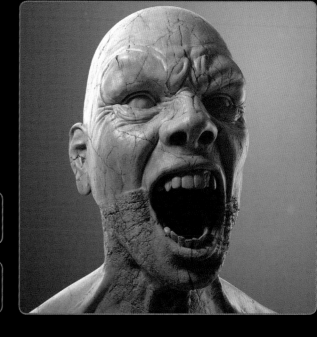

GÓMEZ, Pablo Muñoz

www.zbrushguides.com
All images © Pablo Muñoz Gómez

When ZBrush first introduced DynaMesh, I knew it would be the next "big thing" to add to my creative process. DynaMesh gives me total freedom to develop a concept as well as setting up the basis for a more detailed project. I have some years of experience sculpting characters in traditional media; I always start each sculpture with a simple ball. DynaMesh allows me to treat a 3D sphere the same way I would tackle a project with real clay, so the transition to using ZBrush has been very smooth for me.

ZBrush has become an indispensable part of my creation process. Tools such as ZSpheres, Decimation Master, Insert Brushes, and FiberMesh, to name a few, allow me to explore ideas and change things very quickly.

I think as an artist you must adapt to the material of your craft, and in the process of understanding that particular material, you will develop a technique based on the tools at hand. To me, 3D polygons would be the "material" I needed to adapt to, and ZBrush would be just the perfect tool to develop techniques in this area; this, among other reasons, is why I sketch in 3D, particularly in ZBrush.

INSPIRATION & IDEAS

Nature is a never-ending source of ideas to me, but it's hard to say specifically what inspires me, because anything could be the spark that will light up the path to develop a concept; a person, a phrase I heard, shapes in the clouds, a song, even a random stain on the concrete

might suggest something to me. But when I'm out of ideas to sketch, my search for references will always start with photography of nature, portraits, macros of insects, abyssal creatures, landscapes, and so on.

TOOLKIT

When sketching, I try to be practical because I tend to produce quite a few options before I start refining a model. ZBrush allows me to explore numerous ideas very quickly. For a model that needs to go into a production phase, there are numerous specific tools for every need. When working on a rough sketch, I limit my brushes to Clay Buildup, Clay Tubes, custom Smooth, Trim Dynamic, and Move. In general, I render straight from ZBrush and use Photoshop to

compose my layers and retouch my renders. Sometimes I go back and forth between these two software packages: for example I might paint over a ZBrush screenshot to explore shapes and before going back to ZBrush.

SCULPTING WORKFLOW

Although I might apply different approaches depending on the nature and size of a project, I have been trying to standardize my sketching workflow: I start with a DynaMesh sphere and use the Move tool to block some shapes; then I use the Clay Buildup tool to quickly add volumes. I use the Dam

Standard brush as a knife to carve in the model and limit some areas to work on. Then I continue with Clay Tubes, varying the brush size to detail the model. At this point I will swap materials to test the smoothness of the surface and use the Move Elastic tool to re-evaluate proportions or find more interesting silhouettes.

Left-hand page: *Scream*. This was originally a sketch to practice neck anatomy but it ended up being a zombie vampire.

This page: A creature sketch inspired by a combination of insects and interesting plants.

129

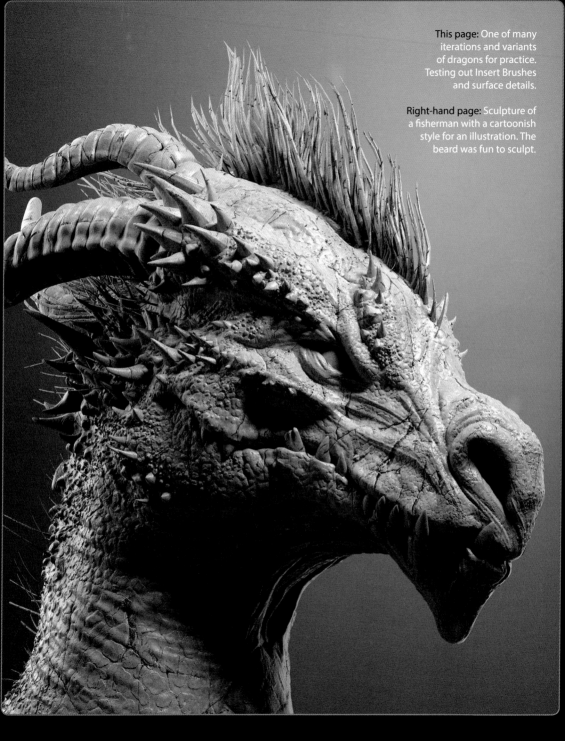

This page: One of many iterations and variants of dragons for practice. Testing out Insert Brushes and surface details.

Right-hand page: Sculpture of a fisherman with a cartoonish style for an illustration. The beard was fun to sculpt.

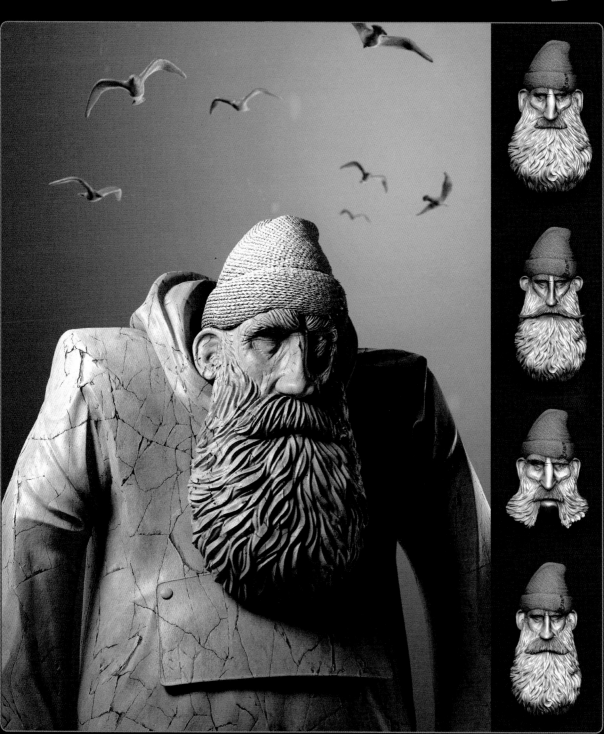

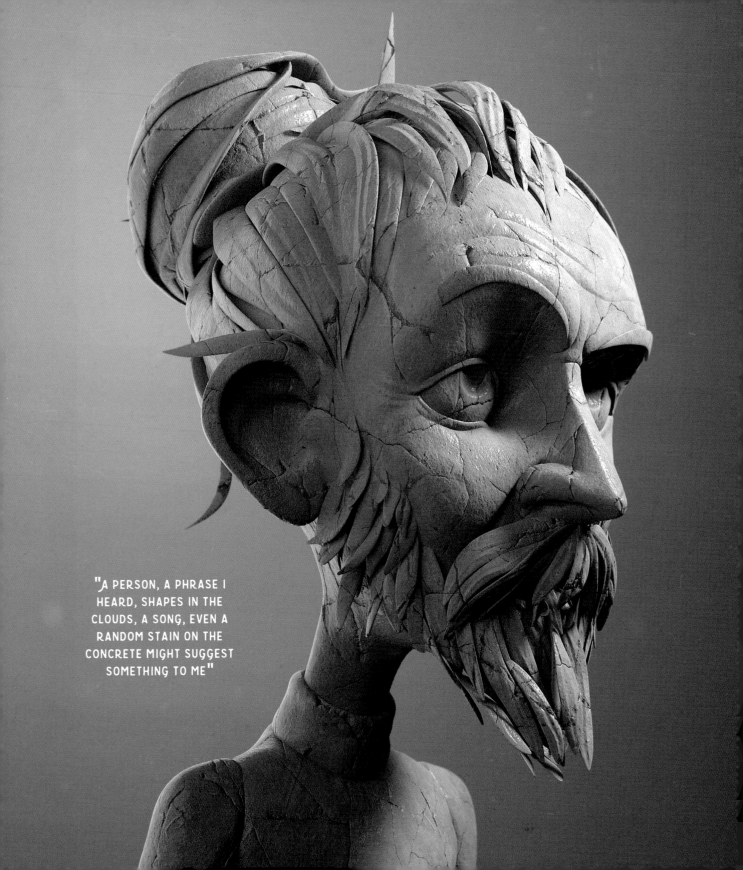

"A PERSON, A PHRASE I HEARD, SHAPES IN THE CLOUDS, A SONG, EVEN A RANDOM STAIN ON THE CONCRETE MIGHT SUGGEST SOMETHING TO ME"

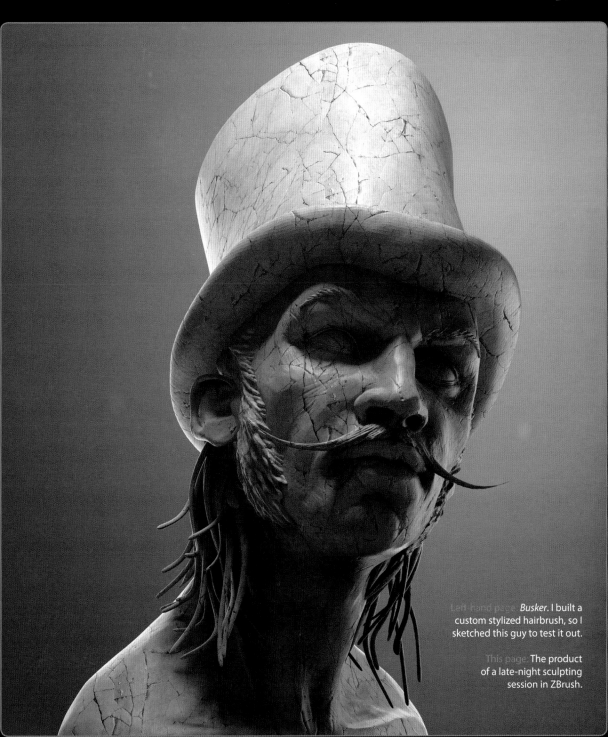

Left-hand page: *Busker.* I built a
custom stylized hairbrush, so I
sketched this guy to test it out.

This page: The product
of a late-night sculpting
session in ZBrush.

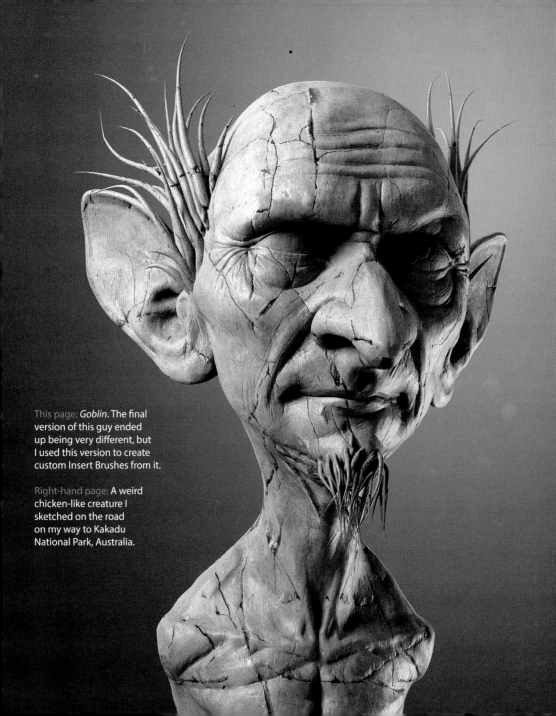

This page: *Goblin*. The final
version of this guy ended
up being very different, but
I used this version to create
custom Insert Brushes from it.

Right-hand page: A weird
chicken-like creature I
sketched on the road
on my way to Kakadu
National Park, Australia.

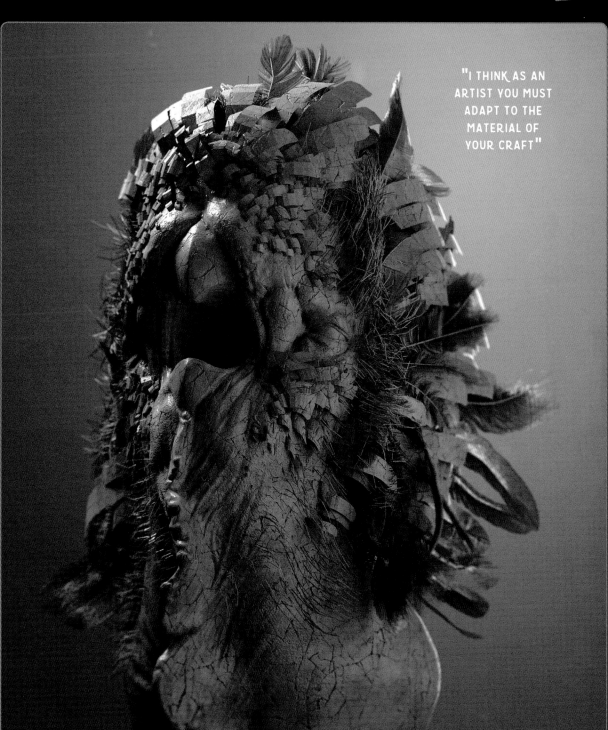

"I THINK AS AN ARTIST YOU MUST ADAPT TO THE MATERIAL OF YOUR CRAFT"

HAO, Jia

www.artofjiahao.com
All images © Jia Hao

Hello world! My name is Jia Hao and it's nice to meet you. I started to venture into the world of 3D back in 2010. After learning a little bit of everything, primarily focused on modeling, texturing, and rendering using a handful of software, including Maya, Mudbox, MARI, and Photoshop, I finally found my passion in designing imaginative creatures and characters. My journey with ZBrush started in 2013, when I found it enabled me to sketch and design in 3D, the dimension I am most comfortable with.

Even without any traditional drawing and sculpting background, ZBrush makes it possible for me to pursue my dream of becoming a character and creature designer. However, I do realize the importance of 2D sketching and I am trying to improve it along the way.

Most of my sketches begin in ZBrush, aside from some rough 2D sketches now and then. Sketching in 3D allows me to spin the model around to look at it from any angle. I can play with light interactively to see the form more clearly as well. On top of that, when I make changes to the form, it will be reflected from all angles. Another benefit of sketching in 3D is the advancement and accessibility of 3D printing technology – I might be able to print my designs in the future!

I will often dedicate an hour daily to sketching in ZBrush to brainstorm and explore ideas for potential future projects. During this stage I stop once I get an idea from the sketch. In order to take it further I have to do some research on the subject and gather some references.

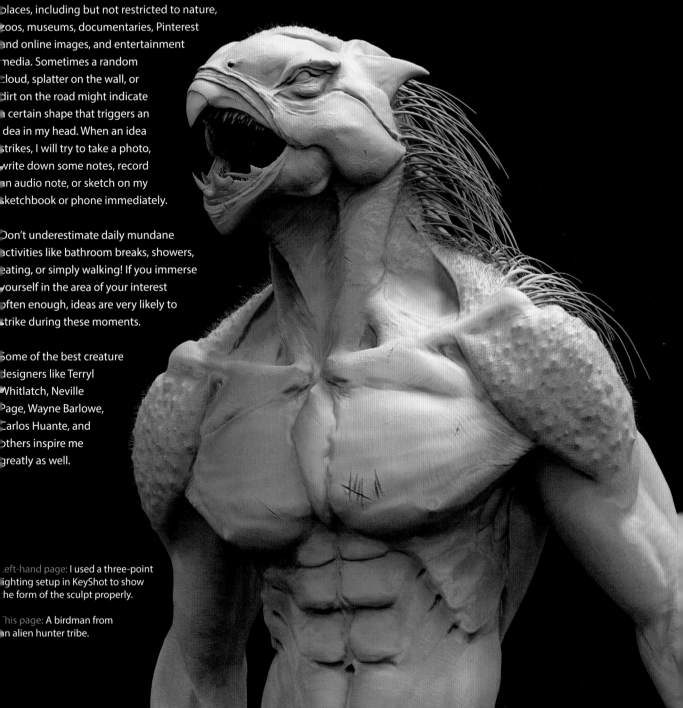

INSPIRATION & IDEAS

My inspirations and ideas come from many places, including but not restricted to nature, zoos, museums, documentaries, Pinterest and online images, and entertainment media. Sometimes a random cloud, splatter on the wall, or dirt on the road might indicate a certain shape that triggers an idea in my head. When an idea strikes, I will try to take a photo, write down some notes, record an audio note, or sketch on my sketchbook or phone immediately.

Don't underestimate daily mundane activities like bathroom breaks, showers, eating, or simply walking! If you immerse yourself in the area of your interest often enough, ideas are very likely to strike during these moments.

Some of the best creature designers like Terryl Whitlatch, Neville Page, Wayne Barlowe, Carlos Huante, and others inspire me greatly as well.

Left-hand page: I used a three-point lighting setup in KeyShot to show the form of the sculpt properly.

This page: A birdman from an alien hunter tribe.

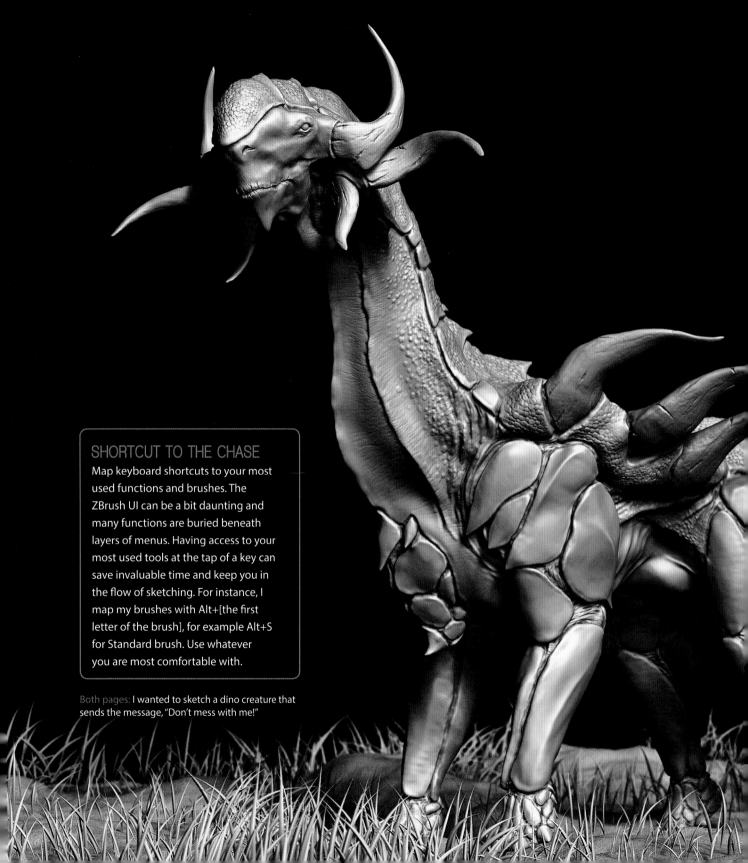

SHORTCUT TO THE CHASE

Map keyboard shortcuts to your most
used functions and brushes. The
ZBrush UI can be a bit daunting and
many functions are buried beneath
layers of menus. Having access to your
most used tools at the tap of a key can
save invaluable time and keep you in
the flow of sketching. For instance, I
map my brushes with Alt+[the first
letter of the brush], for example Alt+S
for Standard brush. Use whatever
you are most comfortable with.

Both pages: I wanted to sketch a dino creature that
sends the message, "Don't mess with me!"

TOOLKIT

Nowadays I primarily use a combo of ZBrush, KeyShot, and Photoshop, or simply ZBrush and Photoshop. I use ZBrush because it offers the most robust sculpting tools, is efficient in both organic and hard-surface sculpting, and has a great community with plenty of online learning resources and great support from the company.

KeyShot offers a very fast and simple way to set up a render, compared to traditional rendering engines. This means I can spend less time on setting up lighting, juggling with render settings, and waiting for the render to complete to see the final result.

Finally, I use Photoshop for any image manipulation, processing, and digital painting needs.

SCULPTING WORKFLOW

In ZBrush, I often start with a DynaMesh sphere at a very low resolution of 16. Then I start sketching using my favorite brushes: Move, Snake Hook, Clay Buildup, Standard, Dam Standard, Inflate, and Form. When I am in need of higher resolution, I will either subdivide with "Smt" turned off or increase the DynaMesh resolution with Blur, with Polish set to 0 in order to retain the form.

If I want to explore more design variations, I will either duplicate the mesh or use layers to store new deformations. Then I play with the combination of the different meshes or layers to find a new design or happy accident.

I also try to keep my polygon count and SubTools as low as possible to maintain the fluidity of my workflow.

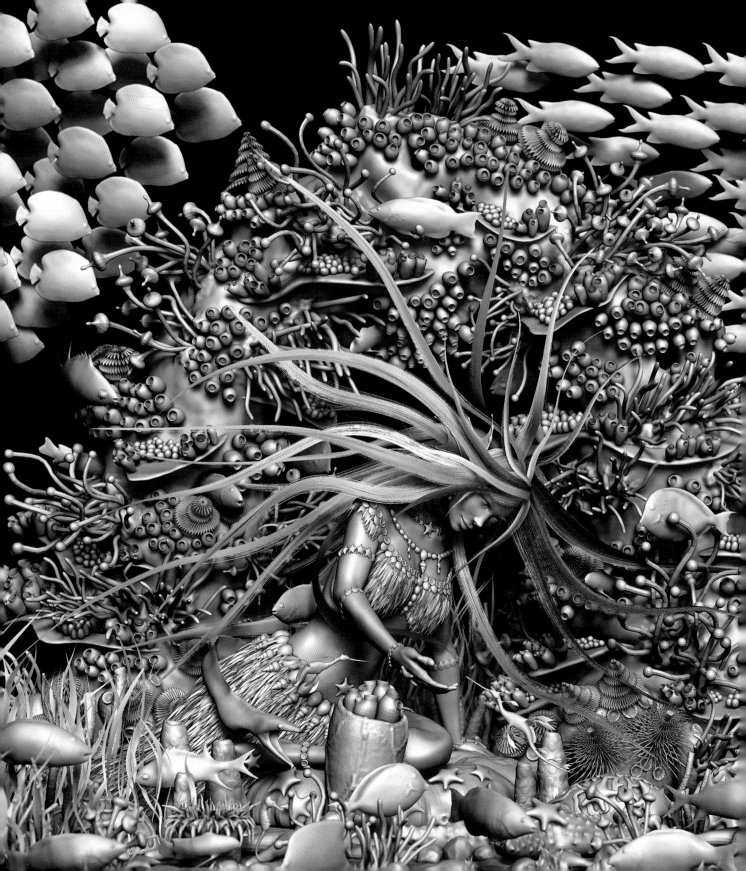

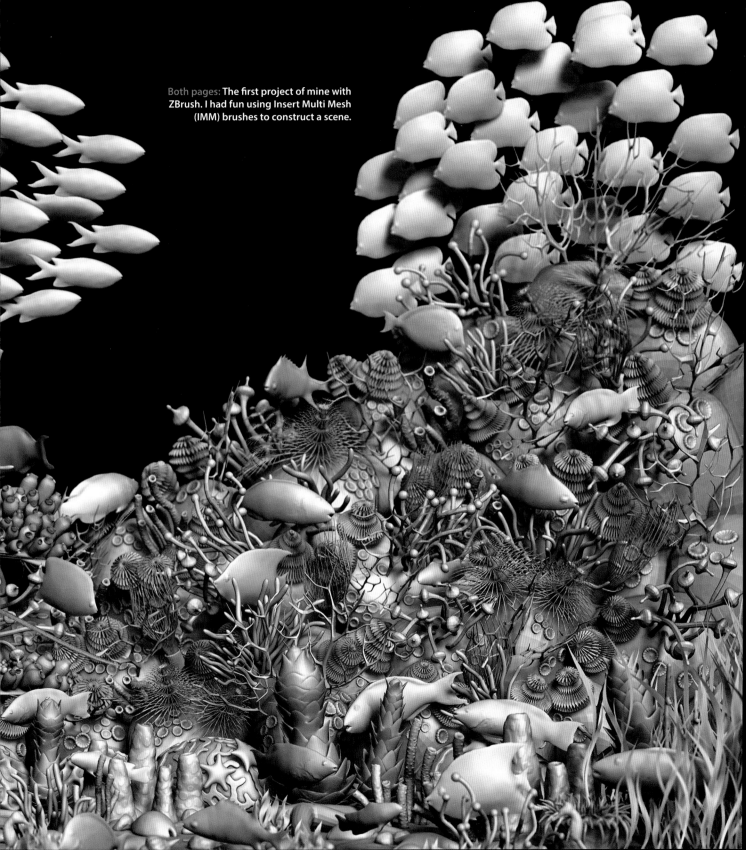

Both pages: **The first project of mine with ZBrush. I had fun using Insert Multi Mesh (IMM) brushes to construct a scene.**

HASLAM, Leo

www.leohaslam.com
All images © Leo Haslam

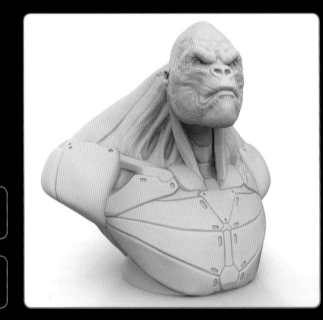

As far back as I can remember I've always loved drawing monsters. I remember some of my school teachers being concerned about the things I would draw in class, but it was all in good fun. I started sculpting when I was in high school and fell in love with it. Many years later I discovered ZBrush and it changed everything.

ZBrush is the perfect blend between sketching and sculpting. I love sketching in ZBrush as I feel it offers the freedom to explore shapes and ideas more quickly and easily than using traditional methods. Whenever I'm stuck for ideas I just jump straight into ZBrush and start sculpting away. Before I know it, new ideas and inspirations are starting to emerge from the shapes in front of me. The great thing about this is that these rough sketches can then be developed further and eventually be used to create anything from concept art to animation-ready characters and even 3D printed models. At any point during the sculpting process I can send my ideas over to KeyShot with the click of a button, where they can be viewed in realistic materials and lighting conditions. This really helps in the visualization process.

All of the images here started off as rough 3D sketches.

INSPIRATION & IDEAS

I draw inspiration from a range of different sources. Of course sci-fi movies, comic books, computer games, and other artists are a big part of my inspiration, but I also find it in nature as well. Things like insects, lizards, strange sea creatures, and exotic plant life.

Another great source of inspiration is music. Drum 'n' bass and Aphex Twin are great for conjuring up ideas.

TOOLKIT

My weapons of choice are ZBrush, KeyShot, and Photoshop. I use an old Wacom Bamboo tablet and a desktop computer or laptop depending on where I am. My preferred ZBrush brushes are Clay Buildup (great for sculpting shape and form), Dam Standard (for roughing in loose details and carving in hard edges), Move (for nudging things into shape), and Trim Dynamic with hPolish (Trim for roughing in hard planes and hPolish for cleaning them up).

SCULPTING WORKFLOW

I start by blocking in the basic shapes using ZSpheres. Once I have something

I like, I'll convert the ZSpheres into a polymesh and then use the Move brush to push and pull the mesh, giving it a bit more shape. Then I use DynaMesh with a low resolution and start sculpting the basic forms with the Clay Buildup brush. As the form becomes more defined, I start to increase the resolution of the DynaMesh and begin adding in the secondary details.

The next stage depends on whether I'm working on a 3D print or concept art. If I'm working on concept art I will duplicate the mesh and then use ZRemesher to create clean topology. I then divide the mesh into millions of polygons and project the detail from the high-resolution DynaMesh back onto the clean topology. Even though this is for concept art, I still want clean topology because it will hold the fine details like skin pores better than a DynaMeshed model will.

I then start sculpting in details like fine wrinkles and skin pores. After this I Polypaint the model, send it over to KeyShot for rendering and then to Photoshop for compositing and tweaking.

When working on 3D prints I don't worry about sculpting ultra-fine details such as skin pores as these will be lost in the printing process. Instead I push the high-resolution DynaMesh as far as I can before using the Curve Slice brush to cut the model into separate components for printing.

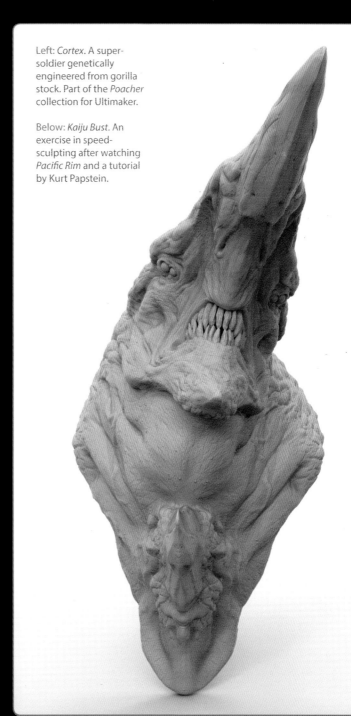

Left: *Cortex*. A super-soldier genetically engineered from gorilla stock. Part of the *Poacher* collection for Ultimaker.

Below: *Kaiju Bust*. An exercise in speed-sculpting after watching *Pacific Rim* and a tutorial by Kurt Papstein.

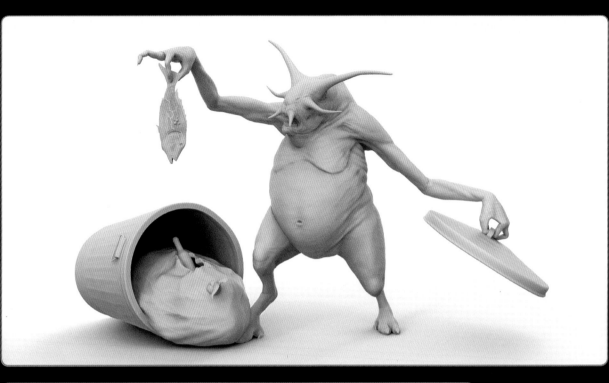

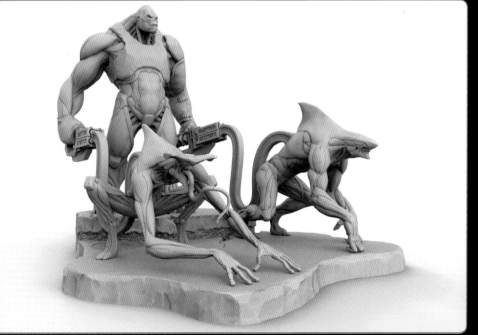

Above: *Lunch Time.* A disgusting slug-like alien creature with a low IQ and an appetite for garbage.

Left: *Shark Unit.* Cortex, Typhon, and Depth Charge. This set was printed on the Ultimaker 2 in 68 separate pieces.

Right: *Blockade.* A super-soldier genetically engineered from rhino stock. Part of the *Poacher* collection for Ultimaker.

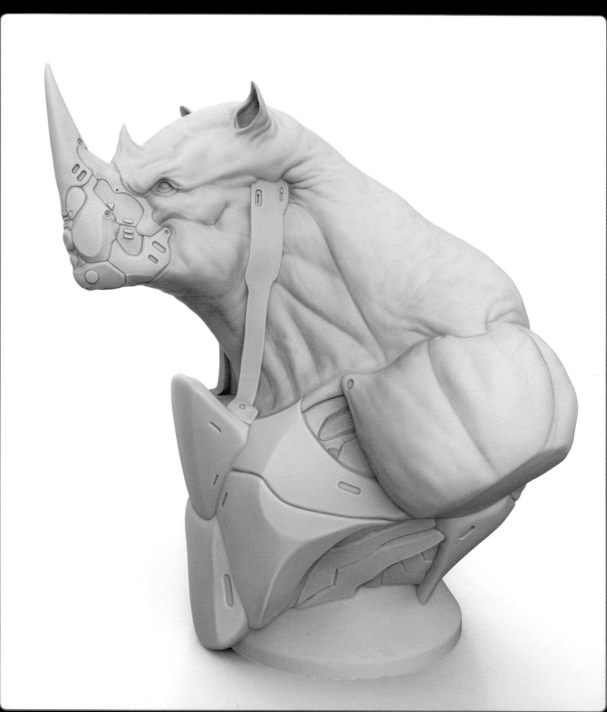

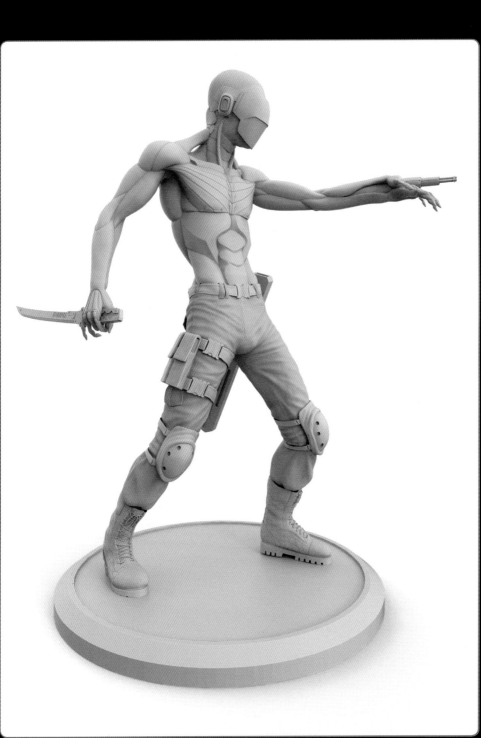

This page: *Military Cyborg*. A military martial arts cyborg inspired by games like *Metal Gear Rising: Revengeance* and *Deus Ex*

Right-hand page (top left): *Combat Droid*. A dark glimpse at the future of drone warfare. The hands were adapted from a free STL file from **www.thingiverse.com**

Right-hand page (top right): *Grinner*. This bust was inspired by the boss of the Clowns gang from *Akira* and the Joker's henchmen from *Batman: Arkham Asylum*.

Right-hand page (bottom): *Genetic Research*. A monster design inspired by *Doom*. This bust was eventually 3D printed.

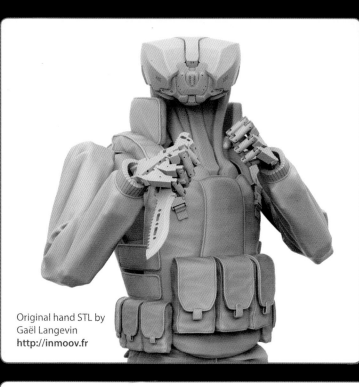

Original hand STL by
Gaël Langevin
http://inmoov.fr

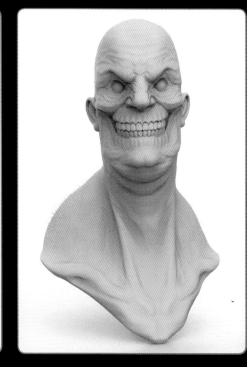

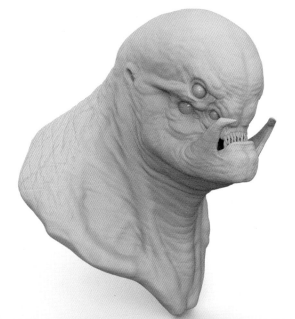

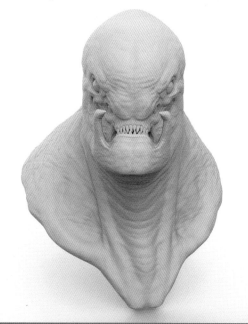

ISLAM, Tanvir

www.incubatorfx.com
All images © Tanvir Islam

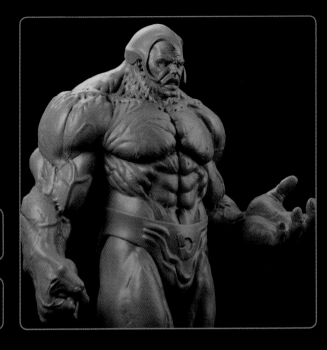

I'm a self-taught CG generalist but I'm more into character creation. I sketch in 3D to keep a record of rough ideas for later use. For me, it's a fast way of expressing a 3D demonstration of a concept, which is viewable from all angles. I love to see how light interacts with form. Sketching in 3D is a way to experiment with complex forms very quickly, to see if something is working or not, and is also good for practicing anatomy or sculpting something new in order to help memorize it visually.

INSPIRATION & IDEAS

My inspiration comes from a lot of places. I am a big fan of sci-fi and fantasy art. I love to see other artists' work from the same genre, which might be in the form of a movie, game, or artwork. I also try to relate my ideas with real-life subjects to come up

with more believable concepts. Old masters are also key in motivating me to push my skills and think further.

TOOLKIT

As my primary software, I use Maya and Houdini, but for modeling and 3D sketching I use ZBrush. I love the way ZBrush's brushes interact with the mesh, almost giving a clay feel. For texture painting and UVs, I use ZBrush and MARI. For rendering, I use Houdini's Mantra Render and Arnold for Maya. 3D-Coat has amazing retopology tools which I love to use sometimes besides ZBrush's ZRemesher.

SCULPTING WORKFLOW

I start most of my sketches from a DynaMesh sphere, which I push and pull into a certain shape. I add more spheres as new SubTools and

sculpt them. I always try to keep the mesh's subdivision level as low as possible while building the form, before subdividing to add details. At the end I merge them if necessary.

Building up form with every layer of strokes is a great technique. The primary forms should not overwhelm the secondary forms, but support them, and the same goes for tertiary forms – it's a great tip I learned from Gio Nakpil which really helps. The Clay Buildup brush plays an important role in this process. I also use the Dam Standard brush with a big radius to break the sculpt into primary, secondary, and tertiary forms, which are polished later using the Standard, Clay Buildup, and Move brushes. The Smooth and hPolish brushes help to blend all the forms together in this process.

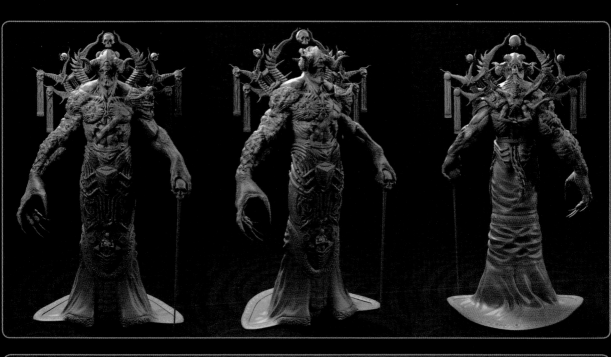

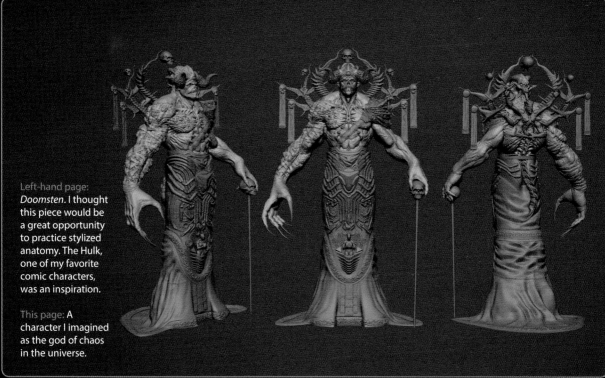

Left-hand page: *Doomsten*. I thought this piece would be a great opportunity to practice stylized anatomy. The Hulk, one of my favorite comic characters, was an inspiration.

This page: A character I imagined as the god of chaos in the universe.

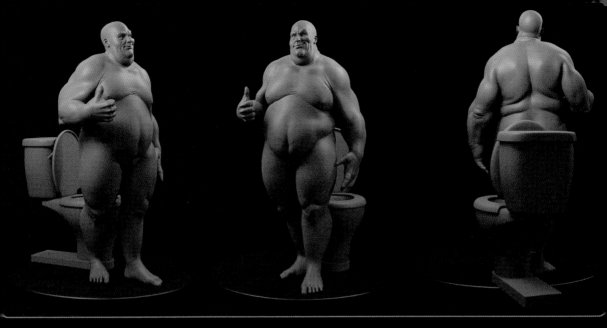

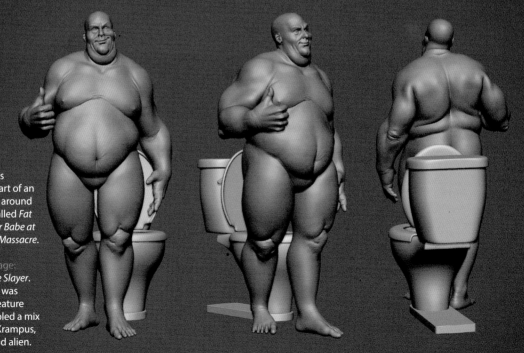

This page: This character is part of an idea crawling around in my head called *Fat Bob and Sugar Babe at the Fast Food Massacre.*

Right-hand page: *Slashcorch the Slayer.* The intention was to create a creature which resembled a mix of werewolf, Krampus, Sasquatch, and alien.

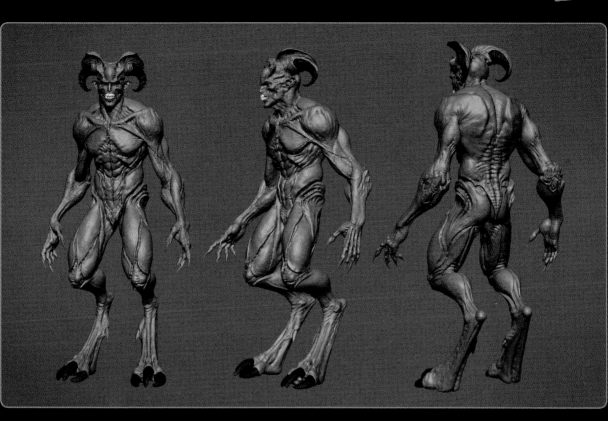

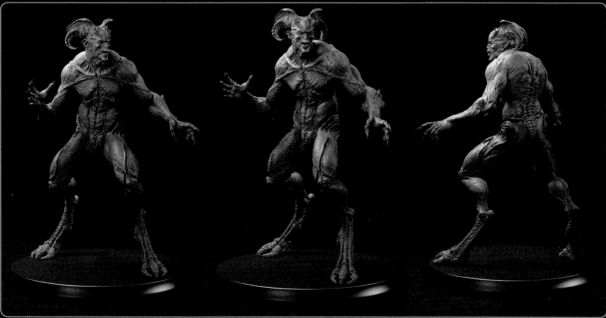

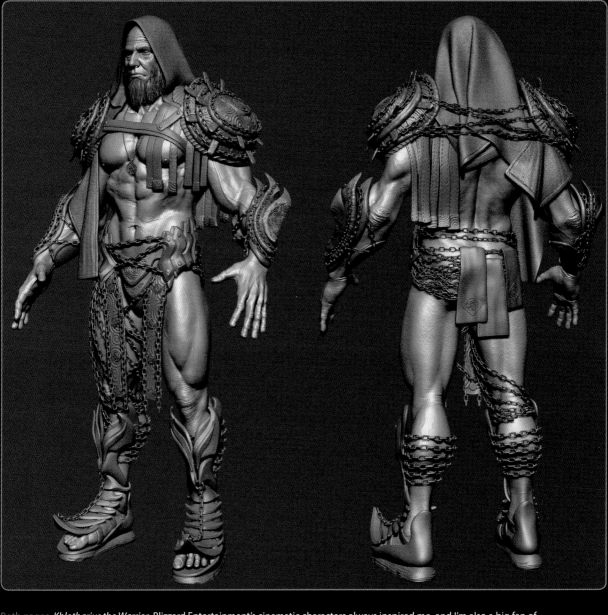

Both pages: *Khlotharius the Warrior*. Blizzard Entertainment's cinematic characters always inspired me, and I'm also a big fan of *The Lords of the Rings* movies. Collecting some shape references and motif designs of earth elements, such as wind and fire, I made my own design for this fantasy piece.

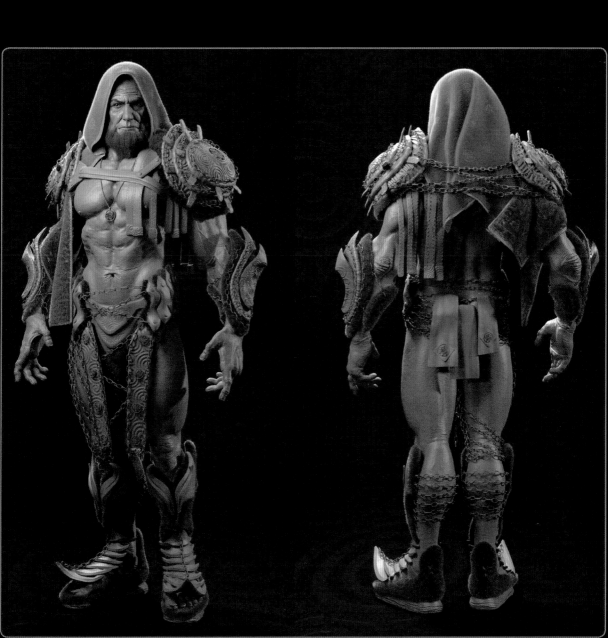

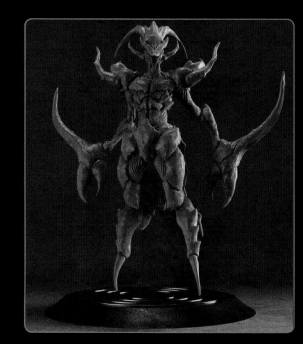

KEAWMAFAI, Pavee

www.khempavee.artstation.com
All images © Pavee Keawmafai

My first experience of 3D software is ZBrush, and I think it's great! It's like the clay I played with when I was young. I can edit everything on my object and see it from all around, not just from one perspective. I can imagine my creation in the real world and design it in 360 degrees. These are the main reasons why I like to sketch in 3D.

Plus, nowadays we have a lot of 3D printers, so I can print my work out!

INSPIRATION & IDEAS
Inspiration is all around: in a movie, in someone's quotes, manga, cartoons, anime, a song, and so on. Everything can inspire me to create something.

My favorite films are *The Lord of the Rings* and *The Hobbit* trilogies, *Hellboy*, *Pacific Rim*, *The Dark Knight* trilogy,

Mad Max: Fury Road, the *Star Wars* series, *Godzilla*, and most movies that have good concept art because they offer a lot of inspiration and great reference. Sometimes I like to read manga and watch anime series because those inspire me too.

I get a feeling when I listen to music, or watch a movie, and then create something without any reference, just using my feelings at that time. I rarely use reference when I work like this.

> "I CAN IMAGINE MY CREATION IN THE REAL WORLD AND DESIGN IT IN 360 DEGREES"

TOOLKIT
I always use ZBrush for sculpting, just using the original Move, Standard, and Smooth brushes. Then I always render

in Maya and make the final composite in Photoshop, because it's an easy-to-use software with a lot of information and tutorials available online.

SCULPTING WORKFLOW
When I want to create something, I always use the Move and Snake Hook brushes to find a good silhouette and main shape first, before I go into detail. In most of my work, I like to make something with a spiky look – I think it makes my work look strong. I like to tweak the proportions a little bit, such as making long arms or long necks, to make my designs look weird and scary!

Above: *Lobs* is a lobster-inspired design that began as a sphere in ZBrush. This is a clay version, rendered in KeyShot.

Right: A clay version of *White* (see page 156), rendered in KeyShot.

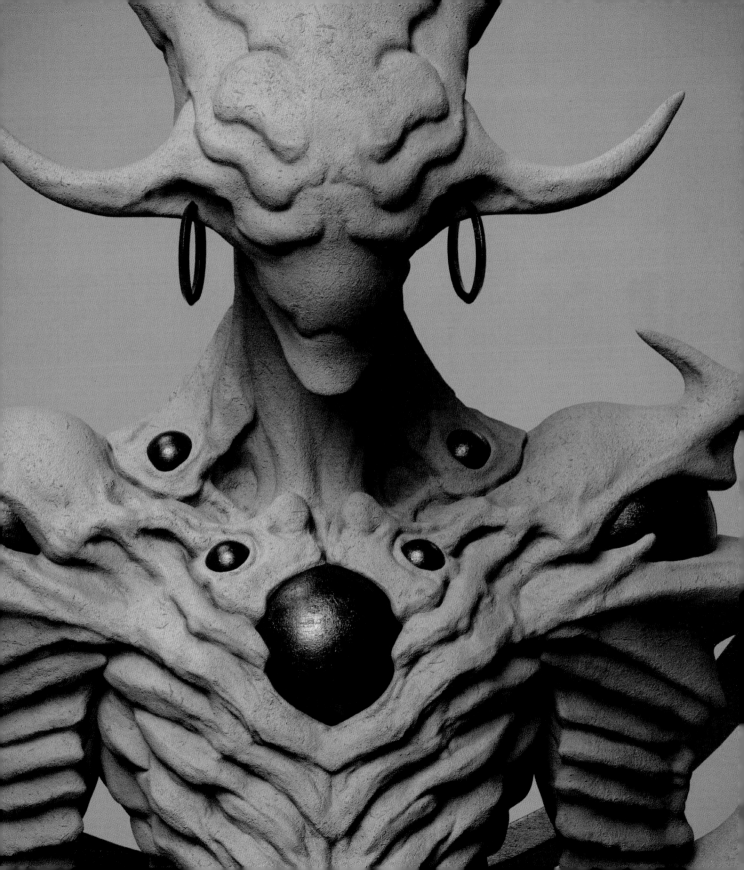

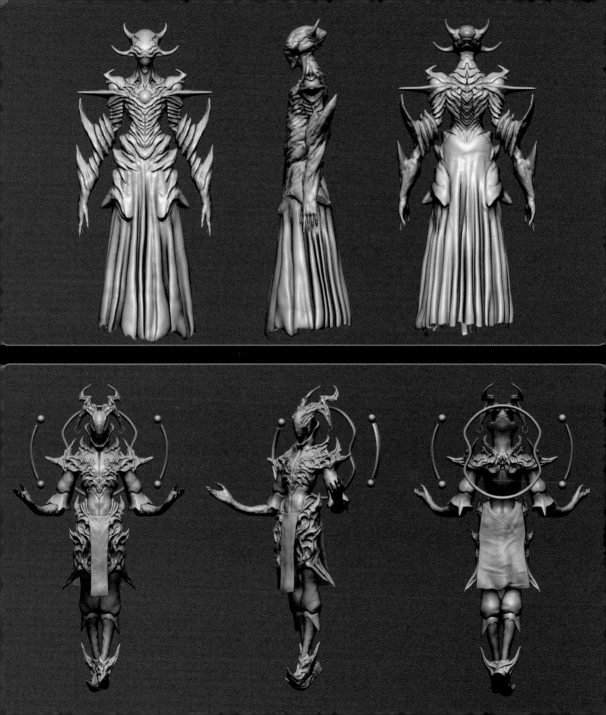

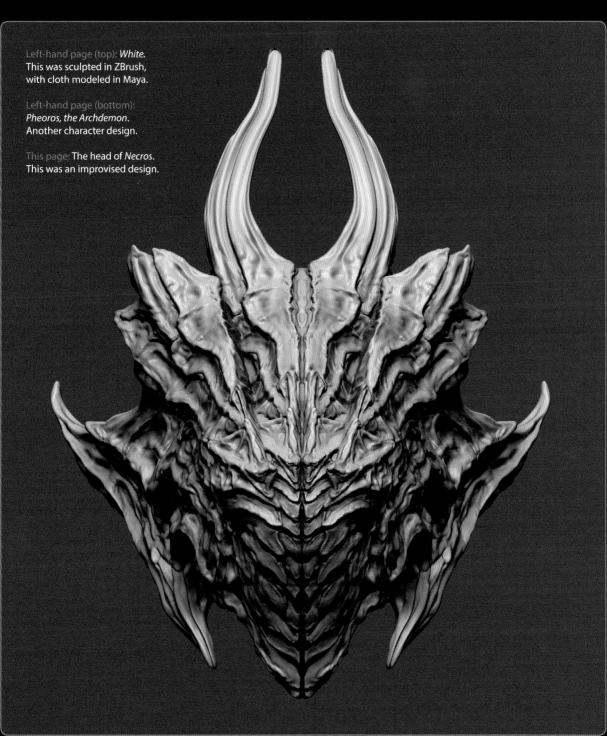

Left-hand page (top): *White.*
This was sculpted in ZBrush,
with cloth modeled in Maya.

Left-hand page (bottom):
Pheoros, the Archdemon.
Another character design.

This page: The head of *Necros.*
This was an improvised design.

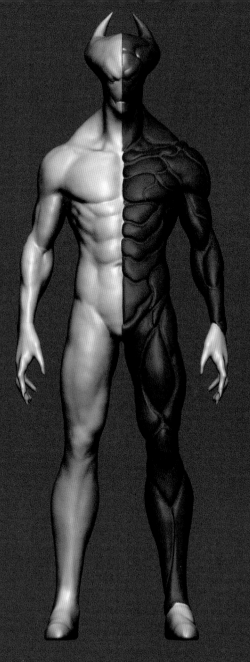
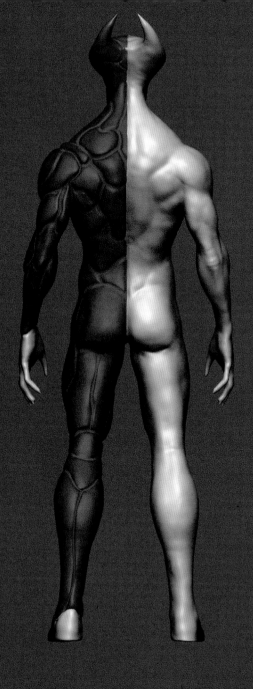

This page: *Xyber*, a half-android character design.

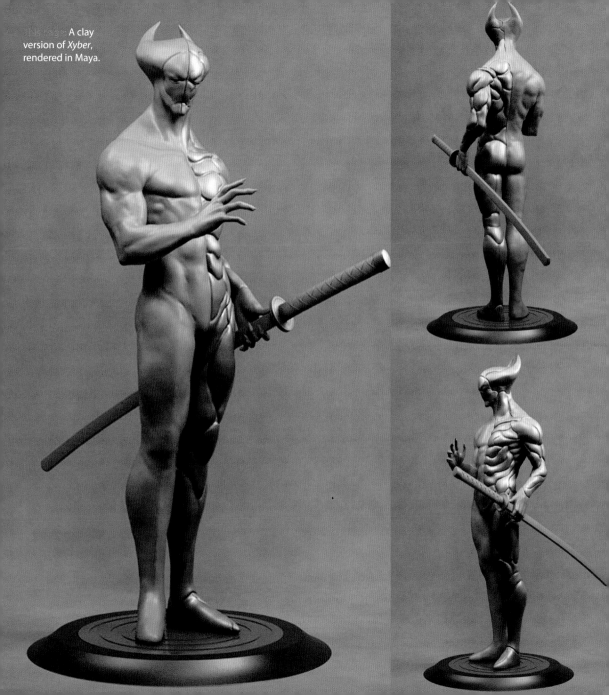

LEISNER, Field

www.leizner.com
All images © Field Leisner

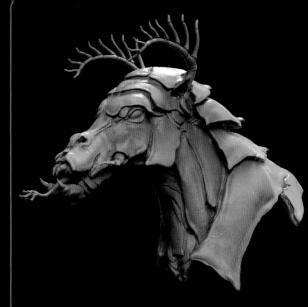

The most rewarding part of being an artist is the journey of learning. I completed college at Laguna College of Art and Design a year ago, studying game art, and from there my journey as an artist began. In high school I played around with making video game maps and putting them on servers. I didn't really know what I was doing or the path that it would take me, but I knew this was something that I was truly interested in. I decided during this time to go to college and pursue a career in the entertainment industry.

While in college I was trained in the fundamentals of drawing, painting, and sculpting while also learning various 3D programs. However, when I was introduced to ZBrush quickly fell in love with it.

INSPIRATION & IDEAS

When it comes to my inspirations and what gets me brainstorming about projects, a lot of my ideas come from nature, thinking about how different species could be combined and how they would survive in their environments. I also really enjoy looking at a lot of different types of art, so fashion and environment paintings are huge inspirations for me as well.

TOOLKIT

Even though there's no faster way for me to get ideas out visually than 2D pen and paper, I believe that if the end goal is a 3D design it's best to start designing in a 3D space from the very beginning. Not all 2D drawings end up panning out well in 3D, while a solid sculptor will always

accomplish the task in a timely manner. The three programs I utilize the most are ZBrush, KeyShot, and 3D-Coat.

SCULPTING WORKFLOW

ZBrush is my go-to program for working with my favorite subject matter of creatures and monsters. I gather the references that I need and then start sculpting the large forms. Finding interesting shapes and creating forms that interact well with each other is the most important task at the beginning. I try not to get too caught up in anatomy until I feel the silhouette is working. The next step is tackling the anatomy to ground the sculpt.

What I believe is the most incredible feature in ZBrush is that it allows you to be loose while designing in

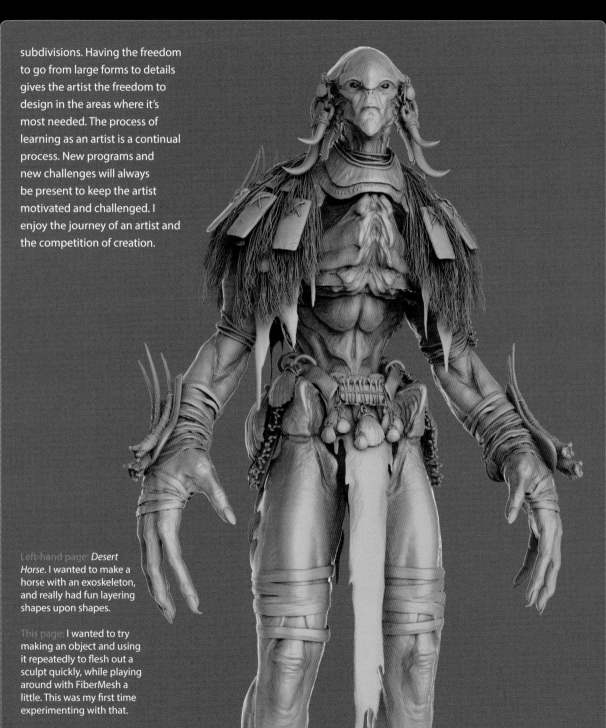

subdivisions. Having the freedom to go from large forms to details gives the artist the freedom to design in the areas where it's most needed. The process of learning as an artist is a continual process. New programs and new challenges will always be present to keep the artist motivated and challenged. I enjoy the journey of an artist and the competition of creation.

Left-hand page: *Desert Horse.* I wanted to make a horse with an exoskeleton, and really had fun layering shapes upon shapes.

This page: I wanted to try making an object and using it repeatedly to flesh out a sculpt quickly, while playing around with FiberMesh a little. This was my first time experimenting with that.

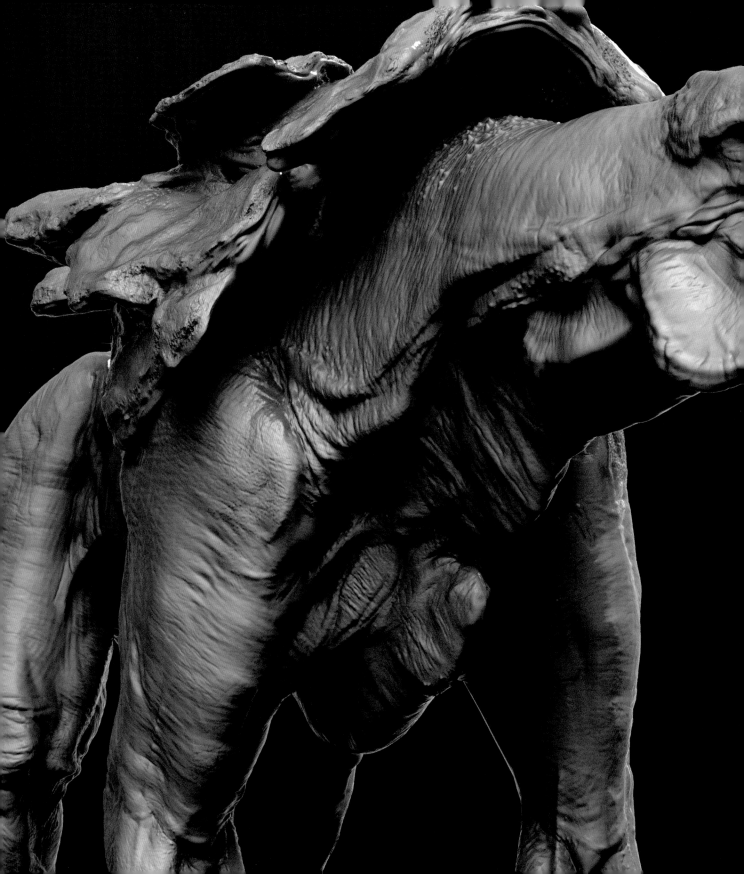

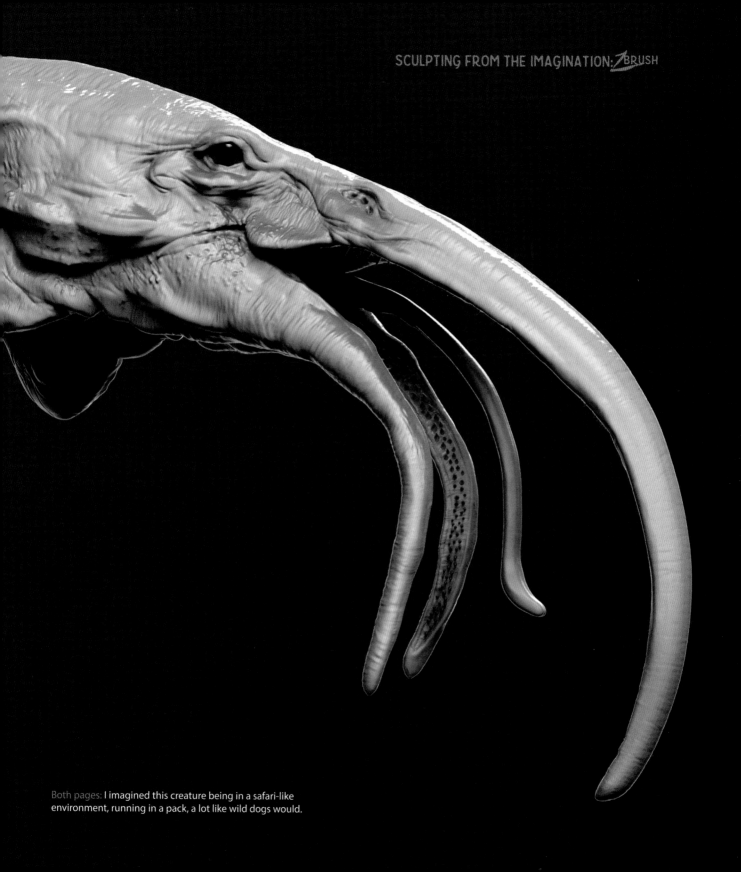

Both pages: I imagined this creature being in a safari-like environment, running in a pack, a lot like wild dogs would.

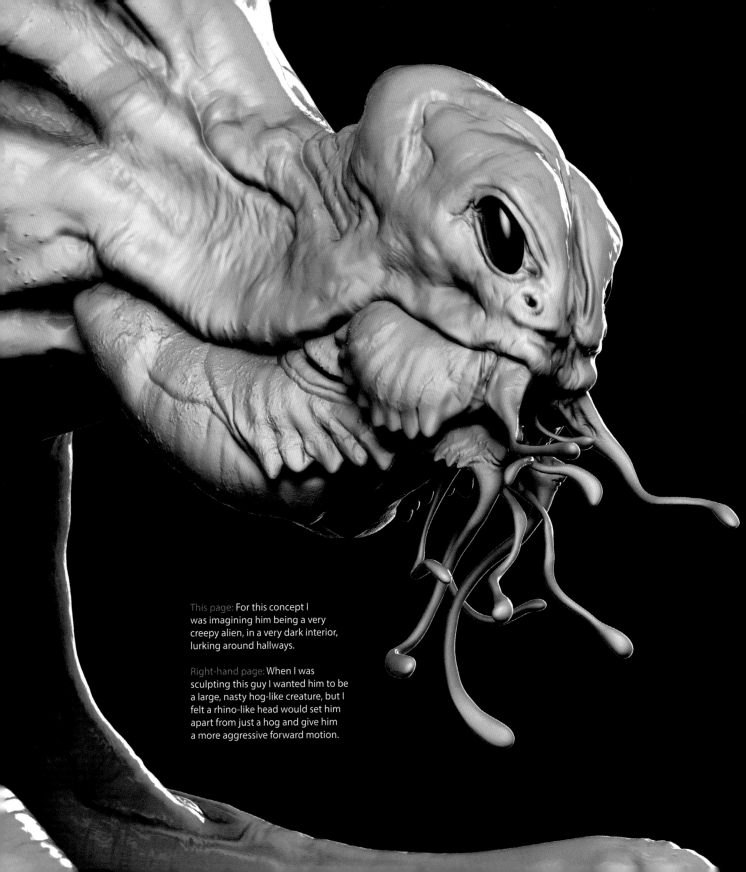

This page: For this concept I was imagining him being a very creepy alien, in a very dark interior, lurking around hallways.

Right-hand page: When I was sculpting this guy I wanted him to be a large, nasty hog-like creature, but I felt a rhino-like head would set him apart from just a hog and give him a more aggressive forward motion.

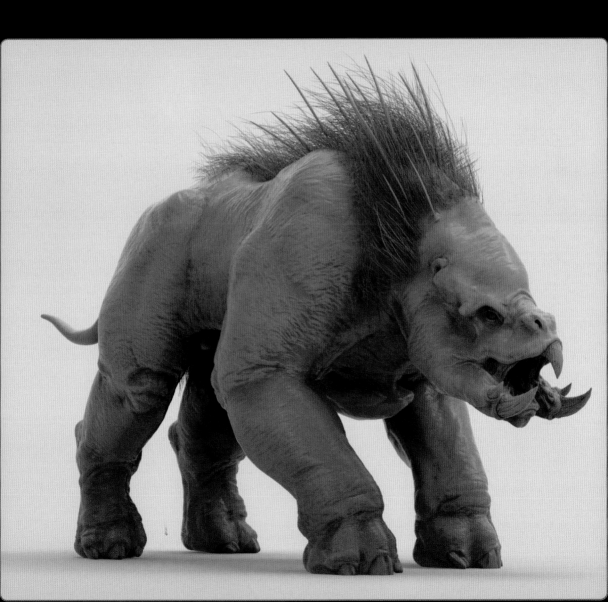

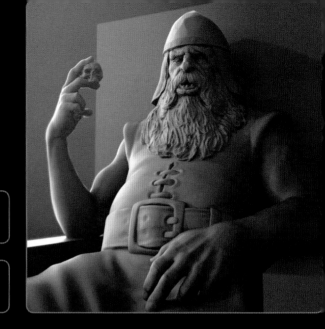

LONGHI, Glauco

www.glaucolonghi.com
All images © Glauco Longhi

I'm a character artist always trying to explore different concepts and ideas. Although I do some life drawing and creature sketching using pencil and paper, 2D is not really my forte.

My background is traditional sculpture. Now with digital media it's much easier to develop ideas and explore different forms and shapes without compromising on time or space (with loads of clay). I love doing ZBrush sketches and make them very frequently.

The "sketching" skill is something that I really appreciate and I'm always trying to improve on, too. The feeling of being able to create or design something on the fly, utilizing anatomy and all the past gathered references in your mind, is nothing less than fantastic!

Sketching in 3D is great because you really have to understand form in space, movement, contraction and extension of muscles, insertions, and so on. It really shows the artist's skill set and what they have to offer. For me, any rough forms should already look solid and interesting. All the exploration and design comes in the primary forms.

You can't cheat too much doing 3D! You have to understand and think about what you're doing.

INSPIRATION & IDEAS

Inspiration can come from many things, such as doing exercises, watching movies, and of course browsing and admiring cool concept art on the internet or in books from my bookshelf.

Sketching is something that I don't like committing myself to too much. Something clicks in my mind and then I instantly have this urge to start something as soon as possible! So I go straight into ZBrush, turn some music on, and let it flow.

Usually I sketch without stopping for one to two hours and, during this time, my mind goes away. You get to that "nirvana" stage where you can think of something else while the other side of your brain is doing all the crazy, hard work. It's the best feeling ever!

My sketches are not only creatures or designs. I like studying anatomy in this same style. I often spend hours studying anatomy with tons of books and references, and from time to time I do some ZBrush sculpts for it.

TOOLKIT

My main software is ZBrush. Sometimes I do a few ZBrush thumbnails and go to Photoshop to explore them more with some paint-overs. In ZBrush, my main tools are the Clay, Move, Dam Standard, and Standard brushes. The Clay brush builds up the volume, while Move smudges it around. Standard and Dam Standard help me with drawing and carving specific shapes and lines. The possibility of saving variations and exploring different features and poses with layers is truly amazing!

SCULPTING WORKFLOW

Depending on the design, I start with ZSpheres or even a simple primitive like a sphere or box. Sometimes I start with a base mesh as well. I like trying to find the overall proportions first, and then I move to the big primary shapes and silhouette, using the Move and Clay brushes. I'll spend most of my time in this big stage, and probably refine a bit more after I'm happy with the result. You can watch timelapse videos of my sculpts on my YouTube channel: **www.youtube.com/user/glaucolonghi**

"YOU CAN'T CHEAT TOO MUCH DOING 3D! YOU HAVE TO UNDERSTAND AND THINK ABOUT WHAT YOU'RE DOING"

Left: Inspired by the work of Serbian fantasy artist Petar Meseldžija. Petar has some really good, loose artwork and sketches; I'd definitely recommend looking at them and learning about dynamic poses and gestures.

Below: Studying anatomy is super important. Here's a really good exercise: start with the skull and build up the face on top, or you can start with the head and carve the skull into it as well. Both ways are great.

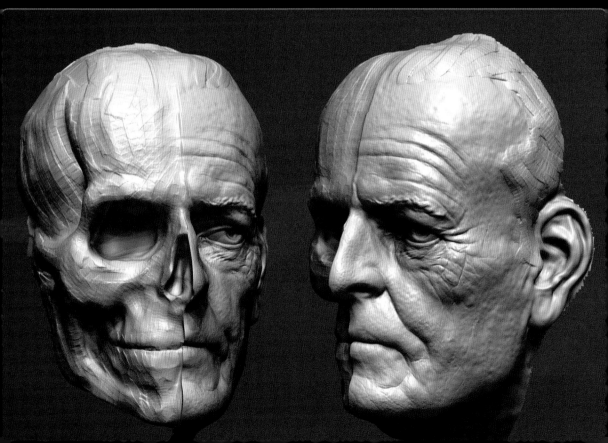

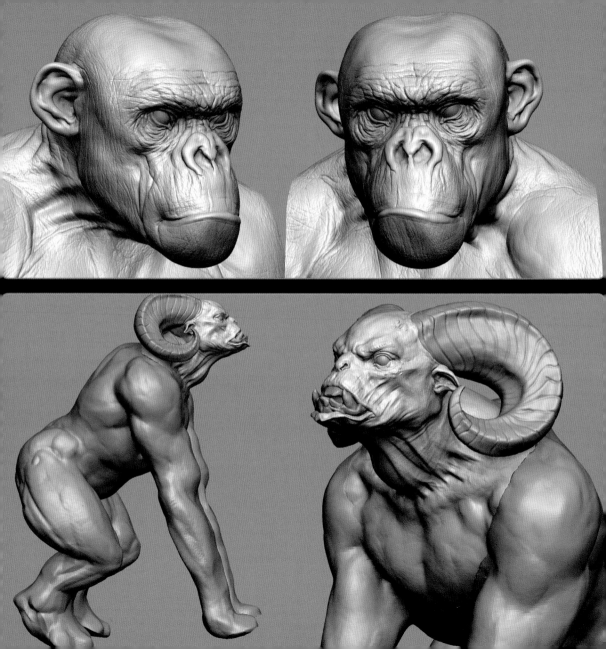

Left-hand page (top): This ape bust started from a sphere and I kept playing with the major shapes. The wrinkles are very sketchy and it would take a lot of work to refine them with the secondary forms too.

Left-hand page (bottom): A creature I created during my lunch time. This was based on the artwork of my work-buddy, Richard Lyons: www.facebook.com/ richardlyonsconceptart

This page: The early stages of a demon sculpt before moving on to higher detail levels.

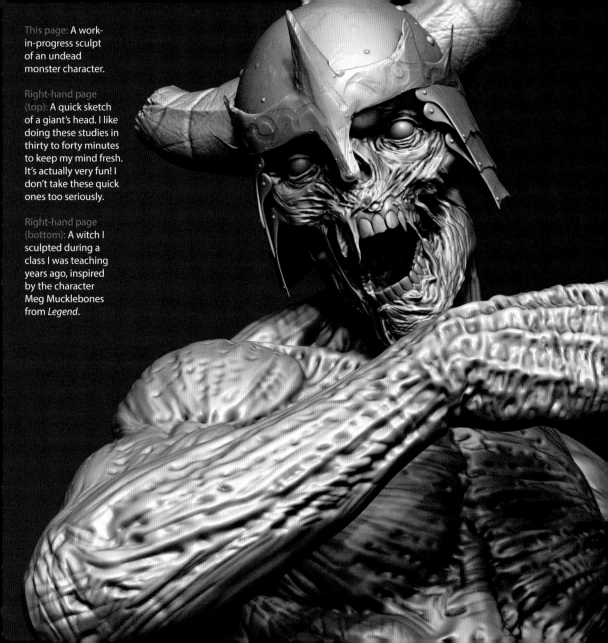

This page: A work-in-progress sculpt of an undead monster character.

Right-hand page (top): A quick sketch of a giant's head. I like doing these studies in thirty to forty minutes to keep my mind fresh. It's actually very fun! I don't take these quick ones too seriously.

Right-hand page (bottom): A witch I sculpted during a class I was teaching years ago, inspired by the character Meg Mucklebones from *Legend*.

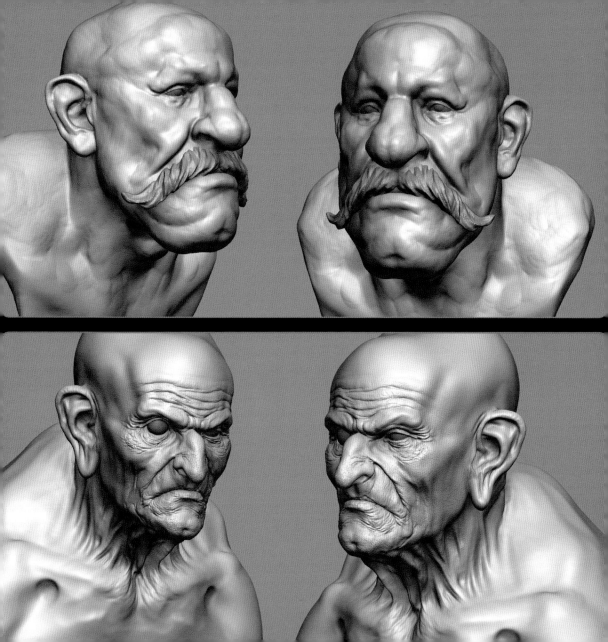

MANOLOV, Ran

www.ranmanolov.wix.com/portfolio
All images © Ran Manolov

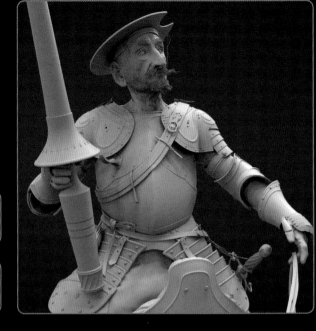

I sketch in 3D because there are no restrictions. I can fulfill my initial ideas and add as much detail as I want. It's great because you can immediately see how the light plays with the volume. The sculpt goes hand in hand with drawing and anatomy – you can't skip that. I spent a decade drawing and studying traditional art, and that was the most valuable thing I could do. Once you do that, there's no difference if the clay is on a table or consists of millions of polygons.

INSPIRATION & IDEAS

My inspirations might come from outside or inside. Some ideas are completely new to me; some ideas can originate from a traditional concept, but then be created in a new way using current technologies. I often have a vision of the final image in my mind, so I just have to take my time to bring it to the rest of the world. Love inspires as well, and that's why I want to thank my partner, Fay, for being who she is. And of course the old and new masters.

TOOLKIT

I first start sketching and exploring in ZBrush. The interface is complicated, but once you make your own menus and shortcuts, the only thing you think about is the sculpt. I often use Maya to block out the props and all the hard surfaces that I need for my projects; its new modeling tools are really powerful. I use 3D-Coat for retopology and UVing. I love the simplicity of that program – everything is like a game. For texturing purposes, I use MARI, of course. The control it gives you is unbelievable.

SCULPTING WORKFLOW

As an artist with a traditional background, I like to use ZBrush to sketch my initial ideas because it feels like real clay. Then it's a matter of using just two or three brushes: Standard, Clay, and Dam Standard. Using reference is important as well; my father taught me anatomy and my mother taught me to observe. I always aim for my works to be convincing but stylized at the same time.

This page: As an illustrator and 3D character artist I couldn't resist making a sculpt of Don Quixote.

Right-hand page (top): A different angle of Don Quixote.

Right-hand page (bottom): A portrait of my beloved grandpa.

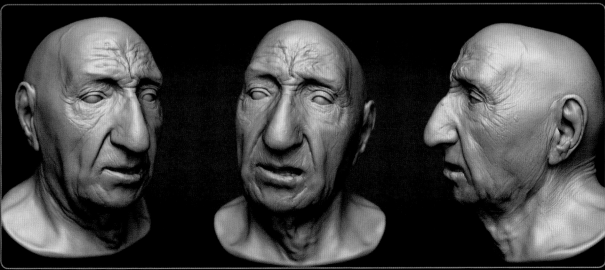

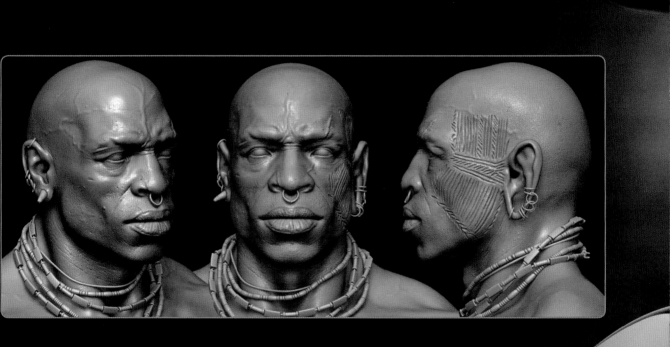

This page: A high-resolution sculpt of my centaur character's head.

Right-hand page: My tribal centaur character, Ameenah.

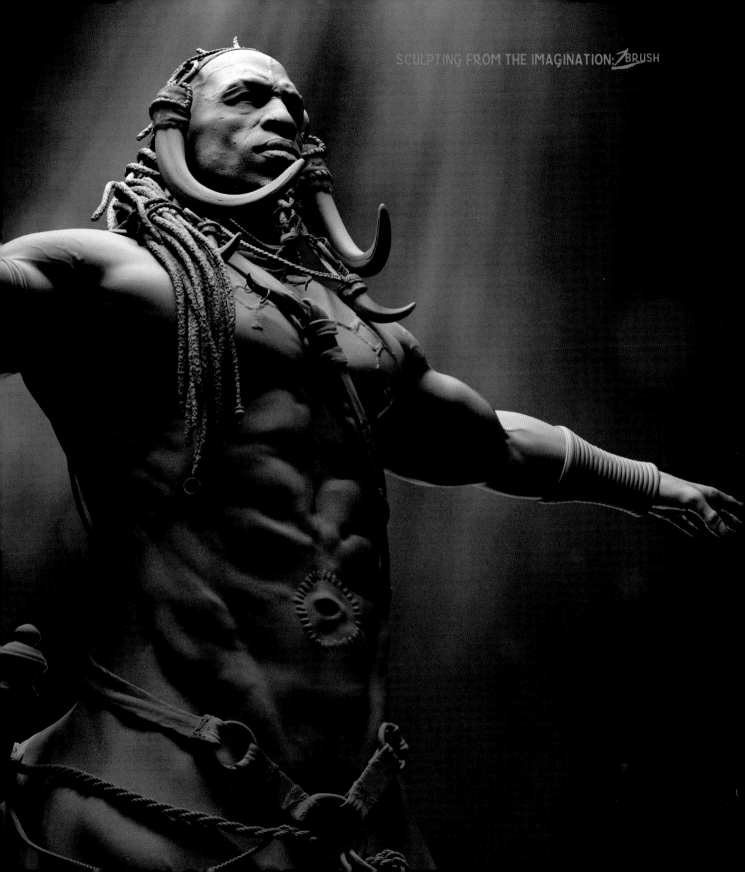

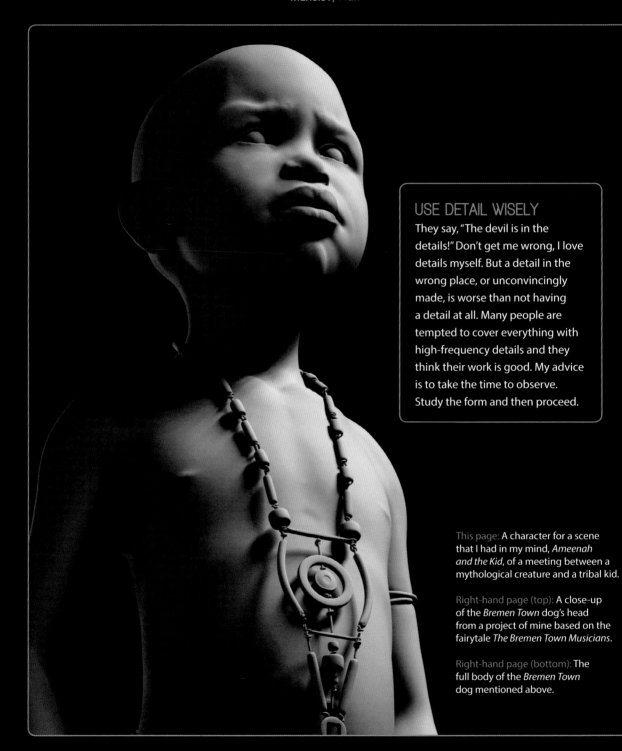

USE DETAIL WISELY

They say, "The devil is in the details!" Don't get me wrong, I love details myself. But a detail in the wrong place, or unconvincingly made, is worse than not having a detail at all. Many people are tempted to cover everything with high-frequency details and they think their work is good. My advice is to take the time to observe. Study the form and then proceed.

This page: A character for a scene that I had in my mind, *Ameenah and the Kid*, of a meeting between a mythological creature and a tribal kid.

Right-hand page (top): A close-up of the *Bremen Town* dog's head from a project of mine based on the fairytale *The Bremen Town Musicians*.

Right-hand page (bottom): The full body of the *Bremen Town* dog mentioned above.

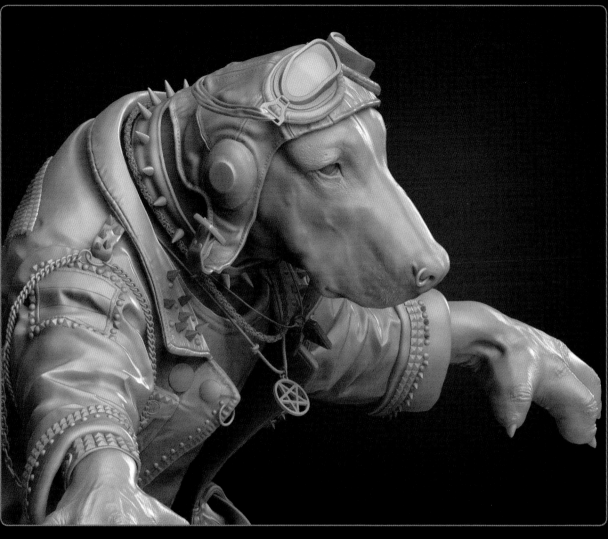

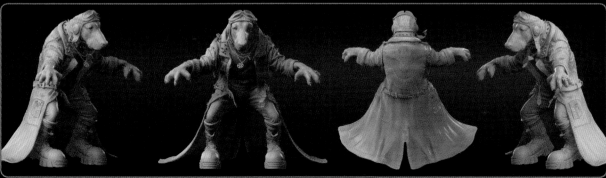

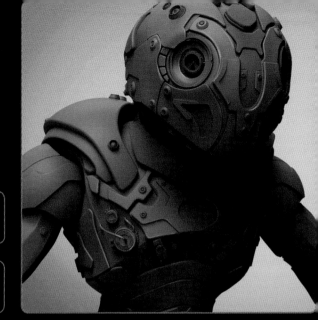

MASON, Richie

www.artstation.com/artist/richenks
All images © Richie J. Mason

When I started out, I used to sketch on paper first. However I quickly realized it was a much faster workflow to sketch in ZBrush, having the ability to change your sculpt as your ideas change (which they always do).

I don't usually have an idea in place when I start, so it's good to play with different forms. If it's going to be a suit design I sketch over a base mesh that I've already created. If it's a creature I just start with a sphere and see what happens, although I find it's always good fun to have a play with the ZSketch tool – it's great for organic subjects and building muscle anatomy.

Once a sketch is at a stage I'm happy with, I'll send it to KeyShot and put some materials on it, trying different combinations to see if it's ready for texturing. Occasionally I'll send it back to ZBrush for touch-ups, but usually most of my rough sketches end up being my finished model.

INSPIRATION & IDEAS

I watch a lot of TV while I work, mainly sci-fi and comic stuff. Things I'm watching will inspire me, and I will go over a sketch many times until I think, "That's what I want!", from a certain curve of armor to a creature claw.

Other artists always inspire me too. I love looking through ArtStation to see what's new. It can give you great ideas for things you might want to try yourself.

TOOLKIT

I use mainly ZBrush for sketching and modeling for art pieces, although I use Maya and Cinema 4D for finished game and movie assets. There isn't a better software available that gives you the freedom to create what you imagine than ZBrush.

Although at first glance all the tools can seem daunting to a beginner, once you get used to them you quickly realize you only need to use a handful to make a finished sculpture. With its new integration with KeyShot (in my opinion the best rendering software available), it just keeps getting better.

SCULPTING WORKFLOW

When sketching something out I like to sometimes use a "mesh bomb" technique for creatures. By using a DynaMesh sphere and placing random inserts, then DynaMeshing them into one and polishing it out, you can come

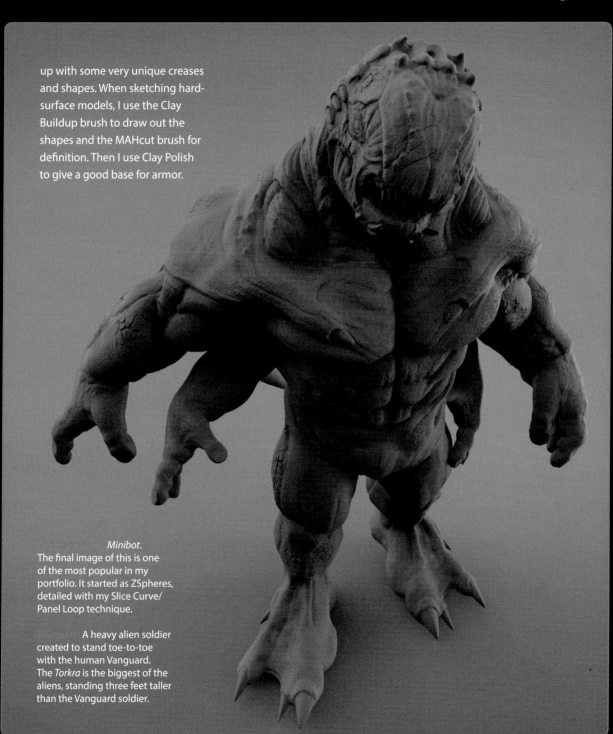

up with some very unique creases and shapes. When sketching hard-surface models, I use the Clay Buildup brush to draw out the shapes and the MAHcut brush for definition. Then I use Clay Polish to give a good base for armor.

Minibot.
The final image of this is one of the most popular in my portfolio. It started as ZSpheres, detailed with my Slice Curve/ Panel Loop technique.

A heavy alien soldier created to stand toe-to-toe with the human Vanguard. The *Torkra* is the biggest of the aliens, standing three feet taller than the Vanguard soldier.

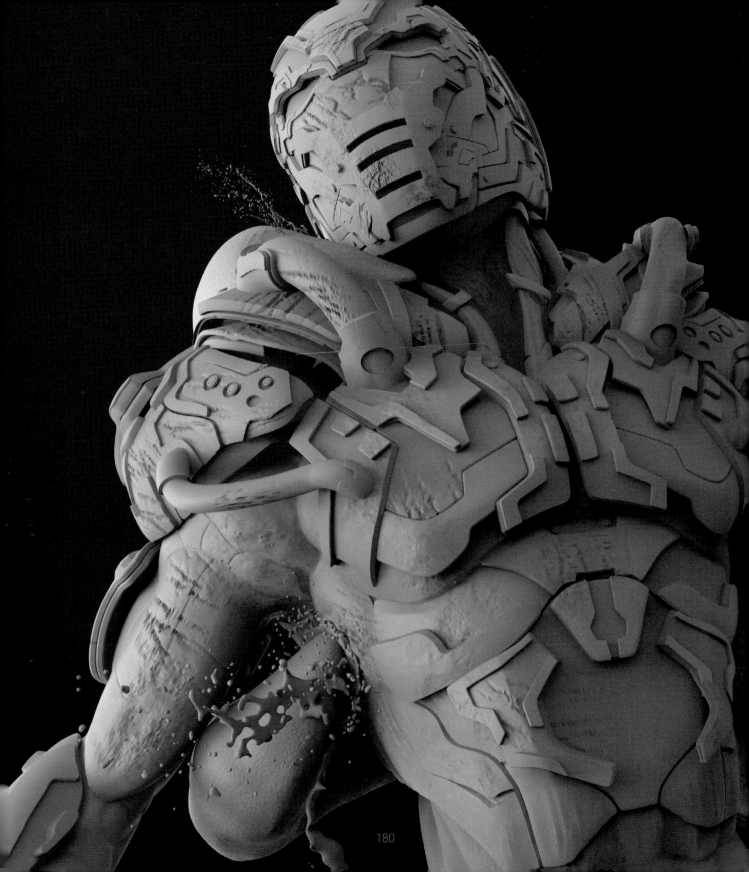

"ALTHOUGH AT FIRST
GLANCE ALL THE TOOLS
CAN SEEM DAUNTING TO A
BEGINNER, ONCE YOU GET
USED TO THEM YOU QUICKLY
REALIZE YOU ONLY NEED TO
USE A HANDFUL TO MAKE
A FINISHED SCULPTURE"

Both pages: *Bad Day*. The
NKS MK-X versus an alien – a
bad outcome for the NKS!

181

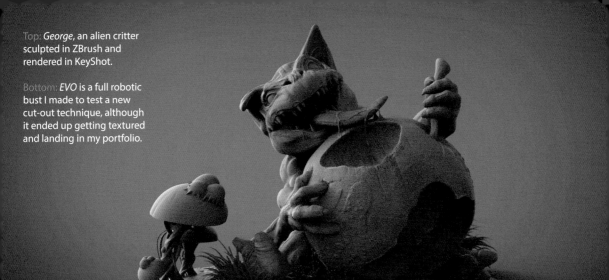

Top: *George*, an alien critter sculpted in ZBrush and rendered in KeyShot.

Bottom: *EVO* is a full robotic bust I made to test a new cut-out technique, although it ended up getting textured and landing in my portfolio.

Top: *Trion vs The Hive*. Two combatants sculpted in ZBrush and rendered with KeyShot.

Bottom: A quick sketch before bed that turned out to be really fun, so I carried on to the next day. I'd just watched *Jurassic World* that day!

MORITA, Yuuki

www.itisoneness.com
All images © Yuuki Morita

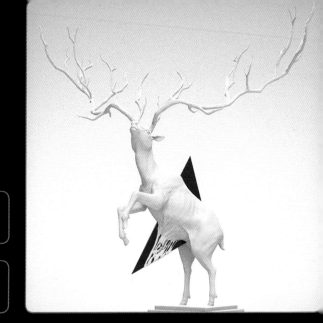

'm Yuuki Morita, a freelance digital artist from Japan. I do concept design, digital modeling, and look development for VFX for the entertainment industry and advertising. I'm often working on organic sculpting and modeling, so ZBrush is the best tool for me. In the production workflow, when we're making concepts or modeling from concept art, the essential thing is that we can finish stuff quickly.

Sketching in 3D directly gets faster results than 2D sketching – perhaps it will replace 2D eventually! If there's a 3D concept sketch made in ZBrush, the only thing we have to do is the retopology to turn it into a final model for animation or VFX in Maya or 3ds Max. If there's no 3D sketch, we have to make the concept model

based on a 2D sketch, and will need to review the overall proportions in 3D again. It's just a waste of time.

I don't only use ZBrush for production work, but also personally for studying animals or abstract organic shapes. Organic things are very structural and anatomical, so we need to see the forms from various angles to sculpt shapes like skin and muscles entwined. ZBrush is the best tool for sculpting anything organic, and we can release our imaginations to their fullest.

INSPIRATION & IDEAS
I'm always inspired and encouraged by nature. When I create some new creatures, or even abstract shapes, I always combine two or more existing shapes of animals or plants, and when I'm sculpting a

creature I try to decide its habitat and ecology as finely as possible.

TOOLKIT
Usually I use Move, Clay Tubes, and Standard brushes for primary shapes while increasing the DynaMesh polygon count. The Move brush is the best to shape for overall proportions; Clay Tubes is the best to fill up mass like muscles. After the sculpting of the base shape, DynaMesh is turned off and I push the divide button for sculpting details. When detailing, I use the Dam Standard, Standard, and Orb Cracks brushes for wrinkles and cracks.

SCULPTING WORKFLOW
I start to sculpt with DynaMesh 64. I'm always careful to keep the resolution low, because if I start with a high-resolution model I tend to sculpt the

details and lose the overall mass. After sculpting the secondary shapes, if I want to animate or render the model in tools such as Maya or 3ds Max, I retopologize the sculpt using ZRemesher and the Guide brush. If I don't use ZRemesher, I use Decimation Master to reduce the polygon count and bring the model into another application.

"WHEN WE'RE MAKING CONCEPTS OR MODELING FROM CONCEPT ART, THE ESSENTIAL THING IS THAT WE CAN FINISH STUFF QUICKLY"

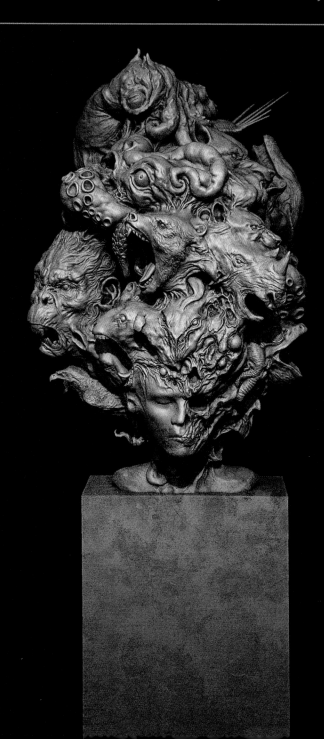

Left-hand page: *Deer*. This was rendered in Maya, and the antlers were made with ZSpheres.

This page: *Explosion*, depicting the inner imagination of a human as the anger or sadness of animals.

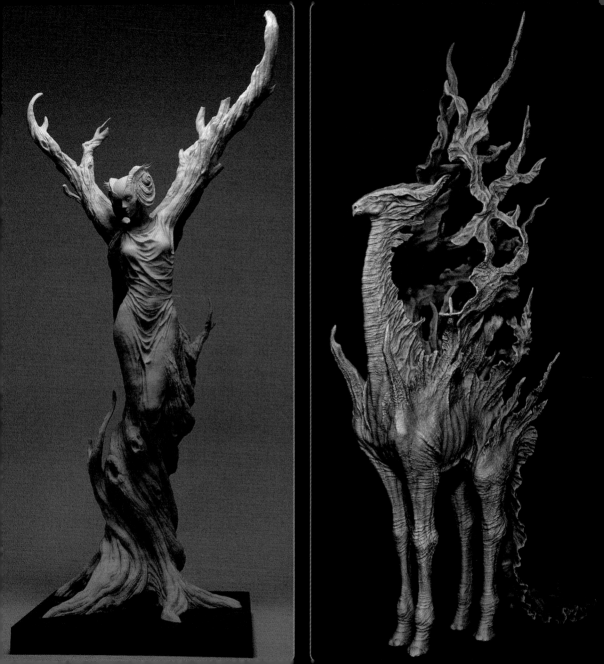

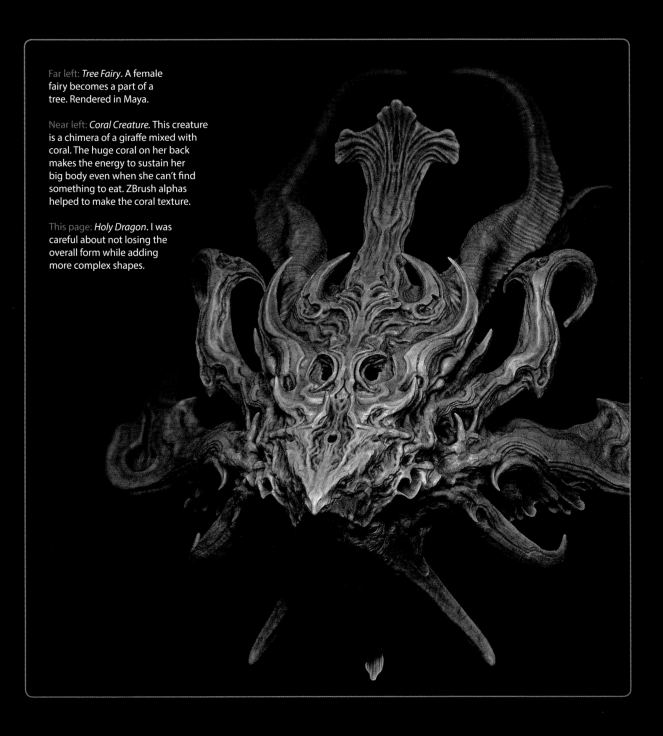

Far left: *Tree Fairy*. A female fairy becomes a part of a tree. Rendered in Maya.

Near left: *Coral Creature*. This creature is a chimera of a giraffe mixed with coral. The huge coral on her back makes the energy to sustain her big body even when she can't find something to eat. ZBrush alphas helped to make the coral texture.

This page: *Holy Dragon*. I was careful about not losing the overall form while adding more complex shapes.

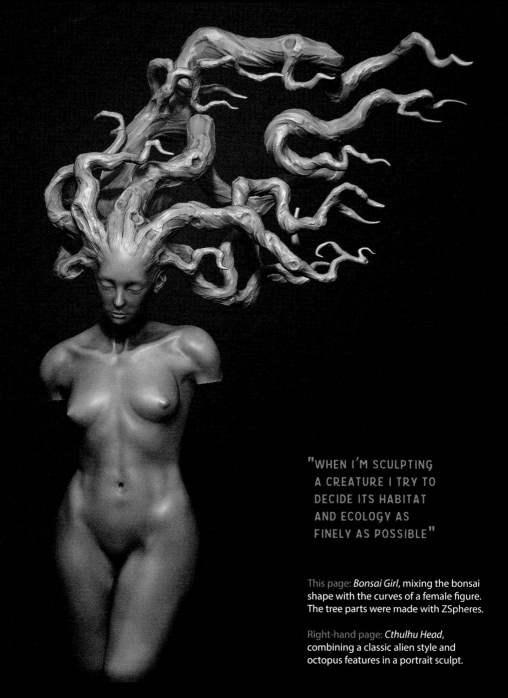

"WHEN I'M SCULPTING
A CREATURE I TRY TO
DECIDE ITS HABITAT
AND ECOLOGY AS
FINELY AS POSSIBLE"

This page: *Bonsai Girl*, mixing the bonsai
shape with the curves of a female figure.
The tree parts were made with ZSpheres.

Right-hand page: *Cthulhu Head*,
combining a classic alien style and
octopus features in a portrait sculpt.

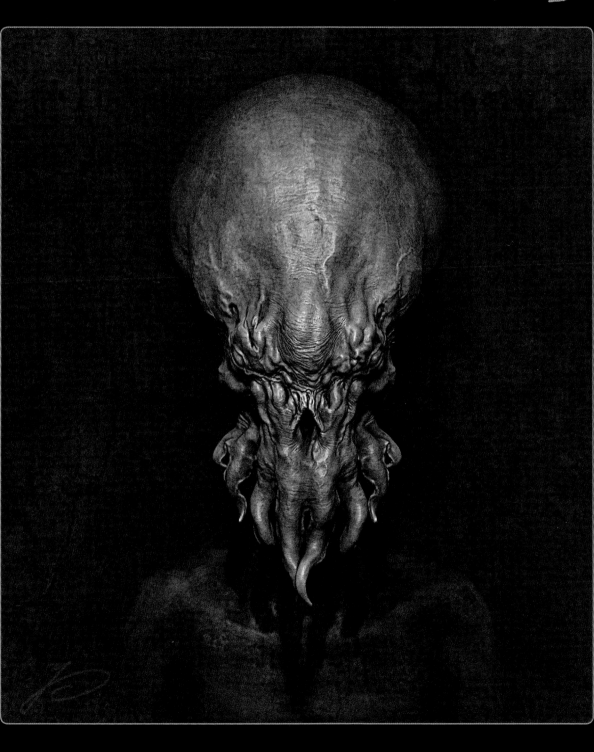

NIKOLOV, Martin

www.mnikoloff.com
All images © Martin Nikolov

Here I'll show you some of my ZBrush work – it's a mixture of some old and some more recent sketches I did in my spare time, mostly for fun. Doing sketches is relaxing after working on long projects and tight deadlines for clients.

Most of my concepts are roughly sculpted just to remember the idea I had at that time, and maybe I'll finish them later on. For me, sketching in 3D is the fastest way to visualize your ideas and look at them from all angles, plus it's fun!

INSPIRATION & IDEAS

Almost everywhere there is someone or something that grabs my attention. When that happens I want to reproduce it the way I see it, not necessarily the way it is or the way it happened.

I can browse the internet for days looking at the works of different artists from past and present in order to obtain my inspiration. The concepts for most of my sketches are mine, but I often grab some concepts or photos from the internet and make slight changes, the way I see them. I also watch a lot of movies.

Generally I don't complain about a lack of sources of inspiration. For me, it's much harder to overcome my natural indolence and start modeling something for fun. And it's even harder to finish it!

TOOLKIT

If you want to be up to date these days, you need to work with a lot of software. The tools I use most often are MODO (I've been a MODO user for

eight years now and I have to say it's a great tool!) and ZBrush, of course. I also use Marvelous Designer, a must-have for realistic cloth simulation, and it saves a lot of time, too. In addition, I like Quixel SUITE for texturing, which also saves a lot of time, KeyShot for really quick and nice renders, Marmoset Toolbag 2 for previewing low-poly models, and lastly Photoshop!

SCULPTING WORKFLOW

This depends on what I want to achieve, but almost every time I start off in ZBrush. There are plenty of tools there to start: ZSpheres, DynaMesh, ShadowBox, and lots of Insert Multi Mesh (IMM) brushes. I keep the DynaMesh object until I am happy with the overall shape and volumes, then I split or cut the DynaMesh object if needed and retopologize the parts

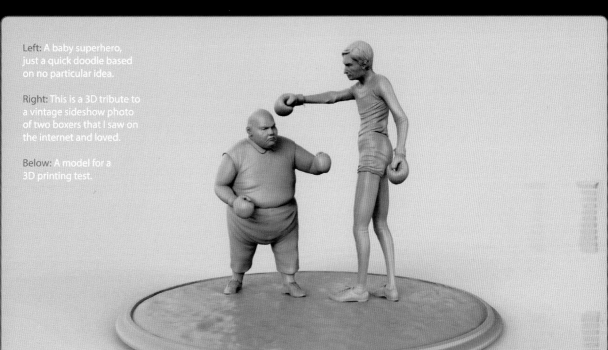

Left: A baby superhero, just a quick doodle based on no particular idea.

Right: This is a 3D tribute to a vintage sideshow photo of two boxers that I saw on the internet and loved.

Below: A model for a 3D printing test.

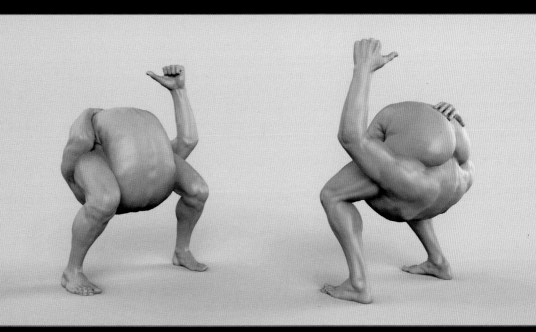

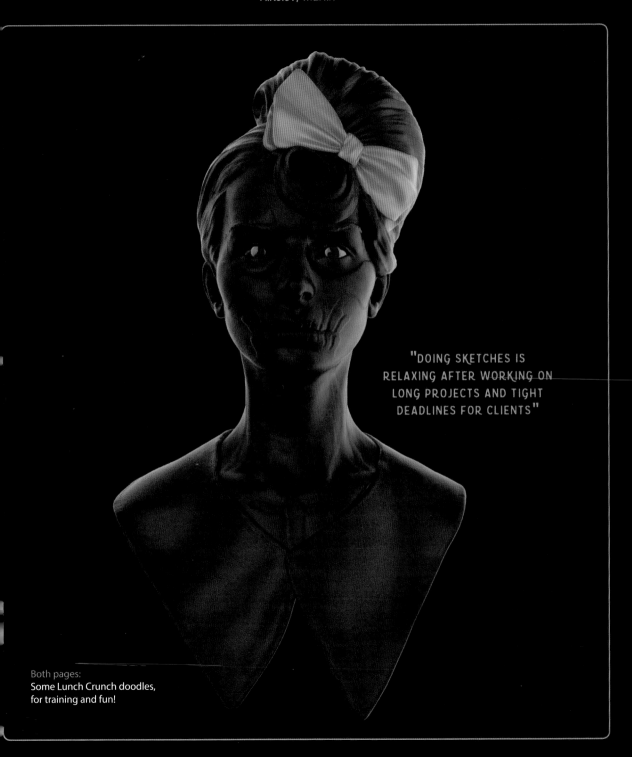

"DOING SKETCHES IS
RELAXING AFTER WORKING ON
LONG PROJECTS AND TIGHT
DEADLINES FOR CLIENTS"

Both pages:
Some Lunch Crunch doodles,
for training and fun!

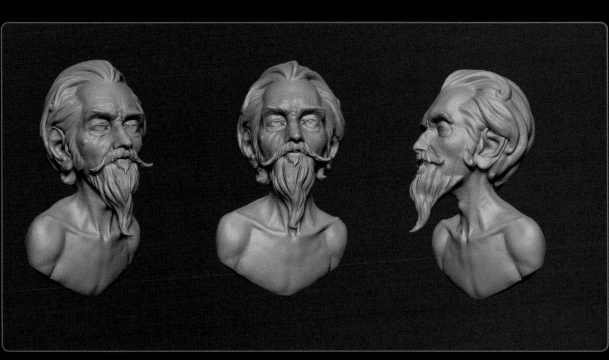

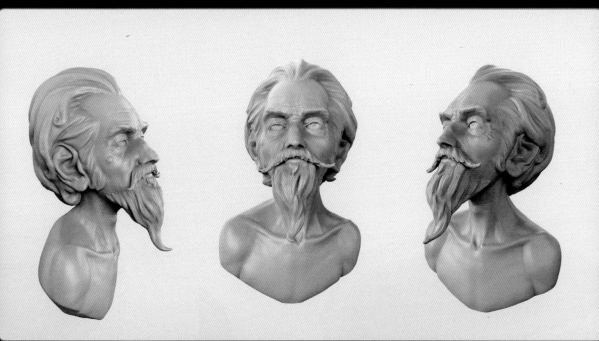

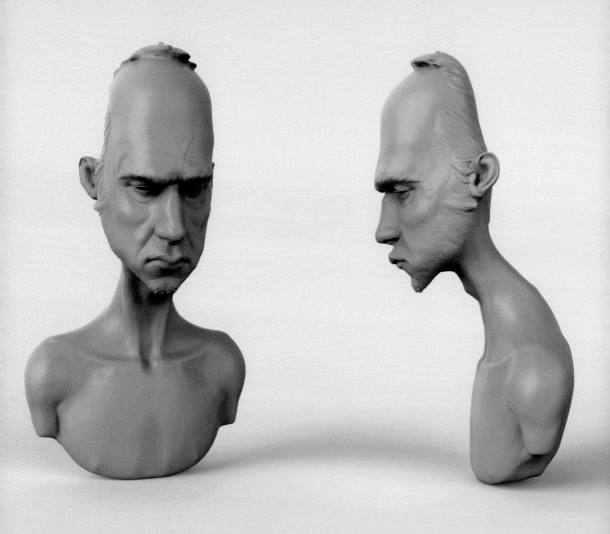

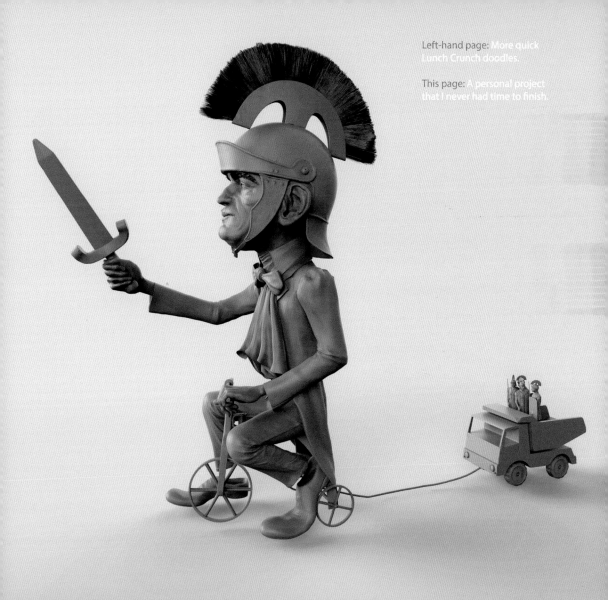

Left-hand page: **More quick Lunch Crunch doodles.**

This page: A personal project that I never had time to finish.

ODENDAAL, Frans

www.artstation.com/artist/frans
All images © Frans Odendaal

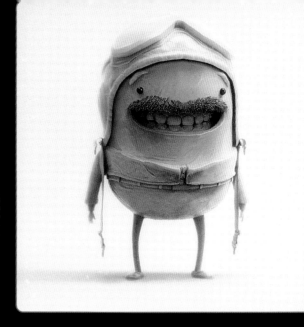

was raised in a small town in South Africa. Art was a rather niche thing to pursue as a career in my community. There were no art schools and most people didn't even know what 3D modeling and digital sculpting entailed. All I knew was that I liked sketching things. I got hooked on 2D sketching after the first release of *Dinosaurs!* magazine. Anyone remember that? The T-rex bones you had to meticulously collect for months?! Dinosaurs may have been my first real source of inspiration for creating my own wacky creatures and characters.

Fast-forward to the end of high school – not knowing what to do with my life, I studied IT for a mind-numbingly boring year. That's when I saw an ad in the paper for a three-year course

on 3D animation. I jumped at the opportunity and moved to Cape Town, which was voted World Design Capital of the Year 2014. Having said that, the 3D industry was rather small, with little demand for 3D art. I worked as a generalist for a design studio, mainly working on TV commercials and print.

Deadlines were always tight and I had to find a faster workflow for character creation. That's when I really got into ZBrush. It was particularly appealing since I was always drawn to realism in my work. Digital sculpting was the only thing at that time I found so stimulating that it didn't feel like work. I would sketch for hours and find myself up at 4:00 a.m. still going at it.

I use ZBrush because it's more versatile than 2D sketching. Presenting full 3D

models to an art director for review is far better than creating a single-angled 2D sketch. It's easier to see the forms, shapes, and silhouettes and how they relate to each other at different angles and with various lighting scenarios. As a bonus, you get free accurate camera perspective, shading, and lighting.

INSPIRATION & IDEAS

I find most of my inspiration on websites like ArtStation and 3dtotal. Every morning I spend about thirty minutes (boss, I hope you aren't reading this) scouring the web for fresh concepts and ideas. It's nice to play around with different ideas from various sources and reinterpret them in your own unique way. I'm inspired by the talented online community out there. I also enjoy keeping up to date with the work

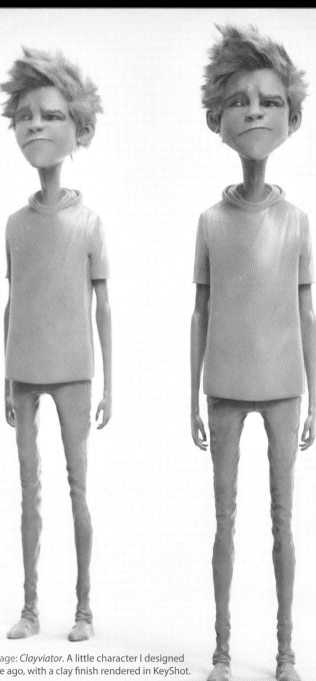
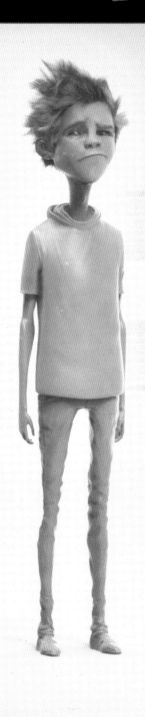

Left-hand page: *Clayviator*. A little character I designed
quite a while ago, with a clay finish rendered in KeyShot.

This page: *Ambivert*. A friend sketched out a quick concept
for me to sculpt during lunch. Original concept by Thabo Mlangeni.

of industry pros like Anthony Jones, Chevon Leo, Frédéric Daoust, Furio Tedeschi, Cédric Séaut – there are way too many talented artists to mention.

TOOLKIT

ZBrush is my tool of choice because it allows me to focus on the creative process, rather than technicalities that interfere with my workflow. When creating models for use in production, I use ZBrush in conjunction with KeyShot, TopoGun, Substance Painter, Maya, V-Ray, Illustrator, and Photoshop.

I think the trick is not to worry too much about fancy brushes when starting out with ZBrush. With the Clay Buildup, Clay, Dam Standard, and hPolish brushes, you should be good to go. You can create almost anything with these alone. I modify existing brushes with various alphas to achieve different results from time to time.

SCULPTING WORKFLOW

I like to start off with a sphere and take it from there. I try to start from scratch whenever possible to keep things fresh and improve on anatomy and posture in my models. ZSpheres are a bit dated in my opinion, but can still be useful in some cases. ZBrush allows me to really focus on the creative process, so I generally start off in ZBrush and end in TopoGun before sending it over to Maya. When I'm doing quick concept sculpts, I use the ZBrush to KeyShot Bridge to go back and forth until I'm happy with where it's going. Lastly, I use Photoshop for touch-ups.

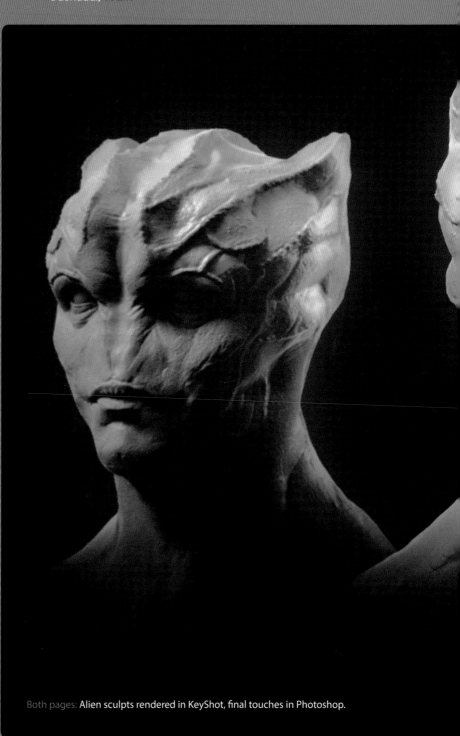

Both pages: **Alien sculpts rendered in KeyShot, final touches in Photoshop.**

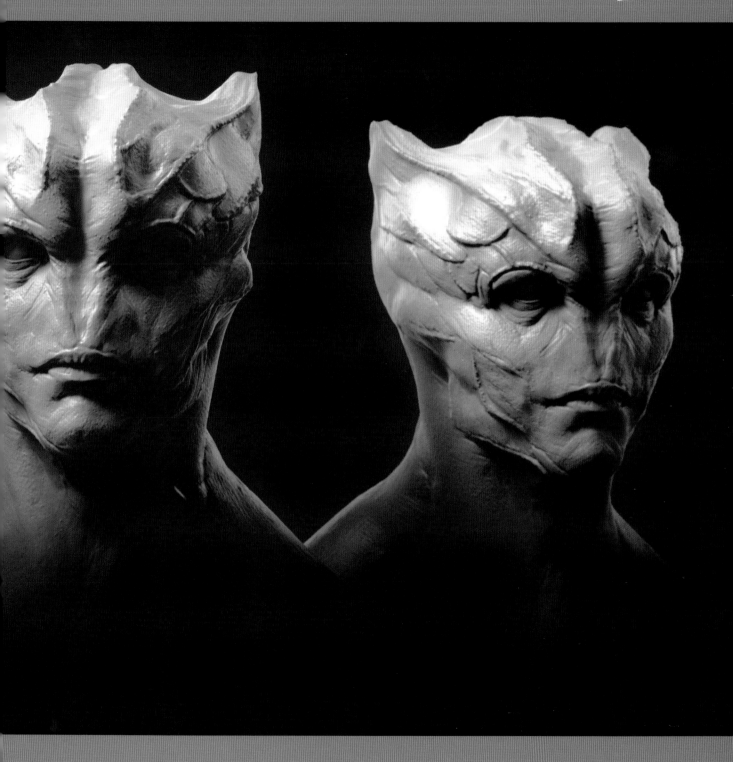

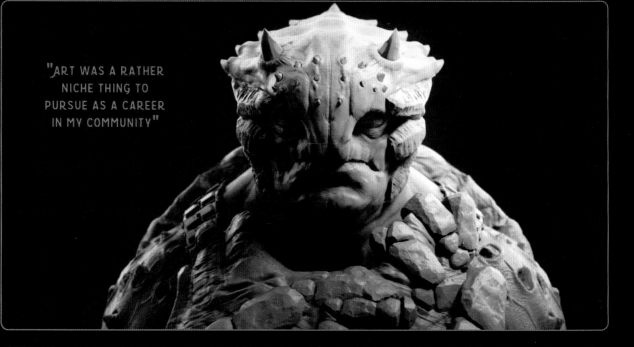

"ART WAS A RATHER
NICHE THING TO
PURSUE AS A CAREER
IN MY COMMUNITY"

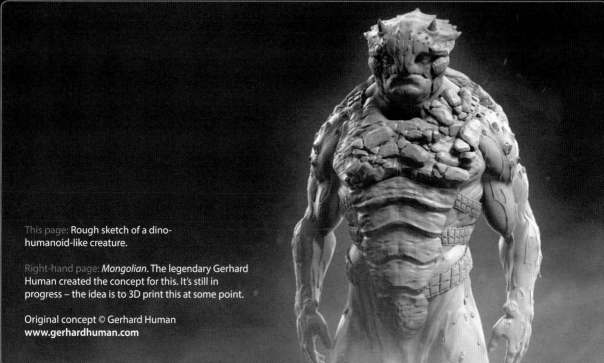

This page: Rough sketch of a dino-
humanoid-like creature.

Right-hand page: *Mongolian*. The legendary Gerhard
Human created the concept for this. It's still in
progress – the idea is to 3D print this at some point.

Original concept © Gerhard Human
www.gerhardhuman.com

LOADING REFERENCE IMAGES

As an alternative to using the Image Plane feature under the Texture palette, you can load reference images to your Spotlight editor. Position the images, go to the Brush palette, select the Samples tab, and make sure Spotlight Projection is turned off. *Voilà*, you are now able to have multiple reference images that you can move around and scale as you sculpt!

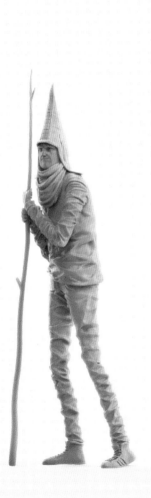
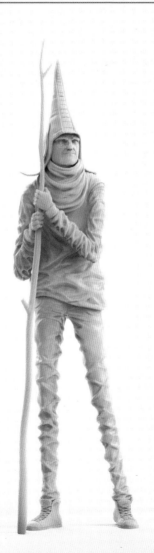
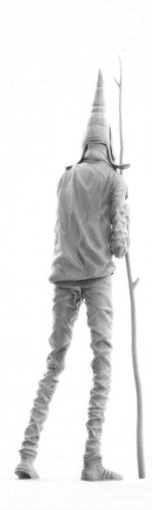

PELTOMÄKI, Laura

www.artstation.com/artist/laloon
All images © Laura Peltomäki

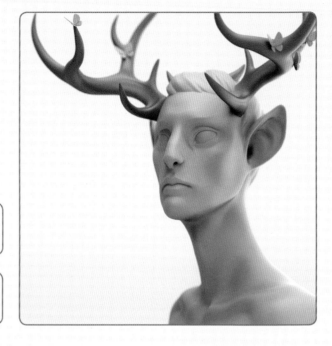

When it comes to art, I'm a huge perfectionist and thus sketching has always been challenging for me. I tend to strive for a finished look from the start and while it definitely can sometimes be useful, it also makes it harder to develop as an artist.

The good thing is that perfectionism is something you can learn to ignore. Ever since I started an art blog where I post work-in-progress images whenever I can, I've managed to develop a far more relaxed outlook on my sketching process. Strict deadlines at work have also helped me to improve my workflow and to know when to stop sketching.

When sketching, the shape of the model is something I pay the most attention to. I constantly spin the sculpt around and try to eliminate anything that doesn't work from a certain angle. I love to make the shapes flow and even my hard-surface models often have a very organic and smooth look. Occasionally switching to a flat material helps me to easily see if the general shape is working, without letting the details be too distracting.

INSPIRATION & IDEAS

I've always been interested in biology and especially zoology. One of the earliest memories I have is watching nature documentaries every week and being amazed by all the interesting creatures that exist just on our planet. Luckily, working in the entertainment business allows me to combine my interests with my work and basically I can just let my imagination run free without anyone complaining.

My ideas tend to be based on reality at least on some level. Background research is something I love and sometimes my sketches take days to finish because I end up reading too many articles online. When designing creatures and aliens, I love to implement strange features that real animals have and make them a bigger theme in my own designs. Earth has so many alien-like organisms on its own that the inspiration pool is endless.

TOOLKIT

Digital sculpting with ZBrush has from the start felt like a very natural way for me to create. I love that I can take quick renders of my works in progress and

make them look slightly more polished than they actually are. By hiding the imperfections I can more easily focus on the shape and flow of the model.

SCULPTING WORKFLOW

Unless I'm doing something for a game engine, most of the time ZBrush is my only tool. For sketching I use ZSpheres, DynaMesh, and ZRemesher together, until I'm happy with the shape and move on to detailing. KeyShot is the newest addition to my workflow; it's perfect for creating nice, polished renders really quickly.

"THE GOOD THING IS THAT PERFECTIONISM IS SOMETHING YOU CAN LEARN TO IGNORE"

Left: Many of my random sketches turn into things with horns.

Right: *Chouwai*. I'm not a fan of very human-looking aliens, but these guys are my guilty pleasure.

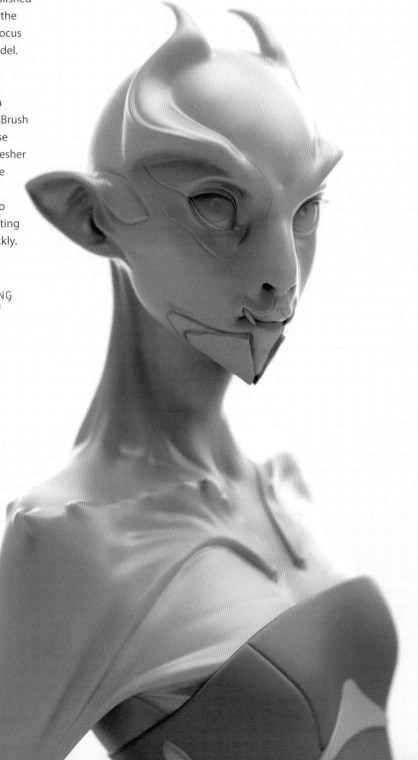

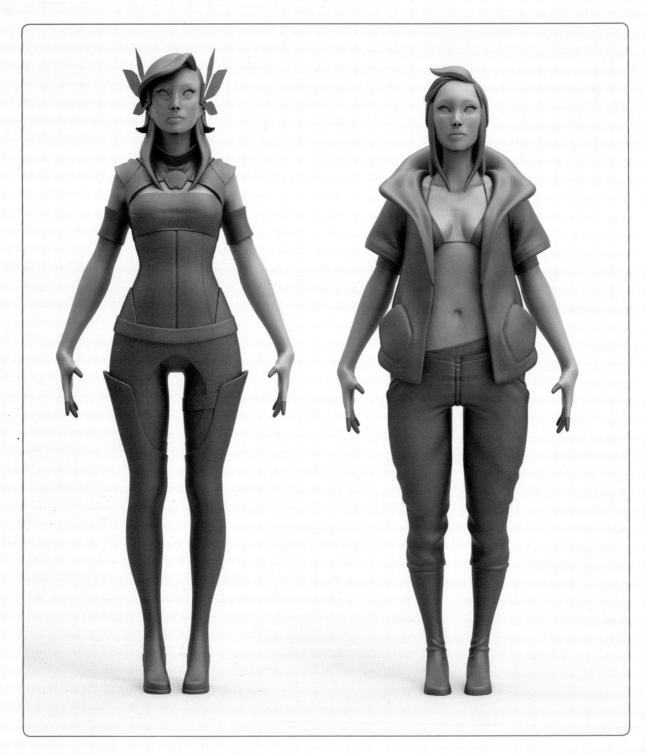

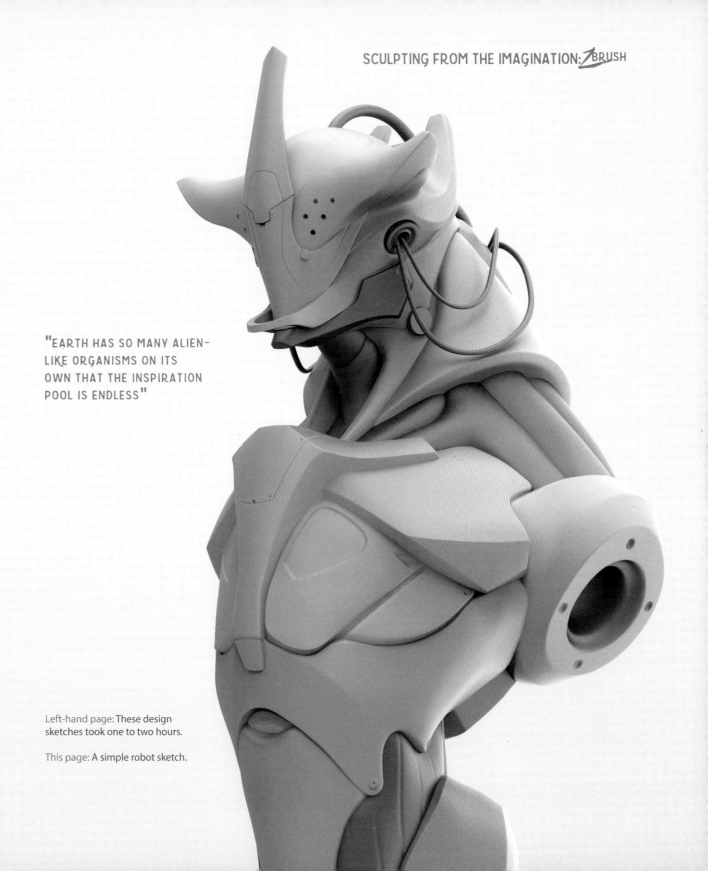

"EARTH HAS SO MANY ALIEN-
LIKE ORGANISMS ON ITS
OWN THAT THE INSPIRATION
POOL IS ENDLESS"

Left-hand page: These design
sketches took one to two hours.

This page: A simple robot sketch.

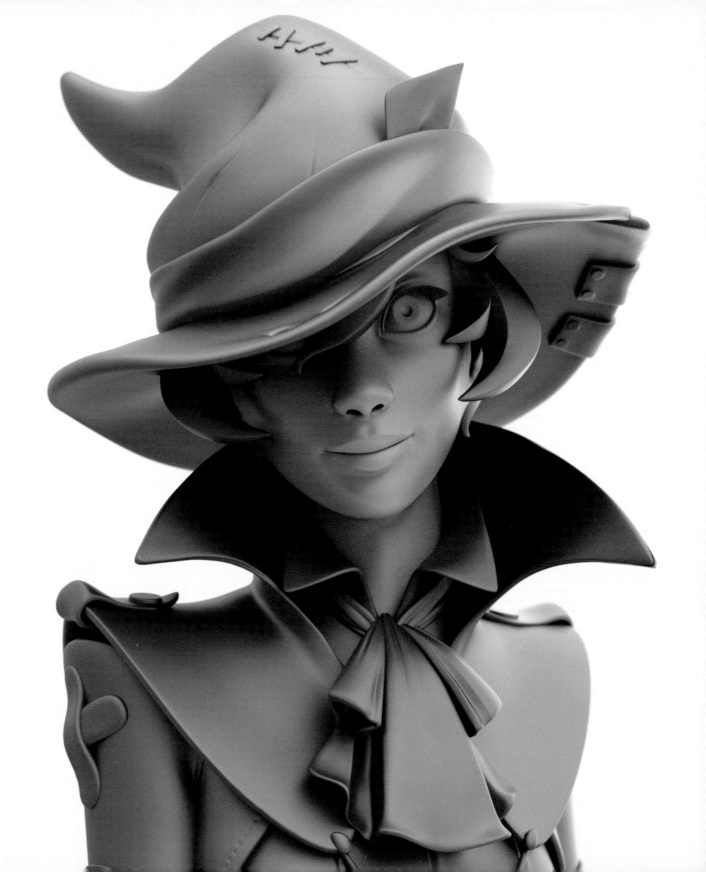

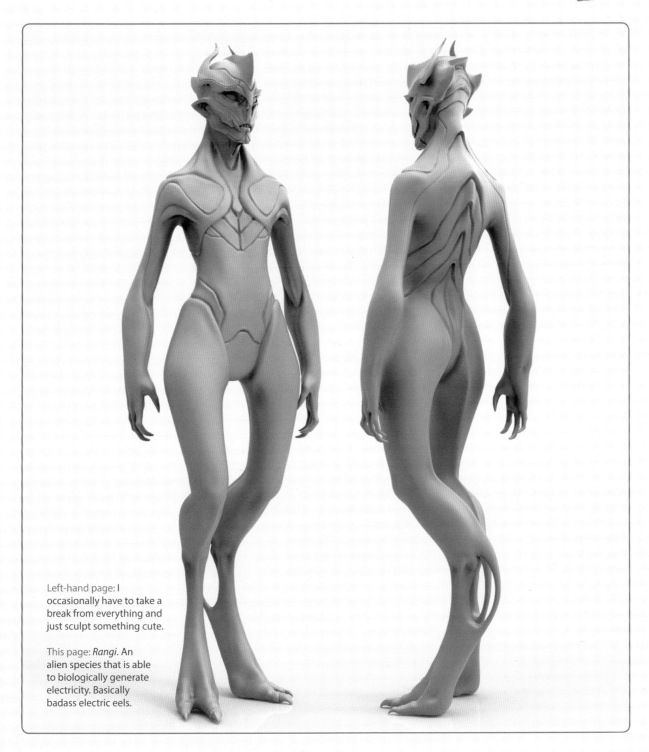

Left-hand page: I occasionally have to take a break from everything and just sculpt something cute.

This page: *Rangi*. An alien species that is able to biologically generate electricity. Basically badass electric eels.

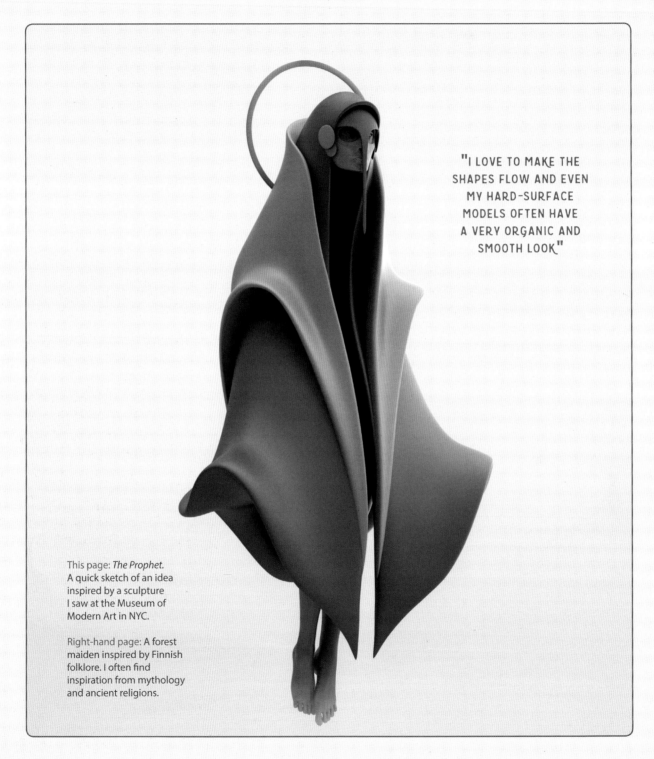

"I LOVE TO MAKE THE SHAPES FLOW AND EVEN MY HARD-SURFACE MODELS OFTEN HAVE A VERY ORGANIC AND SMOOTH LOOK"

This page: *The Prophet*. A quick sketch of an idea inspired by a sculpture I saw at the Museum of Modern Art in NYC.

Right-hand page: A forest maiden inspired by Finnish folklore. I often find inspiration from mythology and ancient religions.

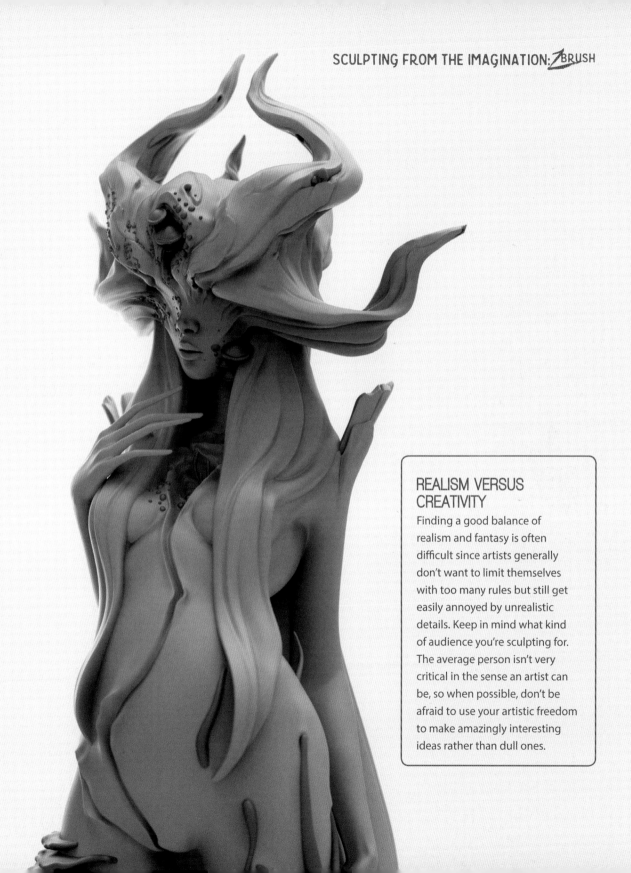

REALISM VERSUS CREATIVITY

Finding a good balance of realism and fantasy is often difficult since artists generally don't want to limit themselves with too many rules but still get easily annoyed by unrealistic details. Keep in mind what kind of audience you're sculpting for. The average person isn't very critical in the sense an artist can be, so when possible, don't be afraid to use your artistic freedom to make amazingly interesting ideas rather than dull ones.

PEYCHEV, Vasil

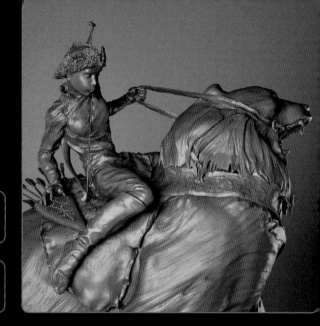

www.artstation.com/artist/vasilpeychev
All images © Vasiliy Peychev

have always created art, by iterally any means – be it painting on porcelain, sculpting statues, or even creating huge exterior designs. I was constantly putting myself in harm's way, working with toxic paint or climbing ladders

My son Maxim (**www.mpeychev. daportfolio.com**) has been working as a game designer at Gameloft for the past five years, where he saw the potential of ZBrush and immediately saw how it might help me. In early 2015 he sat me down, showed me the basics of ZBrush, and left me some tutorials. began with tasks involving anatomy and organic shapes, but within a week he couldn't keep up with me!

ZBrush opened a whole new world of possibilities for me. Especially

now such a high level of fidelity is required for games and CG, a more traditional approach is essential. Here I'll share some of the approaches to my work and the tools that I use.

INSPIRATION & IDEAS

For a long time I imagined an underwater world filled with beautiful, scary, and contemplative characters. Now I've finally had the chance to develop it with the freedom that ZBrush allows. This environment is great to experiment with and explore how weightlessness affects forms, and how all movements seem to appear effortless and graceful.

TOOLKIT

I started learning ZBrush recently, and it was my first experience with 3D. The switch from a traditional approach

to CG was effortless – the only thing that required getting used to was learning to trust one's eyes, since you can't touch a digital sculpt. ZBrush puts all the tools I need at my disposal, especially DynaMesh, which allows me to pursue my ideas and concentrate on the art side, instead of topology.

Maxim often helps me with the rendering side – we use Next Limit's Maxwell Render. It's easy to set up and the results are always consistent, if you know a thing or two about photography.

SCULPTING WORKFLOW

I start my sculpts with a DynaMesh sphere. Over the course of the sketching phase, I tend to duplicate my sketch to SubTools when trying to change something drastic, to see

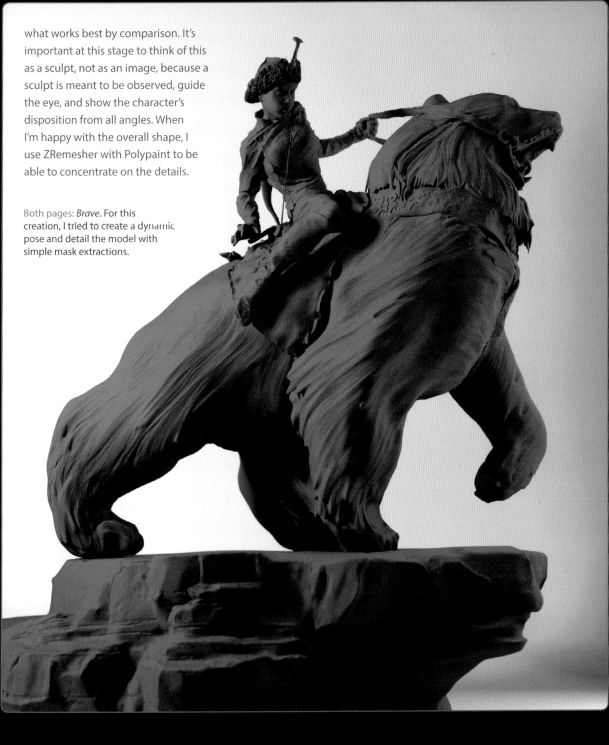

what works best by comparison. It's important at this stage to think of this as a sculpt, not as an image, because a sculpt is meant to be observed, guide the eye, and show the character's disposition from all angles. When I'm happy with the overall shape, I use ZRemesher with Polypaint to be able to concentrate on the details.

Both pages: *Brave*. For this creation, I tried to create a dynamic pose and detail the model with simple mask extractions.

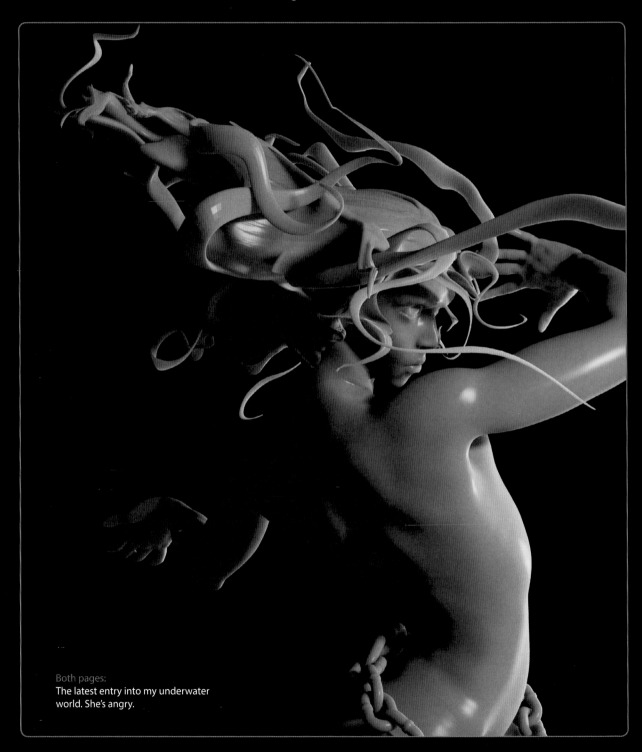

Both pages:
The latest entry into my underwater
world. She's angry.

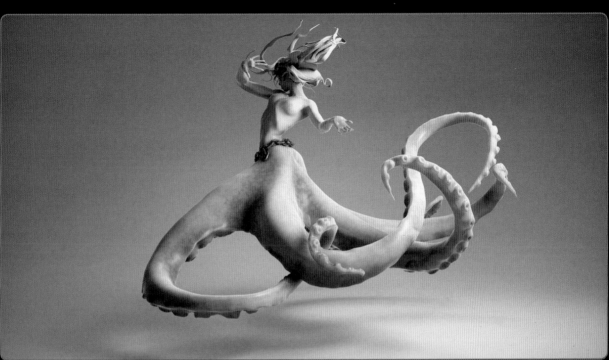

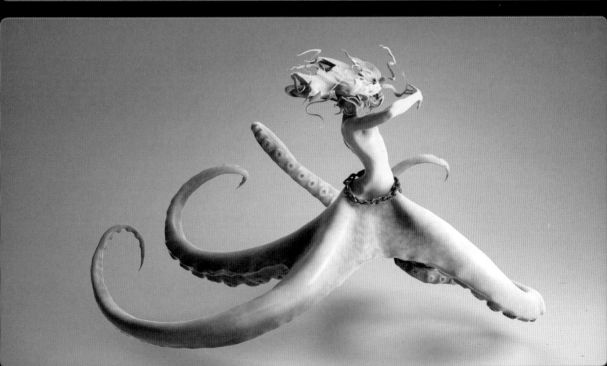

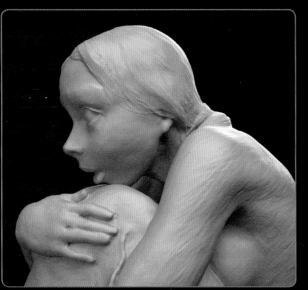

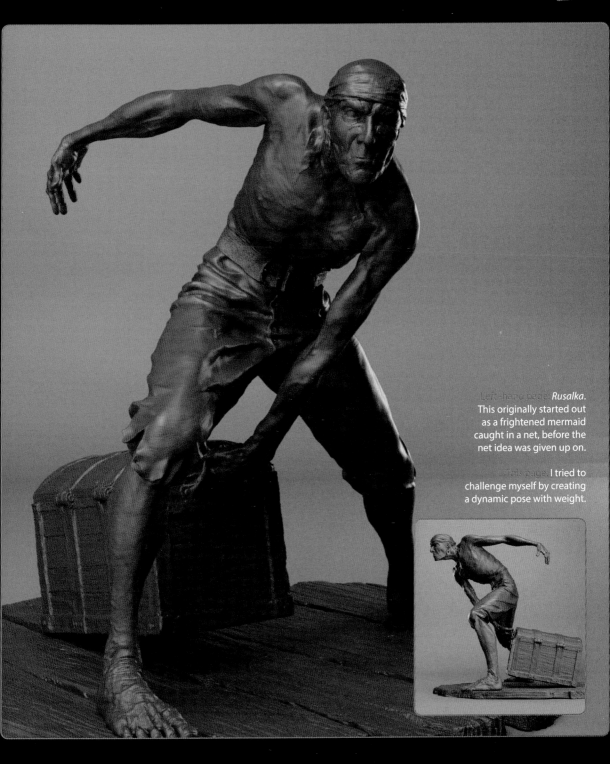

Left-hand page: *Rusalka*. This originally started out as a frightened mermaid caught in a net, before the net idea was given up on.

This page: I tried to challenge myself by creating a dynamic pose with weight.

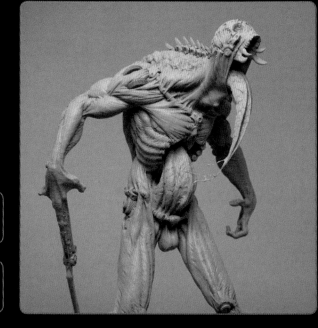

PLOUFFE, Marco

www.marcoplouffe.com
All images © Marco Plouffe

When I was a kid and was given coloring books, I never really liked to color inside the lines. I remember drawing my own things like fire trucks and such. When I started playing video games and playing with action figures, I started drawing my own iterations of the *Teenage Mutant Ninja Turtles* and *Mega Man* bosses, and later it became drawing my friends' characters in *Dungeons & Dragons* and my own comic books.

I never really went to school to learn how to draw properly, but after wasting my time with a job I didn't like, I decided to move to Montreal and learn 3D modeling for video games at Campus Ubisoft. It was the first time that I was actually mentored with an artistic medium so I became very confident of the skill I acquired

there. When I learned ZBrush, it almost felt like I knew the software already because it spoke to me as a kid doing my little doodles on pieces of paper.

I've played with ZBrush for so long and learned so many tricks from my teachers and tutorials, and later from my colleagues, that I've acquired the speed and knowledge of tools necessary to use it as a way to generate ideas. That being said, you don't need much knowledge of the software to start generating ideas: you just need to take the first few steps and let your imagination drift without judgment or fear. And, like every good thing, you just need passion and time to master it.

INSPIRATION & IDEAS

I work differently depending on if I'm working with a client or just for myself.

If I work for a client, I usually ask for a reference board and a biography of the character to make sure I'm heading in the right direction. If I work for myself, I really just use what I find inspiring in my everyday life: sometimes I'm inspired by a character on a show, by something I learned in a nature documentary, by images I see in my head when listening to music, or by images I see on my bathroom tiles when taking care of business...

"IF YOU LOOK AT OTHER PEOPLE'S WORK, USE IT AS A DRIVE MORE THAN AN INSPIRATION"

I suggest finding inspiration from things other than fellow artists' work, because you don't want to just replicate something another artist did... and believe me, you'll

always, by default, accidentally "copy" something that already exists, thanks to your subconscious! If you look at other people's work, use it as a drive more than an inspiration.

It's not important if you start with or without an idea, because if you keep an open mind when starting the first few steps of sketching something, you'll figure out where your brain wants to go. After that it's just a question of exploring beyond that default place your mind goes, but without losing perspective of what you like to design and what makes you "you" as an artist.

TOOLKIT

I use mostly ZBrush but also KeyShot for rendering passes, and Photoshop to assemble the passes and to make post-production work on top (moods, corrections, and so on). In ZBrush, I explore shapes using DynaMesh and sculpt with a few brushes: Move or Snake Hook to move things roughly, Clay Buildup to create volumes, and Dam Standard and Orb Crack to create cavities and details.

When sketching mechs, I usually use the Smooth brush to create smooth surfaces but sometimes

I will use hPolish. I use the Mask brush a lot to move parts around or even create surface shapes.

Left: *Exovirus*. The idea here was to design a parasite that hosts itself in a robot because it can't create its own skeleton. Once it's inside, it generates muscle-shaped larvae until it has total control of the robot's inner structure. In that case, the larva eggs are on its neck and trapezius.

Below: *Greed* (a.k.a. The Prospector) refuses to give away his dark gold and therefore fused with it, making it a burden. This is why he is hunched. I went for ape-like anatomy to make him more imposing.

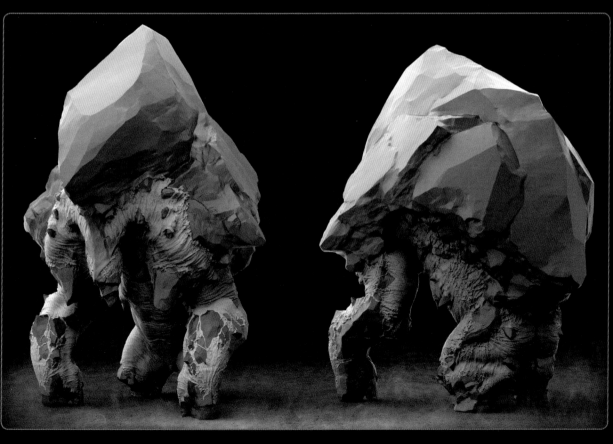

SCULPTING WORKFLOW

I usually start from a sphere and I try to find a good thumbnail shape. I always work in stages: the big volumes first, then the medium shapes, and finally the smaller details. I try to stick to simple brushes to make the exploration phase less complicated and as free-flowing as possible.

I also like to duplicate existing SubTools and move them around to maybe generate happy accidents. Around that same idea, I sometimes use pre-existing ZTools or IMMs to insert on my model and let my eye decide if there is a match to be made. Once I've done all that and I've found a good overall design, I commit to it and start rendering it to give it a bit of polish.

Sketching doesn't need much polish to sell an idea, but when I have the time, I like to spend some of it making my design appealing to the eye. Remember that you need twenty percent of the time to represent eighty percent of your idea, and eighty percent of the time to finish the last twenty percent of your presentation!

Right: *Rockerbot*. The idea was to represent how sentient robots of the future will still celebrate eighties metal culture.

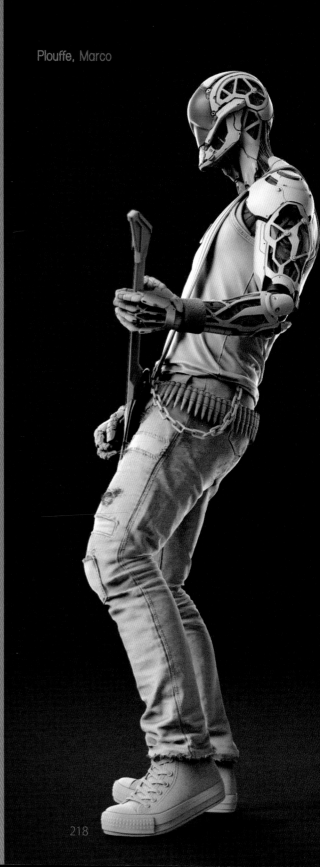

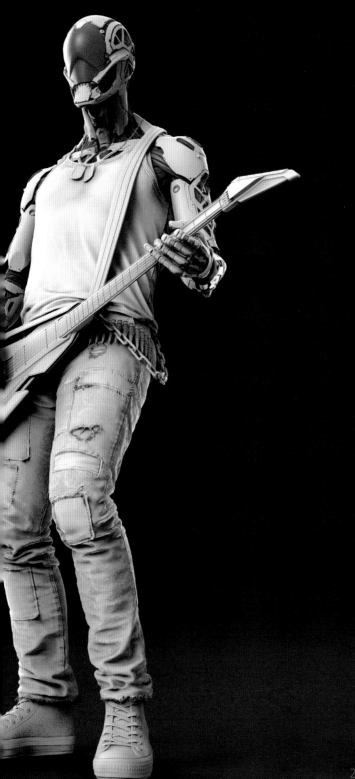
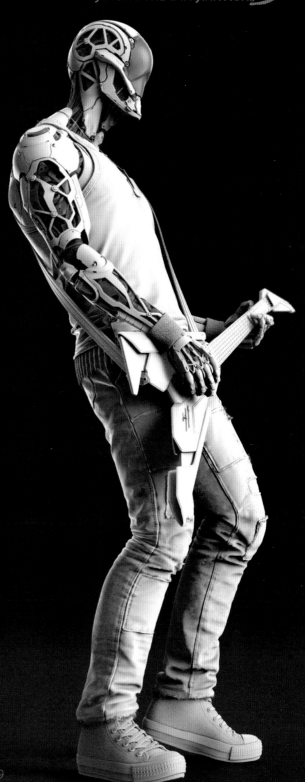

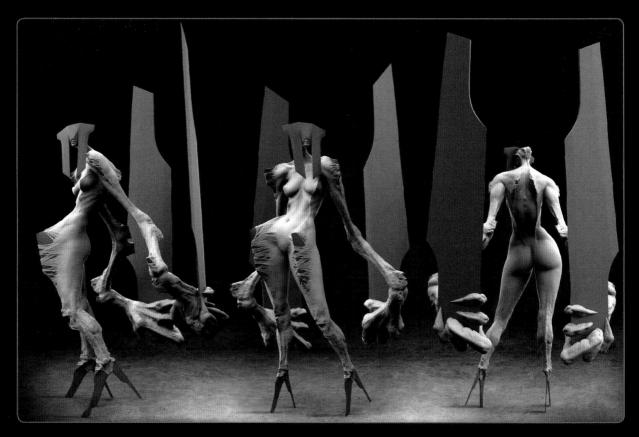

Above: *Pride* (a.k.a. The Peacock) wants to gaze upon herself for eternity. I decided to replace her eyes with mirrors so she gazes into the abyss when she's looking into them.

Right-hand page (top): *Envy* (a.k.a. The Collector) envies everybody else to the point that it will take what others have (by "subtracting" skin, eyes, and limbs with its scissors) to dress itself with them and hide what's underneath.

Right-hand page (bottom): *Gluttony* (a.k.a. The Gorge) is a bottomless hole that digests whatever she can grab with her rib cage. I purposefully did not go for a fat creature and instead was inspired by carnivorous plants.

DON'T HESITATE TO "MURDER YOUR DARLINGS"

It sounds pretty gruesome but it basically means do not get too attached to your work while designing. If you get attached too much, you might hesitate to change the design and stop exploring further. During the concept stage of my *Sinners* project, I became attached to a lot of ideas while doing my first rough sketches, but since I learned to "murder my darlings" before, I was able to consciously stop caring about the first few design ideas that I liked so much and to explore a bit more beyond them.

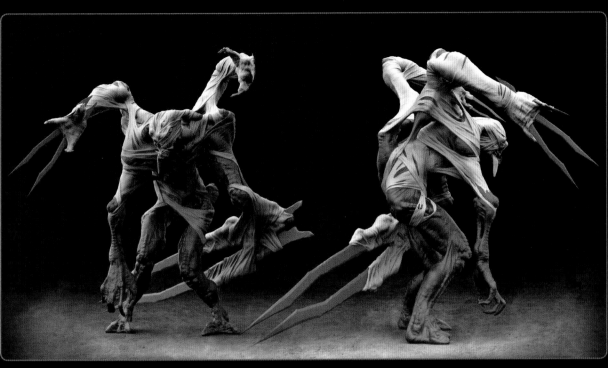

PUSHKAROVA, Ekaterina (Katerin)

www.ekaterinapushkarova-katerin.tk
All images © Ekaterina Pushkarova

Making concepts in 3D gives you the freedom to be flexible, fast, and creative in your work. When the art director comes up to you and says, "Awesome creature. Now can we quickly try to extend his torso or change the silhouette?", this can be done with a few clicks of the mouse, particularly in a program like ZBrush.

Another big plus is that along with the idea, you're already creating a high-poly mesh which is ready to pass to the 3D production artists for retopology or rigging. That saves a lot of time, of which there's never enough! If your team need a profile or back view, you simply rotate, render, and it's ready. There is no need to draw several views. If there is a specific camera for the project, you can quickly see what the object is going to look like in-game – for example in orthographic view. And if you don't like something, simply combine several SubTools and in about an hour you can offer at least a few variations.

INSPIRATION & IDEAS

Inspiration is always around the corner – you only need eyes to see it and a heart to feel it. The beggar on the street with eyes tired of life, a girl's pensive look, the strange dog standing on the sidewalk in front of your house… you're in a hurry, here and now, and you need a ball of clay to work with without thinking, something that allows you the free stroke of your hand. Then you discover the digital clay called ZBrush.

TOOLKIT

ZBrush is so comfortable, so flexible to work with. The creator must have the freedom to experiment without restrictions, with thousands of opportunities to change things again and again. That's exactly what this program offers to the artist: freedom! There are layers with which you can combine different parts of the body, quickly testing new forms; Insert brushes with which you can add parts of the body or individual elements already made by you; alphas that you can make to help you with the fine details. While working I often use the Clay Tubes brush, which is very organic and close to sculpting with real clay, as well as the Inflate and Magnify brushes, which add a sense of organic volume.

SCULPTING WORKFLOW

I often start with a sketch in which I seek to boldly experiment and change the shape until I like it. Then

I go through DynaMesh and change it again. I use the NoiseMaker plug-in for the general surfaces to convey their material nature. Combinations of several noises, one over another, can create quite a natural texture.

The Insert brush is sometimes very useful in quick sketching with various collections of parts, especially when you need to quickly try out different combinations of shapes. For the fine details, I often use Clay Tubes, Inflate, and Planar Polish, but in combination with alphas (especially when it comes to the skin). Experimentation always remains the most important of all – surprisingly good results are obtained through experiments.

Left-hand page: *1789*. While traveling by boat to a small island in the Black Sea, I was thinking about Napoleon's exile and the French Revolution. And then she appeared, with white hair and a timeless look. She had no name, like the thousands who had begun the revolution.

This page: *The Ice Mage*. This shows how fast you can cover surfaces using the NoiseMaker plug-in with an alpha which you like.

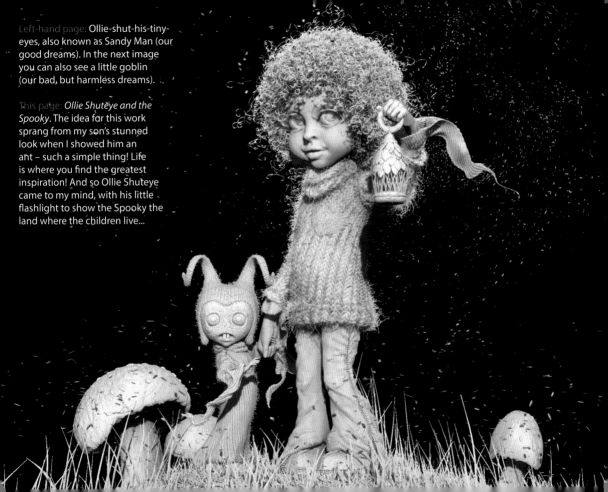

Left-hand page: Ollie-shut-his-tiny-eyes, also known as Sandy Man (our good dreams). In the next image you can also see a little goblin (our bad, but harmless dreams).

This page: *Ollie Shuteye and the Spooky*. The idea for this work sprang from my son's stunned look when I showed him an ant – such a simple thing! Life is where you find the greatest inspiration! And so Ollie Shuteye came to my mind, with his little flashlight to show the Spooky the land where the children live...

Pushkarova, Ekaterina (Katerin)

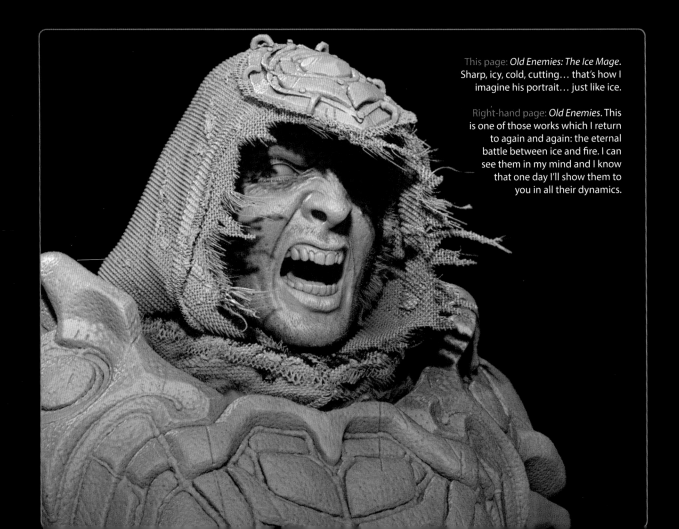

This page: *Old Enemies: The Ice Mage*.
Sharp, icy, cold, cutting… that's how I
imagine his portrait… just like ice.

Right-hand page: *Old Enemies*. This
is one of those works which I return
to again and again: the eternal
battle between ice and fire. I can
see them in my mind and I know
that one day I'll show them to
you in all their dynamics.

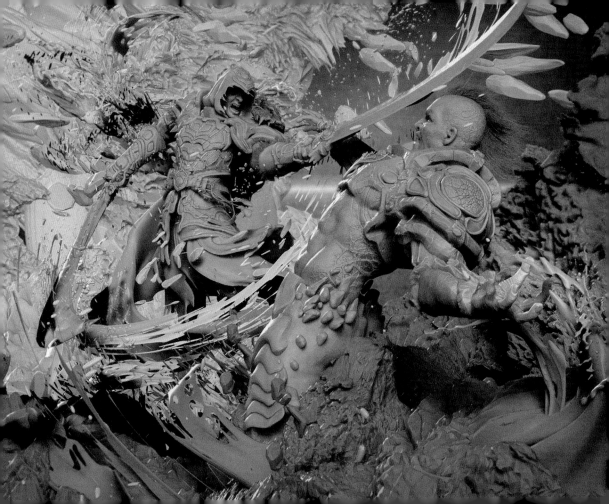

RABIE, Mohamed Aly

www.rabieart.com
All images © Mohamed Aly Rabie

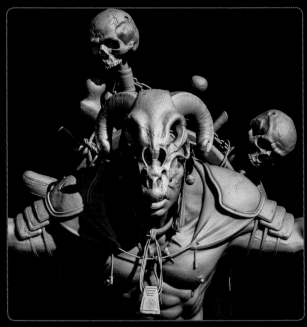

I have ten years' worth of experience in CG, and throughout these years I have worked on a wide range of projects. I received my bachelor's degree with honors from the International Academy for Engineering and Media Science, Egypt, and my diploma in 3D animation and visual effects from the Vancouver Film School, Canada. I had concentrated on hard-surface and organic modeling in Maya, but when I started using ZBrush during my study at Vancouver Film School, I quickly realized that my passion lies in character creation, no matter what the design might be – humans, creatures, or aliens – though I also enjoy building environments and weapons.

With the development of ZBrush, I found my skills evolved automatically. After using ZBrush as a secondary application to add details to my models or to only build certain things in, I discovered DynaMesh and how to use it with other great tools such as Transpose and ZSpheres. I now had the ability to implement my own ideas with ease, without thinking much about tools as I focus on my artistic ideas.

INSPIRATION & IDEAS

Inspiration is that thing that gives you a high level of emotion, makes you excited, or pushes you to have an idea to create something. Maybe you'll get inspired by an animal, a bird, or an insect, or even an organic disease; maybe by something you've seen in a movie or read in a book or seen in another artist's artwork.

If you want to make solid artwork, you have to do your bit as a researcher first. You should be looking and looking to determine the nature, form, time, and place of your character or creature, and then search for its strength and weaknesses. No matter how beautiful and wonderful your design is, it should have something related to reality to make it believable.

TOOLKIT

The software packages I use are Maya, ZBrush, MARI, Photoshop, V-Ray, mental ray, headus UVLayout, 3D-Coat, Marvelous Designer, KeyShot, Marmoset Toolbag 2, Knald, CrazyBump, After Effects, and Premiere. My favorite brushes in ZBrush are Move, Move Topological, Move Elastic, Standard, Dam Standard, Form Soft, Inflate, Clay, Clay Tubes, hPolish, Trim Dynamic, Smooth, and Smooth Stronger. Out of these, my favorite in

ZBrush (or any other digital sculpting application) is the Move brush, for how it allows you to move a set of points from one place to another.

SCULPTING WORKFLOW

If I have a specific idea then I prefer building a simple base mesh in Maya or by using a ZSphere in ZBrush. If I have no ideas, I open ZBrush and use a DynaSphere with the Move, Move Elastic, and hPolish Brushes until I get an interesting and distinct shape.

I begin to think of three things: gesture, because no matter how detailed your sculpture is, it will look dead if you can't nail a strong gesture; form, using Light > Lights Placement and VBlur Radius (Ctrl+B) so I can focus on shape and silhouette; and proportion, which is unique to each individual and a big part of personal identity.

Once I have a clearer idea, I attend to the basic shapes and refine the details later. Once I'm done with the main and secondary forms, I start retopologizing my mesh. If it's not for production use, I use ZRemesher to save time, but if the model is for production (such as animation), I go for manual topology using 3D-Coat.

I duplicate my new retopologized model and project the details from the old sculpture, then start to add small details on the new model such as skin pores, pimples, veins, and asymmetry. Then I unwrap the UVs with a mixture of headus UVLayout and Maya. For texturing, I add the overall colors with ZBrush's Polypaint tool, and go into more detail in MARI later on.

When all this is done, the model is ready for production (shading, rigging), or for me to pose and render with ZBrush before taking all the render passes into Photoshop.

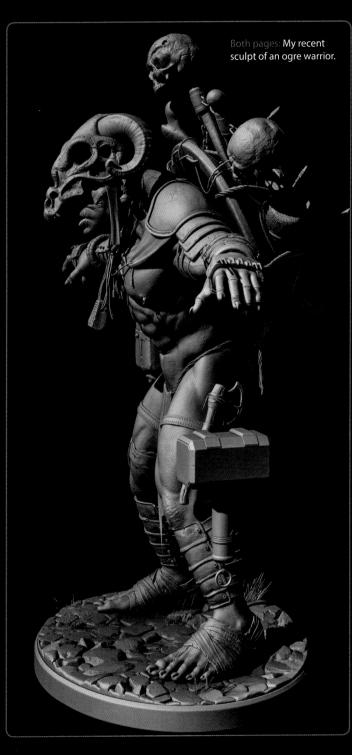

Both pages: My recent sculpt of an ogre warrior.

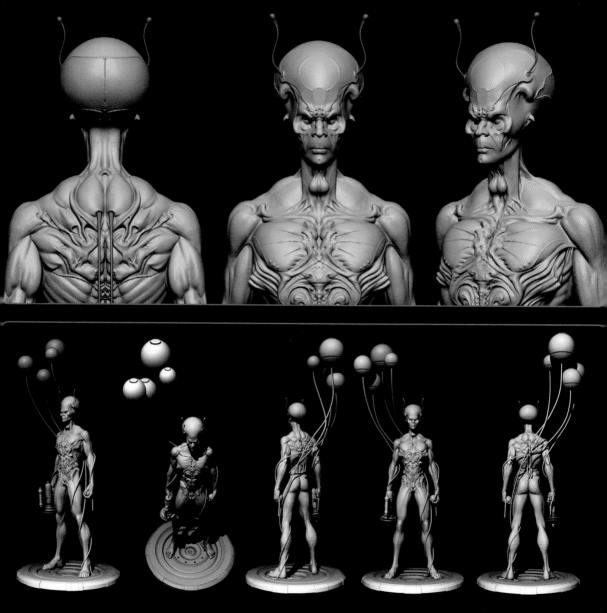

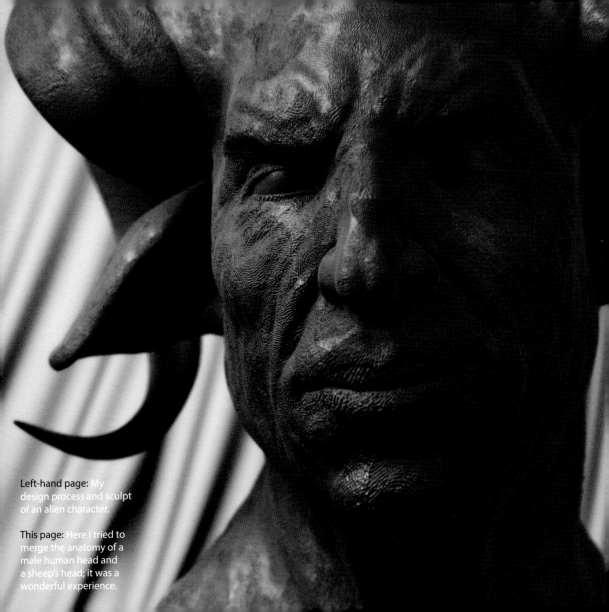

Left-hand page: My design process and sculpt of an alien character.

This page: Here I tried to merge the anatomy of a male human head and a sheep's head; it was a wonderful experience.

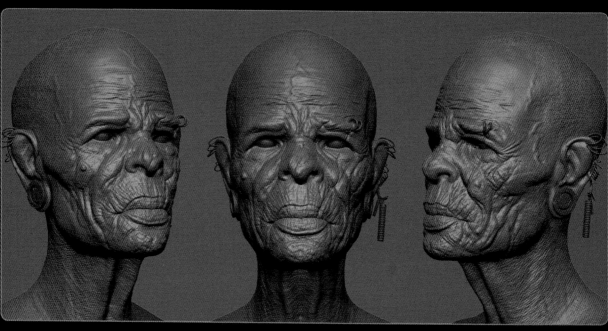

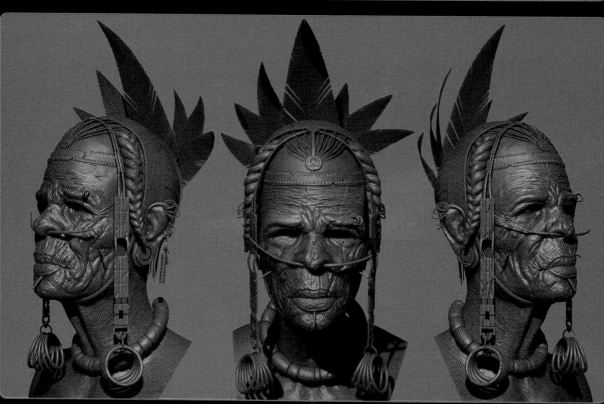

"NO MATTER HOW DETAILED YOUR SCULPTURE IS, IT WILL LOOK DEAD IF YOU CAN'T NAIL A STRONG GESTURE"

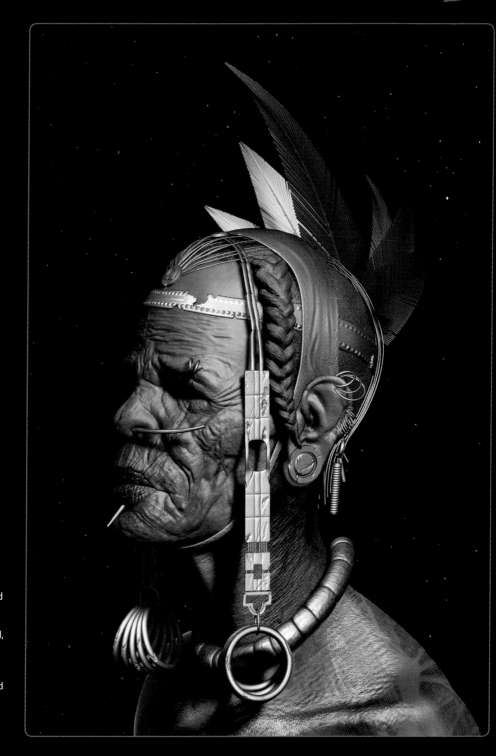

Left-hand page: It's important to collect many photo references to use as a guide while sculpting. During the sculpting process, I work in the lowest subdivision levels that can handle and support the type of details that I'm trying to make.

This page: *Roots*. At the end of 2010, Somalia suffered a famine crisis. I felt a lot of pain about what happened, and wanted to make something to reflect the tragedy and express what was bothering me. I wanted to say that we shouldn't forget Mother Africa, the roots of everywhere else.

REEVES, Alexandra (Lex)

www.elementaldragonart.wix.com/apeirondiesirae
All images © Alexandra Reeves

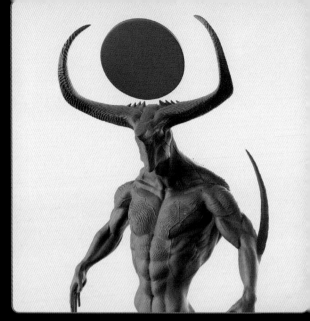

Being self-taught, I discovered ZBrush pretty early on but was way too young to really understand what it was. After a while of staying 2D and painting for most of my teenage years, I felt ready to move into the 3D world and ended up getting ZBrush when was 18; I haven't stopped using it since. I found some tutorials online and, after the initial learning curve, have added ZBrush to my software repertoire by using it regularly.

INSPIRATION & IDEAS

My main inspirations always stem from nature, but I find that a lot of the time what gets me most excited to work is looking at other artists, nabbing whatever free or cheap tutorials are out there, and competing

to find a constraint to cap ideas off, like competition guidelines. Usually that helps me get projects done in a good amount of time and stay motivated, excited, and challenged.

TOOLKIT

Within ZBrush I tend to use whatever is free on the Pixologic website or what I've made in the past. So alphas, brushes, and meshes are either made by me, or are a free resource from Pixologic, and sometimes from BadKing (**www.badking.com.au**) as well.

After working in ZBrush I like to do a few simple passes in KeyShot and then take it to Photoshop for the finishing touches. Sometimes all I need to do here is sharpen, but other times I decide to add a

lot more elements, such as color, environment, and additional lighting.

SCULPTING WORKFLOW

If I have a constraint in mind that is very specific, for example for a competition, I usually start with a sketch – sometimes with traditional media, or in Photoshop, or when I'm having a really hard time I'll use an experimental drawing program called Alchemy (**www.al.chemy.org**).

After that, I usually start with the default DynaMesh sphere with a pretty low resolution. From there I focus on silhouette until I'm satisfied and continue subdividing, adding secondary forms, then tertiary forms, until I've reached the level of detail I want.

Left-hand page: A sculpt I did for fun when I found some cool new alphas on Pixologic's website. I was in the mood to make a demon with really large horns.

This page: I found some extremely high-resolution images of insects online and wanted to make some sort of alien out of them. I got my concept by photo-bashing several insects together and then going into ZBrush.

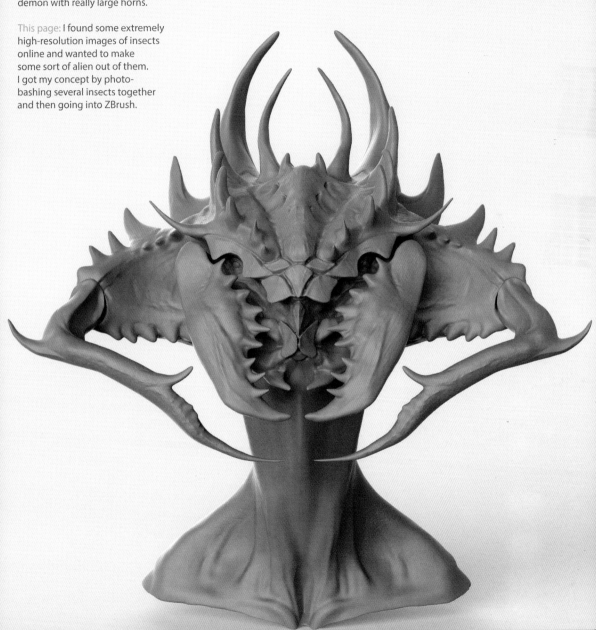

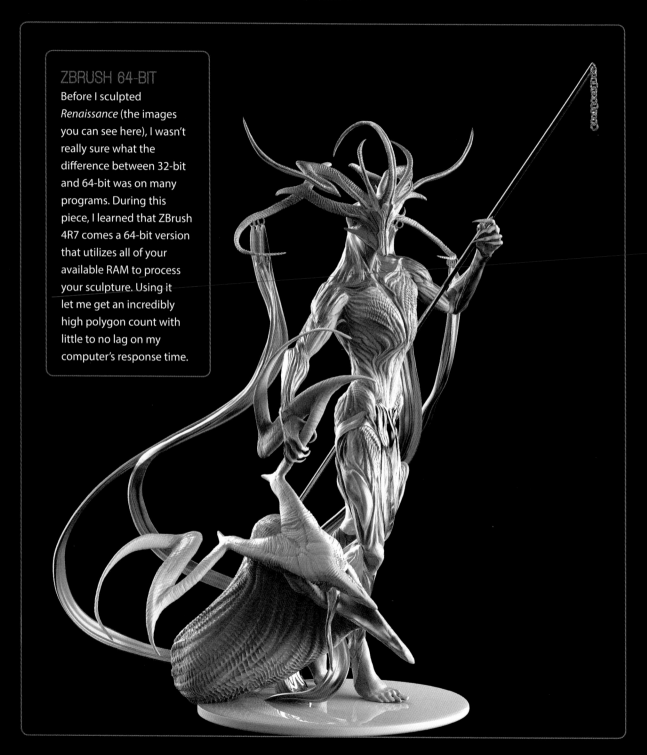

ZBRUSH 64-BIT

Before I sculpted *Renaissance* (the images you can see here), I wasn't really sure what the difference between 32-bit and 64-bit was on many programs. During this piece, I learned that ZBrush 4R7 comes a 64-bit version that utilizes all of your available RAM to process your sculpture. Using it let me get an incredibly high polygon count with little to no lag on my computer's response time.

Both pages: *Renaissance:*
My most recent sculpture
and the one I'm the
most proud of, where I
really, really challenged
myself. I wanted it to be
an extremely detailed,
clean mesh and based
on old Renaissance
styles. This sculpture was
also meant to test my
ability to create high-
resolution detail, cloth,
posing, and introducing
a second character.

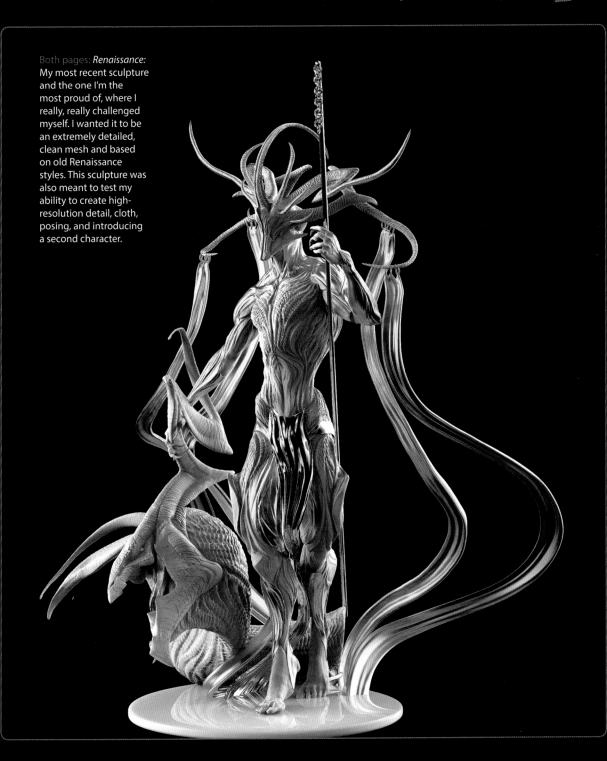

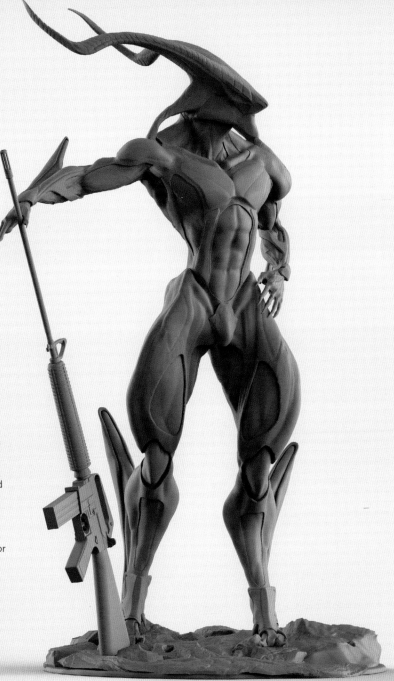

This page: This creature needed to be more brutal and war-driven than technological or machine-like. This was the first time I ever tried KeyShot.

Right-hand page (top): This was for a competition on DeviantArt for a card game. You could pick from some categories and I chose dragons. I used this ZBrush sketch to speed up my painting by using ZBrush's BPR (Best Preview Render), and then moved to Photoshop for painting.

Right-hand page (bottom left): One of my first sculptures in ZBrush. I tried to sketch an idea for a creature every day for a week.

Right-hand page (bottom right): This was my sketch from the creature week exercise, inspired by insects and giraffes.

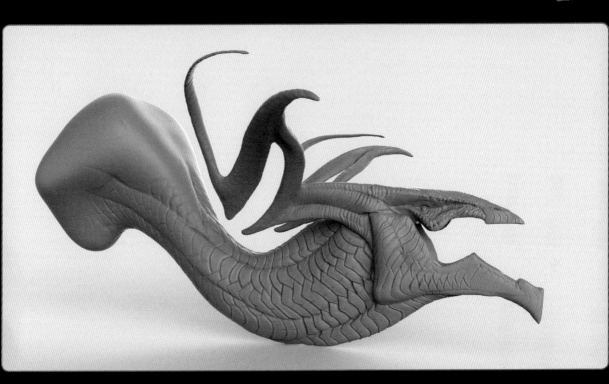

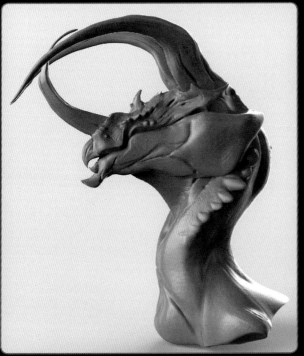

RIESCO, Nacho

www.nachoriesco.com
All images © Nacho Riesco

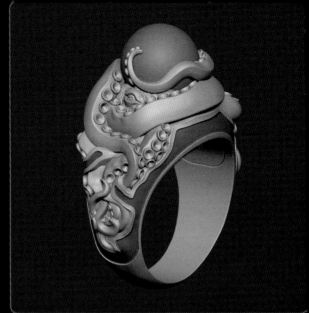

'm a self-taught artist with artistic concerns that have led me to learn and develop all kinds of techniques, from drawing to painting to airbrushing. Nowadays I am fully immersed in the digital world, as a digital sculptor focused on 3D printing, mainly making organic designs for jewelry. work as a freelance digital sculptor getting orders from professionals and brands in the jewelry industry.

My career as a digital sculptor began when I discovered ZBrush almost ten years ago, and I was totally in love with what the software was able to do. The ability to use a digital app to sculpt as if with real clay, and its way of working without most of 3D modeling's boundaries, makes ZBrush an amazing artistic tool to use for jewelry design

INSPIRATION & IDEAS

When I make jewelry designs my inspiration comes mostly from nature. Some of my favorite creatures are felines and snakes, although insects are also a great source of inspiration. I love to make all kinds of rock and roll or dark designs, such as skulls, dragons, tattoo iconography, and so on. I'm also inspired by Japanese mythology, Celtic style, Baroque, Art Nouveau, and Art Deco – there are many places to get ideas.

TOOLKIT

My main and only tool is ZBrush. With it, I can cover all my needs, from concept sketching to the final piece. For rendering, I use KeyShot, a great rendering software for product representation

SCULPTING WORKFLOW

All my sketching, and even my production workflow, is based on DynaMesh. I usually split the design into as many SubTools as possible, which allows me more freedom to change single elements, position, size, and so on, and is also useful for making Booleans.

Once I'm happy with the design, I merge all the desired SubTools into one, which is compacted in the last DynaMesh. As I'm not a 3D modeler, I try to avoid anything related to box modeling techniques or topology concerns. I love how ZBrush works as if I was using clay in real life, so what I basically do is transform basic shapes into more complex ones using clay sculpting techniques

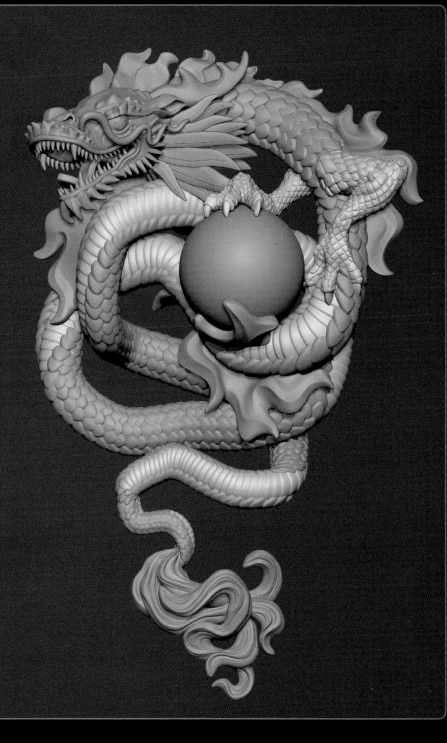

Left-hand page: The design of this ring is inspired by the mythological creature the Kraken, with tentacles coiled on the ring's band and holding a black pearl on top. The surrounding deep black waters can be represented by rhodium metal and black enamel, or rhodium metal and black stones pave the way for a more luxurious finish.

This page: A concept design to be used as a pendant, with a pearl or stone as the central element. It still needs a lot of work to be transformed into a wearable piece of jewelry. When making jewelry, it is important to remember that in reality many of the surface details can be lost once cast and polished; I try to make reliefs deeper, exaggerating details, to get readable details and shapes on the real piece.

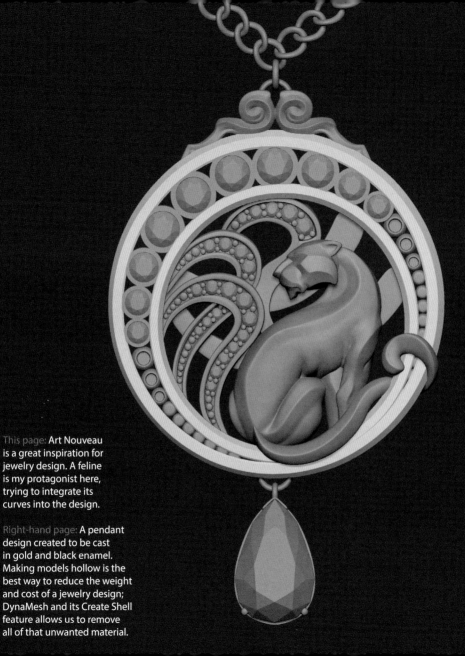

This page: **Art Nouveau** is a great inspiration for jewelry design. A feline is my protagonist here, trying to integrate its curves into the design.

Right-hand page: **A pendant design created to be cast in gold and black enamel. Making models hollow is the best way to reduce the weight and cost of a jewelry design; DynaMesh and its Create Shell feature allows us to remove all of that unwanted material.**

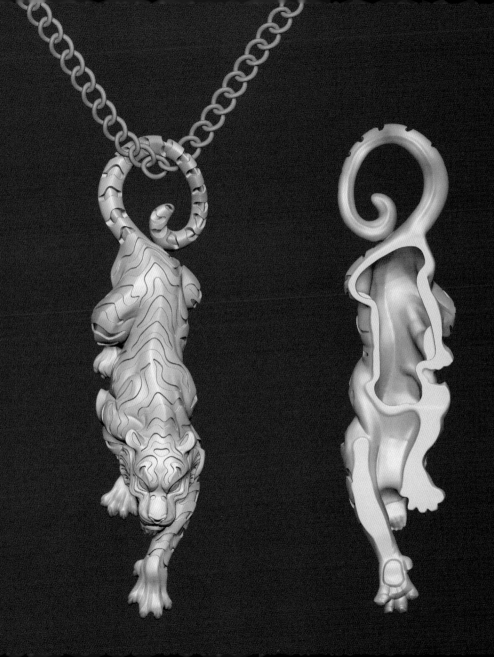

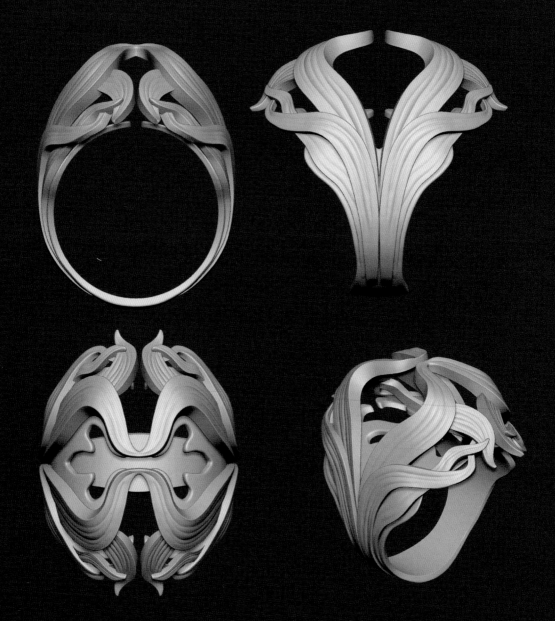

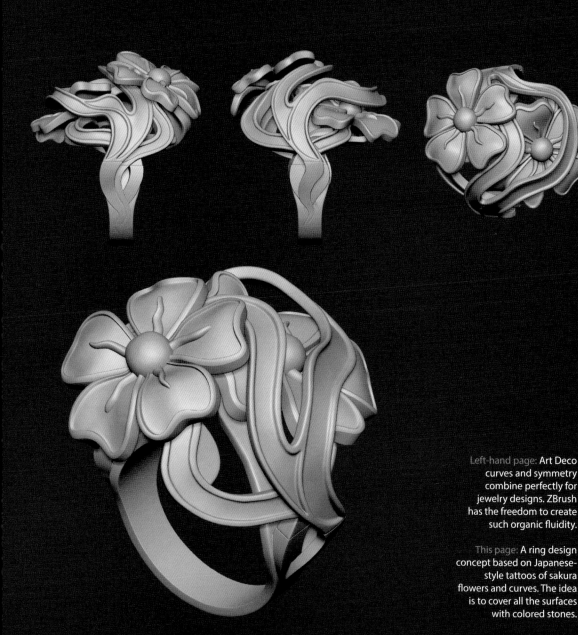

Left-hand page: Art Deco curves and symmetry combine perfectly for jewelry designs. ZBrush has the freedom to create such organic fluidity.

This page: A ring design concept based on Japanese-style tattoos of sakura flowers and curves. The idea is to cover all the surfaces with colored stones.

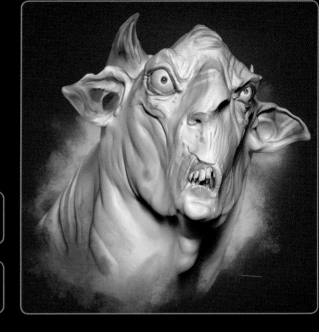

SANDEN, Henning

www.henningsanden.com
All images © Henning Sanden

I've always been very interested in design and shapes and how they impact storytelling. You have a multitude of tools available for the job, pen, paper, and the always trustworthy Photoshop among them. While these tools definitely have their place in a character designer's toolbox, ZBrush is pretty much the *de facto* designing tool for me these days. It really allows me to think purely about the design without any technical limitations being in the way of my creative process. I can very easily change the design to my heart's desire at any point. This is of course great for personal projects, but where I find ZBrush to really shine is when designing for production.

As a designer, one of the key aspects of your job is to communicate visual ideas as quickly as possible. By using ZBrush, I can get very close to a final render of what a creature will look like on screen. This means that a director or supervisor will have a solid idea of the end product, and that I've successfully communicated a visual idea to the people in charge, which I consider to be a key part of the job. The ZBrush sculpt can then quickly be pushed down the pipeline for rapid tests by other departments, getting you even closer to a final product. A huge part of my job involves sculpting and designing in 3D. ZBrush is really one of my main tools for the job for this very reason.

INSPIRATION & IDEAS

The more I work with 3D and art in general, the more inspired I am by the real world around us all. I used to freestyle from my imagination,

and while that's a lot of fun, your work will improve tremendously the moment you start sourcing your ideas from the natural world.

A great example of this is human anatomy and figure sculpting. I find a huge amount of inspiration in classical figure sculpting, such as the work by Bernini. One of the key aspects of learning figure sculpting is that your imaginative work will really be pushed to the next level; it will feel far more grounded and solid than it would otherwise.

TOOLKIT

It's no secret that ZBrush is my preferred choice when it comes to sculpting. It allows me to explore ideas in a way no other software can. I only use a few brushes for the majority of

the work. Clay Buildup with the alpha set to Alpha06 (the semi-sharp round one) is my main tool for most aspects of the sculpt. It's amazing for building volume and defining shapes. I avoid using the Smooth brush, as you lose a lot of definition; instead I go over the shapes with the Clay Buildup brush, so I can control the planes better. The results are usually far more interesting.

My second most used brush is Dam Standard. The moment you want to add wrinkles or any kind of crease, this brush is your man.

'MAKE YOUR FOUNDATION SOLID, THAT'S WHERE YOU MAKE THE PIECE — THE REMAINING STEPS ARE JUST LABOR"

SCULPTING WORKFLOW

The most important tip I can give anyone interested in sculpting or art in general isn't to use a specific brush or alpha in ZBrush. The key to good sculpting is what goes on in your mind while you work. I'm not thinking "Clay, Smooth, Standard, Clay, Trim Dynamic..." as I go. Instead I find good references before I even start, to get a clear idea of what I want.

Once you've started sculpting, spend as much time as you need to build a solid foundation. The foundation includes making the silhouette work, adding gesture to the character, defining skeletal landmarks, and getting the correct feeling in the model. If the foundation is rushed, your piece will

fail to reach its potential. This is by far one of my most valuable tips for sculptors: make your foundation solid, that's where you make the piece – the remaining steps are just labor.

Left: This orc was a quick two-hour sketch inspired by the *Warcraft* universe. Before I even opened ZBrush, I thought about which animal I should base it on; I went with a gorilla. By sourcing the skull of a gorilla, I was able to ground it in reality from the very first brushstroke.

Below: An evening sculpt inspired by *Dishonored*'s style. Maybe the most important part of an image is what it makes you feel like. I ask myself this for every single piece I do. For this sketch, I wanted the character to feel twisted and gnarly – as though there's just something off. I'd sculpt an untrustworthy character in a different manner from an innocent one – down to the way I put down my brushstrokes.

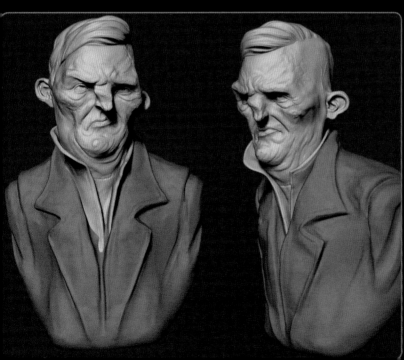

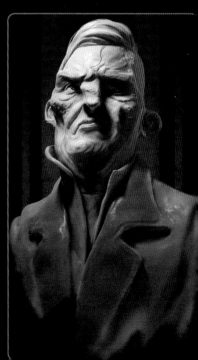

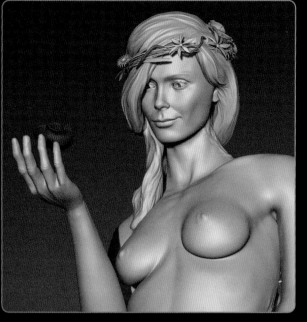
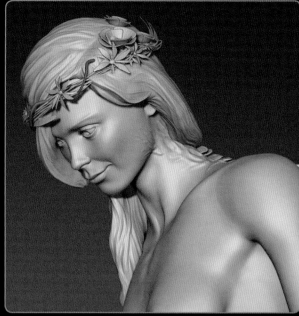
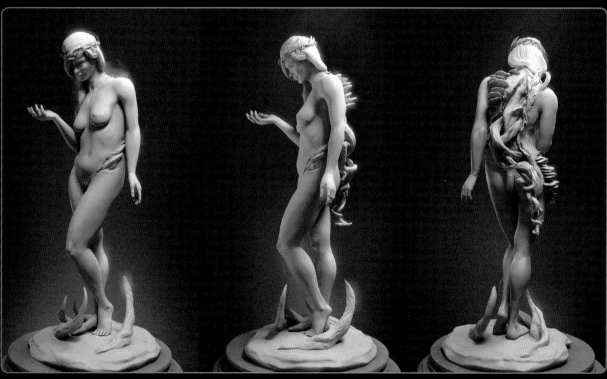

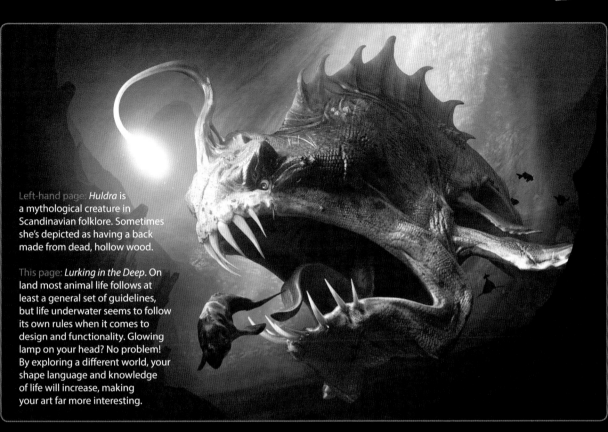

Left-hand page: *Huldra* is a mythological creature in Scandinavian folklore. Sometimes she's depicted as having a back made from dead, hollow wood.

This page: *Lurking in the Deep*. On land most animal life follows at least a general set of guidelines, but life underwater seems to follow its own rules when it comes to design and functionality. Glowing lamp on your head? No problem! By exploring a different world, your shape language and knowledge of life will increase, making your art far more interesting.

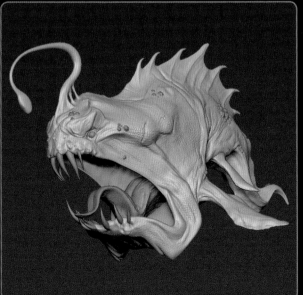

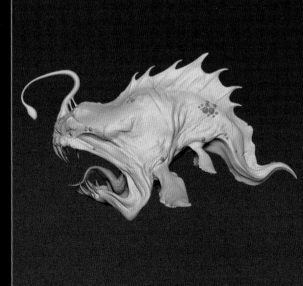

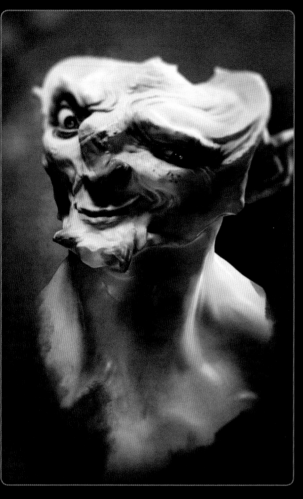

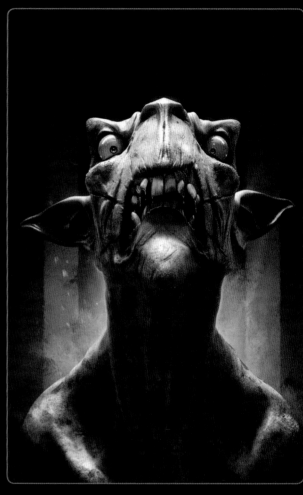

Top left: A late-night doodle. A lot of my work comes from simply sitting down and playing around. You don't always have to redefine what art is or make every piece you do push you forward. Sometimes you just want to sit down, relax, and enjoy sculpting without the need for harsh criticism – when you work as a character modeler, you get enough of that on a daily basis!

Top right: *Moody Conrad* is a piece I did some time ago. I was severely monster-deprived at that point in my life, and I had to get him out for my future sanity.

Right-hand page: A sculpt made over a couple of days in ZBrush and MODO.

APPEAL IS KING!

When doing anything regarding sculpture, you have to take the concept of appeal into account. This isn't just how pretty the face is or how beautiful a female figure can be. Appeal goes far beyond that. In essence, it means that the model is appealing to look at. "But Henning, how can an orc have appeal if he's butt-ugly?" Well, hypothetical book-reader, let me try to answer this. A character can have proportion which doesn't conform to our standard of beauty and still be appealing in the sense that he has a personality, his proportions are well thought out, and his pose is interesting and well balanced.

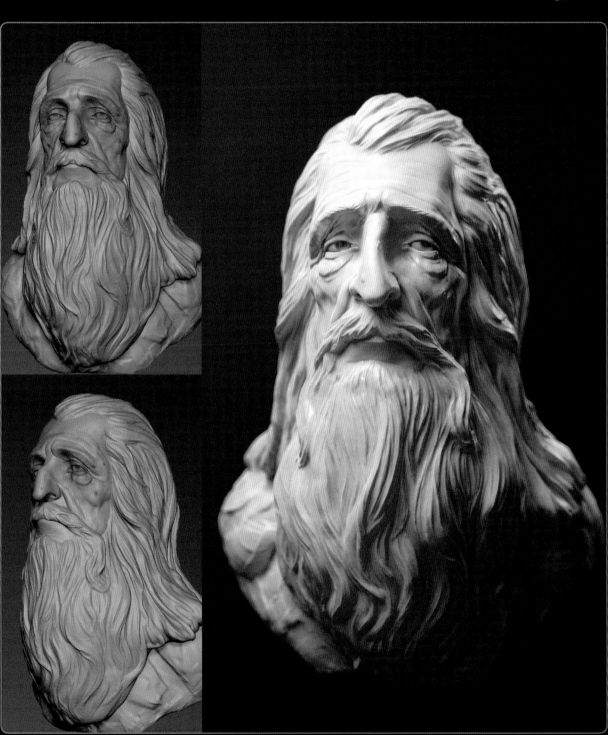

SCHNELLER, Will

www.willschneller.com
All images © Will Schneller

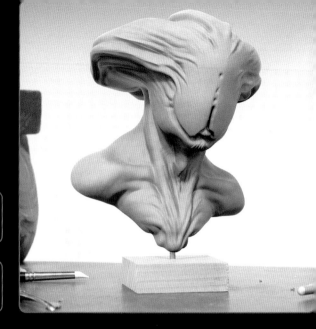

Having worked professionally on smaller games and a fair amount of personal work, I've had ample opportunities to experiment with various tools and workflows. By far one of my favorite activities is sketching in 3D using ZBrush. The feeling of pushing and pulling digital clay is, in my opinion, unmatched. ZBrush feels so natural and I find working in it to be relaxing, almost therapeutic.

ZBrush has become so important in my workflow that this is the method I tend use for designing most of my characters and creatures. Working in 3D allows the artist to evaluate the design in the round; that is to say, you're able to rotate around the model and see it from other perspectives. It really encourages you to not work

quickly discover that something which looks great from one angle may look terrible from another. If you're working professionally, it's likely your sketches are the starting point of a final output that will be viewed from different angles, so it only makes sense to have the same experience your audience will as you create your design.

While designing in 3D isn't as fast as pencil and paper, what you lose in speed I think you make up for in clarity, plus you have a solid base to build from if you want to make a finished 3D asset or maybe do a 3D print.

INSPIRATION & IDEAS
Nature, with its plethora of strange shapes, textures, and volumes, tends

love traveling to zoos to see creatures in person, but in a pinch, thumbing through books or websites works too. I favor somewhat of a chimera approach taking bits and pieces from different creatures to make something fresh and unique. Typically, I don't get too caught up in reference too early as I find it more constrictive. Instead, I'll quickly glance at a large number of reference images to see if something will spark an idea, then assemble more specific references as the design evolves.

TOOLKIT
My most used tools right now are ZBrush for sculpting, KeyShot for rendering, and Photoshop for bringing it all together. Specific to ZBrush, I tend to use only a few brushes. The Clay Buildup, Clay Tubes, Dam

Snake Hook brushes are the ones I use on practically every sculpt. I use the Transpose tool for large-scale adjustments, or Transpose Master when I'm working with multiple SubTools. I always use Polypaint to get a good initial color pass on my designs.

SCULPTING WORKFLOW

My ZBrush design workflow varies depending on if I already have some ideas or not. If I do, I'll block out the design using ZSpheres as it's a good way to quickly build proportions. Once I have something that's close, I convert to a regular mesh and start using the Clay brushes. If I have no ideas, I'll start with a DynaMeshed sphere and use the Snake Hook brush to push and pull it until I find an interesting silhouette. As the shapes come into focus I'll start to flesh out the design with the Clay brushes and Dam Standard.

Left-hand page: Inspired by H. R. Giger's eyeless *Alien* design, finding other ways that creatures interpret their world can lead to some interesting designs.

This page: Learning the biology behind the life cycles of various creatures goes a long way to strengthening your concepts.

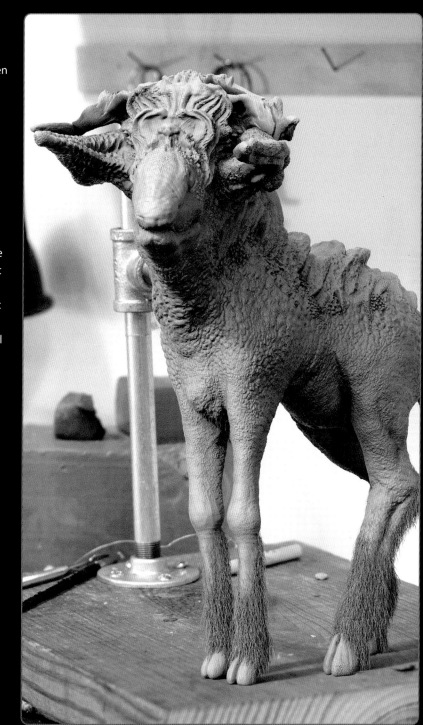

Right: Playing with FiberMesh
can be a great way to add some
different textures to your sculpts
and increase the realism.

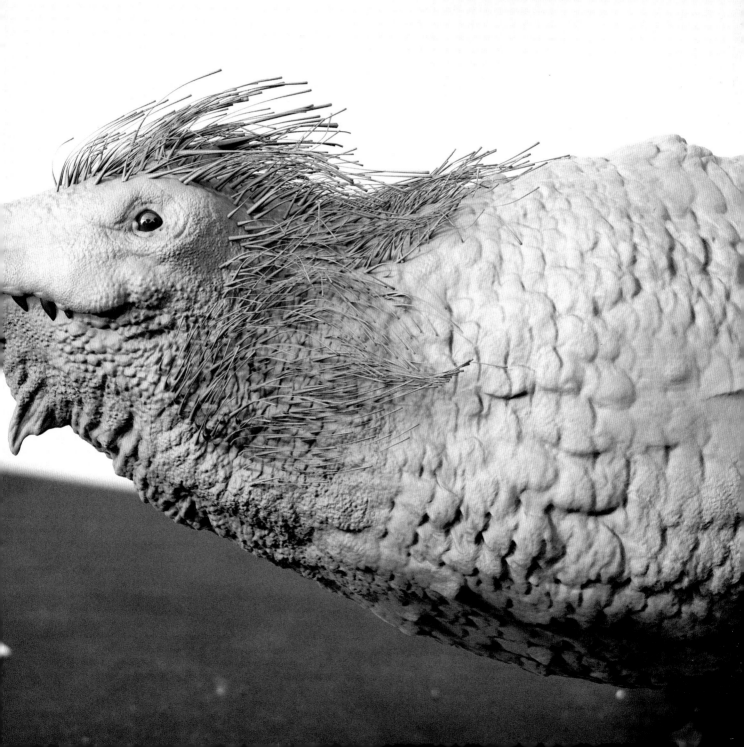

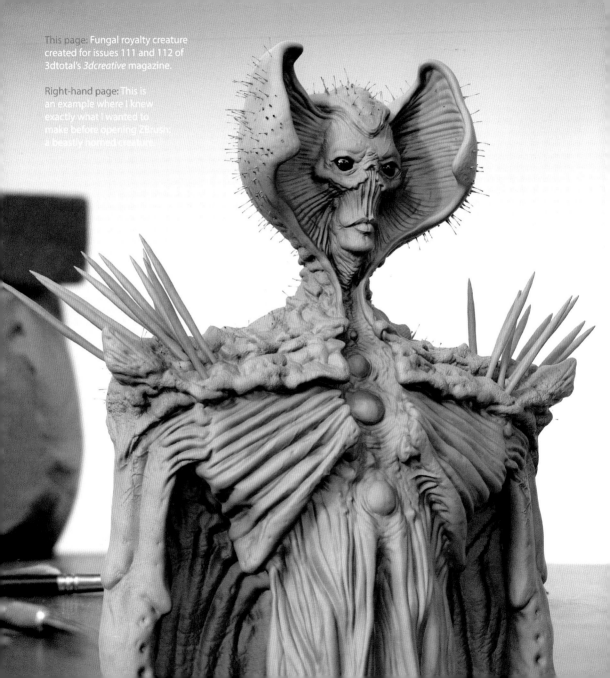

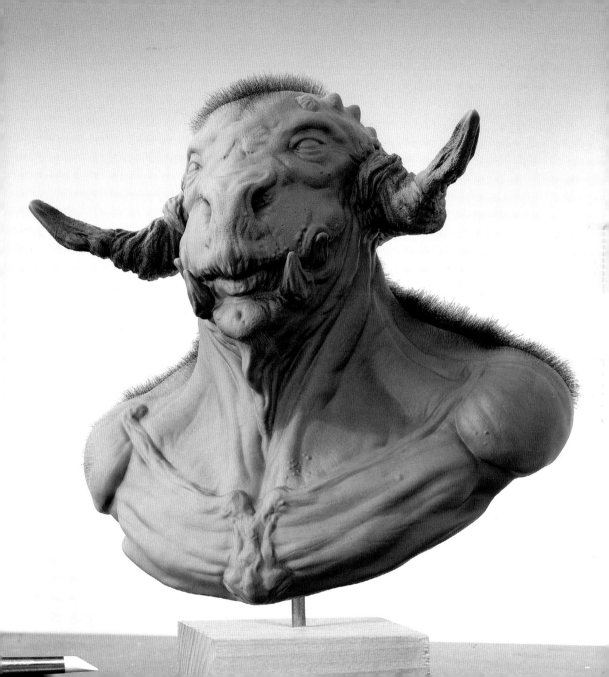

SHERMAN, Shaun

www.shaunsherman.com
All images © Shaun Sherman

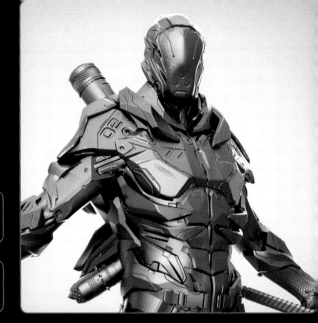

have always been inspired by the incredible images that I saw in films, games, and CG renders, and wanted to have that same level of realism in my own concept art and illustrations. Even though I can paint digitally, to get the level of realism I wanted I had to learn 3D.

After experimenting with various traditional 3D applications, I discovered ZBrush. 3D sketching in ZBrush allows me to explore a design from different views, which makes it easier to solve design problems, and also allows me to evaluate if a design works from different angles.

In 3D, realism and lighting are already taken care of, so I can spend most of my time focusing on the design of a concept. If I really like a

sketch that I've done, I can develop it further and take it all the way to a final high-quality sculpt in ZBrush to use for an illustration or final concept design. 3D renders are very forgiving, so another reason I like to sketch in ZBrush is the ability to sculpt a concept quickly, render it in KeyShot, and then do a paint-over and photobash in Photoshop.

INSPIRATION & IDEAS

To explore an idea in 3D, I start off with the big basic shapes of the design, and make sure that the design works at a very low resolution or subdivision level (similar to adding big chunks of clay to a sculpture to build mass). When I'm happy with the basic large masses, I start to define the basic forms with the Move, Clip Curve, and hPolish brushes. From there I work

my way down to smaller and smaller forms and details, and push the sculpt as far as I can with each subdivision level before subdividing again.

TOOLKIT

My favorite applications are ZBrush, KeyShot, and Photoshop. I do most of my sculpting in ZBrush, even hard-surface designs. For hard-surface modeling in ZBrush, I like to use the Clip Curve, hPolish, and Dam Standard brushes. In KeyShot one of my favorite tools is Pin lights, because I can place highlights and rim lights exactly where I want them. Two of my favorite tools in Photoshop are Liquify and clipping masks. Liquify is brilliant for making final adjustments to your concept, and clipping masks are great for working non-destructively when you are compositing several layers

SCULPTING WORKFLOW

When I'm creating a mech suit design, I start by adding large simple armor shapes (low-resolution spheres shaped with the Move tool) on top of a base figure, and then define the armor pieces with the Clip Curve, Move, and hPolish brushes. I repeat this process for smaller armor pieces as well, until the entire character has basic armor paneling. Once the basic shapes are done, I move on to the smaller forms and details like panel cuts with the Dam Standard brush, alpha stencils for logos and textures, and so on, and Insert Mesh brushes for extra details.

"I HAVE ALWAYS BEEN INSPIRED BY THE INCREDIBLE IMAGES THAT I SAW IN FILMS, GAMES, AND CG RENDERS, AND WANTED TO HAVE THAT SAME LEVEL OF REALISM IN MY OWN CONCEPT ART AND ILLUSTRATIONS"

Left-hand page: A futuristic soldier suit concept design. Typography or detail stamps like squares, rectangles, and logos are great ways to break up a surface and create interesting and complicated graphic details.

Right-hand page: A concept design of what a futuristic Navy SEAL could look like.

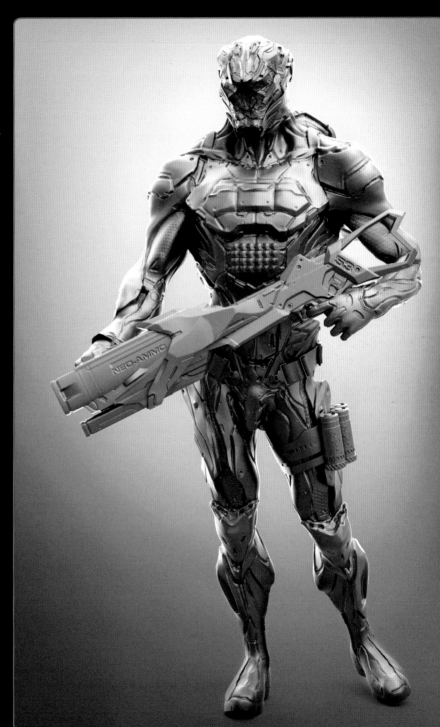

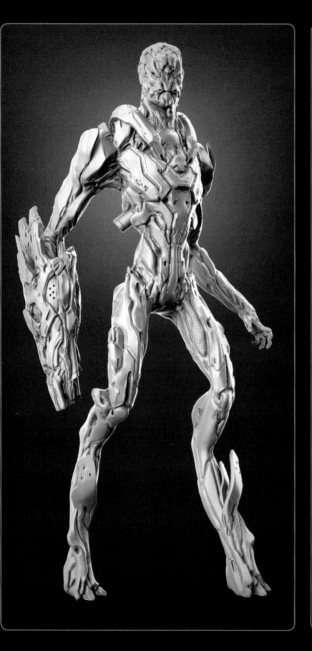

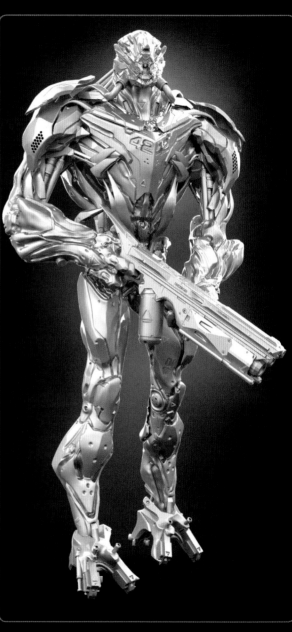

Left: An alien suit design for a portfolio piece.
Right: A robotic alien mech concept design.

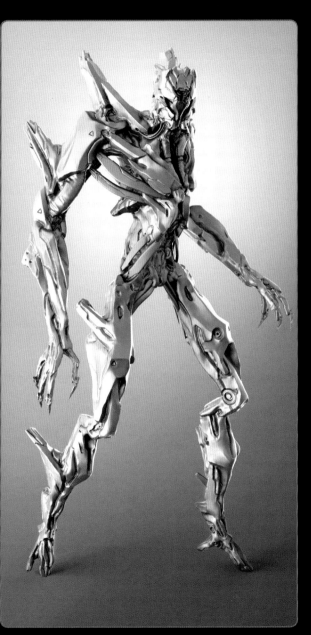

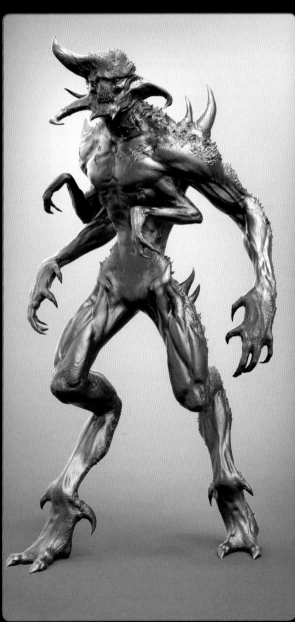

Left: An alien suit concept design.
Right: A concept for a film character design workshop.

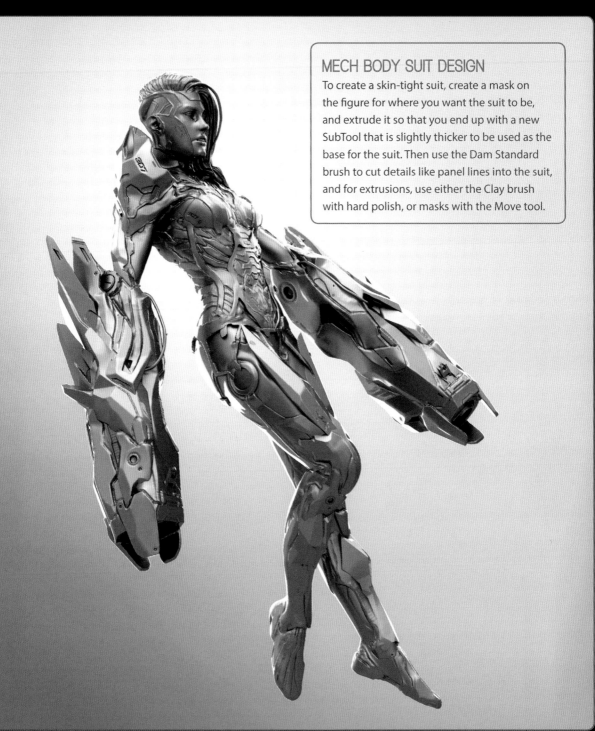

MECH BODY SUIT DESIGN

To create a skin-tight suit, create a mask on the figure for where you want the suit to be, and extrude it so that you end up with a new SubTool that is slightly thicker to be used as the base for the suit. Then use the Dam Standard brush to cut details like panel lines into the suit, and for extrusions, use either the Clay brush with hard polish, or masks with the Move tool.

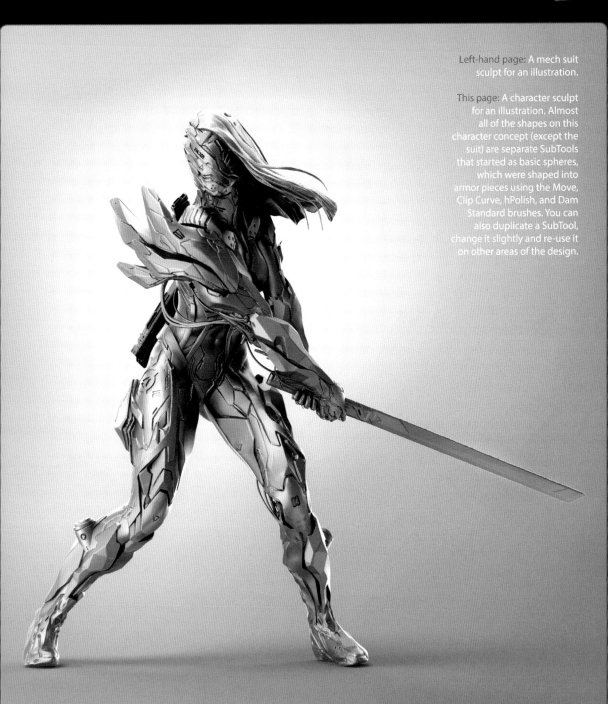

Left-hand page: A mech suit sculpt for an illustration.

This page: A character sculpt for an illustration. Almost all of the shapes on this character concept (except the suit) are separate SubTools that started as basic spheres, which were shaped into armor pieces using the Move, Clip Curve, hPolish, and Dam Standard brushes. You can also duplicate a SubTool, change it slightly and re-use it on other areas of the design.

SOUTHERN, Glen

www.southerngfx.co.uk
All images © Glen Southern unless stated

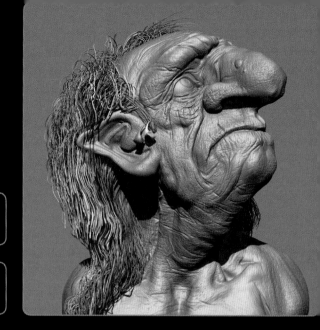

Sketching in 3D is simply an extension of the process I've been using all my life. Getting my ideas out of my head is the important thing, not where I put them. In recent years my go-to method for idea generation was always a Moleskine sketchbook and often just a ballpoint pen. While I will always sketch that way, I've found that it is often faster and more fulfilling to get straight into 3D and sculpt my idea right into ZBrush. Sometimes I just prefer to work my thoughts into a design, and if I can see it in my mind's eye it doesn't take very long to get that done with digital sculpting tools.

I've found that some of my clients like to sit with me and give me "live" art direction as I interpret their designs. We now have tools to rapidly build character and then pose it without investing hours or days in rigging and skinning. Having the ability to draw your ideas is crucial in my line of work and, as I said, sculpting is simply an extension of that skill. Rather than taking time to do a full range of turnarounds, I often do a rough pass of my design and then export a full set of turnaround images. That helps me quickly see where the character isn't working from other angles and I can amend an issue before it becomes a problem. Most of my work is either character- or creature-based, to which this type of 3D sketching lends itself perfectly.

INSPIRATION & IDEAS

These days I get inspiration overload rather than artist's block. From Pinterest to YouTube, "art of" books to game trailers, stunning commercials and insanely complex CG in films, I find I'm constantly bombarded with visual stimuli. Being able to go from a spark of inspiration to a fleshed-out idea in 3D is amazing and helps me to get more done in a week. I do lots of anatomy studies to push my own development and I find I'm constantly discovering new areas of human and animal anatomy to study.

TOOLKIT

I'm a long-time ZBrush user, having started to sculpt in 1999. My technique hasn't change dramatically over the years and I use a very simple set of tools. I generally start with any mesh and DynaMesh that into a rough shape, often using Insert Mesh for more complex parts. I still use older tools like ZSpheres and ShadowBox for complex parts, and they get DynaMeshed into

the core model. My basic brushes are Move, Move Topological, Clay Buildup, Inflate, Flatten, and of course Smooth.

SCULPTING WORKFLOW

One technique that I use really helps to keep my models working well on any system. Once I have a really good idea of the basic form for my character (for example I have decided on the number and shape of limbs and digits, the core facial landmarks are in place, and it is roughly the correct proportions), I then duplicate the model and ZRemesher one of them to a low polygon count. I subdivide that one up and project the details from the higher-resolution mesh back onto the lower-resolution one. That way the system never slows down and I can go up and down the subdivisions for posing. I might even do this two or three times in a session.

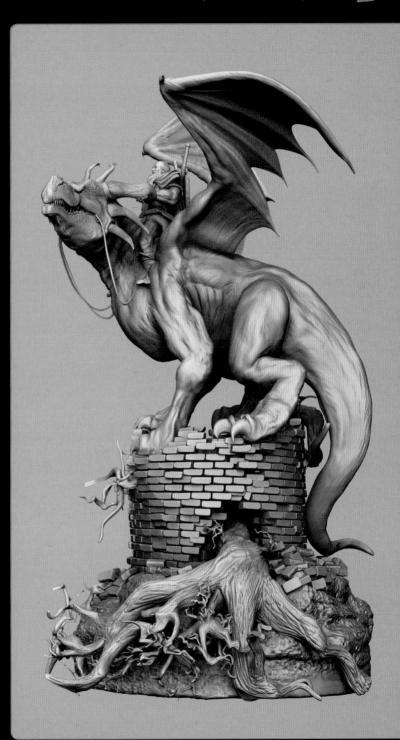

Left-hand page: As this sculpt developed his personality I tried adding a very quick FiberMesh hair test instead of the more usual quick and dirty hair sculpt.

This page: *Dragon Rider*. A large dragon sits quietly atop a ruined tower. This unused sketch idea was created for a magazine cover and helped me to work out scaling and composition early on in the project.

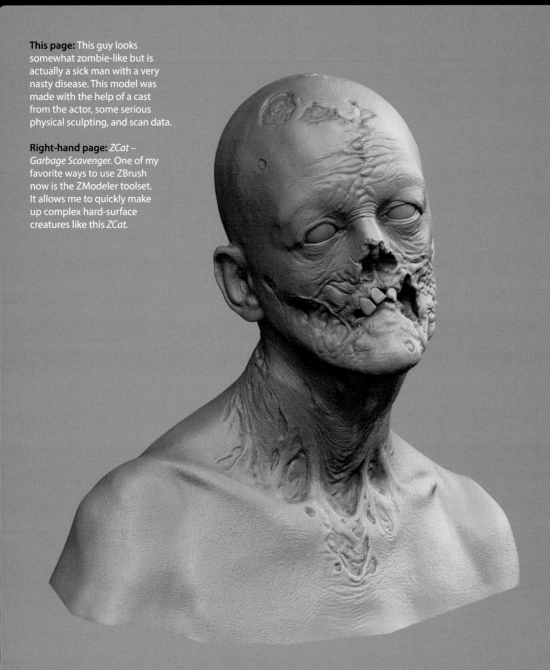

This page: This guy looks somewhat zombie-like but is actually a sick man with a very nasty disease. This model was made with the help of a cast from the actor, some serious physical sculpting, and scan data.

Right-hand page: *ZCat – Garbage Scavenger.* One of my favorite ways to use ZBrush now is the ZModeler toolset. It allows me to quickly make up complex hard-surface creatures like this *ZCat.*

A sculpt for ITV's *Frankenstein Chronicles* (2015) © Screen Scene, Dublin. Original actor life-cast by Barrie Gower. Digital sculpting by Glen Southern.

To get these complex organic shapes into your 3D sketches, go to the Tool palette and look for the Initialize panel. You need to have selected one of the basic 3D meshes from the Tool palette. For a horn, use the Ring3D mesh. In the Initialize panel, change the coverage to less than 360 degrees – 180 is a good start. Then change the settings for the scale and the twist. If you then change the L-Divide and S-Divide, you will start to get incredibly detailed patterns out of that one basic primitive.

Left-hand page: *MakerBot Demon.* One of my early sketch models of a demon bust to test my MakerBot Replicator 2 3D printer. This one had a seriously complex coiled horn setup, but ZBrush gives you an amazing set of primitive shapes to work with.

This page: *Rock Lord* began as a daily speed-sculpt. I find fifteen to twenty minutes of sketching like this warms me up for the day ahead.

STARKIE, Luke

www.starkieart.com
All images © Luke Starkie

I'm a self-taught artist who specializes in character and creature art for games. Born and raised in East Yorkshire, England, I now live in Edinburgh, Scotland, where I work at Rockstar North as a character artist.

Although I feel this is said a lot, I have been drawing from a young age, dedicating a lot of my free time to it. I always had a strong passion for drawing characters and creatures – as if they were going to fit into the worlds of existing games or films.

One day I discovered tools like 3ds Max and ZBrush after looking into the character workflow for games, which then led to learning from tutorials and teaching myself. I eventually managed to build a portfolio. Ever since then I've been spending my free time digitally sculpting creatures and characters in ZBrush.

I sketch in 3D because I feel there are many ways to experiment with design. It's easy to see what looks good and what doesn't. Just being able to move and pull shapes around makes it for me. The ability to see your design in multiple angles and lighting conditions is great. As loose as your 3D sketch may be, it can be polished later on in ZBrush after the sketch phase, or taken into Photoshop to paint over and manipulate or further edit with photos and textures.

INSPIRATION & IDEAS

I get a lot of inspiration by looking at artwork made by others throughout the day. I specifically enjoy looking at the work of traditional sculptors.

Characters in games and film have always stuck with me and also influenced my work in some way: *Doom* and *Dead Space* are games that have inspired me greatly. I like to look at the designs in those for inspiration.

When exploring ideas in ZBrush, I tend to start with a bust or a sphere. For example I'll take a base head I've made in the past (just to speed things up) and DynaMesh it at a low resolution so I don't have to worry about the topology. From there I can smooth it out and start playing with the silhouette and form, changing the shape of the overall head, trying to find something unique looking.

Once I'm happy with the main shapes I can start to think about features of the design: whether it's going to

have eyes, large teeth, ears, and so on. All the while, I'm always looking at reference and trying to pull from it.

TOOLKIT

The main tools I use are ZBrush, Photoshop, and KeyShot: ZBrush for design, sculpting, and texturing; KeyShot for rendering; and Photoshop for compositing, texturing, and design.

Within ZBrush, the main brushes I like to use are Clay, Clay Buildup, Move, Dam Standard, and Slash. I feel these are the best preset brushes for building form and cutting into it.

SCULPTING WORKFLOW

Something I like to do often when creating a creature in ZBrush (assuming you have multiple SubTools, such as eyes, teeth, and claws) is to use Transpose Master, create a layer, and start experimenting with brushes like Spiral, Move Elastic, Snake Hook, and Inflate. Using them to effectively distort the proportions and features of your model, you can quickly see what changes could improve or add more interest to your design. Then you can use the layer you created to either tone down your changes or to see whether you prefer the old or the

new. For example I like to use the Spiral brush on a lower intensity to quickly rotate eyes and the socket areas, then a brush like Move Elastic to shift around larger portions of the model.

Left: A sculpt I made called *Imp*. I wanted to create a creature that looks small for a change.

Below: I came up with this design, *Lurker*, after experimenting in ZBrush.

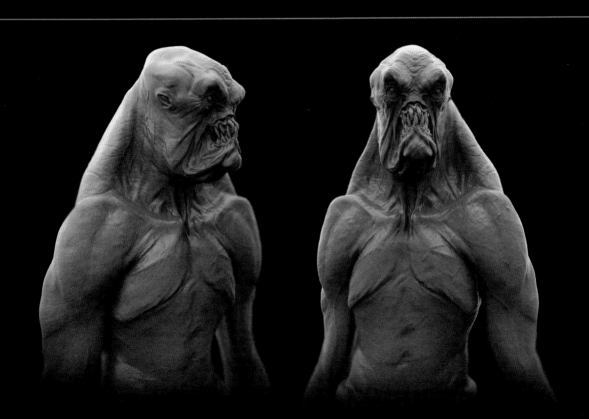

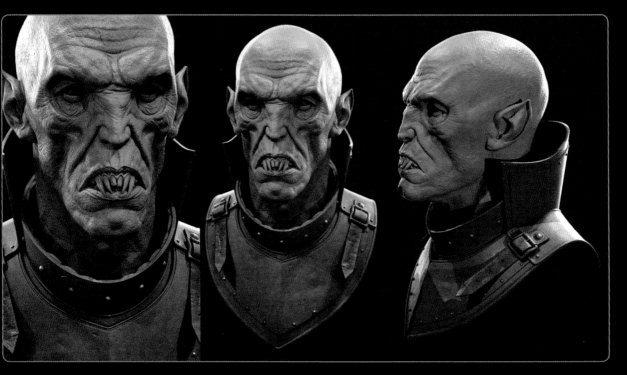

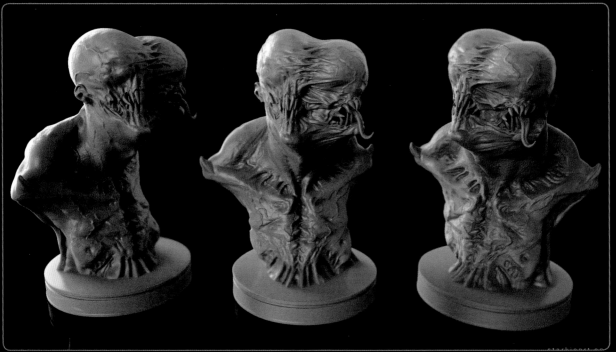

Left-hand page (top): A vampire lord bust I designed and sculpted in ZBrush then rendered in KeyShot.

Left-hand page (bottom): A sculpt I made called *Twins*. I liked the idea of having two heads in one, almost as if they would try to pull away from each other.

This page: Two views of *Imp*, rendered in KeyShot.

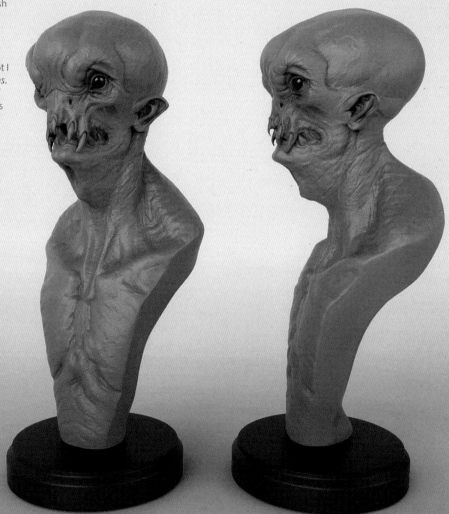

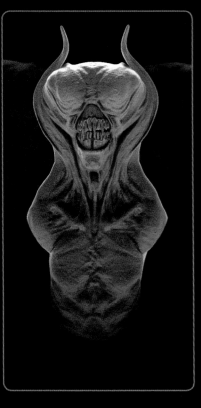

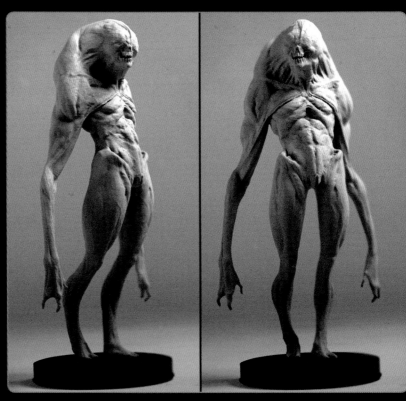

Above: I didn't have much in mind when I created this design – I was just experimenting with shapes.

Top right: A creature design I made to try to distort and experiment with a humanoid figure.

Right: A quick ZBrush sketch I made in my free time. I wanted to introduce grayscale Polypaint to add to the image once rendered using BPR in ZBrush.

Right-hand page (top): A rough design I created while having the word "King" in mind. I wanted to create someone that looked powerful and boss-like. I was going to finish this and create more generic-looking variants which would appear in groups and be servants of the king.

Right-hand page (bottom): A work-in-progress sculpt of a werewolf. Skin detail and sculpted fur are still to be added, eventually.

STÜBEN, Carsten

www.carstenstueben.com
All images © Carsten Stüben

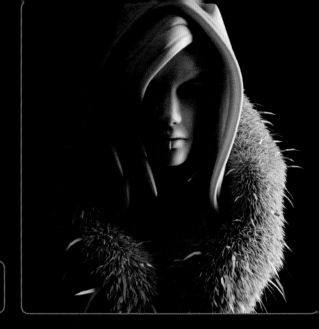

I'm a designer and 3D artist. I've been using ZBrush for three years now, with growing enthusiasm, and I really want to keep evolving in this area. Originally I started with illustration and was always interested in anatomy, character design, vehicle design, and comic art. Drawing and sketching is something very free. All you need is a pen, a piece of paper, and a rough idea. It's intuitive; you can let yourself drift away and anything can arise from this. Making a model from a sketch with a classic 3D program is like having to translate it into another language, copying and interpreting. This can be fun, but it takes time.

For me, ZBrush serves as a bridge between these worlds. All I need is a pen, a DynaMesh sphere, and a rough idea. Just as I do when drawing, I

can try out rough shapes, see what happens, scrap them, extend them, and go into detail wherever I like the design. It's just intuitive and time-saving. This is the reason why I've distanced myself from making 3D designs from 2D sketches. I can't claim that this method is better, but it's often the right method for me. I think everyone has to find their own way to develop and visualize ideas.

INSPIRATION & IDEAS

Inspiration is a crazy thing. It can come from anywhere, but sometimes it feels completely out of reach. Needless to say, I follow community websites in the 2D and 3D area to see what other artists do, and some of them are very inspiring. Strolling through the city, a film, a song, a game... or just staring at the rain can be just as inspirational.

When I have a basic idea of what I want to do, my way of getting inspiration depends on the project. If I want a certain style, it's helpful to do research in that direction, but when the topic is more free I prefer not to look at anything and see what my head might send forth.

TOOLKIT

ZBrush offers quite a lot of tools to realize any imaginable shape. The tools and brushes I use greatly depend on the desired object. If I want organic shapes, characters, and creatures, it's sufficient to work with a small range of brushes: the Move, Standard, Clay Buildup, Dam Standard, and Mask tools.

If I want hard-surface design, I expand this range with the Trim Dynamic, hPolish, Pinch, and Clip brushes.

SCULPTING WORKFLOW

At the beginning of each new sketch
I start with a DynaMesh sphere in
medium resolution. I then employ the
Move tools, Masking and Transpose,
to shape a basic body which I can
use as a starting point for sculpting.
When sketching, DynaMesh really is
the magic word for me. I don't have
to worry about topology or edge flow
and no step is a step too far. A piece
of digital clay. I can just go for it.

Left-hand page: This character is an
image I had in my head, but it remained a
study. DynaMesh sculpt and FiberMesh.

This page: I created this horned
lady some time ago for a personal
project. I really like to sculpt hair.

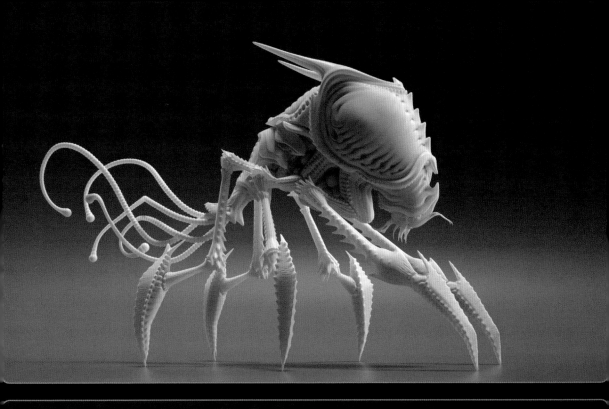

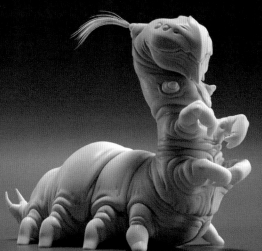

Above: The basic shape of this insect is based on a mosquito. I like to start with a familiar shape which I make alien later on.

Left: A kind of caterpillar. In contrast with the insect above, I wanted something soft and fleshy with deep wrinkles.

Right-hand page (top): A sketch from a row of buggies. In each sketch I tried to find another focus. The first buggy had a very big tail, so I put the focus on the middle part here. This resulted in a buggy that seems slower, but also heavier and stronger.

Right-hand page (bottom): A top-down view of all three buggy sculpts.

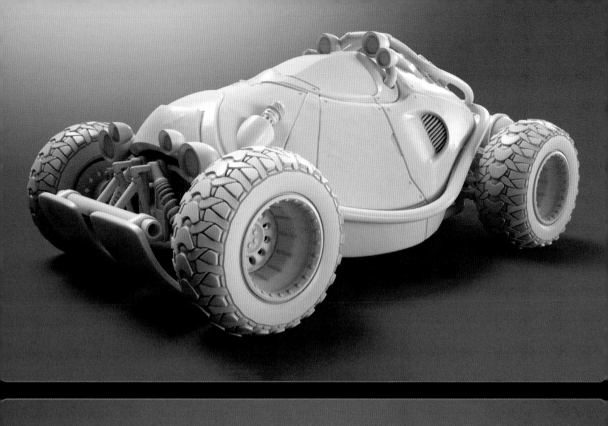
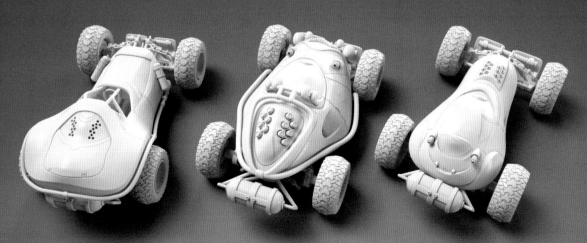

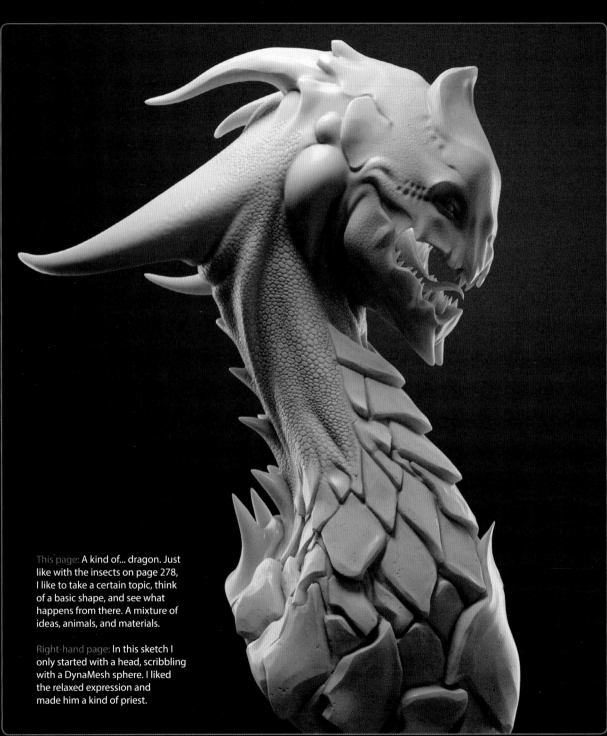

This page: A kind of... dragon. Just like with the insects on page 278, I like to take a certain topic, think of a basic shape, and see what happens from there. A mixture of ideas, animals, and materials.

Right-hand page: In this sketch I only started with a head, scribbling with a DynaMesh sphere. I liked the relaxed expression and made him a kind of priest.

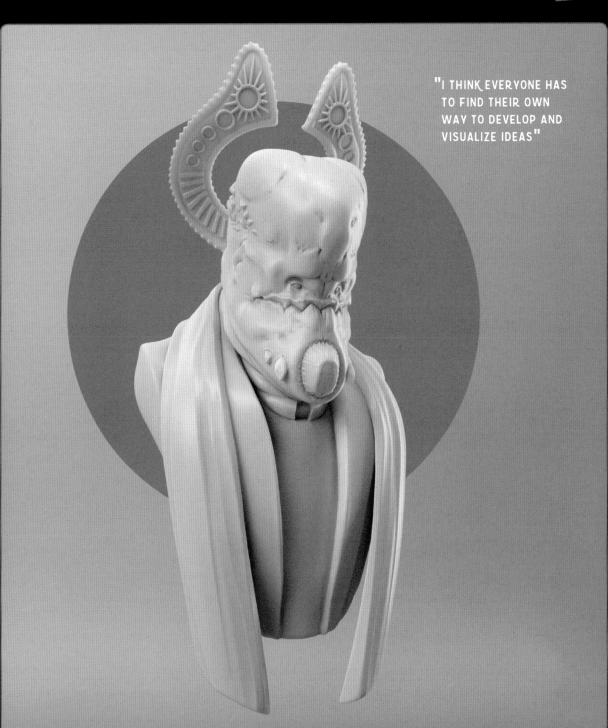

"I THINK EVERYONE HAS
TO FIND THEIR OWN
WAY TO DEVELOP AND
VISUALIZE IDEAS"

SURET, James

www.artstation.com/artist/zerojs
All images © James Suret unless stated

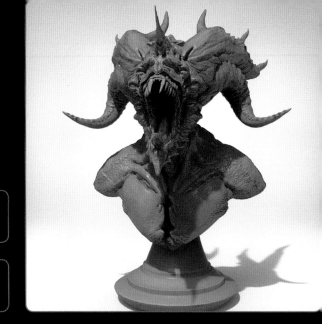

have used pencil, paint, and clay in the past to attempt to express my creativity in the physical world. While I found a sense of satisfaction in finishing a traditional piece, there was always something that constrained me from bringing my imagination to life. Then I found ZBrush and the fantastic creative freedom it allows. As soon as I learned to use ZBrush, I was amazed at the speed at which I could create a 3D model of what was in my mind. I actually find it easier to work this way rather than drawing in 2D first. With traditional sculpting you would need to plan or have a concept ready first, but with digital sculpting you can work directly from your imagination.

INSPIRATION & IDEAS

I started sketching in pencil and ink when I was very young; my main source of inspiration was manga and anime film. As I got older I found inspiration in sci-fi and fantasy films. Without a doubt the artist that inspired the biggest change in me artistically was H. R. Giger. His work showed me that art can be dark, twisted, and provoke fear as well as joy. I stared at his original designs for *Alien* for many hours thinking how beautiful they were, but at the same time disturbing.

TOOLKIT

I used to generate the basic 3D form of a model in traditional 3D modeling software and then import into ZBrush for sculpting, but now I can work from start to finish in ZBrush thanks to the many improvements that have been made. I sometimes use KeyShot for ZBrush to create quick, professional quality renders; other times I create several renders in ZBrush and composite them in Photoshop.

SCULPTING WORKFLOW

When I am creating a character based on human anatomy, I start from a pre-made base mesh and then change the proportions and add to the form. However, if I am creating a character from my imagination I start by creating a ZSphere skeleton, then pull out the rough form using the Move and Inflate brushes. From there I mostly use the Clay and Dam Standard brushes to build up the definition and form of the character. During this process I use DynaMesh to recreate the mesh and increase the polygon count. After posing the character using the Transpose tools, I then use several alpha materials to add finer surface details such as wrinkles and pores.

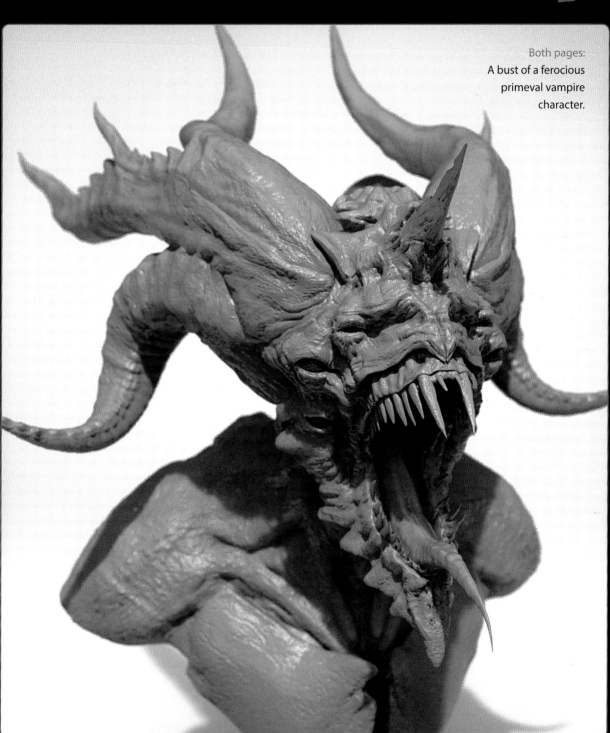

Both pages:
A bust of a ferocious
primeval vampire
character.

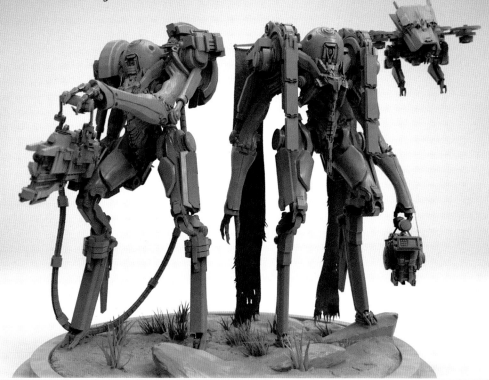

This page: A robotic alien invasion force created using DynaMesh and kitbashing.

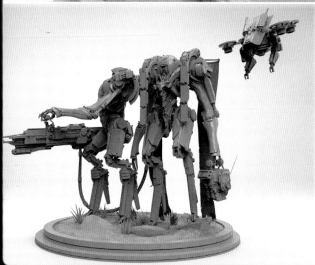

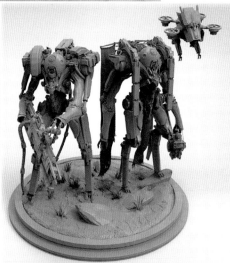

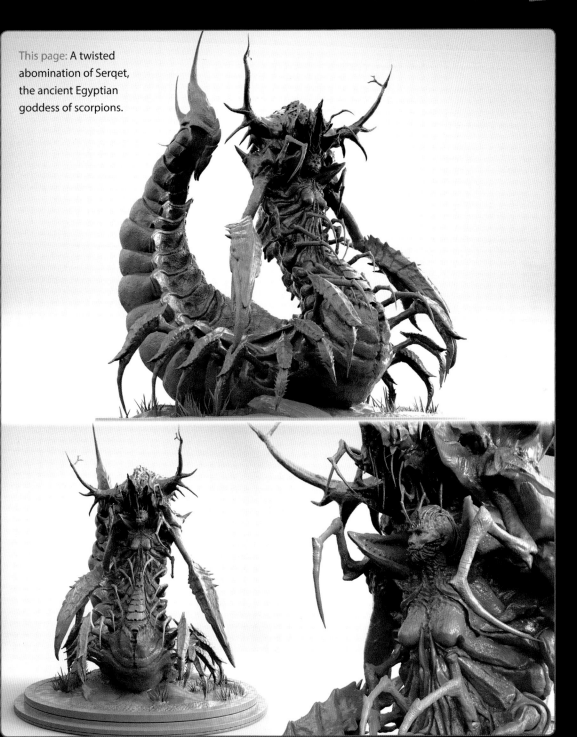

This page: A twisted abomination of Serqet, the ancient Egyptian goddess of scorpions.

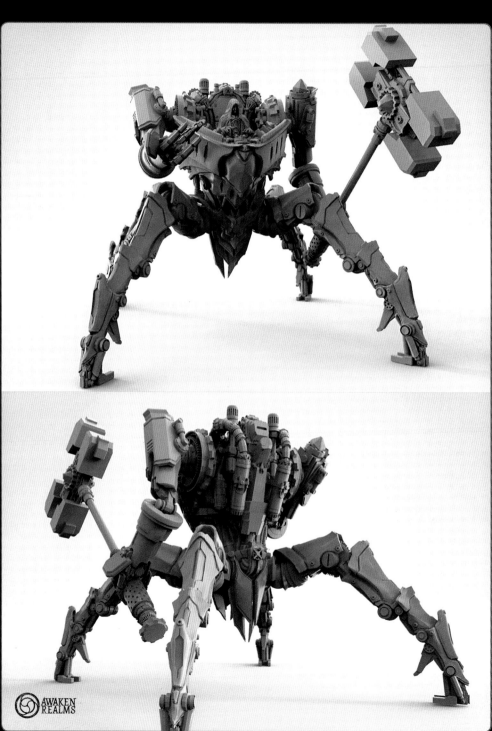

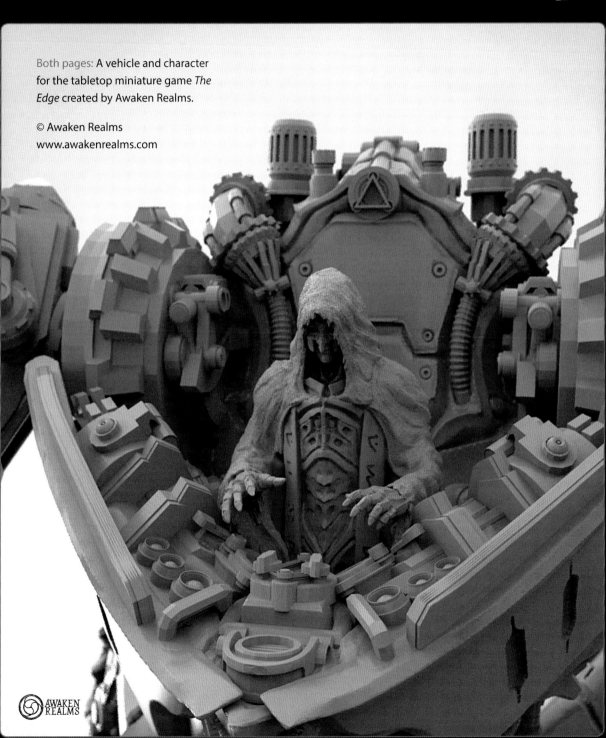

Both pages: A vehicle and character for the tabletop miniature game *The Edge* created by Awaken Realms.

AWAKEN REALMS

TAVARES, Raul

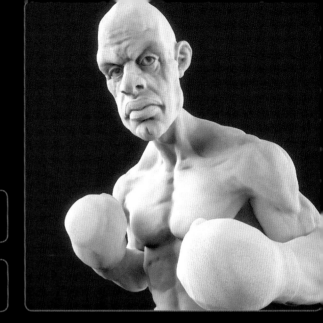

have always been keen on quick but steady development. A day where no progress is made or that I haven't earned anything is a failed one. In that sense, sketching in 3D has proven to be the quickest way for me to do two things: see daily personal development and communicate ideas fast.

The industry and its variants have grown tremendously. Competition is fearsome when there is no time to lose. Being able to sketch something that you can view interactively in 3D is a huge advantage over a static drawing. Silhouette, form flow, light, shape, and so on, are all interactive and can be changed on the fly, which speeds up the whole pipeline. I specialize in creature and character creation for any medium: TV, film, video games, cinematic or collectible figures for print

Though each has its own pipeline, they also have one thing in common: fast pace. So the sketching process allows one to visualize things quickly. On top of that, one can literally have that "sketch" refined and detailed and then turned into a game asset or a 3D print in a matter of a couple of weeks.

Although you need all those foundation skills, like anatomy and shape language, the difference is that you see them grow in front of you and you grow and learn along with them. Instead of struggling to see results fast, you literally see them shaped in front of you in a dynamic and interactive way.

The one thing to keep in mind is detail. I've always been a perfectionist and this has led me to keep working on some things indefinitely (personal work).

Sketching with ZBrush has allowed me to leave perfectionism aside a bit and focus on the information required to communicate the idea.

INSPIRATION & IDEAS

People, for me, are the most inspiring things in this world. If you look at the web of complexity that makes up a human being and his surrounding context, you have indefinite stories to tell. People's life experiences and adventures are pure, raw storytelling waiting to be told. This doesn't mean you have to sculpt just people all the time. On the contrary, let people inspire you to come up with stories that can be told in different ways.

One thing that ties my inspiration to my ideas is a basis in reality. We can be wild and bold but people always

Left-hand page: An anatomy study sketch. I tried to stylize some of the shapes to make it more interesting. There's a satisfaction in picking up a DynaMesh sphere and seeing a character come out of it.

This page: Love is fragile... all it takes is a breeze to fly away. I guess we've all "been there." This was just the sketch of an image I saw in my head – the resemblance to a Banksy creation was unintentional!

need something to relate to or be able to identify themselves with. I can make a weird-looking alien but it will always have some sort of anatomy that is reality-based, like the arms or legs. Fantasy, sci-fi, whatever, it needs to be read as, "Oh… this could exist or happen!" That's always something I look for to ground my designs.

TOOLKIT

I've come to realize that the saying "less is more" makes every bit of sense. So, I use mainly ZBrush and Photoshop with very few brushes for the sketching stage. In Photoshop, the basic brush is my best friend and in ZBrush it's mainly Clay, Clay Build Up, and Move for simplicity's sake. ZBrush feels very intuitive, as do its brushes once you overcome the UI's complexity. You'll find yourself using just a couple of

brushes to quickly sketch things. Don't rule out experimentation, but remember that foundation is key. Actually, foundation is the best tool you can have in your toolkit. Techniques can be learned, but that's just the roof on your house and you need to start with its pillars. Remember to keep things simple and focus on what's important: anatomy, shape language, form flow, storytelling, pose, and so on.

SCULPTING WORKFLOW

I normally start my work directly in
ZBrush, though occasionally I draw
some simple thumbnail sketches to get
my work planned, or other times I'll first
build a small A4 sheet with references
and inspirations to guide my decisions.

My workflow in ZBrush can be a bit
chaotic, though one thing is always
consistent: DynaMesh. I normally
start from a sphere or cylinder and
work my way through the sculpt by
changing DynaMesh levels. If I'm doing
something more specific with weird
features, I might use ZSpheres for a
quicker overall feel of the silhouette.

When I'm happy with the overall shape
and silhouette, I use ZRemesher to
improve the polygon flow for sculpting
and then increase the levels as needed
for detail. Two things I normally don't
do while sketching are to go above
secondary details or to stay too long
on just one part of the model. I try
to jump around the sculpt as much
as I can to see how things work,
connect, and relate to each other.

The reason why I don't focus on detail is to
keep the ideas and creative momentum
flowing, and also because I can always
make some quick renders and make the
sketches look slightly more polished than
they are. Enhancing the sculpt and hiding
some imperfections can be done in 2D,
which leaves more room to focus on the
important stuff like shape language, how
the form reads under different lighting
conditions, composition, and so on.

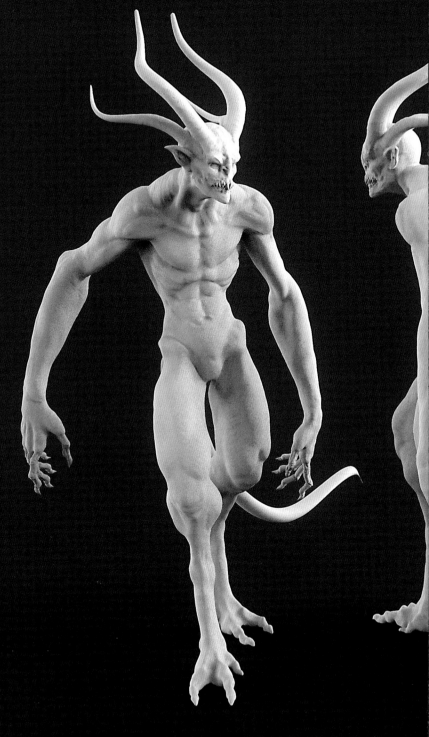

Both pages: Everyone loves demons. I'm no exception. It's a mix of an anatomy study and a bit of fun, with subtle forms and exaggerated proportions.

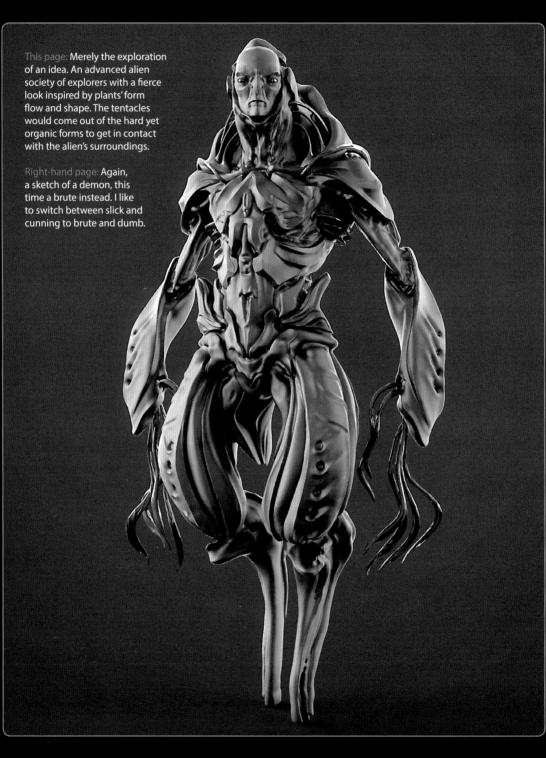

This page: Merely the exploration of an idea. An advanced alien society of explorers with a fierce look inspired by plants' form flow and shape. The tentacles would come out of the hard yet organic forms to get in contact with the alien's surroundings.

Right-hand page: Again, a sketch of a demon, this time a brute instead. I like to switch between slick and cunning to brute and dumb.

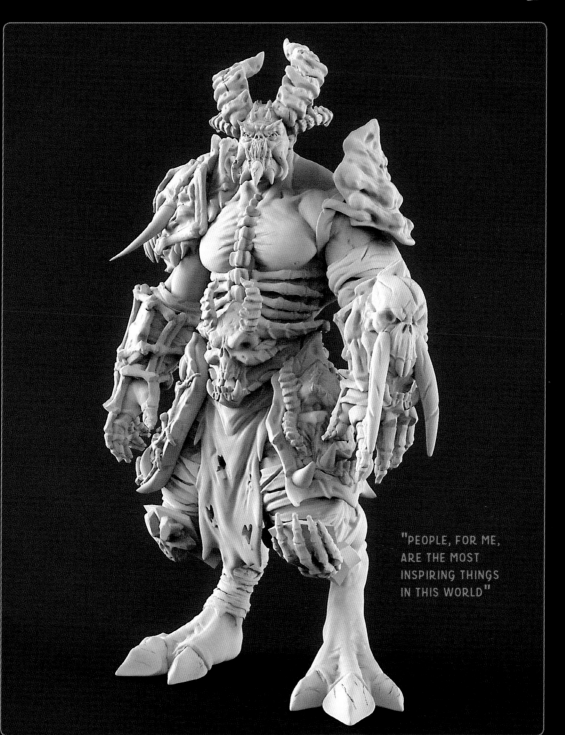

"PEOPLE, FOR ME,
ARE THE MOST
INSPIRING THINGS
IN THIS WORLD"

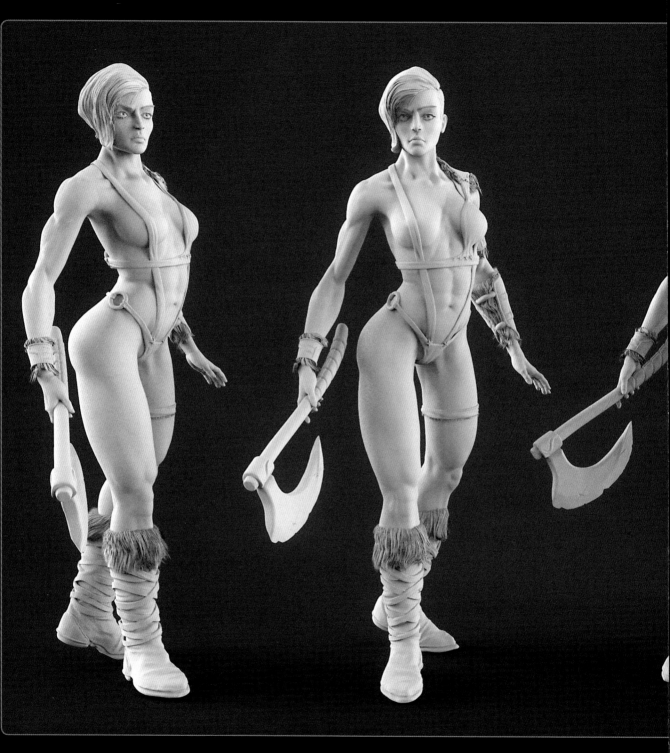

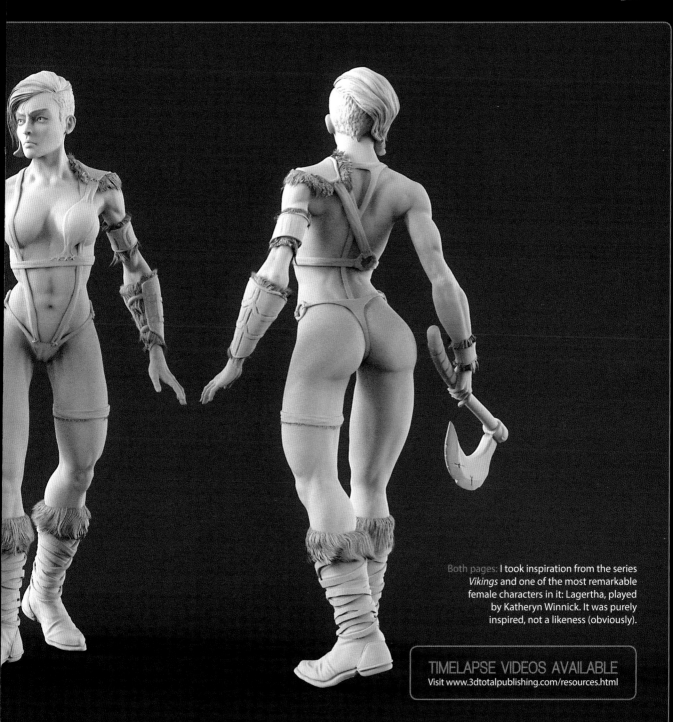

Both pages: I took inspiration from the series *Vikings* and one of the most remarkable female characters in it: Lagertha, played by Katheryn Winnick. It was purely inspired, not a likeness (obviously).

TIMELAPSE VIDEOS AVAILABLE
Visit www.3dtotalpublishing.com/resources.html

TEREKHOV, Pavel

www.goodatom.blogspot.com
All images © Pavel Terekhov

' 've worked in the CG industry for
twelve years. It all began with watching
Shrek. It made such a strong impression
that it literally made me dive into CG
graphics! I'd studied at art school and
classical animation didn't give me
any issues; I understood that to make
a cartoon, you need to just sit down
and draw. But creating characters
for 3D, and how they interacted with
each other, seemed like some kind
of magic, a secret which was open
to only a few people in the world.

started to gather crumbs of
information about how to create such
films. Unfortunately, because I lived
in a small provincial town, no one
around me knew. The internet was very
expensive and slow – at night, when
the speed was a little higher, I could
download 25–30 MB of information

in about eight hours. As each picture
took five to fifteen minutes to load, I
looked for text resources about the
videos I could only dream of. All of
this slowed my progress towards
my goal. It was the year 2003.

Several times I went to Moscow from
my tiny town – internet cafés had
begun to open where the connection
was faster and cheaper. Now we have
the internet in every home, but at the
time I had to travel four hours one way
to download the information for a few
months of studying. But such obstacles
strengthened my resolve even more!

After a while I realized that to develop
in a favorite specialty and start working
in this field, I should move to a larger
town, so I moved to Moscow. I started
as a junior modeler and texture artist

in the game industry, then I worked
on animation projects as a modeler,
setup, and light artist. Then once
again life threw me in the game
development – as a lead concept
artist and then as an art director.

For the last few years I have been
working in the film industry and I
am glad that each new task is more
complex than the previous one, and
that I am entrusted with the work
of a full cycle: from concept to final
model that goes into production.

I use ZBrush very often. This powerful
program allows me to do everything,
from organics to hard-surface.
For this book I chose different
characters to show the power and
possibilities of ZBrush as an ideal
platform for 3D concepting.

INSPIRATION & IDEAS

I practice three ways of sketching and concepting. The first way is to spend thirty minutes in the morning developing an idea before my regular work. I do not limit themes and subjects. I can be inspired by the movie watched the day before or a street scene I saw. But the rule is "thirty minutes at most!" This activity works as a warm-up before everyday tasks and it wakes my brain up. I don't necessarily develop a new sketch every day – I can continue a previous idea if it's exciting.

In the second way, I aim to create a concept or sketch in two to eight hours, mainly for my commercial projects. When I have an opportunity to divide the work over two days I take it and it guarantees a much better result. Our brain thinks over all information of the previous day while we're sleeping, so the next morning I get more than just a "fresh look" at my work – I get new ideas for how to improve it! I read about this effect in popular scientific literature and prove it by experience.

Left-hand page: Sketches of girls always take longer because we must do everything carefully, so they don't look like grandmothers. I intentionally gave a kid's facial features to this model – small chin, round cheeks, large eyes.

This page: I've been developing this character for a long time. I created the head in about two working days, but before that I had done a lot of preparatory work. I'd gathered a mood board and developed a huge amount of 2D and 3D sketches, not only of the head, which you see now, but also of the body, hands, and feet, which you can find on my blog.

Finally the third way – a hardcore one – is when I need to develop a high-quality "ready-for-production" model in a very short amount of time. And at the beginning I do not even have a sketch. This type of project usually appears once or twice a year as freelance work and it's the most challenging type!

TOOLKIT

I work with a Wacom Intuos Pro tablet, and I generally use ZBrush, Maya, and Photoshop, with V-Ray for rendering. I've worked in KeyShot before but V-Ray allows me to set the light and materials more flexibly. I mainly use four brushes in ZBrush: Move, Standard, Dam Standard, and Clay Tubes. All the rest are rare and occasional. I always apply layers.

SCULPTING WORKFLOW

In ZBrush I sculpt in a whole piece and divide the geometry very rarely during the sculpting process, leaving it for the final stage. First of all I develop massive basic sizes and forms. When the form is appropriate, I move to the details and decorations. I work in the traditions of classical Russian sculptural schools! Before I start an important project I read and observe a lot. I study the essentials of each detail and how it works. I learnt first-hand that the basis of every form above all is functionality.

Left-hand page: This is a morning sketch, but in this case I set myself more of a challenge. I took a box primitive and set it to 40 degrees on the X axis, 30 for Y, and 20 for Z, and started to sculpt with symmetry turned off.

This page: In this work I wanted to show the anatomy of the machine – a metal frame without an outer shell. I spent more time on this sketch – over eight hours, mainly for the details. It was done in four days (averaging two hours per day).

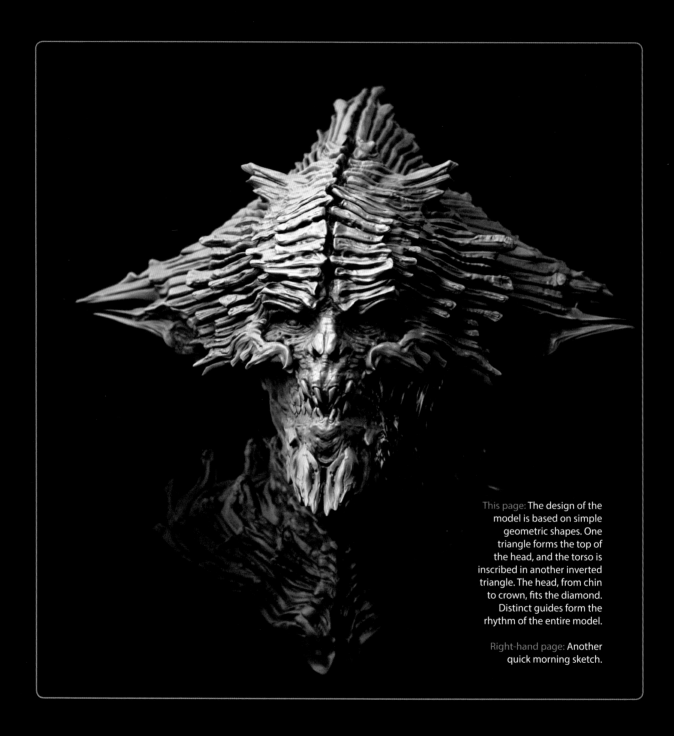

This page: The design of the model is based on simple geometric shapes. One triangle forms the top of the head, and the torso is inscribed in another inverted triangle. The head, from chin to crown, fits the diamond. Distinct guides form the rhythm of the entire model.

Right-hand page: Another quick morning sketch.

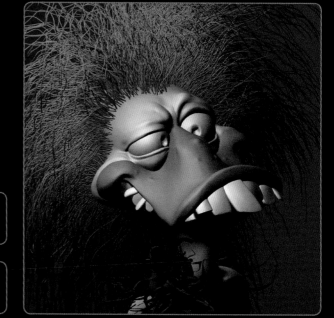

WARMING, Rasmus

www.rasmusw.dk
All images © Rasmus Warming

My name is Rasmus Warming and I live and work in Copenhagen. For the last couple of years I've been doing pre-viz modeling for kids' television. Professionally, I have contributed to commercials, kids' TV shows, and both national and international feature films. After my kids have been put to bed, I often relax doing my own many projects.

INSPIRATION & IDEAS

I take a lot of inspiration from what's out there on the big web; I have a daily routine of a bunch of sites I visit regularly.

I've also been a great admirer of wildlife and mythology since I was a kid. Comics have a big influence too. So I guess a lot of my work comes from mixing all that.

TOOLKIT

Apart from good old pen and paper, I use ZBrush (my weapon of choice), Maya, Silo (still a fantastic and simple modeling package), and Photoshop. I relied heavily on MatCaps in the earlier versions of ZBrush, but now I use the basic material almost solely. It's great for checking shapes and reactions to light.

SCULPTING WORKFLOW

Most of my sketches start with a DynaMesh sphere, which I then push and pull. I try to block out as many of the major forms as possible to begin with, but sometimes I feel the character or creature has to evolve on its own. For example hands might be added at the very end of the sculpting process. If I find a cool idea for some detailing, I don't shy away from trying it out

early in the process, even though it might not be the most efficient way to go. Then I add more spheres as new SubTools and merge them as the sketch progresses. I also use ZSpheres as a starting point; they sometimes help the ideas because of their look, especially if you want to make a chubby or bulky-looking creature.

"I TRY TO BLOCK OUT AS MANY OF THE MAJOR FORMS AS POSSIBLE TO BEGIN WITH"

After the initial sculpt, I might move on to remodeling, perhaps do a paint-over in Photoshop, or simply move on to the next sketch. I use all the usual suspects when it comes to brushes, and I have made my own UI with all the features I use the most.

Left-hand page: I was inspired by Florian Satzinger's awesome duck drawings and decided to make a beaked fella myself. All the parts started with a DynaMesh sphere and were then merged together. His hair is done with FiberMesh.

This page: My initial idea for this creature was a chicken-headed dragon with big pointy scales. While working on it, it sort of found its own look far from my first thoughts. As with most of my work, this started with a ZSphere rig and a simple sphere for the head. I used the Clay Buildup, Crease, Standard, and Move Topological brushes, and FiberMesh for the mane.

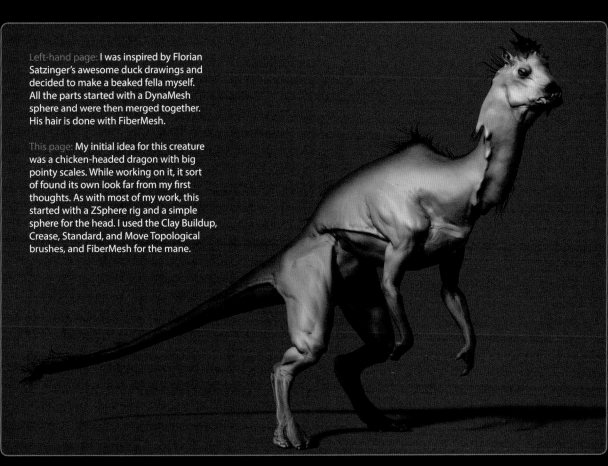

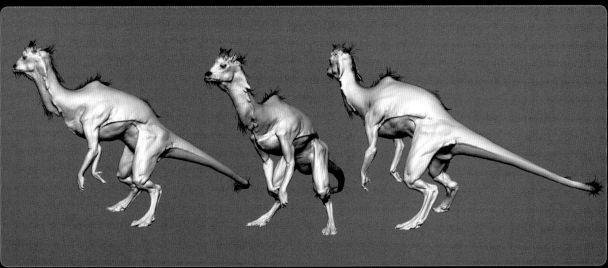

This page: While sketching this, I came up with a small story (something I like to do if the sketch invites it). In British folklore, there are lots of stories of "red caps": old men hiding and attacking travelers in the hills, and dipping their hats in the victims' blood. The model is still very rough but I'd like to add more details to his skin and outfit.

Right-hand page: I knew I wanted to do a quadruped of some sort, but other than that I didn't really have any clue. I still haven't decided whether it should be a forest- or marshland-dwelling creature. This was all done from a DynaMesh sphere.

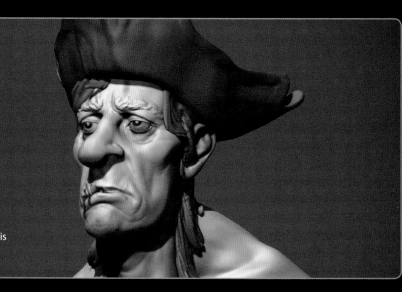

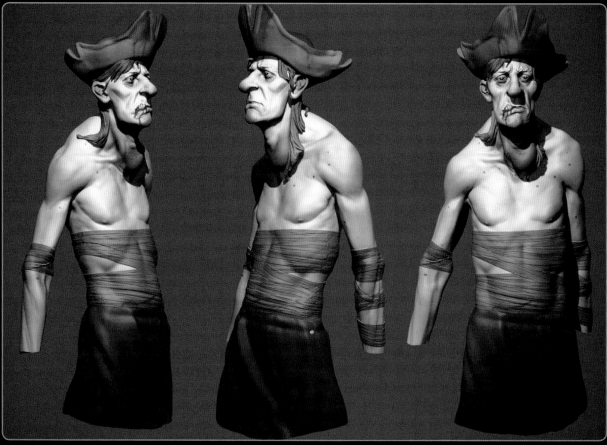

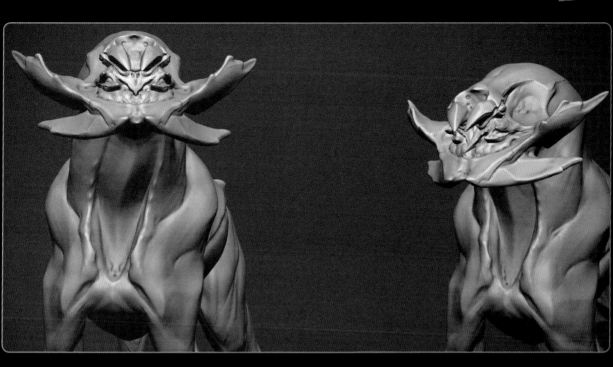

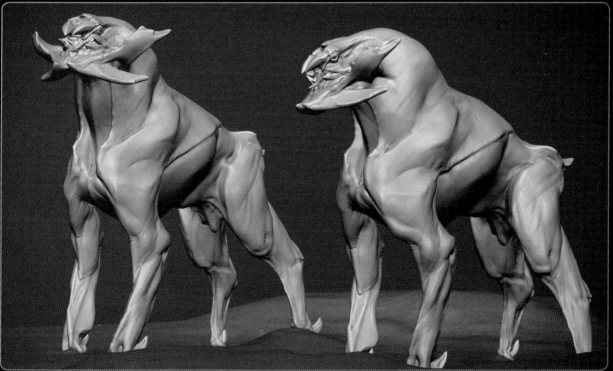

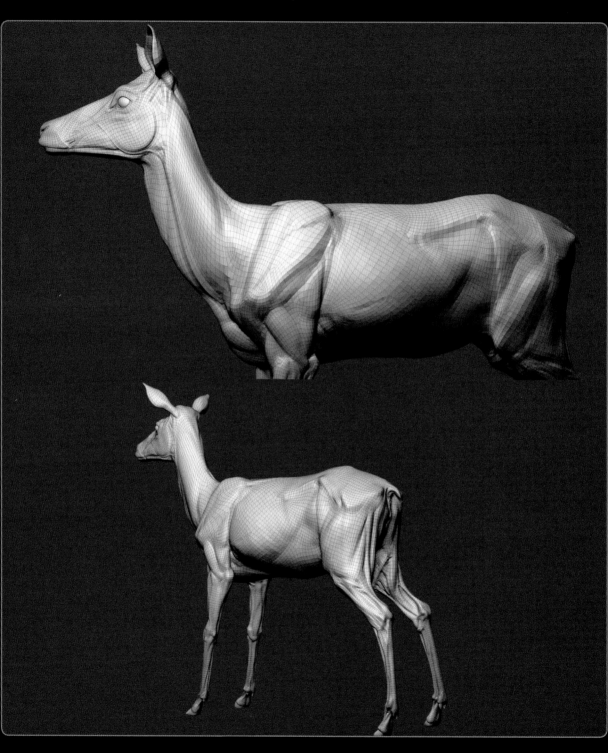

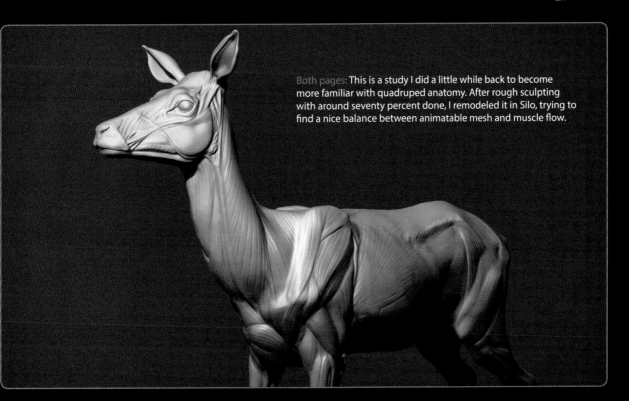

Both pages: This is a study I did a little while back to become more familiar with quadruped anatomy. After rough sculpting with around seventy percent done, I remodeled it in Silo, trying to find a nice balance between animatable mesh and muscle flow.

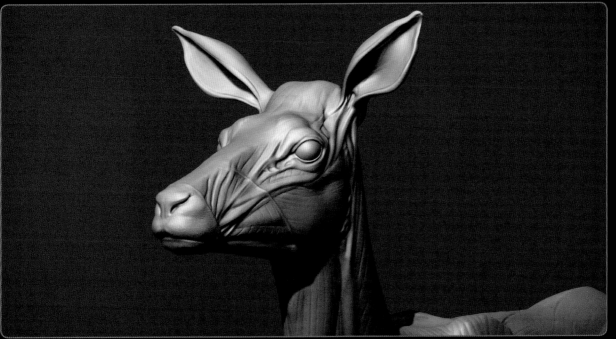

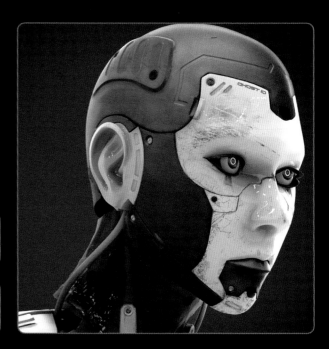

WILKINSON, Lance

www.lancewilkinson.weebly.com
All images © Lance Wilkinson

I've been using ZBrush for about three years now. We didn't get many opportunities at university to use sculpting software but I loved the time spent using it. As soon as I graduated, I made an effort to learn how it worked and what part it could play in my career. At my job with Clever Beans, I spent a good chunk of time working in ZBrush. Prototyping, sketching, detailing, and even texturing were affected by using it. Doing the work in 3D, being able to visualize an idea, quickly gives the asset more life. It's far easier to tell what will or won't work when it comes to video game implementation, which helps when iterating concepts.

I try to find some time outside of my regular working hours to do some digital sculpting; additionally, many of my lunchtimes are also spent sculpting in an effort to break up my tasks and remain fresh-minded. In an industry where speed is paramount, sketching in 3D makes perfect sense. 2D still plays a massive part in getting a basic idea, but roughing it out in 3D with lighting and materials just helps the idea develop so much faster and in most cases looks superior.

INSPIRATION & IDEAS

There is way too much stuff out there that inspires me. I love Blizzard Entertainment's artwork; anything they produce artistically always grabs my attention, both in their cinematic and game works. I am also a huge *Transformers* fan; Josh Nizzi's robot designs are fantastic motivators. I like to watch "making of" documentaries and game play-throughs while I work

in hope of passively gaining inspiration or ideas. When sketching I tend to work really roughly and bash things about in 3D. Duplicate, mirror, scale, deform – sometimes the best ideas found during sketching have been accidental.

TOOLKIT

ZBrush is my bread and butter, it's liberating and stress-free to work in. Some of my go-to brushes are Clay Tubes, Dam Standard, and Trim Dynamic. As for tools, DynaMesh and ZRemesher have really sped up my workflow.

In terms of other software, I use 3D-Coat for video game asset retopologizing, UV, and texturing purposes, alongside Photoshop. 3D-Coat is really fast at mundane tasks and makes UVs fun. Eventually

everything is put together in Maya. I present the final results with either Marmoset Toolbag 2 or KeyShot as they're quick with some awesome results. The ZBrush to KeyShot GoZ app is also a godsend.

SCULPTING WORKFLOW

Like many, I start with a sphere. I like to work as long as I can with low polygon counts and simple Insert meshes to get the basics in; trying to do this with high amounts of geometry is a pain and can cause severe warping or lumpiness in the mesh.

Once all the big volumes are down, it's time to up the DynaMesh resolution and start making the primary forms work well together. I try to remain pretty loose and scrappy in these stages as things tend to flow better. From there it's ZRemesher, Project All, then sculpting to completion.

"IN AN INDUSTRY WHERE SPEED IS PARAMOUNT, SKETCHING IN 3D MAKES PERFECT SENSE"

Left-hand page: A female cyborg head made using hard-surface techniques in ZBrush.

This page: A hard-surface character, my first one using the new ZModeler tools in ZBrush. It went on the be the main character in a game called *APT*.

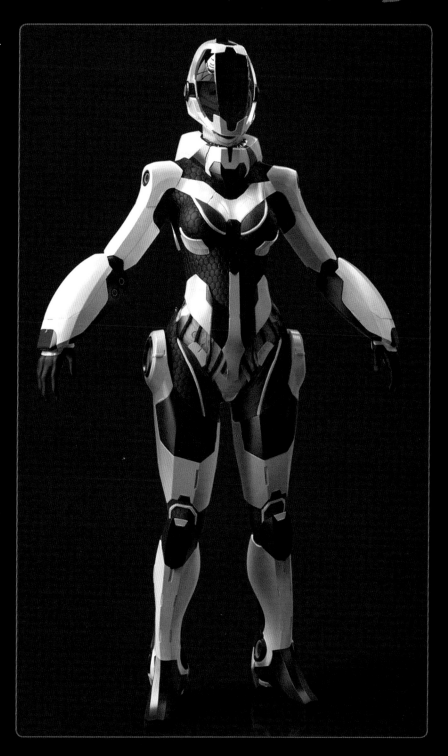

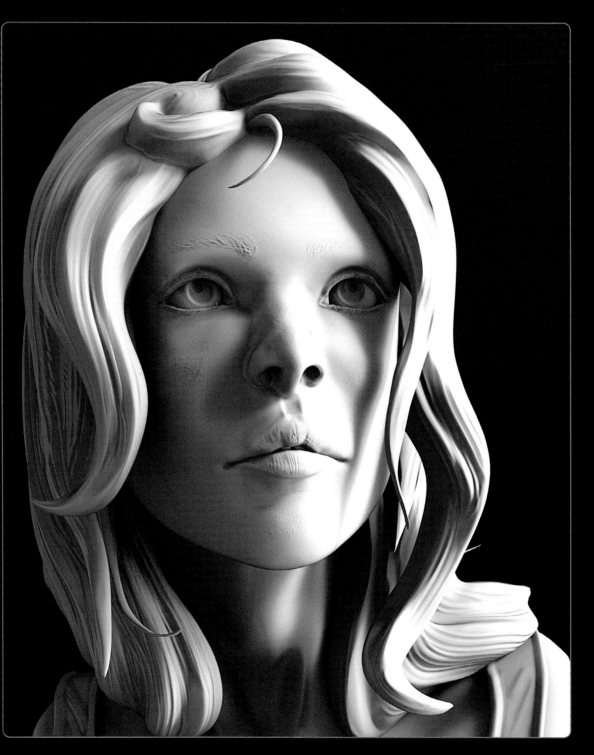

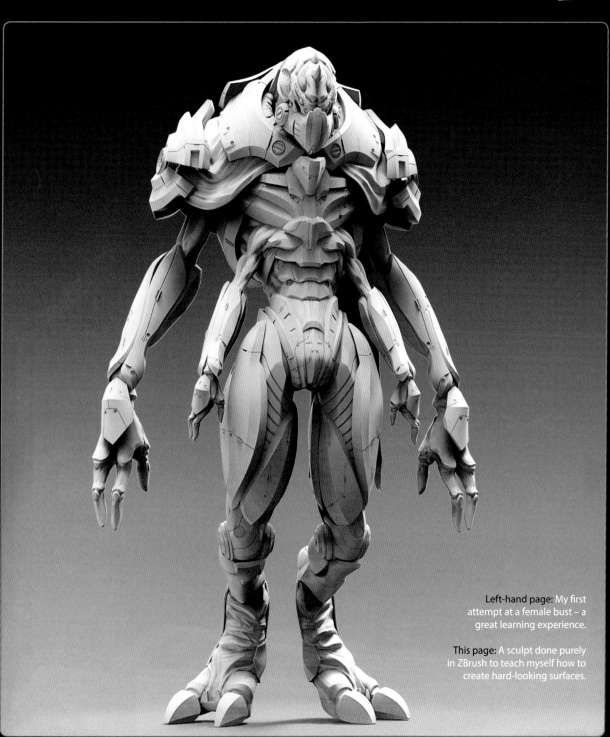

Left-hand page: My first attempt at a female bust – a great learning experience.

This page: A sculpt done purely in ZBrush to teach myself how to create hard-looking surfaces.

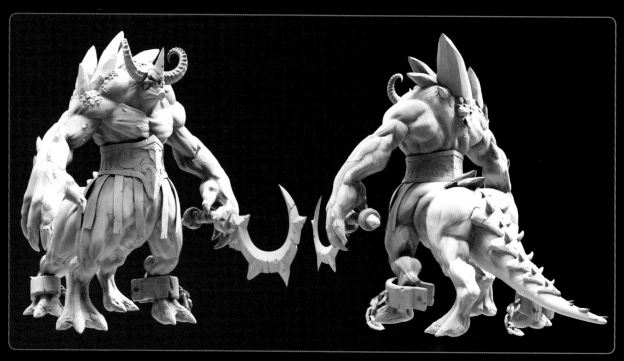

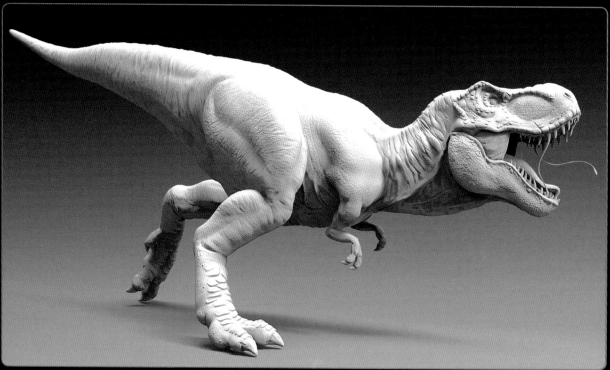

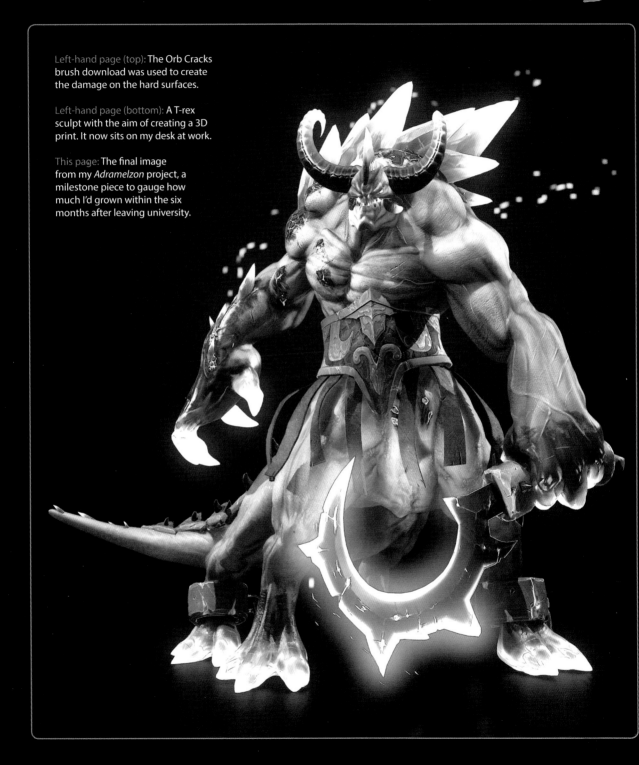

Left-hand page (top): The Orb Cracks brush download was used to create the damage on the hard surfaces.

Left-hand page (bottom): A T-rex sculpt with the aim of creating a 3D print. It now sits on my desk at work.

This page: The final image from my *Adramelzon* project, a milestone piece to gauge how much I'd grown within the six months after leaving university.

ARTIST INDEX

ABDOULLINA, TAISSIA
www.bleuacide.artstation.com
Taissia Abdoullina is a French character artist who made her first steps into the video game industry six years ago. She now works for Ubisoft, with credits including five *Assassin's Creed* titles.

ALBA, RUBEN
www.rubenalba.com
Ruben Alba is a concept artist for film and video games, currently based in the Netherlands. He's worked for Gameloft, Sidhe Interactive, The Aaron Sims Company, and more.

ANUFRIEVA, OLGA
www.he77ga.ru
Olga Anufrieva currently lives in Voronezh, Russia. She works at Wizart Animation as Lead Character Modeler on *Sheep and Wolves*.

ATTARAN, MOHAMMAD HOSSEIN
www.mhattaran.com
Mohammad Hossein Attaran became familiar with 3D art when he was twenty years old, and now he's a freelance hard-surface concept and character artist.

B. N., VICHAR
www.vichar.carbonmade.com
Vichar B. N. is a digital and traditional sculptor based in Bangalore, India, with sixteen years' experience sculpting characters, sets, and props.

BOONYANATE, KONTORN
www.behance.net/dongkont
Kontorn "Dongk" Boonyanate graduated with a BFA in Computer Art from Rangsit University, Thailand. He's interested in 3D sculpture and illustration, and currently works at Igloo Studio.

BOVORNSIRISARP, PANUWAT
www.eternity-nu.blogspot.com
Panuwat "NU" Bovornsirisarp is currently a 3D model supervisor at Picture This Animation in Thailand. He's worked for clients including LEGO, and he also teaches at Digital Box CG.

BRADDOCK, PAUL
www.paul-braddock.com
Paul Braddock has worked as a film VFX artist for over twelve years, specializing in modeling and visual development. He currently works full-time for Animal Logic in Sydney, Australia.

BRANDÃO, CÉZAR
www.cezarbrandao.deviantart.com
Character artist Cézar Brandão studied design and animation at university before heading to Gnomon School of Visual Effects. He now works freelance, with credits including *Halo 4*.

CAIN, JAMES W.
www.jameswcain.co.uk
James W. Cain is a freelance digital sculptor specializing in sculpting for physical production.

CAMEHL, TONY
www.tonyeight.carbonmade.com
Tony Camehl is a self-taught creature designer and concept artist, currently working as a freelancer for the film and games industry.

CHIAMPO, ANDREA
**www.artstation.com/artist/
CA_ANDREACHIAMPO**
Andrea Chiampo is currently a freelance concept artist and industrial designer for the entertainment industry.

CHIN, ANDY
www.andychinart.com
Andy Chin is a young, budding 3D character and creature artist, with a passion for art. He began his 3D art journey in September 2015 and ZBrush is his sculpting software of choice.

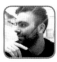

CROSSLAND, JOHN WILLIAM
www.revidge.tumblr.com
John William "Revidge" Crossland is a graduate in Fine Arts from England. He works as a freelance digital sculptor and is currently Senior Character Artist at Remedy Entertainment.

DAOUST, FRÉDÉRIC
www.fredericdaoust23.artstation.com
Frédéric Daoust is a character artist who's been in the industry since 2011 and is currently working at BioWare Montreal on *Mass Effect: Andromeda*.

DIEPENDAAL, IVO
www.ivodiependaal.com
Ivo Diependaal has over seven years' experience of working on commercials and 3D- and VFX-related projects. His specialties are character design, hard-surface, and organic modeling.

ERDT, BENJAMIN
www.ben-erdt.de
Ben Erdt is a character and creature artist, creating both organic and hard-surface concepts. He's currently a character artist at Guerrilla Games, working on *Horizon Zero Dawn*.

FIUZA, JOÃO
www.inkognit.carbonmade.com
João Fiuza was born as "Inkognit" on 17 January 2013, with the dream of becoming a concept artist.

GAO, XIN
http://funkyboy.artp.cc/cover
Xin Gao is a 3D artist from Beijing with an interest in making characters and creatures. He works on mobile games, where he's involved with modeling, animation, effects, and rendering.

GAZA, VICTOR
www.vickgaza.com
Victor "Vick" Gaza is a junior character artist at Guerrilla Games. He has previously worked on Project Morpheus at Sony London Studios.

GÓMEZ, PABLO MUÑOZ
www.zbrushguides.com
Pablo Muñoz Gómez works as a concept artist and animator. He's also a seasonal 3D instructor and heavily involved with 3D and traditional sculpting.

LEISNER, FIELD
www.leizner.com
Field Leisner is a 3D sculptor with a passion for creature design and making monsters.

HAO, JIA
www.artofjiahao.com
Jia Hao is a 3D hobbyist with a passion for designing imaginative creatures and characters. He hopes to step into the entertainment industry and create 3D designs professionally.

LONGHI, GLAUCO
www.glaucolonghi.com
Glauco Longhi is a traditional and digital sculptor, currently employed as a character artist on *Uncharted 4* at Naughty Dog in Santa Monica, California.

HASLAM, LEO
www.leohaslam.com
Leo Haslam is a freelance 3D concept artist and 3D printing enthusiast.

MANOLOV, RAN
www.ranmanolov.wix.com/portfolio
Ran Manolov is a 3D character artist currently freelancing and living in London. He was the main digital sculptor of one of the heroes in *Batman v Superman: Dawn of Justice*.

ISLAM, TANVIR
www.incubatorfx.com
Tanvir M. N. Islam is a 3D generalist from Dhaka, Bangladesh. He founded Incubator Effects Studios in 2012, after several years' working as a CG trainer and modeling supervisor.

MASON, RICHIE
www.artstation.com/artist/richenks
Richie J. Mason is a freelance character and asset artist for video games, movies, and short films. He's thirty years old and lives in Mansfield Woodhouse.

KEAWMAFAI, PAVEE
www.khempavee.artstation.com
Pavee Keawmafai is a 3D modeler and character artist who has worked in the CG industry for three years, working on feature films, TV series, TV commercials, and toys.

MORITA, YUUKI
www.itisoneness.com
Yuuki Morita is a twenty-five-year-old freelance digital artist and creature designer from Tokyo, Japan, where he creates work for film, advertising, TV, and games.

SCULPTING FROM THE IMAGINATION: ZBRUSH

NIKOLOV, MARTIN
www.mnikoloff.com
Martin Nikolov has eleven years' experience in the CG industry, working mostly on game projects, and occasionally on 3D printing and movies. He's currently freelance, based in Sofia, Bulgaria.

ODENDAAL, FRANS
www.artstation.com/artist/frans
Frans Odendaal is from Cape Town, South Africa. He's currently employed as a 3D artist/graphic designer, overseeing and creating 3D assets for apps and games.

PELTOMÄKI, LAURA
www.artstation.com/artist/laloon
Laura Peltomäki is a character artist and 2D generalist working at Mental Moustache, Finland. She loves world-building and constantly wants to create something new.

PEYCHEV, VASIL
www.artstation.com/artist/vasilpeychev
Vasil Peychev is a traditional sculptor and painter currently utilizing ZBrush to 3D print sculpture in polyfoam.

PLOUFFE, MARCO
www.marcoplouffe.com
Marco Plouffe has worked for THQ, BioWare, and Eidos, and freelanced for other big video game, film, and toy companies. Recently, he and Cédric Séaut founded their own company, Keos Masons.

PUSHKAROVA, EKATERINA (KATERIN)
www.ekaterinapushkarova-katerin.tk
Ekaterina "Katerin" Pushkarova is currently a 3D concept artist at Gameloft. She has worked as an animator and technical director for films including *Righteous Kill* and *Conan the Barbarian*.

RABIE, MOHAMED ALY
www.rabieart.com
Mohamed Aly Ramadan Rabie is currently working as a freelance modeler, texture artist, and online instructor in digital character creation. He was born in Cairo, Egypt, in 1985.

REEVES, ALEXANDRA (LEX)
www.elementaldragonart.wix.com/apeirondiesirae
Alexandra "Lex" Reeves, originally from Texas, was a self-taught artist until the age of nineteen, and started attending Gnomon School of Visual Effects in 2015.

RIESCO, NACHO
www.nachoriesco.com
Nacho Riesco Gostanza is a freelance digital sculptor with a special focus on 3D printing and creating designs for the jewelry industry.

SANDEN, HENNING
www.henningsanden.com
Henning Sanden makes monsters for a living from a dark and secluded room. At night he works on **www.flippednormals.com**, creating CG-related content for all you lovely folks!

SCHNELLER, WILL
www.willschneller.com
Will Schneller currently works as an art director in the educational gaming field, but in his free time he likes to build worlds and has a soft spot for character and creature design.

SHERMAN, SHAUN
www.shaunsherman.com
After being a graphic designer for many years, Shaun Sherman followed his true passion and became a concept artist and illustrator. He's working on various comic book projects, as well as freelance character and concept art.

SOUTHERN, GLEN
www.southerngfx.co.uk
Glen Southern is a freelance digital sculptor, certified Pixologic ZBrush instructor, and Wacom Evangelist for the UK and Ireland. His credits include *Penny Dreadful* and work for clients including LEGO and Google.

STARKIE, LUKE
www.starkieart.com
Luke Starkie is a character artist in the games industry, currently working at Rockstar North. He has a passion for digital sculpture and creature design, but enjoys the overall character workflow for games.

STÜBEN, CARSTEN
www.carstenstueben.com
Carsten Stüben has worked as a creative director in a packaging-design agency for nine years, where he uses 3D for rendering product simulations, food, and accessories.

SURET, JAMES
www.artstation.com/artist/zerojs
James Suret is a full-time web developer and freelance 3D artist, focused on creating detailed character and creature sculptures.

TAVARES, RAUL
www.art.artstation.com
Raul Tavares currently works as a freelance concept designer in Portugal. He considers himself a problem solver, not limited to a set of specific tools, whether he's working in 2D or 3D.

TEREKHOV, PAVEL
www.goodatom.blogspot.com
Pavel Terekhov works in post-production, creating movie graphics and freelancing for games and animation. He also enjoys playing guitar, photography, and traveling the world with his beloved wife.

WARMING, RASMUS
www.rasmusw.dk
Rasmus Warming lives in Denmark and drew a lot of odd critters as a kid. When he grew up and saw the chance to work in the creative industry, he took it.

WILKINSON, LANCE
www.lancewilkinson.weebly.com
Lance Wilkinson is a freelance character artist currently working for Rebellion. He's previously worked at Cloud Imperium Games and at TT Fusion on various LEGO games.

© Ian McQue

In each book of the *Sketching from the Imagination* series, 50 talented traditional and digital artists have been chosen to share their sketchbooks and explain the reasons behind their design decisions. Visually stunning collections packed full of useful tips, these books offer inspiration for everyone.

Sketching from the imagination

Sketching from the Imagination:
An Insight into Creative Drawing

Sketching from the
Imagination: Fantasy

Sketching from the Imagination: Sci-fi

Available from shop.3dtotal.com